ART OF TENNESSEE

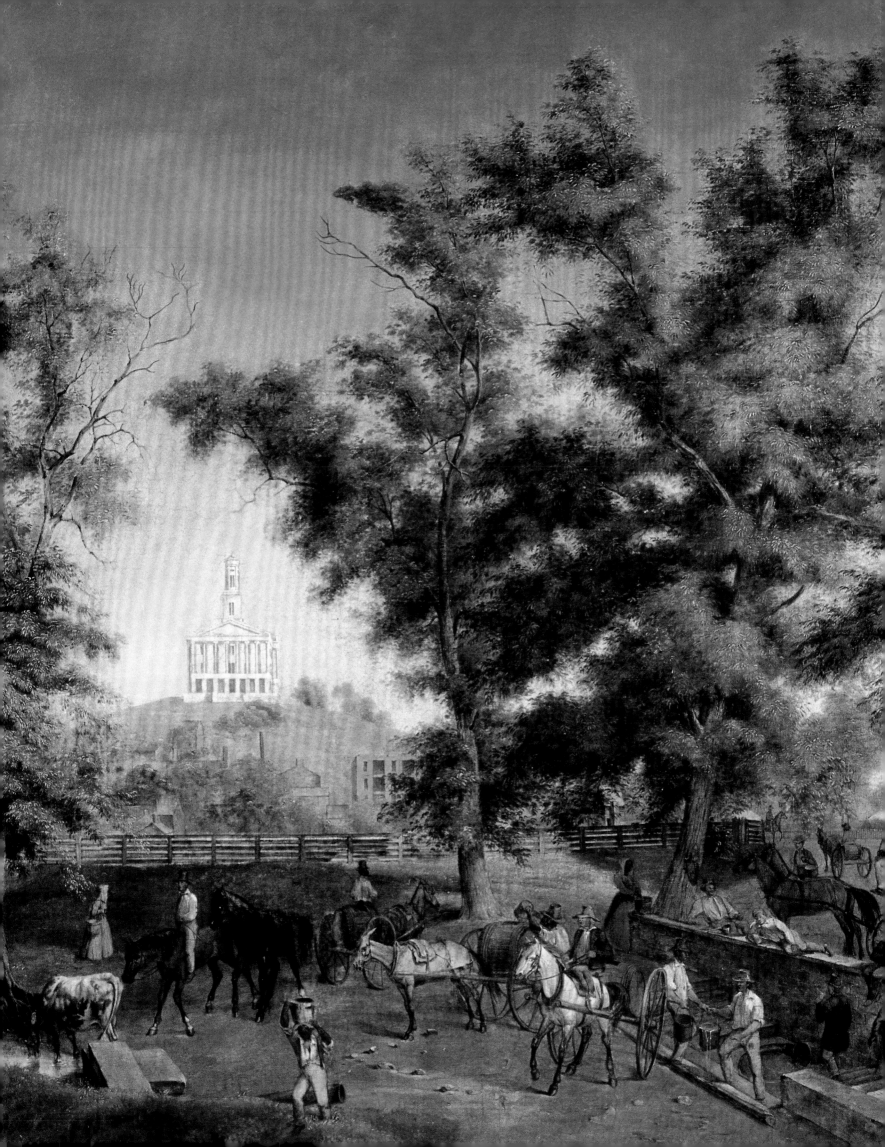

ART OF TENNESSEE

BENJAMIN H. CALDWELL JR.

ROBERT HICKS

MARK W. SCALA

EXHIBITION CURATORS

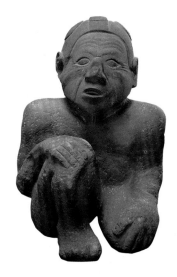

FRIST CENTER for the VISUAL ARTS

Nashville, Tennessee

CONTENTS

6 LENDERS TO THE EXHIBITION

7 CONTRIBUTORS OF ESSAYS AND SIDEBARS

9 CONTRIBUTORS OF ENTRIES

11 FOREWORD AND ACKNOWLEDGMENTS
Chase W. Rynd

15 INTRODUCTION
Benjamin H. Caldwell Jr., Robert Hicks, and Mark W. Scala

19 PREHISTORIC NATIVE AMERICAN ART IN TENNESSEE
Jefferson Chapman

35 YOUNG TENNESSEE AND THE SPIRIT OF AMERICA
Wendell Garrett

Tennessee Maps
Ann Harwell Wells
42

51 THE MATERIAL CULTURE OF NINETEENTH-CENTURY TENNESSEE
Jonathan Leo Fairbanks

55 ANTEBELLUM FURNITURE
Robert Hicks

Sugar Chests
Benjamin H. Caldwell Jr. and Robert Hicks
80

William Winchester Jr., Cabinetmaker
C. Tracey Parks
86

Richard "Dick" Poynor
Rick Warwick
90

Silver Production and Importation in Tennessee
Benjamin H. Caldwell Jr.
92

Pottery
Stephen T. Rogers and Samuel D. Smith
110

Nineteenth-Century Quiltmaking in Tennessee
Bets Ramsey
126

Textile Art in Tennessee through the Early Twentieth Century
Candace J. Adelson
132

141 ANTEBELLUM PAINTING
James A. Hoobler

Ralph E. W. Earl
Estill Curtis Pennington
162

167 TENNESSEANS ON THE NATIONAL STAGE
James C. Kelly

Decorative Arts at The Hermitage
Marsha Mullin
190

"Holding the Line": William Gilbert Gaul as a Military Artist
Dan E. Pomeroy
194

199 PAINTING IN TENNESSEE, 1865–1920
Jack Becker

219 TWENTIETH-CENTURY FIGURATIVE AND NARRATIVE ART
Celia Walker

Celebrating the Human Spirit: Nashville Murals by
Aaron Douglas, Ben Shahn, and Thomas Hart Benton
Katie Delmez Welborn
238

Structures of Recollection: Tennessee Photography as
Document and Art
John Wood
242

259 TENNESSEE FOLK ART
Michael Hall

William Edmondson, Sculptor
Leslie King-Hammond
276

285 MODERN ART FOR MODERN TIMES
Susan W. Knowles

Aaron Douglas's *Building More Stately Mansions*
Amy Kirschke
300

305 CONTEMPORARY CRAFT
Lynn Jones Ennis

337 NEW DIRECTIONS: CONTEMPORARY ART IN TENNESSEE
Mark W. Scala

370 SUGGESTED READING

373 INDEX OF ARTISTS

Lamar and Honey Alexander

Michel Arnaud

The Arts Company

Association for the Preservation of Tennessee Antiquities, Woodruff-Fontaine House

Michael Aurbach

William Baucom and Susan Spurgeon

Belle Meade Plantation

Birmingham Museum of Art

Kell Black

Akira Blount

Blue Spiral 1, Asheville, North Carolina

Michael and Mary Jane Boyd

Jane Braddock

Jason Briggs

Cynthia Bringle

The Briskin Family Collection

Curtiss Brock

Mr. and Mrs. Henry Brockman

Martin and Betty Brown

Trudy and Will Byrd

Ben and Gertrude Caldwell

Ann and Gerald Calhoun

Mary Jo Case

Center for Creative Photography, The University of Arizona

Cheekwood Museum of Art, Nashville, Tennessee

Martha Christian

Larry M. Cognata

Jim Collins

Steve Conant

Martha Connell

Mrs. Thomas Connor

Mr. and Mrs. Charles W. Cook Jr.

Cooper, Love & Jackson, Inc.

The Corcoran Gallery of Art

Country Music Hall of Fame and Museum

Emily Daniel Cox

Carolyn and Giles Cromwell

Ned and Jacqueline Crouch

Customs House Museum and Cultural Center, Clarksville, Tennessee

Faye Dean

George Ducas

Robert Durham

Ewing Gallery of Art and Architecture, The University of Tennessee, Knoxville

Federal Express Corporation

First Tennessee

Fisk University Galleries, Nashville, Tennessee

Fogg Art Museum, Harvard University Art Museums

Robin and Peter Formanek

Solie Fott

Estelle E. Friedman

Bill Griffith

William H. Guthman

Gale Haddock

Paul Harmon

Nathan and Jean Harsh

Alicia Henry

Pinkney Herbert

The Hermitage: Home of President Andrew Jackson

Robert Hicks

Historic Cragfont, Inc.

The Hokes Archives

Dr. Albert Z. Holloway

Earl J. Hooks

Jim Ann Howard

Hunter Museum of American Art, Chattanooga, Tennessee

Jed Jackson

Richard Jolley

Anderson Kenny

Walter and Sarah Knestrick

Knoxville Museum of Art, Knoxville, Tennessee

Lucy Scott and Sam Kuykendall

Paul Lancaster

Paul Pak-hing Lee

Suta Lee

Judy and Noah Liff

Jack and Joanne Little

Russell Love

John and Jane Luna

Frank Martin

Calvin M. McClung Historical Collection, Knox County Public Library

Frank H. McClung Museum, The University of Tennessee, Knoxville

Memphis Brooks Museum of Art

The Metropolitan Museum of Art

April and Bill Mullins

Marilyn Murphy

Museum of Appalachia, Norris, Tennessee

The Museum of Fine Arts, Houston

Greely Myatt

Nashville Public Library

National Archives, Washington, District of Columbia

National Portrait Gallery, Smithsonian Institution

North Carolina State University Gallery of Art and Design

The Ogden Museum of Southern Art, University of New Orleans

Pace Wildenstein Contemporary Arts Gallery and Robert Ryman

C. Tracey Parks

Philadelphia Museum of Art

James K. Polk Ancestral Home, Columbia, Tennessee

Private Collections

David and Peggy Rados

Bets Ramsey

Abby Aldrich Rockefeller Folk Art Museum, Colonial Williamsburg Foundation

Stephen T. Rogers

Michael Rosenfeld Gallery, New York, New York

Tommie Rush

Andrew Saftel

Diana and Robert Samples

San Jacinto Museum of History, Houston, Texas

Nancy and Alan Saturn

Joel and Nelda Shumaker

Smithsonian American Art Museum

Stanford Fine Art

John and Anne Stokes

Ann (Callender) Sharp Street

Tennessee Agricultural Museum

Tennessee State Museum

Travellers Rest Plantation and Museum

Randy and Margaret Trentham

Porter Wagoner Enterprise

Carole Carpenter Wahler

Rick Warwick

Ruth and David Waterbury

Dr. Jerry E. Waters

Timothy Weber

West Tennessee Regional Art Center

Raymond and Linda White

Mr. and Mrs. Ridley Wills II

Ernest C. Withers

Dr. and Mrs. Lawrence K. Wolfe

T. W. Wood Gallery and Arts Center, Montpelier, Vermont

Monty and Linda Young

Namuni Hale Young

CONTRIBUTORS OF ESSAYS AND SIDEBARS

Candace J. Adelson, Senior Curator of Fashion & Textiles at the Tennessee State Museum, holds a Ph.D. in art history from New York University. She has worked internationally as a curator and scholar, publishing extensively on the history of tapestry, costume, textiles, decorative art, and European painting.

Jack Becker is currently Director of the Cheekwood Museum of Art in Nashville, Tennessee, and previously served as Curator of the Florence Griswold Museum in Old Lyme, Connecticut. He received his B.A. from Carleton College and his M.A. and Ph.D. from the University of Delaware and has held fellowships from the Henry Luce Foundation, the Smithsonian Institution, and the National Gallery of Art. Becker has published and lectured on a range of topics connected with American art and gardens.

Benjamin H. Caldwell Jr. is a co-curator of *Art of Tennessee,* the author of *Tennessee Silversmiths,* and has written articles for several periodicals, including *The Magazine Antiques.* He has lectured at Winterthur and Colonial Williamsburg and has served as a consultant to The Hermitage, Cragfont, Oakland, and Belle Meade Mansion. A retired physician, Caldwell served as a member of the Advisory Board of Vice President Gore's Residence Foundation and currently sits on the Advisory Board of Directors of the Museum of Early Southern Decorative Arts Institute in Winston-Salem, North Carolina.

Dr. Jefferson Chapman is Director of the Frank H. McClung Museum at the University of Tennessee, Knoxville, and a Research Associate Professor in the Department of Anthropology. He has more than twenty-five years of archaeological field experience in Tennessee and has curated a number of museum exhibitions on archaeology and the Native peoples of the state.

Lynn Jones Ennis received her A.M. from Duke University and her Ph.D. from the Union Institute and University, where her area of concentration was American Studies. She has studied and written about twentieth-century American crafts and was a James Renwick Fellow at the Smithsonian American Art Museum. Currently, Ennis is Curator of the Collection, Gallery of Art and Design, North Carolina State University, Raleigh. She also serves on the North Carolina Humanities Council.

Jonathan Leo Fairbanks was at the Winterthur Museum in Delaware before founding the Department of American Decorative Arts and Sculpture at the Museum of Fine Arts, Boston, serving as curator from 1971 to 1999. He is guest curator for *Becoming a Nation: Americana from the Diplomatic Reception Rooms of the U.S. Department of State,* which opened at the Portland (Oregon) Museum of Art in April 2003. Fairbanks is the recipient of numerous awards and honors and is the president of the Decorative Arts Trust, an organization dedicated to enlarging public understanding through seminars, lectures, and tours both in this country and abroad.

Wendell Garrett is Senior Vice President, Americana, at Sotheby's and Editor-at-Large, *The Magazine Antiques.* Garrett served as Assistant Editor of the *Diary and Autobiography of John Adams* (4 vols.) and Associate Editor of the first two volumes of *Adams Family Correspondence* and is the author of *Monticello and the Legacy of Thomas Jefferson.* He served as Chairman of the Board of Trustees of the Thomas Jefferson Memorial Foundation from 1987 to 1993 and was awarded the Henry Francis du Pont Award for distinguished contributions to the American arts in 1994.

Michael Hall is an artist, collector, and critic. He is the author of *Stereoscopic Perspective,* a volume of collected essays on folk and fine art, and co-author of *The Artist Outside: Creativity and the Boundaries of Culture* and *Paintings of Charles Burchfield: North by Midwest.* Until his retirement in 1990, Hall was head of the Sculpture Department, Cranbrook Academy of Art, Bloomfield Hills, Michigan. The Hall Collection of American Folk Art is on permanent view at the Milwaukee Art Museum.

Robert Hicks, co-curator of *Art of Tennessee,* is a collector, essayist, and student of Tennessee's material culture. Hicks sits on the Advisory Board of Directors of the Museum of Early Southern Decorative Arts Institute in Winston-Salem, North Carolina. He has served on the boards of the Tennessee State Museum Foundation, Williamson County Historical Society, and Historical Carnton Plantation. A music publisher and artist manager in the music industry, Hicks authored, with the French photographer Michel Arnaud, *NASHVILLE: The Pilgrims of Guitar Town.*

James A. Hoobler is Senior Curator of Art and Architecture at the Tennessee State Museum. From 1978 to 1988 he served as Director of the Tennessee Historical Society. Hoobler is currently chair of the American Association of Museums Curators Committee.

James C. Kelly received his Ph.D. in history from Vanderbilt University in 1974. He was Chief Curator of the Tennessee State Museum from 1980 to 1989, and since 1990 he has been Director of Museums for the Virginia Historical Society. He has published articles on both portrait and landscape painting in Tennessee. Among his recent books are *The Virginia Landscape: A Cultural History* (with William M. S. Rasmussen) and *Bound Away: Virginia and the Westward Movement* (with David Hackett Fischer).

Leslie King-Hammond is the Dean of Graduate Studies at the Maryland Institute College of Art in Baltimore. She is also on the faculty of the art history department, where she teaches courses on women artists, contemporary criticism, African art, and African American art. She has curated numerous exhibitions nationally and writes extensively on a wide range of artists and topical themes.

Amy Kirschke is an assistant professor of art and art history at Vanderbilt University. She received her doctoral degree in art history and history from Tulane University and is the author of *Aaron Douglas: Art, Race and the Harlem Renaissance* and *Art in Crisis: W. E. B. Du Bois and the Art of "The Crisis" Magazine* (Indiana University Press, forthcoming).

Susan W. Knowles is an art historian, curator, and art critic. She has recently completed projects for the Tennessee State Museum, the Frist Center for the Visual Arts, the Customs House Museum and Cultural Center, Fisk University, and the Nashville Public Library. The Tennessee editor for *Art Papers Magazine,* she has also contributed articles to *Sculpture, Number,* and *Raw Vision.* Her essay on the history of sculpture in Tennessee is included in the book

Creating Traditions, Expanding Horizons: 200 Years of the Arts in Tennessee (Tennessee Historical Society and Tennessee Arts Commission, 2003).

Marsha Mullin is Chief Curator at The Hermitage and Director of Museum Services Division (Archaeology, Collections, Education, Interpretation, and Preservation). She co-directed the $2.2 million project that restored the Hermitage mansion interior to conform to its appearance from 1837 to 1845.

C. Tracey Parks is the editor of *The Art and Mystery of Tennessee Furniture and Its Makers through 1850.* He is a practicing attorney, independent scholar of Tennessee furniture, and collector of Southern decorative arts.

Estill Curtis Pennington has been involved in Southern art studies for the past twenty-five years. He is the author of *William Edward West, Kentucky Painter; Look Away: Reality and Sentiment in Southern Art;* and *Catherine Wiley: Southern Impressionist,* among other titles. During his association with the Morris family of Augusta, Georgia, he assisted in the creation of the first museum dedicated entirely to the display of painting in the South.

Dan E. Pomeroy is Chief Curator and Director of Collections at the Tennessee State Museum. He currently serves as Vice President of the Tennessee Association of Museums.

Bets Ramsey is a fiber artist and quilt historian. She is the co-author, with Merikay Waldvogel, of *The Quilts of Tennessee: Images of Domestic Life prior to 1930* and *Southern Quilts: Surviving Relics of the Civil War.* In addition to teaching, lecturing, and writing, she has curated more than fifty craft and quilt exhibitions.

Stephen T. Rogers, Historic Preservation Specialist, has been involved with archaeological and historic site surveys for the Tennessee Division of Archaeology and Tennessee Historical Commission for the past twenty-seven years. Rogers, with Samuel D. Smith, has researched the history of Tennessee's pottery industry for the past two decades.

Mark W. Scala, the Frist Center's Exhibitions Curator, was a co-curator of *Art of Tennessee.* Scala has worked in museums for thirteen years and specializes in organizing exhibitions of contemporary and American art. Before that, he was a critic and editor of *The New Art Examiner,* a periodical devoted to regional, national, and international contemporary art.

Samuel D. Smith has served as Historical Archaeologist for the Tennessee Division of Archaeology since 1974. He is the author, co-author, or editor of numerous reports and publications concerning historic period archaeological research and is a member of several archaeological and historical organizations, including the Register of Professional Archaeologists.

Celia Walker is Senior Curator of American Art at the Cheekwood Museum of Art. Recent publications include the museum's collection catalogue and Fisk University's *Two Paths to Progress* CD-ROM, co-curated with Susan W. Knowles. Her essay on twentieth-century painting in Tennessee will appear in the forthcoming book *Creating Traditions, Expanding Horizons: 200 Years of the Arts in Tennessee.*

Rick Warwick has written a number of books on Williamson County, Tennessee, including *Leiper's Fork and Surrounding Communities; Leiper's Fork: Our Family Albums; Williamson County: Out There in the First District; Historical Markers of Williamson County;* and *Who's Who in Williamson County.* He has inventoried the county's material culture and curated exhibits on local artists, chairs, sugar chests, coverlets, and samplers.

Katie Delmez Welborn is the Associate Curator at the Frist Center for the Visual Arts. She has worked at the Cheekwood Museum of Art, the Museum of Fine Arts, Boston, and the Boston University Art Gallery. After graduating from Vanderbilt University, she pursued her master's degree in art history and museum studies at Boston University.

Ann Harwell Wells is an independent scholar whose articles on Tennessee maps have appeared in *Tennessee Historical Quarterly.* She has written a history of Ensworth School in Nashville and has edited and published a collection of her parents' World War II letters as well as two books by her husband, author and retired psychiatrist Charles Wells.

John Wood is a prizewinning poet and photographic critic. He has published more than twenty books, co-curated the 1995 Smithsonian Institution exhibition *Secrets of the Dark Chamber,* and is editor of *21st: The Journal of Contemporary Photography.* He holds professorships in both English literature and photographic history at McNeese University in Lake Charles, Louisiana.

Candace J. Adelson (CJA) is Senior Curator of Fashion & Textiles at the Tennessee State Museum, Nashville.

William Baker (WB) is Curator of Military History at the Tennessee State Museum, Nashville.

Mike Bell (MB) is Curator of Furniture & Popular Culture at the Tennessee State Museum, Nashville.

Benjamin H. Caldwell Jr. (BHC) is an author, lecturer, and collector of Tennesseana.

John Case (JDC) collects and researches early decorative arts from the East Tennessee region.

Nancy Cason (NFC) is Curatorial Projects Manager for the Frist Center for the Visual Arts.

Jefferson Chapman (JC) is Director of the Frank H. McClung Museum at the University of Tennessee, Knoxville.

Cheekwood Musum of Art (CMA), Nashville, Tennessee.

Brittany Conner (BC) is an adjunct professor of photography and photo history at Watkins College of Art & Design and Belmont University, Nashville.

Jennifer C. Core (JCC) is a folklorist with the Tennessee Arts Commission.

Ned Crouch (NPC), Executive Director of the Customs House Museum in Clarksville, Tennessee, is a collector of American folk art and regionalist paintings.

Paul Harmon (PH) is an artist with studios in Paris, France, and Brentwood, Tennessee, who has exhibited internationally.

Janet Hasson (JH) is Curator at Belle Meade Plantation, a historic-house museum in Nashville, Tennessee.

Robert Hicks (RH) is a collector, essayist, and student of Tennessee's material culture.

Dana Holland-Beickert (DH-B) is an independent scholar and the Visual Arts Curator of "Experience Art in Memphis," Tennessee.

James A. Hoobler (JAH) is Senior Curator, Art & Architecture, at the Tennessee State Museum, Nashville.

James C. Kelly (JCK) is Director of Museums for the Virginia Historical Society, Richmond.

Susan W. Knowles (SWK) is an independent scholar in Nashville, Tennessee.

Lucy Kuykendall (LK) is an independent scholar and collector.

Joyce Mandeville (JM) is the Director of the T. W. Wood Gallery and Arts Center, Montpelier, Vermont.

Marilyn Masler (MM) is the Associate Registrar at the Memphis Brooks Museum of Art, Memphis, Tennessee.

Memphis Brooks Museum of Art (MBM), Memphis, Tennessee.

C. Tracey Parks (CTP) is a practicing attorney, independent scholar of Tennessee furniture, and collector of Southern decorative arts.

Thomas Price (TP) is the Curator of Collections at the James K. Polk Ancestral Home, Columbia, Tennessee.

Bets Ramsey (BR) is a fiber artist and quilt historian in Nashville, Tennessee.

Mark W. Scala (MWS) is Exhibitions Curator at the Frist Center for the Visual Arts.

Susan Shockley (SS) is Curator at the Parthenon in Nashville, Tennessee.

Christi Teasley (CT), fiber artist, teaches and directs the gallery program at St. Andrew's–Sewanee School in Sewanee, Tennessee.

Tennessee State Museum (TSM), Nashville, Tennessee.

Lauren Thompson (LT) is Rights and Reproductions Coordinator at the Frist Center for the Visual Arts.

Carole Carpenter Wahler (CCW) is an independent scholar and collector of Southern pottery.

Celia Walker (CW) is Senior Curator of American Art at Cheekwood Museum of Art in Nashville, Tennessee.

Rick Warwick (RHW) is a student of Williamson County history and local material culture.

Timothy Weber (TW) is a ceramist, teacher, and Director of Visual Art, Crafts and Media for the Tennessee Arts Commission.

Katie Delmez Welborn (KDW) is Associate Curator at the Frist Center for the Visual Arts.

Ann Harwell Wells (AHW) is an independent scholar and collector of early Tennessee maps.

Raymond White (RDW) is a collector of American portrait miniatures on ivory.

Stephen Wicks (SW) is Curator of Collections and Exhibitions at the Columbus Museum in Columbus, Georgia.

Sam Yates (SY) is Director and Curator of the Ewing Gallery of Art at the University of Tennessee, Knoxville.

FOREWORD AND ACKNOWLEDGMENTS

IT IS WITH A GREAT SENSE OF CELEBRATION THAT WE PRESENT THIS MAMMOTH SURVEY of the best of Tennessee art. The planning for the exhibition and catalogue has been ongoing for more than five years and has involved scores of curators, artists, collectors, and scholars. In the end, we have accumulated more than 250 works of art that we think tell a story of aesthetic achievement that is nothing short of astonishing.

The idea of organizing an exhibition surveying Tennessee's art has been around for years, well before the Frist Center for the Visual Arts became a reality. The art collector Robert Hicks, long a lover of Tennesseana, conceived of this project in 1997, envisioning it as a comprehensive follow-up, merger, and update of such exhibitions as the Cheekwood Museum of Art's *Made in Tennessee* (1971), the Tennessee State Museum's *Landscape and Genre Painting in Tennessee, 1810–1985* (1985) and *Portrait Painting in Tennessee* (1987), as well as the East Tennessee Historical Society's *Art and Furniture of East Tennessee* (1997). Each of these exhibitions contributed to our appreciation for the art of the state, but none had done so as comprehensively as the project conceived by Hicks would do. Additionally, new works of scholarship, especially Nathan Harsh and Derita C. Williams's book *The Art and Mystery of Tennessee Furniture,* underscored the value of a periodic updating of our assessment of the state's art. And finally, it was evident that in the years since these exhibitions, important works had been discovered, which would add significantly to the story of Tennessee art that had begun to unfold in previous exhibitions.

Hicks invited Ben Caldwell, himself a distinguished collector, connoisseur, and scholar, particularly of Tennessee silver, to collaborate on an exhibition that would survey the artistic life of Tennesseans from the earliest days to the present. The two presented the idea to Kenneth Roberts, who, as president of the Frist Foundation, was then coordinating the organization of the Frist Center and today remains the president of the Center's board. Welcoming the contribution that this exhibition would make to Tennesseans' appreciation for their own heritage, Mr. Roberts asked Lord Cultural Resources, consultants who had been retained to help shape the initial plans for the new Frist Center for the Visual Arts, to research the feasibility and desirability of the Frist Center's organizing such a project. Lord Cultural Resources performed a preliminary survey of the art and decorative arts of the state and advised the Frist Center's board that this would indeed be a worthwhile endeavor.

Soon after curator Mark W. Scala joined the staff in March 2000, the task of identifying the "greatest hits" of Tennessee art began. Research took Hicks, Caldwell, and Scala to every corner of the state, where they visited museums, historic houses, and private collections, viewing and documenting promising candidates for inclusion. Along the way, they engaged in lively curatorial debates, usually centered on whether to include one-of-a-kind works of the highest artistic quality or to choose distinctive examples of vernacular forms that would give our audience insights into the lives of everyday Tennesseans but which might not be exceptionally visually compelling. Generally, the exhibition was weighted toward the former, but with an underlying motive of chronicling the history of the state and its people through its art, including vernacular expressions.

There are numerous people to thank for their assistance in bringing this project to fruition. First, I acknowledge our museum colleagues around the state. A significant amount of advice and assistance came from the staff of the Tennessee State Museum, including Director Lois Riggins-Ezzell, Chief Curator and Director of Collections Dan Pomeroy, and Curators Candace Adelson, William Baker, Mike Bell, Stephen Cox, and Jim Hoobler,

George W. Chambers, *In the Tennessee Mountains,* 1887, detail, cat. no. 157

as well as Registrars Ron Westphal and Robert White. On a related note, we have been most pleased to collaborate with the Tennessee State Museum, which presents a portion of the exhibition in its galleries. At the Frist Center, the chronological arrangement of *Art of Tennessee* from the time of prehistoric Native American habitation to the present includes a dozen works from the State Museum's rich collections. The State Museum's component, selected by the *Art of Tennessee*'s curatorial team entirely from the State Museum's holdings, emphasizes the important history and the ongoing significance of the state's official collection. A companion exhibition at the State Museum presents its extensive holdings in Tennessee's handmade furniture.

At the Cheekwood Museum of Art, Jack Becker and Celia Walker provided access to their collections and offered their advice on various artists. Walker's 2002 exhibition *A Century of Progress: Twentieth-Century Painting in Tennessee* provided scholarly background for much of the work in our exhibition. Other museum colleagues who helped with curatorial research and provided access to their collections were, in the Nashville area, Wesley Paine, Lila Hall, and Susan Shockley of the Parthenon; Sarah Burroughs at Fisk University's Van Vechten Gallery; Desirée O'Neill at Travellers Rest; Angela Calhoun at Carnton Plantation; Lowell Fayna at Cragfont; Marsha Mullin at The Hermitage; and Janet Hasson at Belle Meade Plantation. Across Tennessee, our museum colleagues were equally gracious in sharing their collections and their knowledge. They include, in Chattanooga, Amy Frierson at The Houston Museum of Decorative Arts and Ellen Simak at the Hunter Museum of American Art; in Clarksville, Ned Crouch at the Clarksville-Montgomery County Museum; in Columbia, Tom Price and John Holtzapple at the James K. Polk Ancestral Home; in Humboldt, Bill Hickerson at the West Tennessee Regional Art Center; in Knoxville, Jefferson Chapman at the McClung Museum, University of Tennessee, Steve Cotham at the McClung Historical Collection, Cindy Spangler and Sam Yates at the Ewing Gallery of the University of Tennessee, and Stephen Wicks, formerly of the Knoxville Museum of Art; in Memphis, Kaywin Feldman, Marilyn Masler, and Marina Pacini at the Brooks Museum and James Wallace of the National Ornamental Metal Museum; and in Norris, John Rice Irwin at the Museum of Appalachia.

Gallerists were also wonderfully forthcoming in helping us to identify significant works, particularly of twentieth-century and contemporary art. In Nashville, thanks to Ann Brown at The Arts Company; Carol Stein of Cumberland Gallery; Vicki Frazier at Madison Arts Center; Carlton Wilkinson of In the Gallery; Stan Mabry of Stanford Fine Arts; Jim Williams of Williams American Art Galleries; and Janice and Manuel Zeitlin of Zeitgeist Gallery. We also thank Mary Morris of the Bennett Galleries in Knoxville; and in Memphis,

Nicole Haney and David Smith of Nicole Perry Fine Art, Jay Etkin of Jay Etkin Gallery, David Lusk of the David Lusk Gallery, and Jack Kenner of the Jack Kenner Gallery.

Many of those listed above also served as advisers to the project. Additional advisers include Vivien Fryd of Vanderbilt University; Andrew Glasgow of the Furniture Society; Carroll Van West of Middle Tennessee State University; Samuel Smith of the Tennessee Division of Archaeology; Cynthia Stowe and Dee Minault of Cumberland Conservation Studios; Ann Toplovich of the Tennessee Historical Society; Timothy Weber of the Tennessee Arts Commission; and James Kelly of The Virginia Historical Society. Our thanks, too, to independent scholars and/or collectors John Case, Mary Jo Case, Betty J. Duggan, Nathan Harsh, John Kiser, Susan Knowles, Lucy Kuykendall, Tracey Parks, Sandra Polk, Rick Warwick, and Ann Harwell Wells.

We also extend our most fervent appreciation to our lenders, whose number is substantial. In the interest of brevity, I will refer the reader to page 6, where they are listed.

Our essay authors are listed on pages 7–8 and entry authors on page 9. We are grateful for the excellent work that these scholars have completed within an extremely tight time frame. The production of the catalogue was a herculean task of its own. Thanks to Bill LaFevor and Charles Brooks for their sensitive photography, which often took place in the field under less than ideal conditions; to Fronia W. Simpson, our copy editor, who calmly and thoroughly identified and smoothed over all the rough patches that come with a project of this magnitude; and to Ed Marquand, Marie Weiler, and designer Jeff Wincapaw of Marquand Books, who have designed and produced several previous projects at the Frist Center that have been quite beautiful. Here, they have surpassed themselves.

I would be remiss if I were not to acknowledge the principal forces behind the exhibition and catalogue, Robert Hicks, Ben Caldwell, and Exhibitions Curator Mark W. Scala. Their persistence, commitment to quality, and connoisseurship have yielded an exhibition and catalogue that very likely will never be exceeded. While all the Frist staff play an important role in our programs, those who contributed directly and substantially to this project include Associate Curator Katie Delmez Welborn, Administrative Assistant and Rights and Reproductions Coordinator Lauren Thompson, Curatorial Projects Manager Nancy Cason (who oversaw the organization of this catalogue), Registrar Amie Geremia, Exhibition Designer Simon Adlam, Graphic Designer Daniela Peón, and Preparator Kristina Lockaby. Additional curatorial assistance was provided by Denise Gallagher and Jason Owens. Our educational and interpretive efforts were ably planned by Director of Education Anne Henderson and Programs Manager Michael Christiano. Although not members of the Frist

staff, Richard Feaster and Dana Holland-Beickert provided invaluable registrarial assistance. My congratulations and appreciation to them all.

Finally, I extend our thanks to our sponsors, First Tennessee and its employees, who have been so generous in their support of this exhibition. I also want always to acknowledge the incredible support of the Frist Foundation and Dr. Thomas Frist, Jr., who continue to keep the dream of a world-class art center alive and vibrant. Thanks, too, to our board president Kenneth Roberts, whose unwavering commitment to the Frist Center, the City of Nashville, and the State of Tennessee finds a voice in the realization of this exhibition.

Chase W. Rynd
Executive Director

INTRODUCTION

Tennessee is known for many things: its beautiful and varied landscape, warm and friendly people, great musical heritage, wonderful foodways, signal contributions to the political and cultural life of the nation. It is not typically known as a place that is congenial to art and artists. To someone in New York or Chicago, pairing the words "art" and "Tennessee" may seem as odd as linking, say, "pineapples" and "Canada." When people not versed in Tennessee art learned of this project, many expressed doubt that we would find works that would be thought of as having any aesthetic consequence outside the state. The wish to show that this supposition arose from a simple unawareness of Tennessee's treasures propelled us to find extraordinary works that show Tennessee as a place that both sheltered and inspired skilled artistry, despite the state's never having been on the cutting edge of artistic developments.

For us, the task of identifying and presenting the highest aesthetic achievements of the state in which we live and take pride seemed at the outset to be perfectly straightforward—just identify the most important artists from the various parts of the state and pick their best works. Yet even this seemingly simple approach presented difficulties: who is important, and why, often had as much to do with the period in which they worked or the extent to which they had built a local reputation as with the quality of their work. For example, one artist may have introduced new ideas to his or her community but have been only a modest practitioner of this imported style. But the same artist may have been extremely influential, teaching a generation of students who transformed these received notions into marvelous and original expressions. Who is more deserving of recognition?

There is also an artificiality to the entire enterprise. Art, like language, customs, and belief systems, is never contained by the political borders on a map. Even the geography of the state does not itself promote a particularly Tennessee frame of mind. It is commonplace to speak of the three great divisions, and to note that East Tennesseans are very close culturally to the people who live in the mountainous regions of western Virginia and North Carolina; and there is also a little bit of truth to the tongue-in-cheek notion of Memphis as the unofficial "capital" of Mississippi, with apologies to our friends in Jackson (Mississippi, not Tennessee, that is).

To examine the art of the state in the context of the art of the nation, we made the parameters for inclusion in this survey as broad as possible: art made by Tennesseans, many of whom studied elsewhere, or by people traveling through Tennessee, or by artists elsewhere documenting famous people from the state. The process of getting our arms around the subject involved a lot of time on the road, interviewing scholars, curators, and collectors in every corner of the state and gathering information from exhibition catalogues, books, and articles. Throw in a bit of detective work to track down that elusive piece by an artist who is little known outside the region, add the luck that comes when a mention of a research problem to the right person opens new doors, and the result is an artistic impression, which, as it turns out, is less an embodiment of regional particularity than it is a microcosm of American art as it coincidentally relates to the State of Tennessee.

The survey begins before the borders were set, when Native Americans lived and traded freely throughout the region. Then it moves to the time when artists documented the exploration and settling of the frontier, a period in which Tennessee was a gateway between the Eastern Seaboard and the yet-to-be-explored West. It proceeds through the nineteenth and twentieth centuries, an era of consolidation and growth in population areas, the

Alexander Helwig Wyant,
Tennessee, 1866, detail,
cat. no. 149

15

Civil War, industrialization and the development of rail and road transportation, and the creation of the Tennessee Valley Authority with its system of dams and hydroelectric power plants that so transformed the physical landscape and the lives of people across the region. Throughout this historical period, artists of great merit came to the state to practice their trade; at the same time, ambitious Tennessee artists were often leaving home to seek training in New York, Philadelphia, or Paris.

By the mid–twentieth century, colleges and universities had begun expanding their art departments, bringing in talented people who exposed their students to the national and international trends that defined modern art. The contemporary art of the state is a legacy of this educational highway, with today's artists creating works that could, in truth, have come from any region in this country. If there is a unifying factor to this immensely diverse range of expressions, it is that Tennessee, like so many of our sister states, has been and remains a cultural crossroads through which ideas and stylistic influences are constantly being transmitted, sometimes undergoing subtle adaptations to reflect the environment or history of an individual place.

Our essay and entry authors—all specialists in their fields—have helped us to place this assortment of art into a comprehensible structure. This publication is composed of principal essays that provide a broad, general framework for each section of the exhibition. Integrated within each of these essays are brief sidebar discussions of subjects that we think are of particular interest to the reader who may not be aware of Tennessee's artistic highlights.

Like the *Art of Tennessee* exhibition, this catalogue is not a comprehensive encyclopedia of all the visual achievements related to this state. Great treasures remain tucked away in people's homes; some wonderful artists could not be included because of space limitations; the scope of the exhibition prohibited the inclusion of architecture and design, important types of visual art that will, we hope, be the subject of future studies and exhibitions. Nonetheless, we hope that our readers and viewers come away with a profound appreciation for the beauty and creativity engendered by this variegated place called Tennessee.

Benjamin H. Caldwell Jr., Robert Hicks, and Mark W. Scala
Exhibition Curators

ART OF TENNESSEE

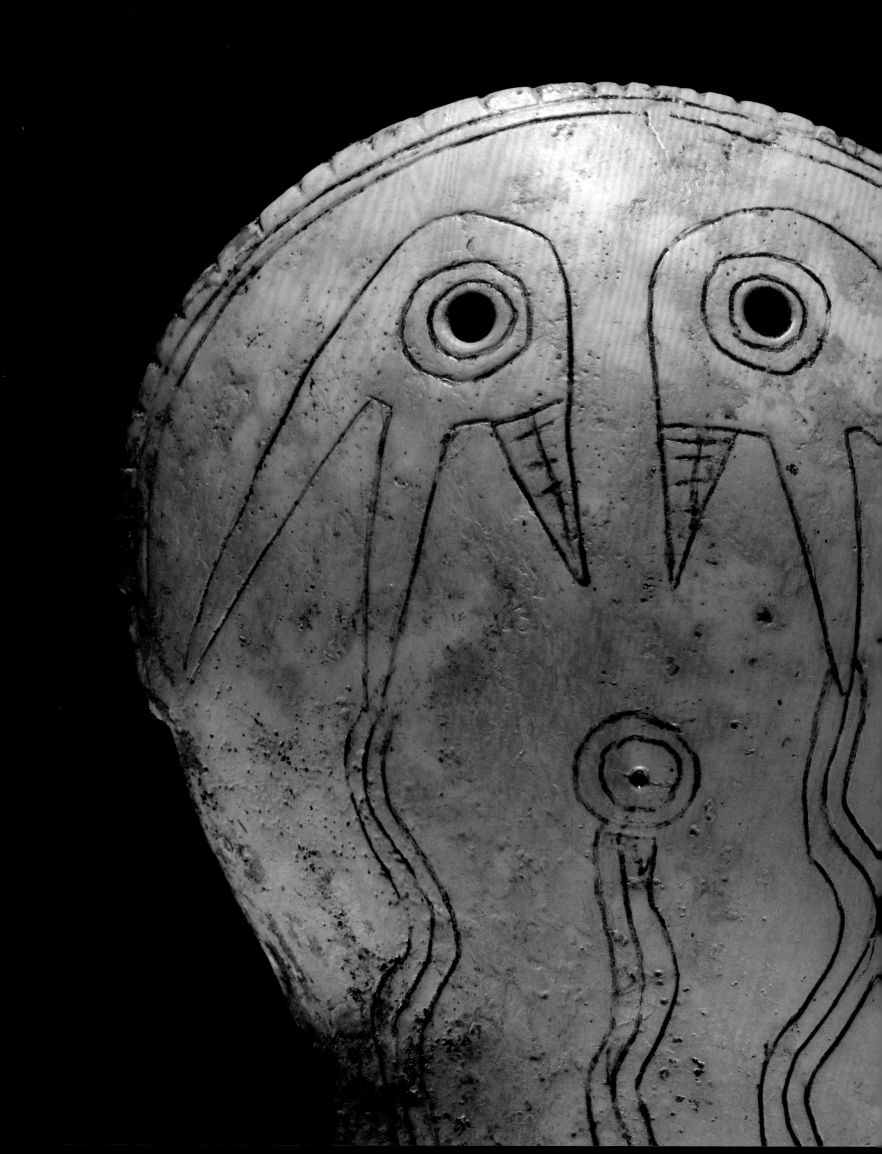

Jefferson Chapman

PREHISTORIC NATIVE
AMERICAN ART IN TENNESSEE

ART IN ITS BROADEST DEFINITION IS A PATTERNED APPLICATION OF HUMAN SKILL THAT evokes a feeling of aesthetic sensibility or sense of beauty. As such, art is a universal of human culture and can be traced archaeologically to at least forty thousand years ago.

Art functions on two levels. First, it can be decorative or purely ornamental in function, as are so many of the so-called decorative arts—a Cybis porcelain figurine or a garden statue. Second, art can be symbolic or actually embody aspects of the values and belief system of the culture in which it occurs. In general, symbolic art is created using formalized styles that have been established for some time and is designed to elicit in the viewer clearly defined expectations and behaviors. For example, a Cherokee wooden mask manufactured in the image of a wolf would have been more than a mask to a member of the tribe; it was a clan symbol that also elicited a set of socioreligious feelings and responses. This symbolic aspect of artistic expression is not restricted to tribal societies. Today, Christian motifs (the cross, the lamb), political logos (donkey, swastika), and commemorative scenes (the Last Supper), are used to elicit social, political, and religious feelings.

To fully appreciate and understand art, it must be studied in the context of the culture and even the individual who produced and used it. It is hard to overcome our own ethnocentrism in interpreting non-Western or tribal art; it is even more difficult when that art is associated with prehistoric cultures hundreds or even thousands of years old.

Our knowledge of the art of the prehistoric Indians of Tennessee is based on archaeological excavations and research over the past 150 years, analogies drawn from historical documents and nineteenth-century ethnographies of the Creeks and Cherokees, and the artifacts themselves. It should be noted that our record of past art media is incomplete; Tennessee's temperate climate generally has precluded the preservation of wood, fiber, feathers, and skins, and in some areas, bone and shell as well. Time, too, takes its toll on the cultural assemblages of groups who lived five to ten thousand years ago.

Our overview is organized chronologically by the five cultural periods used by archaeologists to define the Native American occupation of Tennessee: Paleoindian (10,000+–8000 B.C.E.); Archaic (8000–1000 B.C.E.); Woodland (1000 B.C.E.–900 C.E.); Mississippian (900–1600 C.E.); and Historic. These labels are both references to some span of time and to some stage in a continuum of increasing cultural complexity that is reflected in political, economic, and social organization. When we refer to Paleoindians, for example, we are applying an archaeological label; names used by the various tribes or earlier bands before the Historic period are lost to us forever.

The first Tennesseans, the Paleoindians, were composed of bands of hunter-gatherers who entered the state during the last glaciation. Adapting to the shift from a late glacial to a modern environment, the groups were mobile, but they left considerable archaeological evidence in Middle Tennessee, where they may have hunted herd animals including the mastodon. The Indians of the Archaic period were the descendants of the Paleoindians. The extinction of the large Ice Age animals and the spread of the modern deciduous forest produced changes in the ways hunter-gatherers lived and sought food. In some parts of the state, large shell mounds represent the consumption of huge numbers of freshwater shellfish for generations. For more than seven millennia,

Engraved Shell Mask, 1300–
1500 C.E., detail, cat. no. 7

populations increased and groups began to define more specific territories. The Woodland period in Tennessee is marked by the appearance of pottery. Life became more sedentary. Cultivated corn, squash, sunflower, and marsh elder began to supplement wild plant foods. The construction of burial mounds and earthworks in some areas suggests the emergence of greater social stratification than was present in earlier periods. Bands, previously autonomous, were united into loosely structured tribes.

The peak of prehistoric Native American cultural development was in the Mississippian period. Population increase, social stratification, and political complexity based on increased corn horticulture are typical of this period. Villages were frequently palisaded with one or more structural mounds arranged around central plazas; certain villages became the political centers for chiefdoms. Certain stylistic elements became widespread, reflecting the ceremonialism that was entwined with the social and religious structure.

The tribal identities of the sixteenth- and seventeenth-century occupants of Tennessee are disputed. By the eighteenth century, the only native peoples living permanently in Tennessee were the Cherokee. The Chickasaw controlled western Tennessee, but there is no archaeological or historic evidence that they used the area for more than hunting. The Shawnee and Creek briefly occupied small areas of the state, but little archaeological evidence has been found.

There is little preserved from the Paleoindian and much of the Archaic periods that could be defined as art. However, the execution of many of the chipped-stone projectile points from this time certainly exceed the utilitarian and evoke aesthetic sensibilities. Catalogue number 1 is an exquisitely made Paleoindian spear point, one in which the maker has gone beyond the utilitarian purpose of the object, and it is doubtful that it penetrated an animal any better than one of lesser workmanship and form. Likewise, the manufacture of spear-thrower weights (atlatl weights, bannerstones) often using non–locally derived stone became an art form in the Archaic period. The spear-thrower is a short stick with a hook at the end; the base of the spear to be thrown was placed in the hook and hurled using the increased leverage provided by the spear-thrower shaft. There is considerable debate as to whether a stone weight on the shaft increased the efficiency; in any case, the workmanship on the weight certainly exceeded utilitarian necessity. A modern analogy would be the engraving and inlay applied to a firearm. By the Late Archaic period, artistic decoration is seen in elaborate geometric carving on bone pins. Regional trade networks emerged by 5000 B.C.E., and the appearance of marine shell ornaments and copper in some burials in Tennessee suggests the emergence of social distinctions—status—enhanced by valued objects, an ideal environment for symbolic aspects of art.

By the Woodland period, the artistic embellishment of objects increases greatly. Stone pendants and pipes are carved in delicate shapes and in the forms of animals and insects. The surfaces of clay pots are impressed with elaborate designs before firing. To the north of Tennessee, the Adena and Hopewell cultures, complex societies with earthworks and ritualism, develop formalized art styles that spread throughout the Southeast. Recent excavations at the Pinson Mounds near Jackson found two rattles made from portions of two human skulls and engraved with typical Hopewellian abstract motifs. The occurrence of much of the art in burials of apparent high-status individuals at Pinson and elsewhere suggests an association of art with social differentiation and political power.

The Woodland period sees the emergence of stylistically consistent images that are probably associated with specific mythic creatures and form part of an iconographic system that reaches its peak of complexity and formalization in the succeeding Mississippian period. The Indians of the Southeast believed in a three-tiered universe. This World is a circular island that existed between the Upper World and the Underworld; life is a constant struggle to maintain a balance between the order and harmony of the Upper World and the disorder and disharmony of the Underworld. These worlds are personified by mythic beings who have analogues in different animals—birds such as the hawk are associated with the Upper World, and creatures such as the rattlesnake are associated with the Underworld; art was a way in which the Native Americans could depict and manipulate this construct symbolically. The celestial bird is seen in numerous manifestations over several thousand years, as is the opposing Underworld monster represented in the rattlesnake.

The Mississippian period in the Southeast was the pinnacle of prehistoric social and political complexity; it was also the peak of artistic expression. Utilizing the media of marine shell, pottery, bone, copper, stone, wood, and fabric, the Mississippian Indians of Tennessee created a spectacular array of artistic objects. Additionally, there is evidence that images were applied to house walls with colored clays, and recent research has revealed what amounts to galleries of Mississippian iconographic symbols on mud and stone walls in the deep recesses of caves—a phenomenon that may extend back to the Late Archaic. Mississippian period art is a fascinating assemblage of symbols and a virtual bestiary of creatures that have been modeled, carved, incised, engraved, or painted.

Basic to all of this art is a formalized iconography based on the construct of the cosmos, veneration of the ancestors, warfare, fertility, and the perpetuation of an elite class. The motifs that are part of this iconography are blended and applied to a myriad of objects. In interpreting the meaning of these symbols, archaeologists realize that they cannot dig up a belief system and are therefore forced to rely on

the recorded beliefs and explanations of the Southeastern Indians as described by explorers, traders, and ethnographers in the eighteenth and nineteenth centuries, and assume that they have some relevance across time. For example, the shell gorget with pileated woodpeckers abounds with symbolism. The form of the circular gorget itself reflects the universe and the circular island that is This World and, at the same time, the Sun—a principal deity. The Sun symbol is repeated in the center, and within the circle is the cross motif—symbolic of the cardinal directions, the sacred fire, and the ritualistically important number four. The spiral-cornered square repeats the four motif. The woodpecker heads also number four and are arranged at each of the cardinal directions. A tie to warfare and warriors has been seen in the analogy of the woodpecker striking like a club and the red crest representing scalped heads. As another example, the rattlesnakes on the disks of the shell necklace are analogous to the Underworld monster, the Uktena, and the spider is perhaps a metaphor for the story of the origin of fire in which a water spider steals a glowing coal from an island and returns it to the humans.

The recognition of the frequent use of a number of motifs in Mississippian art gave rise in 1940 to a belief in the supposed existence of a Southeastern Ceremonial Complex (Southern Cult, Buzzard Cult, Death Cult). Most scholars today reject the idea of a unified cult and instead see this distinctive iconography as symbols in a widespread complex system that was social, political, and economic as well as religious. Rejected also is the notion that the inspiration for Mississippian art derives from the cultures of Mesoamerica (Maya, Aztec, and so on); the similarities are more likely due to fundamental ideologies shared by the North American Indians for centuries.

Mississippian art continues into the 1600s but disappears with the cataclysmic impact of European intrusion and diseases that brought decimation and social change. In the eighteenth century, the rapid culture change among the Cherokee and Chickasaw all but eclipsed any traditional art with the exception of basketry.

Tennessee has a rich Native American heritage that extends back more than twelve thousand years. Artistic expression can be seen in the objects manufactured throughout this long occupation, reaching the peak of diversity and expression in the Mississippian period. More than 150 years of collecting and scientific excavations in the Cumberland and Tennessee River valleys have resulted in vast collections of artifacts that now reside in museums and institutions throughout the United States. These will continue to be valuable resources in the never-ending effort to understand and appreciate our past.

NOTE

This essay is adapted from my entry "Prehistoric Native American Art," in *The Tennessee Encyclopedia of History and Culture,* ed. Carroll Van West (Nashville: The Tennessee Historical Society, 1998), 748–49.

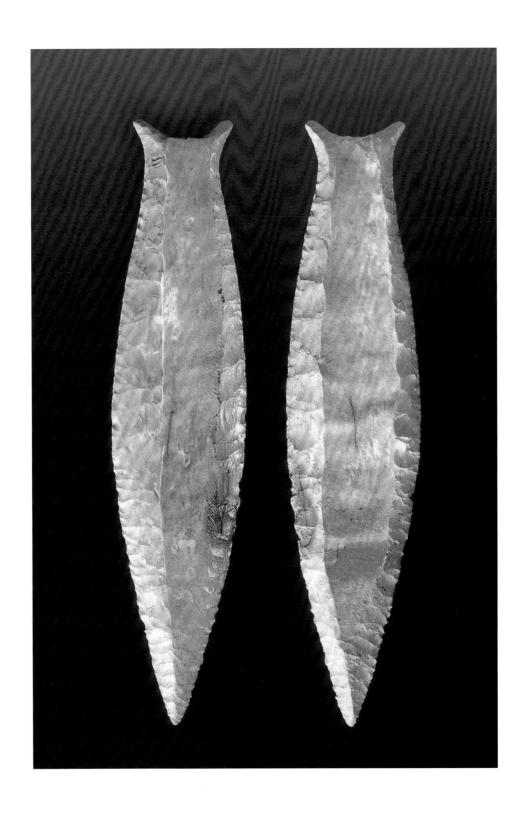

1 **SOUTHEASTERN NATIVE AMERICAN**
Paleoindian Period; East Tennessee

Fluted Spear Point, 10,000–8000 B.C.E.
Stone; 5¼ × 1¼ × ⅜ in.
Private Collection

IN EXECUTING THIS ELEGANT SPEAR POINT (shown here from two views), the maker has clearly gone beyond the utilitarian needs of a hunting tool or battle weapon. The flute—a depression that runs the length of the point on both sides—is produced by the removal of a single flake, a technological achievement requiring great skill. JC

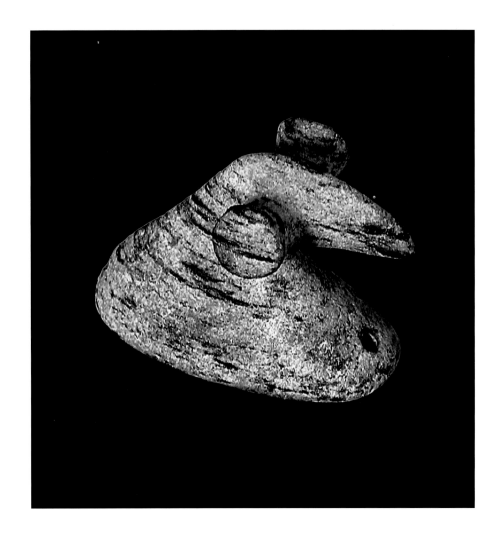

3 · **SOUTHEASTERN NATIVE AMERICAN**
Woodland Period; East Tennessee

Pop-eyed Birdstone, 800–200 B.C.E.
Stone; 3¼ × 1⅝ × 2½ in.
Private Collection

POPULARLY CALLED BIRDSTONES because of their resemblance to an abstract bird, the stones probably were mounted to spear-thrower shafts, where they functioned as weights. This form, which lacks the abstract tail, may, in fact, depict a frog. Both birds and frogs are common in later Mississippian period art. JC

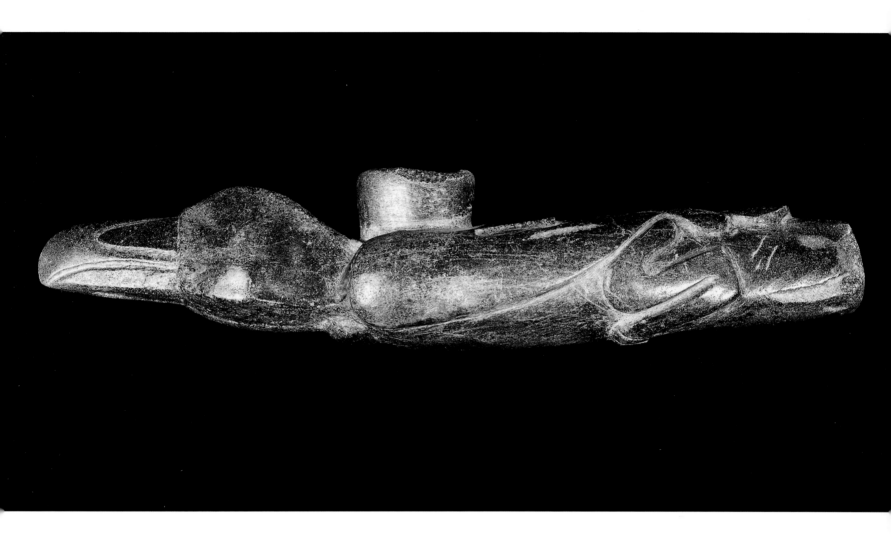

4 · **SOUTHEASTERN NATIVE AMERICAN**
Woodland Period; Jefferson County,
Tennessee

Bird Effigy Pipe, 200–800 C.E.
Steatite; length 17⅛ in.
Frank H. McClung Museum, The University of
Tennessee, Knoxville, 1/163

LARGE ZOOMORPHIC STONE PIPES have been found throughout much of Ten-
nessee. It is assumed that they are associated with Middle to Late Woodland cultures;
however, none has been scientifically recovered in context. This pipe is carved soapstone
(steatite) and is a stylized raven or crow. The artist has accommodated the wings, legs, and
tail to the tubular shape almost in the tradition of Northwest Coast Indian art. JC

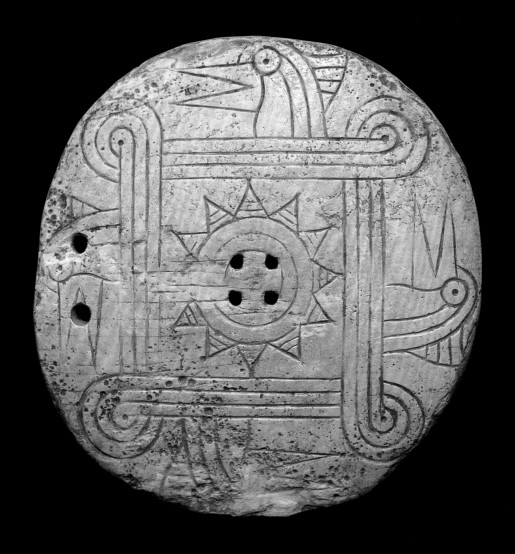

5 · **SOUTHEASTERN NATIVE AMERICAN**
Late Mississippian Period; Davidson County,
Tennessee

Gorget (Pendant), 1300–1500 C.E.
Marine conch shell; 3 × 3 × ½ in.
Tennessee State Museum, Gates P. Thruston
Collection of Vanderbilt University, 82.100.731

ENGRAVED SHELL GORGETS were an important medium for art in the Mississippian
period. Most combine a number of iconographic symbols that relate to socioreligious
beliefs. This example combines the sun circle and cross motif in the center with the four
quadrant concept repeated in the looped square. For the Cherokee, the pileated wood-
pecker heads symbolized war because their red feathers made them look as if they had
been scalped. JC

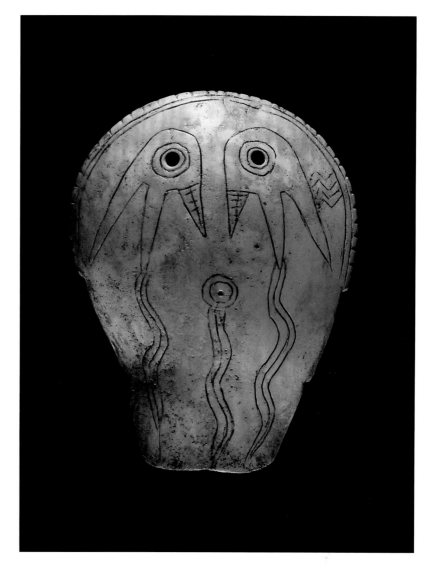

6 · **SOUTHEASTERN NATIVE AMERICAN**
Late Mississippian Period; Monroe County,
Tennessee

Shell Necklace, 1300–1500 C.E.
Marine shell; spider gorget diam. 3⅝ in.
Frank H. McClung Museum, The University of
Tennessee, Knoxville, B241/40MR6 (1-11)

7 · **SOUTHEASTERN NATIVE AMERICAN**
Late Mississippian Period, Dallas Phase;
Hamilton County, Tennessee

Engraved Shell Mask, 1300–1500 C.E.
Marine shell; 4⅞ × 3⅞ in.
Frank H. McClung Museum, The University of
Tennessee, Knoxville, 673/8HA1

EACH OF THE TEN SHELL DISKS on this necklace
exhibits a stylized rattlesnake. In the Mississippian belief
system, the rattlesnake was associated with the Under-
world and led the never-ceasing struggle with the powers
above. The spider decorating the large shell is perhaps an
analogue for the belief that the water spider brought the
first fire to man. JC

WHETHER "WEEPING-EYE MASKS" such as this
functioned as death masks is unknown. The forked-eye
design may symbolize the distinctive eye markings of rap-
torial birds such as the falcon, a motif thought to be asso-
ciated with the warrior organizations of the Mississippian
peoples. The zigzag designs have been interpreted by some
as lightning bolts that emanate from the Thunderbird. JC

8 · SOUTHEASTERN NATIVE AMERICAN
Late Mississippian Period; Davidson County,
Tennessee

Dog Effigy Bottle, 1300–1500 C.E.
Shell-tempered clay and negative painting;
9⅜ × 8¼ × 4¾ in.
Tennessee State Museum, Gates P. Thruston
Collection of Vanderbilt University, 82.100.47A

DOG EFFIGIES MAY REPRESENT the small dogs that the Spanish chroniclers reported as being bred for food. However, in examining this bottle, Dr. Charles Hudson, of the University of Georgia, has suggested that the snakelike tail, peculiar snout and nose, and non-doglike feet make it more like the "water cougar," a prominent monster of the Underworld. JC

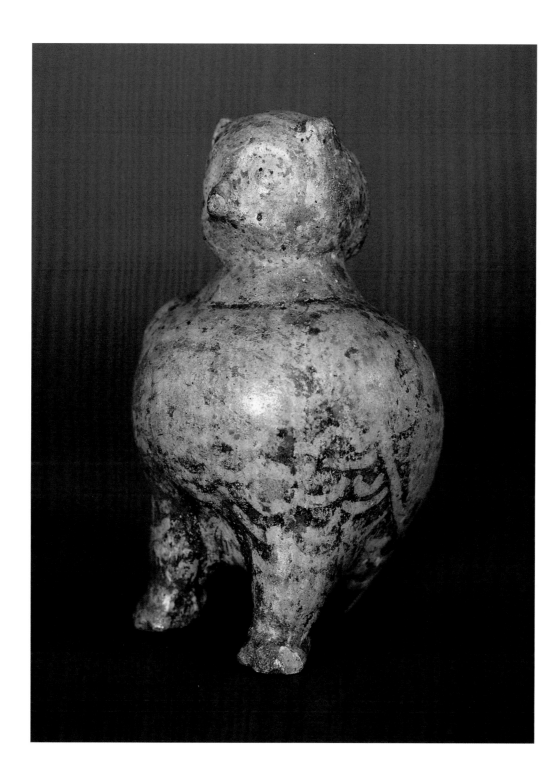

9 · **SOUTHEASTERN NATIVE AMERICAN**
Late Mississippian Period; Davidson County, Tennessee

Owl Effigy Bottle, 1300–1500 C.E.
Clay and negative painting; 6½ × 4 × 3¾ in.
Tennessee State Museum, Gates P. Thruston
Collection of Vanderbilt University, 82.100.21

THIS BOTTLE WAS DECORATED with negative painting. The technique involved covering the vessel with wax, cutting away the wax except for the design pattern, and then painting the rest of the surface. When the vessel was fired, the wax disappeared and the light design stood out against the dark painted background. As a nocturnal animal able to see in the dark, the owl was different from the other birds of the Upper World and played a role in the creation stories. JC

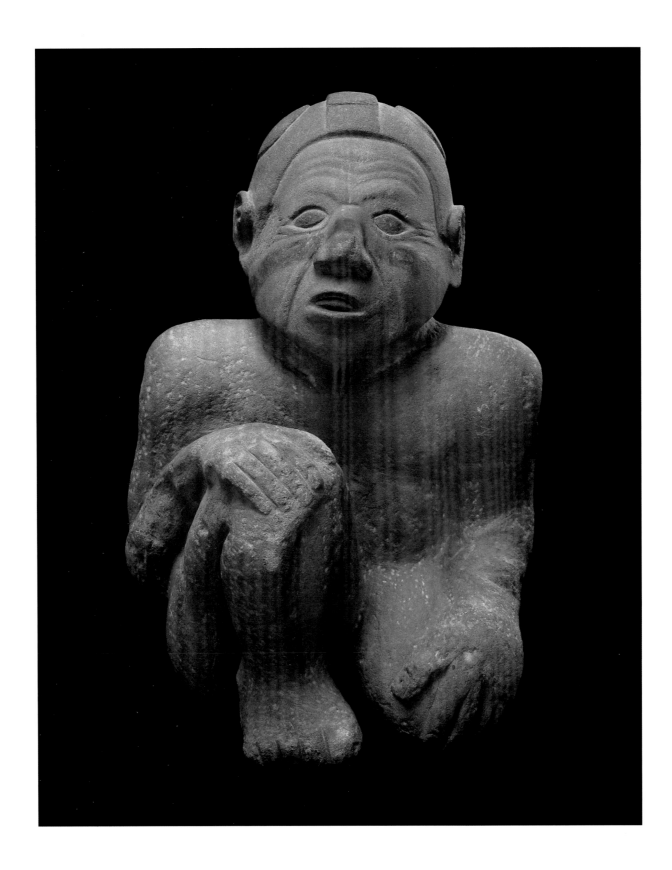

10 · **SOUTHEASTERN NATIVE AMERICAN**
Late Mississippian Period; Wilson County,
Tennessee

Kneeling Male Figure, 1300–1500 C.E.
Sandstone; 18 × 12½ × 10 in.
Frank H. McClung Museum, The University of
Tennessee, Knoxville, 1/1WI1

THIS STATUE WAS FOUND together with that of a female of similar size at the Sellers site in Wilson County. Stone statues are thought to have served as ancestor figures— material embodiments of important ancestors or lineage founders. This interpretation is based on similar usage by the eighteenth-century Natchez Indians and by sixteenth-century Indians of coastal Virginia. JC

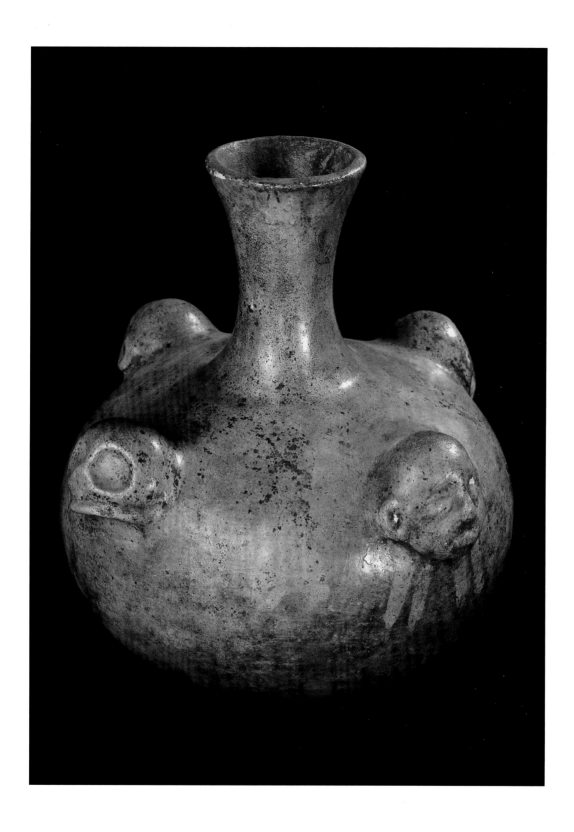

11 · SOUTHEASTERN NATIVE AMERICAN
Late Mississippian Period, Dallas Phase;
Hamilton County, Tennessee

Bottle with Appliqué Heads, 1300–
1500 C.E.
Ceramic and negative painting; 8⅝ × 7⅞ in.
Frank H. McClung Museum, The University
of Tennessee, Knoxville, 313/8HA1

ALTERNATING SKULLS OR DESICCATED HEADS and fleshed heads have been
interpreted as symbolizing trophy heads, an aspect of the Mississippian focus on warfare.
Other scholars believe they reflect the focus on the ancestors, as body parts were retained
and cared for in mortuary temples. Yet another interpretation is that the heads depict the
dualism of life and death. JC

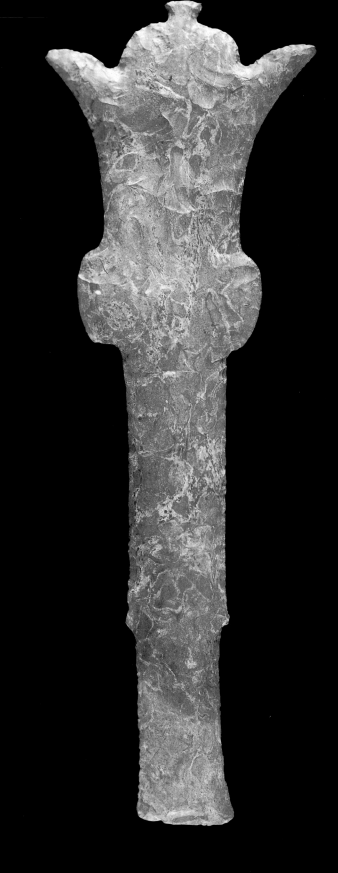

12 · **SOUTHEASTERN NATIVE AMERICAN**
Late Mississippian Period; Sumner County,
Tennessee

Mace, 1300–1500 C.E.
Stone; 15¼ × 5¾ × ¾ in.

THE OUTCROPS OF FINE-QUALITY CHERT (a flintlike stone) near Dover, Tennessee, were quarried for millennia. They were the source of raw material for spectacular flaked maces, hooks, "swords," and other eccentric objects made by Mississippian peoples. The pieces were never used as weapons or tools but served instead as symbols of authority or rank in warrior societies, and as ritual paraphernalia. JC

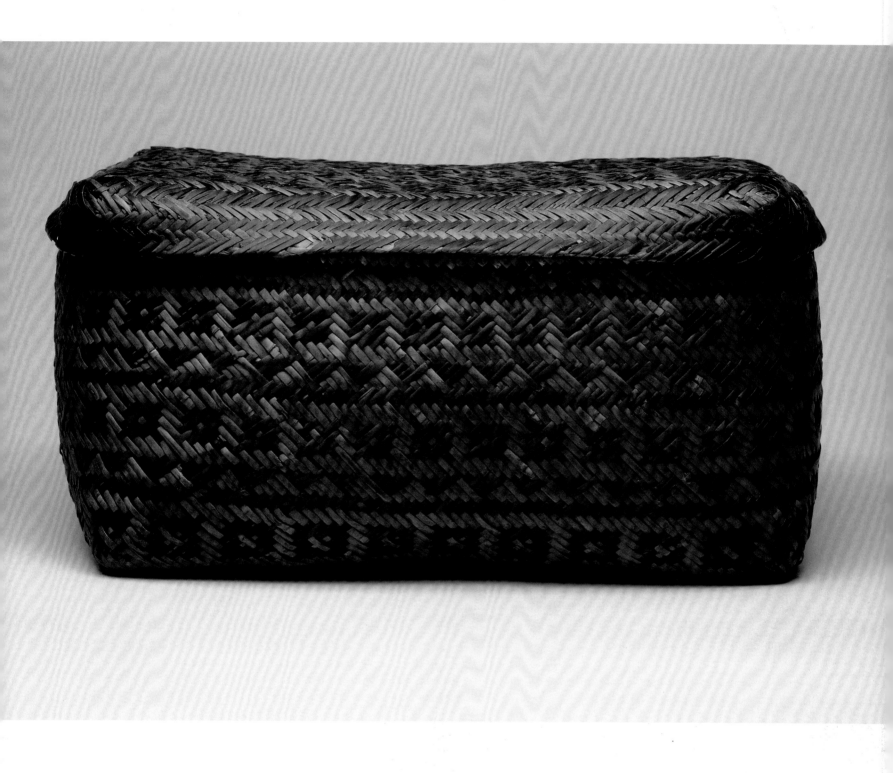

13 · **SOUTHEASTERN NATIVE AMERICAN**
Cherokee; Knox County, Tennessee

River Cane Double-Weave Basket with Lid,
ca. 1790–1838 C.E.
River cane and natural dyes; 6⅞ × 9⅞ × 15⅜ in.
Frank H. McClung Museum, The University of
Tennessee, Knoxville, 29/602

IT WAS COMMON FOR ANGLO AMERICANS living near the border with the Chero-
kee nation to acquire baskets through barter with Cherokee families. This basket closely
resembles in construction the Cherokee basket acquired by the royal governor of South
Carolina in 1725, which is now in the British Museum. JC

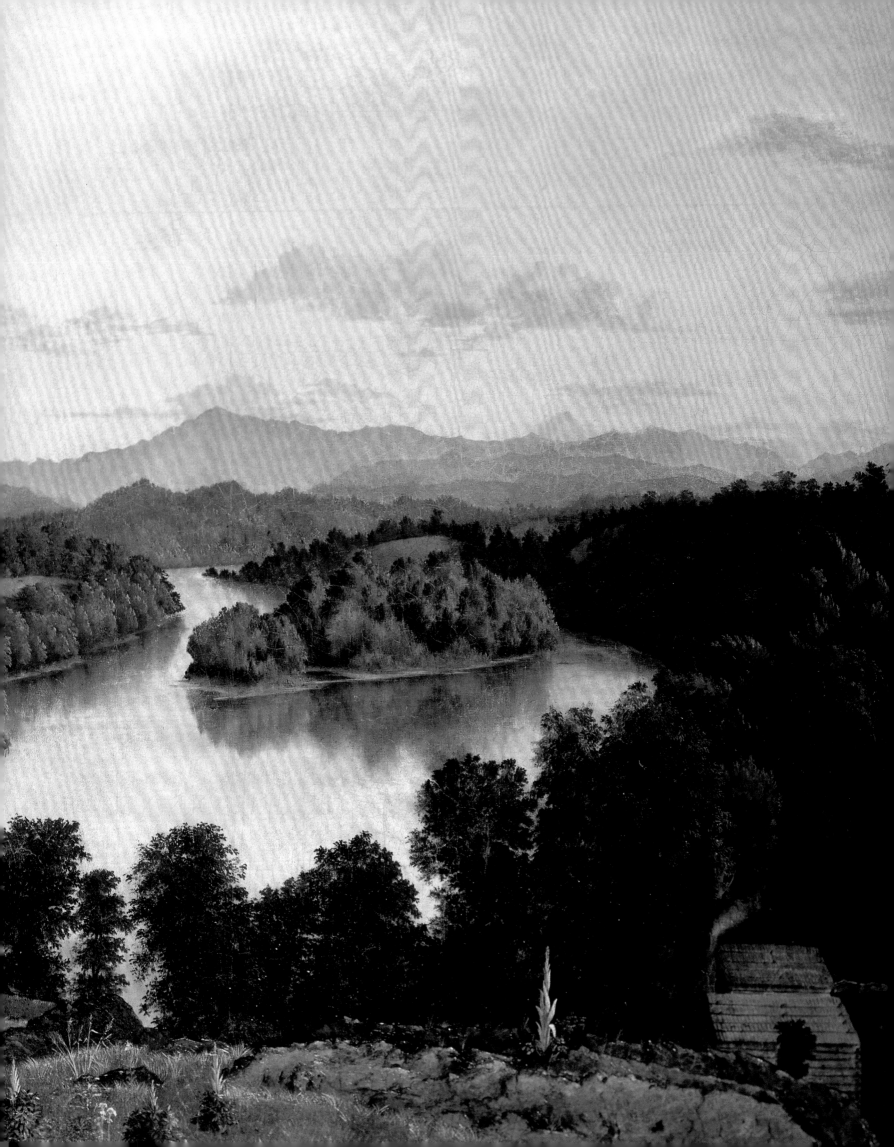

Wendell Garrett

YOUNG TENNESSEE
AND THE SPIRIT OF AMERICA

THE VOLUNTEER STATE IS DIVIDED INTO THREE DISTINCT REGIONS: EAST, MIDDLE, AND West Tennessee. The sections have long acknowledged a sense of separateness, which is even symbolized by three stars on the Tennessee state flag.

The East is largely mountainous, beautiful but rugged, with its forested peaks and rushing streams, and was the first area of the state to be settled. Pioneers, primarily of Scotch-Irish extraction, filtered into the isolated coves and ridges during the late eighteenth century, built log structures, and lived relatively undisturbed until the first half of the twentieth century.

Middle Tennessee is bluegrass country, a region of gently rolling hills and fertile fields that is bounded by the Cumberland Plateau on the east and the Tennessee River on the west. The plantation system prospered here during the first half of the nineteenth century, nurturing a lifestyle similar to that of the Deep South.

West Tennessee is more akin to the Mississippi Delta than to its sister sections and is clearly delineated by two rivers: the Tennessee on the east and the Mississippi on the west. Still decidedly rural, the region's eastern portion is rolling, flattening to the east. Money made from the cultivation and sale of West Tennessee cotton helped build the city of Memphis, which remains one of the world's largest cotton markets.

The American Revolution found Tennessee home to several powerful personalities who helped to shape the thinking in a series of scattered communities in terms of permanence and growth. Already land had become a central theme, as it was on so many frontiers of the trans-Appalachian west. Opportunities for landownership and land speculation flowered with the close of the Revolution, and several fascinating personalities connived to shape the future of Tennessee to their own ends. These early frontiersmen possessed a hardy constitution and an independent spirit. John Sevier, an Indian fighter, became the state's first governor in 1796. Perhaps the most famous Tennessee frontiersman was David Crockett. He served three terms in the United States Congress, becoming famous for his homespun humor and backwoods naive wisdom, but when he lost his bid for a fourth term, he headed for Texas, where he died in 1836 defending the Alamo.

A circuit-riding lawyer who traveled the Tennessee wilderness, Andrew Jackson became the soldier-hero of the Battle of New Orleans. Elected the nation's seventh president, the populist Jackson personified the ordinary man made good, the frontiersman triumphant. The rise of the masses over the higher classes, the elevation to such high office of Old Hickory in 1828—a frontiersman without family, education, or wealth—sent shudders through the ranks of the socially prominent and conservative society of the Eastern Seaboard. But their gloomy predictions of chaos did not materialize.

During this era of laissez-faire, the nation manifested unrestrained optimism and self-confidence. It was a period that has become known as the Age of the Common Man. In the time of Jackson, the "mission of America" became, according to the Jacksonian Democrat and historian George Bancroft, "the culture and the happiness of the masses."[1] It was a time of peaceful revolution during which "the wheel of fortune is in constant operation, and the poor in one generation furnish the rich of the next," as the statesman and clergyman Edward Everett put it in 1838.[2] In the arts, as in politics, it was a watershed, one of the hinges of history on which one age turns to another. A brave new world was being born.

James Cameron, *Belle Isle from Lyon's View*, 1861, detail, cat. no. 118

In Jacksonian America and frontier Tennessee, most men were farmers, the plow was their symbol, and agriculture formed the lion's share of the country's export. Andrew Jackson wrote: "The planter, the farmer, the mechanic, and the laborer … form the great body of the people of the United States. They are the bone and sinew of the country."[3] For Tennessee farmers, the economy through the state's formative period depended on land, and its productive potential was measured in agricultural terms. The earliest settlers cleared fields for corn, planted orchard trees and vegetable gardens, raised a few farm animals, and fenced their fields for protection against roaming livestock. By the 1790s farmers were exporting hogs, horses, and cattle to the eastern states, and by 1800 nascent planters on the Cumberland were shipping tobacco and a small amount of cotton downriver to New Orleans—and ultimately to world markets. By the 1830s plantation-based production of cotton for the export market was becoming increasingly significant both in the southern part of Middle Tennessee and in recently opened West Tennessee, with Memphis emerging as a market center.

Corn was a major product in all three regions of the state, and when the frontier era ended in 1840, Tennessee ranked first nationally in its production. Corn provided the near universal sustenance for frontier families. In addition to the use of corn for animal fodder, a major use of surplus corn was the making of whiskey. Corn liquor was the ideal product—indispensable, easy of manufacture, easy to transport, and improving with age. People in the Tennessee backwoods also distilled rye, peaches, and apples. All echelons of frontier society, including women and children, used whiskey both as medicine and to lubricate social interaction. In those cash-starved times, Tennesseans also paid their taxes with whiskey and used it in barter arrangements. By 1840 distilling was the state's most widespread manufacturing industry.

From the onset, merchandising was an essential economic activity in Tennessee. Though backcountry residents were isolated, they were never immune to consumerism and the market economy, and itinerant peddlers and small storekeepers whetted their material appetites. As transportation links between Tennessee and the outside world improved, general stores became more common, offered more goods, and emerged as social centers, especially when they were designated as local post offices. There was a burgeoning consumption of material goods, and by the 1790s advertisements in the *Knoxville Gazette* touted a wide range of merchandise shipped in from Richmond, Baltimore, and Philadelphia.

The work habits of early American artisans and craftsmen were marked by industriousness, energy, efficiency, and zeal for the task at hand. As the French economist Michel Chevalier observed when sent by his government to study American public works, "The American mechanic is a better workman, he loves his work more than the European. He is *initiated* not merely in the hardships, but also in the rewards, of industry."[4] Well before midcentury, Tennessee practitioners of the mechanical arts—craftsmen distinguished by their leather aprons and fierce pride in their skills and products—were producing goods that could be favorably compared with the finest East Coast workmanship. In their attempt to gain respectability in the eyes of the community, artisans placed a premium on achieving independence. In some crafts they organized friendly societies "to Promote mutual fellowship, Confidence, good Understanding, and Mechanic Knowledge,"[5] to offer financial support to needy families, and to settle disputes among members. Economic independence also meant making the transition from apprentice to journeyman and then to master craftsman. This evolution from servitude to self-employment was crucial to artisans, for in addition to economic rewards it gave them the freedom to control their working hours and enabled them to have an autonomous existence outside the workplace.

America was the land of opportunity for the wage earner. Not only were workers well paid, but in 1831 it was asserted in a newspaper that "there is no more honorable character … than the independent American Mechanic." In the very first sentence of *Democracy in America,* Alexis de Tocqueville was beguiled by "the general equality of condition among the people."[6] Augmented by Jacksonian democracy, this trait baffled, amazed, horrified, and occasionally delighted British and Continental visitors to the United States after about 1820. The English actress Fanny Kemble declared her American inferiors "never servile, and but seldom civil," although she rather liked their independence of mind.[7] The novelist Frances Trollope felt that the penchant for equality was "a spur to that coarse familiarity, untempered by any shadow of respect, which is assumed by the grossest and the lowest in their intercourse with the highest and most refined."[8]

In America the skilled craftsman was the aristocrat of labor, who expected to earn a "decent competency" and did not anticipate the grinding poverty of the laboring poor in Europe. The high wages allowed workmen to wear what the English traveler Harriet Martineau described as "sleek coats, glossy hats, gay watch guards, and doe-skin gloves! … Happy is the country where the factory girls carry parasols, and pig-drivers wear spectacles."[9] America was bursting with ideas, experiments, and inventions, offering an almost ideal setting for tinkerers and ambitious entrepreneurs. "Our greatest thinkers," it was said, "are not in the library, nor the capital, but in the machine shops."[10]

In their unharnessed enthusiasm, Americans cried out for an art of their own, forms that would suggest the limitless abundance and marvels they discovered in their native land. In his oration before

the Phi Beta Kappa Society chapter at Harvard University in 1837, Ralph Waldo Emerson proclaimed, "Our day of dependence, our long apprenticeship to the learning of other lands, draws to a close."[11] And Herman Melville called Americans the advance guard of mankind, "sent on through the wilderness of untried things, to break a path in the New World that is ours."[12] Romantic beliefs led artists to seek truth and beauty in the commonplace of daily life. Emerson urged young Americans to find their inspiration and materials in the "meal in the firkin; the milk in the pan; the ballad in the street, the news of the boat ... I embrace the common, I explore and sit at the feet of the familiar, the low."[13] This kind of vernacular art would be democratic and practical, moral and optimistic. It would reflect American society and its ideals. And it was in this spirit, over the next several decades, that literature was written and arts, both ornamental and useful, were created across this nation.

During the great experiment of Jacksonian democracy, the United States was viewed as the land of hope, an asylum, the "nation of futurity," "the nation of many nations ... destined to manifest to mankind the excellence of divine principles,"[14] where unity dominated diversity. But America was also maddeningly pluralistic in this age of individualism, a mosaic of sections subdivided into regions and localities with widely disparate economic pursuits. The economic revolutions that promoted massive migrations westward and from rural areas to industrial centers also resulted in the destruction of the self-sufficient farm economy, the collapse of the artisan and apprenticeship system, and the breakdown of traditional familial and communal ties. It also generated new areas of conflict—between capital and labor, wealth and poverty. Within this context, the nation's continental landmass of the fertile West was nothing if not an "appointed remedy," in Emerson's words,[15] or "the great safety valve," in those of Horace Greeley,[16] which permitted the governing tenet of antebellum America to remain the doctrine of the harmony of interests. Such faith underscores the basic premise of Jacksonian democracy—implicit trust in the common sense of the common man, an unshakable belief in the will of a virtuous and competent people.

Although foreign visitors and domestic critics often could not understand the importance to an American of qualities that seemed to be solely the product of an artist's or writer's or craftsman's own genius, the idea of being self-taught ran deep in American culture during the first half of the nineteenth century. However much these folk might complain of the disregard of academic techniques in the work of American craftsmen-artists of the period, the latter had devised ways of reaching out to the new nation with inventive, colorful, and compelling images and objects of everyday use that also display standards of excellence—as the sections in this catalogue of Tennessee arts and crafts so well demonstrate. In the process, these self-made, self-taught, and self-controlled men and women broke free of tradition and of the past itself.

Notes

1. Quoted in Michael Kraus, *The Writing of American History* (Norman: University of Oklahoma Press, 1953), 118–19.

2. Quoted in Henry Streel Commager, *The American Mind* (New Haven: Yale University Press, 1950), 311.

3. Quoted in Glyndon G. Van Deusen, *The Jacksonian Era, 1828–1848* (New York: Harper & Brothers, 1959), 98.

4. Michael Chevalier, *Society, Manners and Politics in the United States, Being a Series of Letters on North America* (1839; New York: Burt Franklin, 1969), 431.

5. Quoted in Sanford Cohen, *Labor in the United States* (Columbus, Ohio: Charles E. Merrill Books, 1960), 9.

6. Alexis de Tocqueville, *Democracy in America*, ed. Phillips Bradley (New York: Alfred A. Knopf, 1945), vol. 1, 3.

7. Fanny Kemble, *Journal of a Residence on a Georgia Plantation in 1838–39* (1863), quoted in *America through British Eyes*, comp. and ed. Allan Nevins (New York: Oxford University Press, 1948), 170.

8. Frances Trollope, *Domestic Manners of the Americans*, ed. Donald Smalley (New York: Alfred A. Knopf, 1949), 121.

9. Harriet Martineau, *Society in America* (1837), quoted in Russel Blaine Nye, *The Cultural Life of the New Nation, 1776–1830* (New York: Harper & Row, 1960), 143.

10. Quoted in Robert E. Riegel, *Young America, 1830–1840* (Norman: University of Oklahoma Press, 1949), 130.

11. Ralph Waldo Emerson, "The American Scholar" (1837), in *The Selected Writings of Ralph Waldo Emerson*, ed. Brooks Atkinson (New York: The Modern Library, 1940), 43.

12. Herman Melville, *Redburn: His Voyage* (1849), in *Herman Melville: Redburn, White-Jacket, Moby Dick* (New York: The Library of America, 1983), 185.

13. Emerson, "The American Scholar," 57.

14. Walt Whitman, *Leaves of Grass* (1855), in *Walt Whitman: Complete Poetry and Collected Prose* (New York: The Library of America, 1982), 142, 256.

15. Ralph Waldo Emerson, *English Traits* (1856), chap. 3, "Land," in *The Selected Writings of Ralph Waldo Emerson*, 485.

16. Quoted in Ray Allen Billington, *The Far Western Frontier, 1830–1860* (New York: Harper & Brothers, 1956), 265–66.

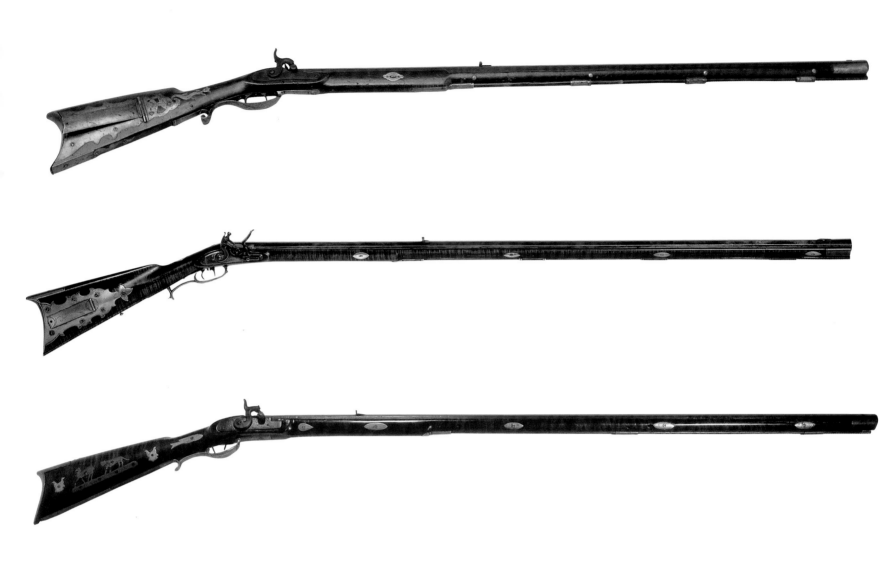

14 · **JOHN BULL**
Active East Tennessee

"Kentucky" or "Pennsylvania" Long Rifle,
ca. 1818–25
Walnut, oak or chestnut, silver, and ferrous metals;
59¾ × 2½ × 7½ in.
Tennessee State Museum Collection, 80.29.2

THIS FINE EXAMPLE OF A SOUTHERN-MADE long rifle is stocked in walnut, still a popular wood for gunstocks. The octagonal barrel is rifled in 52 caliber. There is a silver plate set at the rear of the top flat engraved "John Bull East Tennessee MGS" (Master Gunsmith?). The lock is an import made by W & G Chance, an English gunmaker of the period. Mounts are brass and German silver. The initials "H. H." are engraved on the side panel, probably those of an owner. The ramrod is of oak or chestnut, and the rifle has double-set triggers, which are often found on hunting or target rifles. WB

15 · **JACOB YOUNG**
b. Virginia 1774–d. Tennessee 1842

Tennessee Long Rifle, ca. 1830
Maple, iron, brass, silver, and gold; 64 × 1¾ ×9 in.
Private Collection

THE NAME OF THE MAKER OF THIS ELEGANT RIFLE, "Jacob Young," is stamped on the lock plate and engraved on a silver plate atop the barrel. The original flintlock has applied gold in the flash pan and around the touch hole of the barrel; the use of gold is very rare in Tennessee rifles. It is believed that Young settled near Springfield, in Robertson County, Tennessee, about 1810, and that the owner, whose name, "Wm Waid Woodfork," is engraved on the side plate, was a Middle Tennessee surveyor and militia officer. JCK

16 · *Rifle,* ca. 1850s–90s
Curly maple, silver, brass, and iron; 59½ in. overall
Collection of Monty and Linda Young

THIS 30-CALIBER PERCUSSION RIFLE was used for hunting many of the animals depicted in silver and brass inlays on the gunstock. Although the maker of the rifle is unknown, markings indicate that the lock was made by Kirkman & Ellis of Nashville. The rifle once belonged to Obediah Wade Hill (1824–1893) of Williamson County, said to be nearly seven feet tall and known for his great strength. NFC

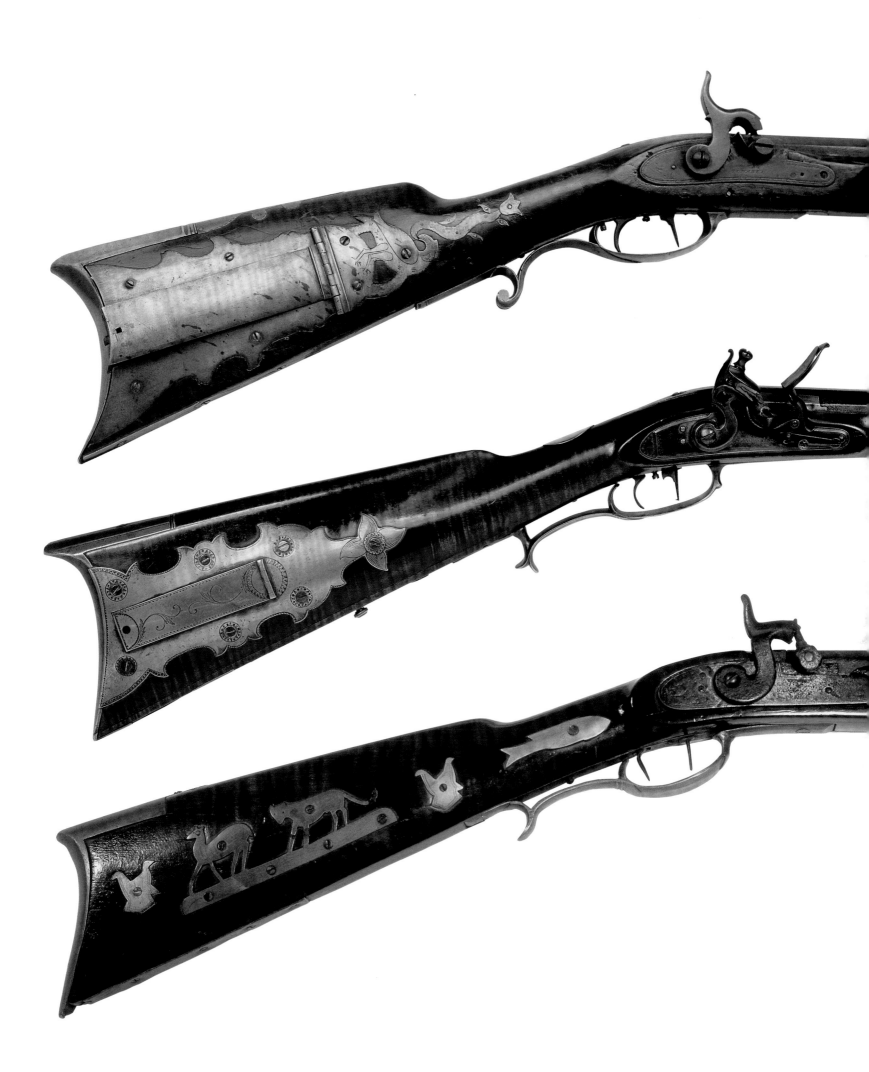

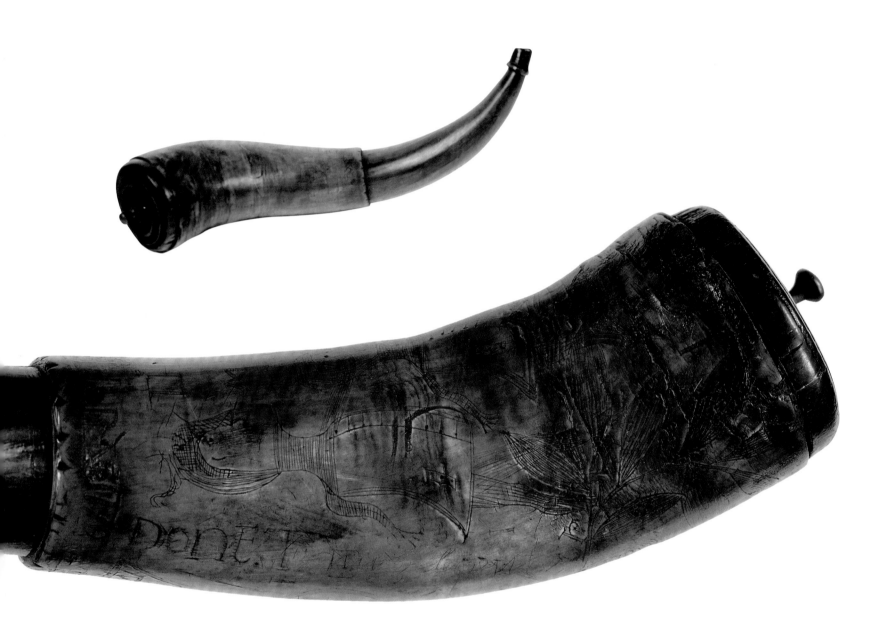

17 · ATTRIBUTED TO AMOS HEATON
b. Fincastle County, Virginia 1740–
d. Middle Tennessee 1795

Amos Heaton Family Horn, 1779
Horn, wood, and metal; 5½ × 5 × 14¼ in.
Collection of Carolyn and Giles Cromwell

A RARE EXAMPLE OF PIONEER FOLK ART, this powder horn was probably owned and decorated by Amos Heaton and his sons. After emigrating from Fincastle County, Virginia, during the 1770s, the Heatons were among the first settlers on the Cumberland River at the site that later became Nashville. Inscriptions and images affirming the Revolutionary War–era sentiments of the horn's owners, such as "Don't Tread on Me," "The Bill of Rites" [*sic*], "Love Liberty," and an American soldier thumbing his nose at the British crown, are scattered among carvings of frontier flora and fauna. These simple depictions provide insight into the culture and attitudes shaping the emerging nation. LT

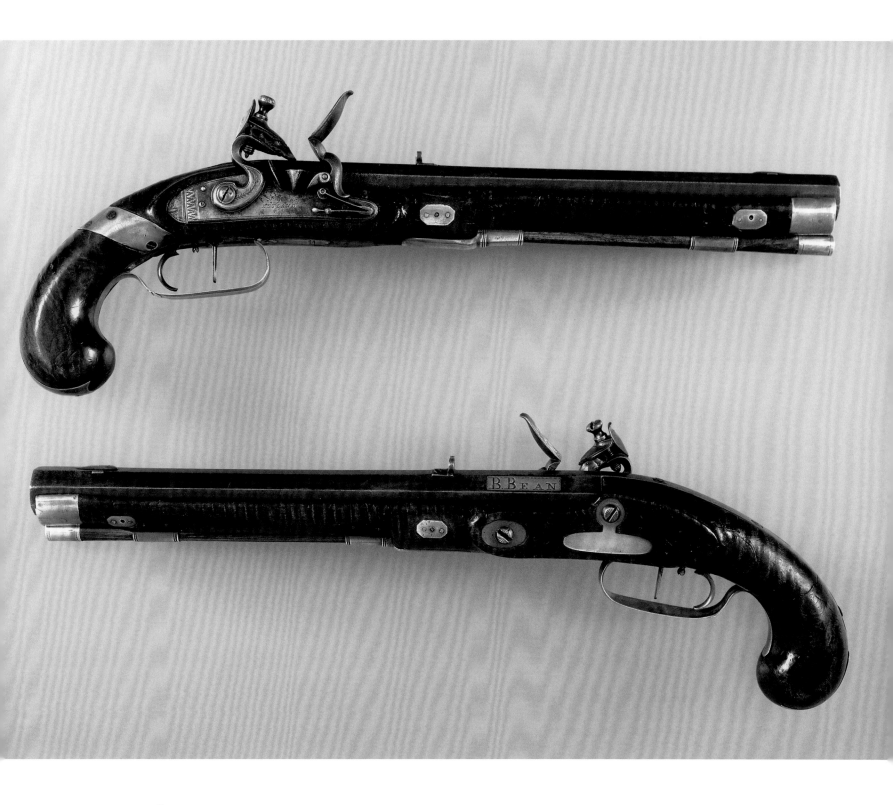

18 · BAXTER BEAN

Active Jonesboro, Tennessee

Horseman or (Saddle) Holster Pistols,
ca. 1812–20
Curly maple, silver, and ferrous metal;
6 × 16½ × 2 in.
Tennessee State Museum Collection, 85.24a–b

THESE PISTOLS WERE MADE by Baxter Bean of Jonesboro in upper East Tennessee. Bean's grandfather was William Bean, the first Tennessee gunsmith, who settled on the Watauga River in 1769. Many other members of the Bean family were also gunsmiths. The pistols are stocked in curly maple, a popular wood for both pistols and rifles. The octagonal barrels are rifled in 54 caliber. There are silver plates set in the barrels at the rear of the left top flat engraved "B. Bean." The locks are imports made by T. Ketland & Co. Thomas Ketland was a famous English gunmaker of the late eighteenth–early nineteenth century, working in Birmingham. The mounts are of silver, with a silver repair band on one grip. Unusually for pistols, they have double-set triggers. WB

Ann Harwell Wells

Tennessee Maps

Early maps of our country not only served as guides for the explorers and pioneers who settled the land; they also served as records of changing configuration as cities, roads, boundaries, and governmental entities evolved. The four maps included in this exhibition illustrate these functions.

One of the pioneer mapmakers, Henry Timberlake, a British Army lieutenant from Virginia, made "A Draught of the Cherokee Country," which became "the first printed map of any part of Tennessee taken from an actual survey."[1] After Timberlake had volunteered to travel through Cherokee Country to "cement friendship" with the Cherokees, he "formed a resolution of going by water" because he felt a "thorough knowledge of the navigation would be of infinite service."[2] In 1762 he used surveys that he made on the trip to produce this map, published in London with his *Memoirs* in 1765. The map follows the Tennessee River from "Mialoguo, or the Great Island," through the Indian towns of Toskegee, Tommotley, Toqua, Tennessee, Chote, Chilhowey, and Settacoo, ending in Tellasee. It names the "Head men" of each town and gives the number of "Fighting Men they send to War," with Settacoo, under Governor Cheulah, providing the most, 204 men.

The earliest maps of Tennessee document its progress from territory to statehood, a period from 1790 to 1796. By Act of Congress, on May 26, 1790, the Territory of the United States, South of the River Ohio, was created. From that time until statehood in 1796, the territory was called the Southwest Territory or Tennessee Government. After June 1, 1796, when President George Washington signed the bill granting statehood, the new state officially became Tennessee, or the State of Tennessee, as often seen on later maps.

General Daniel Smith's "A Map of the Tennassee Government...,"[3] published in Philadelphia in 1794, has the distinction of being the first American map of Tennessee. It has been said of General Smith, a surveyor, soldier, and public official: "In ability, education, and usefulness [he] ranked with the ablest men who moved to the West in this early period."[4] His work as surveyor for this map attests to his ability, for in the 1790s the "Tennassee Government" was remote and inaccessible. Still, Smith surveyed much of it, providing the foundation for many Tennessee maps.

Another Tennessee map, also named "Map of the Tennessee Government," was published in London in 1794 by John Stockdale and appeared in Jedidiah Morse's *The American Geography*. This small map's charm lies in its simplicity, for it has the barest of identifying markers, principally the rivers of Tennessee.

Although new counties and cities had appeared in the state by the early 1800s, they were often not reflected on its maps. Thus most Tennessee maps of that time were almost identical to those made earlier. By 1820, however, Tennessee maps were becoming sophisticated and contemporary with political developments. Methods of publishing were advancing, so that maps often were issued in color, whereas earlier ones had been printed uncolored. The publishers Mathew Carey, Isaac Lea, and Fielding Lucas produced handsome, accurate maps, such as "Tennessee—Geographical, Statistical, and Historical Map of Tennessee," which appeared in Carey and Lea's *American Atlas* of 1822. This map, drawn by Fielding Lucas, shows fifty-two counties, identifies many towns and roads, and locates "Cherokee Lands" in southeast Tennessee. The map is accompanied by text with information about rivers, climate, chief towns, and county populations. It notes that whereas the population in 1790 had been 35,691, by 1810 it had jumped to 261,727.

From 1765, when Lieutenant Timberlake produced his magnificent, detailed map, through the times of Daniel Smith and later mapmakers, Tennessee has held a fascination for all who have surveyed and mapped it. Evolving political changes, new towns, new counties, and changing boundaries have gradually been recorded on these maps, as a monument to the development of the great State of Tennessee.

Notes

1. Margaret Beck Pritchard and Henry G. Taliaferro, *Degrees of Latitude—Mapping Colonial America* (New York: The Colonial Williamsburg Foundation in association with Harry N. Abrams, 2002), 193.

2. Samuel Cole Williams, *Lieut. Henry Timberlake's Memoirs, 1756–1765* (Johnson City, Tenn.: The Watauga Press, 1927), 41.

3. In the early days, Tennessee was occasionally spelled "Tennassee."

4. Dumas Malone, ed., *Dictionary of American Biography* (New York: Charles Scribner's Sons, 1935–36), vol. 9, pt. 1, 254.

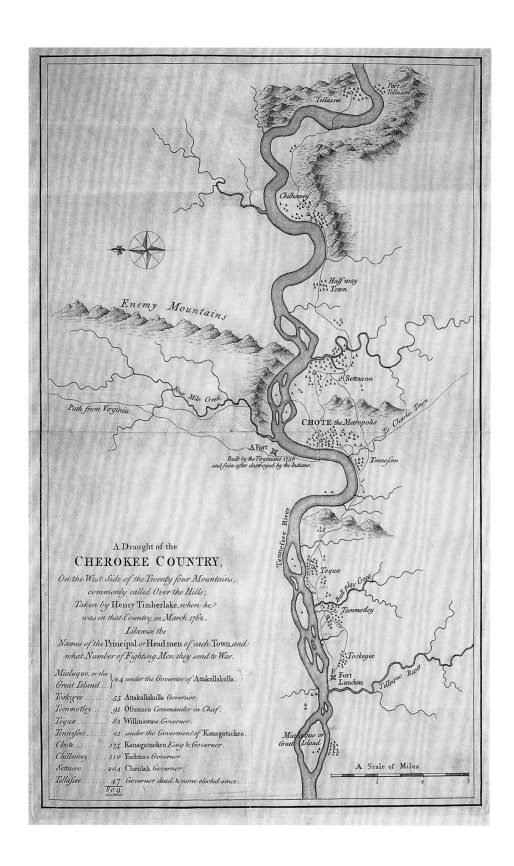

A Draught of the
CHEROKEE COUNTRY,
On the West Side of the Twenty four Mountains,
commonly called Over the Hills;
Taken by Henry Timberlake, when he
was in that Country, in March 1762.

Likewise the
Names of the Principal or Head men of each Town, and
what Number of Fighting Men they send to War.

Mialaquo, or the } 124 *under the Governor of Attakullakulla.*
Great Island }
Toskegee 55 *Attakullakulla Governor.*
Tommotley 91 *Ostenaco Commander in Chief.*
Toqua 82 *Willinawaw Governor.*
Tennessee 21 *under the Goverment of Kanagatuckeo.*
Chote 175 *Kanagatuckeo King & Governor.*
Chilhowey 110 *Yachtino Governor.*
Settacoo 204 *Cheulah Governor.*
Tellassee 47 *Governor dead, & none elected since.*

809

19 · **HENRY TIMBERLAKE**
d. 1765

Draught of the Cherokee Country
From *The Memoirs of Lieut. Henry Timberlake*
(London, 1765)
Engraving on paper; 15¾ × 9⅝ in.
Ann Harwell Wells Tennessee Map Collection,
Nashville Public Library Special Collections Division

HENRY TIMBERLAKE, A YOUNG BRITISH ARMY lieutenant from Virginia, made a perilous but productive trip on the Tennessee River in 1761 through Cherokee Country to "cement friendship" with the Indians. He used surveys that he made on that trip to produce this map, which is "the first printed map of any part of Tennessee taken from an actual survey." AHW

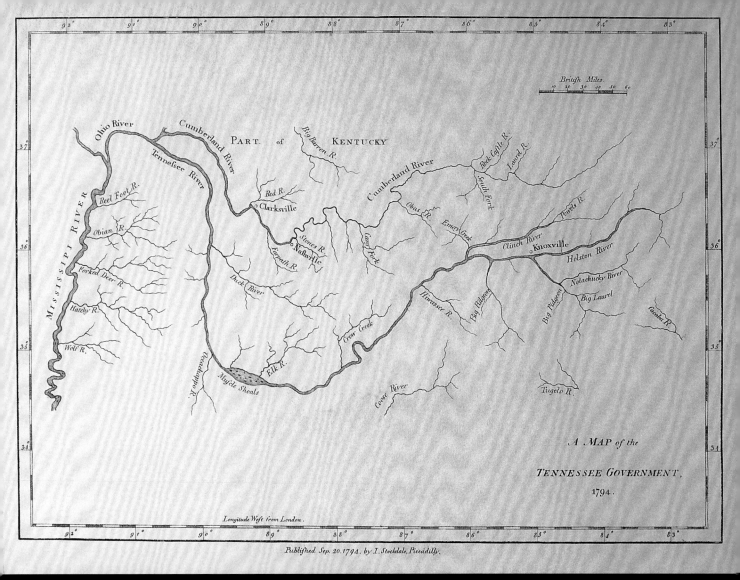

British Miles.
10 20 30 40 50 60

Ohio River Cumberland River PART. of KENTUCKY

Tennessee River

Big Barren R.

MISSISSIPI RIVER

Reel Foot R.

Obian R.

Red R.

Clarksville

Cumberland River

Rock Castle R. Laurel R.

South Fork

Powels R.

Forked Deer R.

Stones R.

Nashville

Obas. R. Emery Creek

Clinch River Knoxville

Holston River

Foxrath R.

Long Fork

Big Ridge

Nolachucky River

Hatchy R.

Deck River

Crow Creek

Hiwassee R.

Big Pidgeon Big Laurl

Cacaba R.

Wolf R.

Occochappo R.

Elk R.

Myrtle Shoals

Coose River

Tugelo R.

A MAP of the

TENNESSEE GOVERNMENT,
1794.

Longitude West from London.

Published Sep. 20. 1794. by I. Stockdale, Piccadilly.

20 · JEDIDIAH MORSE
b. 1761–d. 1826

JOHN STOCKDALE
b. 1739–d. 1814

A Map of the Tennessee Government, 1794
In Jedidiah Morse, *The American Geography*
(London: John Stockdale, 1794)
Engraving on paper; 6½ × 9¼ in.
Collection of Lamar and Honey Alexander

THE CHARM OF THIS SMALL MAP lies in its simplicity, for it has the barest of
identifying markers, principally the rivers of the Tennessee Government. Morse's small
geography, in which it was published, "cannot be regarded as an atlas [but it] contains a
collection of the earliest maps of the states in the union," according to P. L. Phillips in the
List of Maps of America in the Library of Congress. AHW

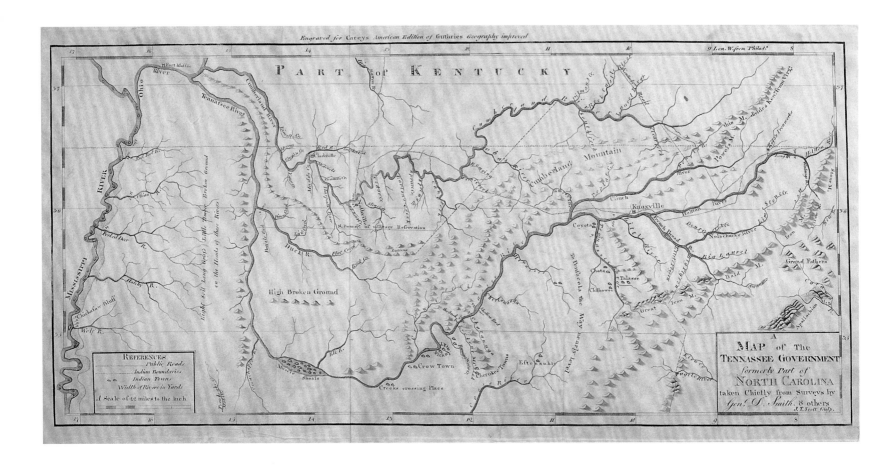

Engraved for Careys American Edition of Guthries Geography improved

REFERENCES
Public Roads
Indian Boundaries
Indian Towns
Width of Rivers in Yards

A Scale of 44 miles to the Inch

A
MAP of The
TENNASSEE GOVERNMENT
formerly Part of
NORTH CAROLINA
taken Chiefly from Surveys by
Genl. D. Smith & others
J. T. Scott Sculp.

21 · **DANIEL SMITH**

b. Stafford County, Virginia 1748–
d. Sumner County, Tennessee 1818

*A Map of the Tennessee Government
formerly Part of North Carolina taken
Chiefly from Surveys by Genl. D. Smith
& others,* 1794

Published by Mathew Carey (Philadelphia, 1794)
Engraving on paper; 10 × 20⅞ in.
Ann Harwell Wells Tennessee Map Collection,
Nashville Public Library Special Collections Division

GENERAL DANIEL SMITH was a surveyor, soldier, and public official, "one of the ablest men who moved to the West in this early period," according to Dumas Malone in the *Dictionary of American Biography*. His 1794 *Map of the Tennessee Government* is the first American map of Tennessee. It was made during the brief period when the area was still the Southwest Territory, or Tennessee [*sic*] Government. AHW

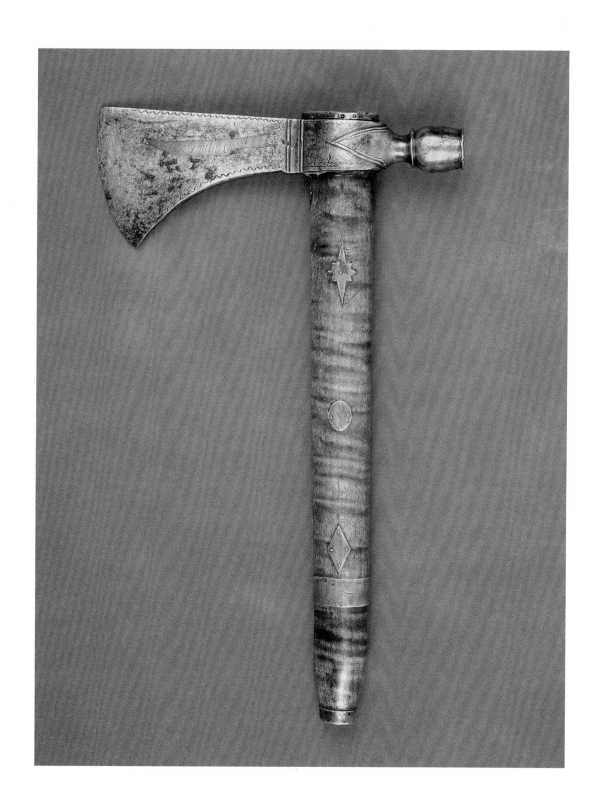

22 · *Tomahawk Owned by Daniel Smith*, ca. 1778
Maple, silver, and steel; 11¼ × 7⅜ × 1 in.
Collection of William H. Guthman

FUNCTIONING AS A WEAPON, smoking pipe, and utility ax, the pipe tomahawk was a common sidearm among eighteenth-century frontiersmen. This finely wrought example, made by a gunsmith, was owned by the frontier surveyor and militia officer Daniel Smith (1748–1818) and is almost certainly the weapon he is known to have lost in 1780 while helping to survey the boundaries of what is now Tennessee. Smith's name and the word "Opost," a corruption of the name Au Poste Vincennes, an early French trading post on the Wabash River, are inscribed in the decorative silver scalping knife that is inlaid on one side of the blade. The name of a subsequent owner, James Stephenson, is carved beside the silver spear that is inlaid on the blade's other side. LT

23 · HENRY CHARLES CAREY
b. 1793–d. 1879

ISAAC LEA
b. 1792–d. 1886

Geographical, Statistical, and Historical Map of Tennessee, 1822

In *Carey and Lea's American Atlas* (Philadelphia, 1822)
Engraving on paper, hand coloring; 16⅜ × 21⅞ in.
Ann Harwell Wells Tennessee Map Collection,
Nashville Public Library Special Collections Division

AFTER 1820 TENNESSEE'S MAPS were becoming contemporary with political developments and quite sophisticated, as demonstrated by this handsome example by Carey and Lea. Drawn by Fielding Lucas, this map shows fifty-two counties, each brightly colored, identifies many towns and roads, and locates Cherokee Lands in southeast Tennessee. It is accompanied by text with information about rivers, climate, chief towns, and county population. AHW

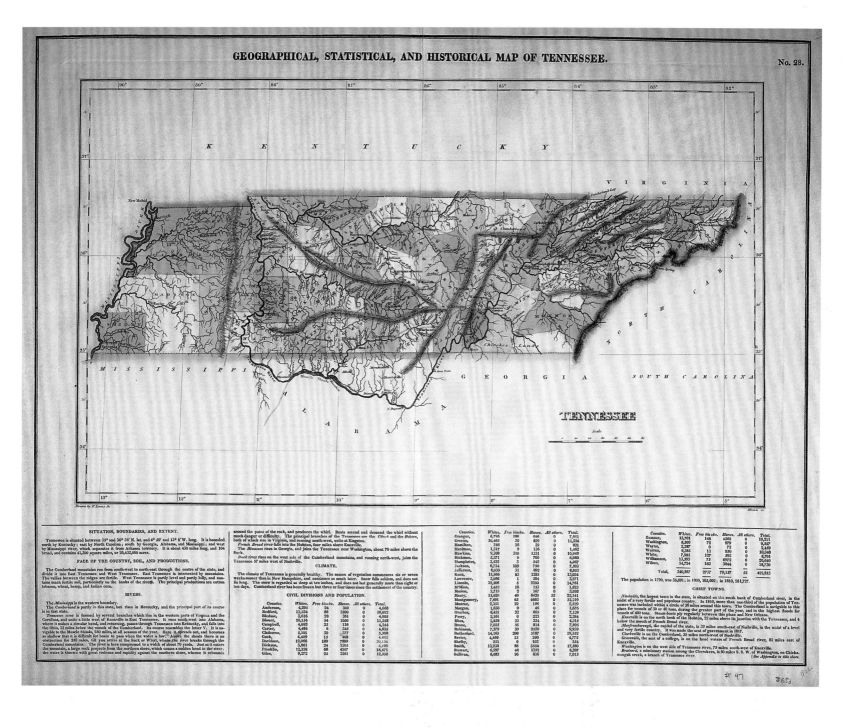

TENNESSEE

Scale

SITUATION, BOUNDARIES, AND EXTENT.

Tennessee is situated between 35° and 36° 30′ N. lat. and 4° 30′ and 13° 8′ W. long. It is bounded north by Kentucky; east by North Carolina; south by Georgia, Alabama, and Mississippi; and west by Mississippi river, which separates it from Arkansas territory. It is about 430 miles long, and 104 broad, and contains 41,300 square miles, or 26,432,000 acres.

FACE OF THE COUNTRY, SOIL, AND PRODUCTIONS.

The Cumberland mountains run from south-west to north-east through the centre of the state, and divide it into East Tennessee and West Tennessee. East Tennessee is intersected by mountains. The valleys between the ridges are fertile. West Tennessee is partly level and partly hilly, and contains most fertile soil, particularly on the banks of the rivers. The principal productions are cotton, tobacco, wheat, hemp, and Indian corn.

RIVERS.

The *Mississippi* is the western boundary.

The *Cumberland* is partly in this state, but rises in Kentucky, and the principal part of its course is in that state.

Tennessee river is formed by several branches which rise in the western parts of Virginia and the Carolinas, and unite a little west of Knoxville in East Tennessee. It runs south-west into Alabama, where it makes a circular bend, and returning, passes through Tennessee into Kentucky, and falls into the Ohio, 12 miles below the mouth of the Cumberland. Its course resembles the letter V. It is navigable to the Muscle Shoals, 250 miles, at all seasons of the year. Here it spreads out, and becomes so shallow that it is difficult for boats to pass when the water is low. Above the shoals there is no obstruction for 250 miles, till you arrive at the Suck or Whirl, where the river breaks through the Cumberland mountains. The river is here compressed to a width of about 70 yards. Just as it enters the mountain, a large rock projects from the northern shore, which causes a sudden bend in the river; the water is thrown with great violence and rapidity against the southern shore, whence it rebounds

around the point of the rock, and produces the whirl. Boats ascend and descend the whirl without much danger or difficulty. The principal branches of the Tennessee are the *Clinch* and the *Holston*, both of which rise in Virginia, and running south-west, unite at Kingston.

French Broad river falls into the Holston, four miles above Knoxville.

The *Hiwassee* rises in Georgia, and joins the Tennessee near Washington, about 70 miles above the Suck.

Duck river rises on the west side of the Cumberland mountains, and running north-west, joins the Tennessee 57 miles west of Nashville.

CLIMATE.

The climate of Tennessee is generally healthy. The season of vegetation commences six or seven weeks sooner than in New Hampshire, and continues as much later. Snow falls seldom, and does not lie long. The snow is regarded as deep at ten inches, and does not last generally more than eight or ten days. Cumberland river has been frozen but three or four times since the settlement of the country.

CIVIL DIVISIONS AND POPULATION.

Counties.	Whites.	Free blacks.	Slaves.	All others.	Total.
Anderson,	4,295	24	349	0	4,668
Bedford,	12,334	88	3590	0	16,012
Bledsoe,	3,616	28	361	0	4,005
Blount,	10,134	54	1050	0	11,238
Campbell,	4,693	35	116	0	4,344
Carter,	4,484	6	345	0	4,835
Claiborne,	5,101	30	377	0	5,508
Cocke,	4,409	15	468	0	4,892
Davidson,	12,066	189	7889	0	20,144
Dickson,	3,861	24	1305	0	5,190
Franklin,	12,338	66	4167	0	16,571
Giles,	9,272	25	3261	0	12,558

Counties.	Whites.	Free blacks.	Slaves.	All others.	Total.
Granger,	6,796	198	666	0	7,661
Greene,	10,465	30	829	0	11,324
Hamilton,	766	16	39	0	821
Hardeman,	1,317	9	136	0	1,462
Hawkins,	9,508	310	1331	0	10,949
Hickman,	5,371	9	760	0	6,080
Humphreys,	3,522	3	542	0	4,067
Jackson,	6,734	109	780	0	7,893
Jefferson,	8,650	31	892	0	8,951
Knox,	11,666	83	1285	0	13,034
Lawrence,	3,066	1	204	0	3,271
Lincoln,	12,306	5	2280	0	14,761
M'Minn,	1,452	18	153	0	1,623
Marion,	3,719	2	167	0	3,888
Maury,	15,620	49	6420	52	22,141
Montgomery,	7,491	65	4663	0	12,219
Monroe,	2,351	22	186	0	2,329
Morgan,	1,630	0	46	0	1,676
Overton,	6,431	32	665	0	7,128
Perry,	2,161	0	223	0	2,384
Rhea,	3,638	23	334	0	4,315
Roane,	7,025	56	814	0	7,895
Robinson,	7,379	39	2510	0	9,928
Rutherford,	14,165	200	5187	0	19,552
Sevier,	4,469	13	290	0	4,772
Shelby,	251	0	103	0	354
Smith,	13,938	88	3554	0	17,880
Stewart,	6,997	48	1352	0	8,397
Sullivan,	6,083	96	836	0	7,015

Counties.	Whites.	Free blacks.	Slaves.	All others.	Total.
Sumner,	13,701	148	5362	0	19,211
Washington,	8,806	72	979	0	9,857
Wayne,	2,387	0	72	0	2,459
Warren,	9,385	13	930	0	10,348
White,	7,981	127	593	0	8,701
Williamson,	13,592	75	6973	0	20,640
Wilson,	14,724	162	3844	0	18,730
Total,	340,867	2737	79,137	52	422,813

The population in 1790, was 35,691; in 1800, 105,602; in 1810, 261,727.

CHIEF TOWNS.

Nashville, the largest town in the state, is situated on the south bank of Cumberland river, in the midst of a very fertile and populous country. In 1810, more than one-third of the population of Tennessee was included within a circle of 30 miles around this town. The Cumberland is navigable to this place for vessels of 30 or 40 tons, during the greater part of the year, and in the highest floods for vessels of 400 tons. Steam-boats ply regularly between this place and New Orleans.

Knoxville is on the north bank of the Holston, 22 miles above its junction with the Tennessee, and 4 below the mouth of French Broad river.

Murfreesborough, the capital of the state, is 32 miles south-east of Nashville, in the midst of a level and very fertile country. It was made the seat of government in 1817.

Clarksville is on the Cumberland, 39 miles north-west of Nashville.

Greenville, the seat of a college, is on the head waters of French Broad river, 81 miles east of Knoxville.

Washington is on the west side of Tennessee river, 75 miles south-west of Knoxville.

Brainerd, a missionary station among the Cherokees, is 30 miles S. S. W. of Washington, on Chickamaugh creek, a branch of Tennessee river. [*See Appendix to this sheet.*]

Drawn by F. Lucas Jr.

47 $650

Jonathan Leo Fairbanks

THE MATERIAL CULTURE OF NINETEENTH-CENTURY TENNESSEE

THIS EXHIBITION HIGHLIGHTS EXTRAORDINARY WORKS PAST AND PRESENT, TRADITIONAL and avant-garde. It prompts a reexamination of how the creative process remains a dynamic, evolving, and fundamental source of collective, public, and personal expression.

Scholars have fairly recently applied the words "material culture" to the study of works made by humankind. Those who seek to understand the underlying meanings or patterns of civilization through the mute objects left behind are many. The raw materials of such study include antiques and collectibles as well as fine arts and the art of the book, manuscripts and tools, buildings, archaeological finds and scientific instruments, to mention some of that vast number of material remains that constitute the inventory of objects left by generations of the people who went before as well as those being made and used in Tennessee today. An exhibition is necessarily selective. It presents a snapshot of insight into the collective material culture of a place, time, and people. It is that insight, recorded in the catalogue of the exhibition, that is a great gift to the public not only today but for years to come—highlighting what was considered most important to feature at the moment the exhibition opened.[1]

The questions that occur to this writer (who is not from Tennessee but who has often visited the state and has enjoyed warm friendship with those from within its borders) are these: In what ways do the works selected for display in this exhibition compare with those made in other states, and how do they differ? Are there circumstances peculiar to Tennessee that give works made in this region a special shape or expression? The irony of museum exhibitions is that many questions asked cannot be answered until after the display is mounted and the catalogue already printed. The reader of this catalogue who visits the exhibition will undoubtedly come away with conclusions the organizers and authors had not anticipated.

A general guide to the evolution of works handcrafted after initial settlement in Tennessee might be helpful. Pioneers brought with them necessities to sustain life in an unfamiliar country. Manufactured goods and homespun or handmade articles were packed into the new country as much as possible until the survival phase of settlement was over, when homes, barns, and other structures were built to sustain a civilized life. Chief among these first-phase settlement needs were small craft shops for such trades as blacksmithing, coopering, and pottery and furniture making. Furniture made in the first phase of settlement was generally practical, utilitarian, and easy to transport—simple ladder-back or mule-eared chairs with splint, thong, or hide seats prevailed. Such chairs carried the general outline of late Sheraton-style Neoclassicism to the frontier—across the continent to the West, to Texas, Utah, the Nevada Territory, as well as California and Oregon. This ubiquitous frontier or pioneer seating was common throughout the continent with only slight variations from region to region, including that of Tennessee.

Depending on the locale of settlement—sometimes on a waterway or trail that subsequently opened to stage or rail traffic—the villagers found themselves, of necessity, largely self-sufficient. Importation of goods was a competitive reality for small-scale craftsmen, if settlement was on a well-traveled road or river. But isolation required settlers to be versatile or skilled in many crafts or trades, including those of farming and the keeping of livestock. It is an amazing fact that a single pioneer family, at virtually any point across the American

Chest, 1829, detail, cat. no. 37

continent, could, within thirty years or less, witness the transformation of their settlement from a cluster of cabins or simple shelters to substantial residences in thriving towns.[2]

The advance from log dwellings to brick or stone was paralleled as the second-settlement phase introduced more elegant furniture and furnishings. Some of it was created by local craftsmen who maintained ever-improved shops powered by water or steam and provided with imported machinery and equipment. To maintain salability of their products, enterprising craftsmen found it necessary to quickly adapt their works to match the style and quality of works that could be acquired through import from larger urban centers. For Tennessee, Philadelphia was a frequent source of goods in the latest style. Yet it might astonish many viewers today to discover just how many silversmiths and cabinetmakers thrived in the boomtowns of Tennessee.[3] Their works, made in this second-settlement phase, exhibit a full understanding of Neoclassical style—though often pared down to essentials to suit the taste and means of their customers. The cabinetmaker James G. Hicks of Nashville advised customers in his newspaper advertisement of 1812 that his connections and correspondence with people in Philadelphia and Baltimore assured that his work was of the latest fashion and in the neatest and best manner. He not only used local woods, but he also imported mahogany for making showpieces. Yet even his works in mahogany have the trim, spare, functional look that one finds on so many pieces of Tennessee furniture as well as silver. Without knowing that a piece of furniture was made in Tennessee, it might be very difficult to distinguish it from its counterpart made in seaboard towns on the Atlantic coast. For example, at Cragfont, a massive stone house in Sumner County, Tennessee, there stands a fall-front desk or secretary desk made about 1800 for General James Winchester. The average antiques collector would be astonished to learn that the desk—with its stylish French feet and scalloped pigeonholes, oval brasses, and elegant overall workmanship—had been made in the Federal period in Tennessee. The sugar chest, less often found among antiques on the East Coast, is frequently encountered in Tennessee—a functional and popular piece of furniture serving a special need.

The pioneer and frontier experience might be seen as part of the environment that developed practical sensibilities in its inhabitants. While The Hermitage, the home of President Andrew Jackson, was by no means spare or simple in its furnishings, this great historic site needs to be seen in terms of the fulfillment of a lifetime of work—which includes its log cabin of 1804 and the early outbuildings. The mansion house itself and its furnishings date to the 1820s and 1830s—when the third phase of settlement can be identified with extensive importation of luxury goods from urban centers in the East. As a seasoned soldier and practical man, Jackson was suspicious of advanced monetary exchange and distrustful of paper currency. His vast collection of silver at The Hermitage reflects his belief in hard currency and durable and valuable goods. In 1832 he revoked the charter on the United States Bank, which was run by Nicholas Biddle in Philadelphia. This bank was responsible for having issued the first uniform currency and was remarkable for its advanced policies.

In 1845, following Jackson's era, one of America's most distinguished classical architects, William Strickland, moved from Philadelphia to Nashville to design and supervise the construction of the State Capitol building.[4] This great classical masterpiece is Strickland's last and most important work. It marks the fourth phase of settlement—that of sophisticated urbanization.

While in Nashville for the last nine years of his life, Strickland designed several structures: two churches, St. Mary's (Catholic), built between 1844 and 1847, and the First Presbyterian (1848). He also designed Belmont, one of the most handsome of Greek Revival mansions in the South (1850) for Joseph H. Acklen. These achievements, when put into perspective with what was being constructed in frontier towns of the Far West, place Tennessee's cultural advances far ahead of settlements in the western territories. Like all other states, Tennessee had its small, rural backwater towns, but the urban centers of this fourth phase of settlement were current with the fashion of the high Victorian period. With urbanization and growth came developed industry. Such industry brought prosperity, wealth, leisure, congestion, and a nostalgia for simpler things from the past. Preservation and antiquarianism, arts and crafts revivals follow. They herald the advent of a modern age and the twentieth century.

Historic Cragfont, Castalian Springs, Tennessee

Tennessee preserves an amazing historic and artistic treasury that perpetuates the aesthetic vision of people from all nations—including Native Americans, immigrant Scotch-Irish, African Americans, Asians, South Americans, and others. The Hartzler-Towner Multicultural Museum of Nashville celebrates such diversity. Other sites and museums honor specific historic figures like David Crockett, Abraham Lincoln, Sam Houston, Andrew Johnson, James K. Polk, and Meriwether Lewis, to name only a few. In Smithville, the Appalachian Center for Crafts provides programs and facilities for workshops and festivals. Lifestyles of frontier people are featured in the Museum of Appalachia in Norris. The American Association for State and Local History and the Association for the Preservation of Tennessee Antiquities are located in Nashville. The Arrowmont School of Arts and Crafts in Gatlinburg provides educational resources for the encouragement of the arts. Today these institutions enable the pioneering spirit to live on in Tennessee as it did in the nineteenth century.

NOTES

1. A seminal catalogue of an exhibition at Cheekwood examining early Tennessee arts is *Made in Tennessee: An Exhibition of Early Arts and Crafts* (Nashville: Tennessee Fine Arts Center, 1971). This catalogue anticipated a number of regional exhibitions in the 1970s that dealt with the decorative arts. Among these were the Witte Memorial Museum's exhibition in San Antonio, Texas, in 1973, *Early Texas Furniture and Decorative Arts* (San Antonio: Trinity University Press, 1973), the exhibition catalogue for *Frontier America: The Far West* (Boston: Museum of Fine Arts, 1975), and the exhibition catalogue for *Two Hundred Years of the Visual Arts in North Carolina* (Raleigh: North Carolina Museum of Art, 1976), to name just three. The celebration of America's bicentennial of the American Revolution generated many more exhibitions, too numerous to consider here, but worthy of a comparative study in methodologies.

2. Building and settlement patterns are well articulated by Fred B. Kniffen, "Folk Housing: Key to Diffusion," 3–26, and Edward T. Price, "The Central Courthouse Square in the American County Seat," 124–46, both in *Common Places, Readings in American Vernacular Architecture,* ed. Dell Upton and John Michael Vlach (Athens and London: University of Georgia Press, 1986). Both articles describe building types and settlement patterns that occurred in Tennessee.

3. The authoritative book by Benjamin H. Caldwell Jr., *Tennessee Silversmiths* (Winston-Salem, N.C.: The Museum of Early Southern Decorative Arts, 1988), not only documents the abundance of well-wrought and stylish silver in early Tennessee, but it also records a family account of an early settler in Tennessee, Joseph Washington, second cousin of George Washington, who arrived in 1796 in an undeveloped area, raised a log house, and eventually built a Neoclassical manor house. This classic story of personal improvements from rude survival dwelling to a refined establishment within the lifetime of the original pioneer was related to Caldwell, who notes it at 194 n. 55. Caldwell's book is a rich bibliographic source.

4. The standard biography of William Strickland is Agnes Addison Gilchrist, *William Strickland: Architect and Engineer, 1788–1854* (Philadelphia: University of Pennsylvania Press, 1950).

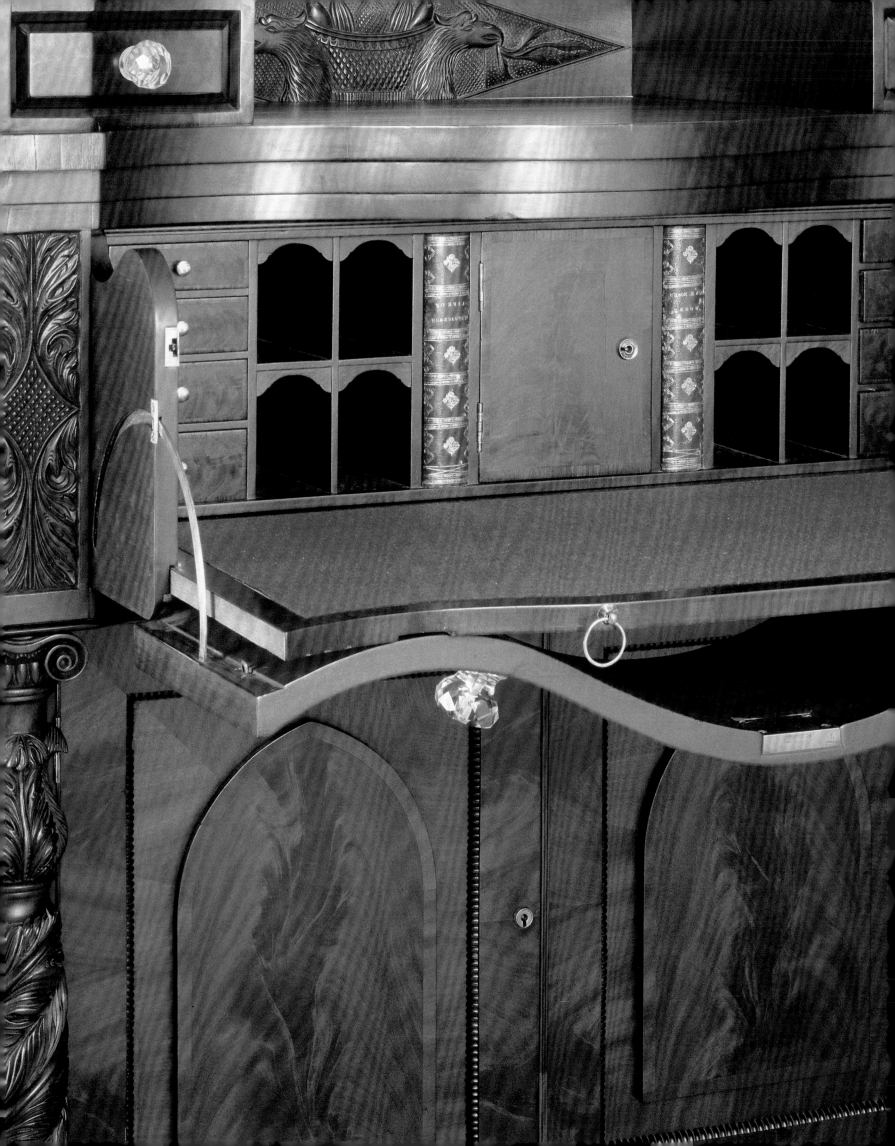

Robert Hicks

ANTEBELLUM FURNITURE

THE STORY OF A TIME AND PLACE CAN OFTEN BEST BE TOLD BY WHAT IS LEFT OF ITS MATERIAL culture. There are probably few better examples of this than Tennessee's antebellum furniture. Throughout its years of exploration, development, and prosperity, antebellum Tennessee produced furniture that mirrored the ever-changing times. From wilderness to backcountry settlement to the mock-Greek temples of slave society, furniture reflected the lives of European and, to a lesser extent, African immigration into the west.

Like the changing and multilayered society that produced it, examples of Tennessee's antebellum furniture cover the gamut, from crude to high style. Since *Art of Tennessee* was conceived as an exhibition of the visual arts of the state, and not as a furniture or history exhibition, we are limited in the story we can tell. So we begin by conceding that there will be many holes in our story, as our goal has been to focus on the visual. That said, there is still an outline of Tennessee's rich antebellum history underlying the role that furniture played in our visual arts.

Fortunately, for both students and collectors of Tennessee furniture, several solid studies and references preceded this exhibition and laid the groundwork for it. Beginning with *Made in Tennessee*, an exhibition with catalogue of early Tennessee arts and crafts presented at Cheekwood in 1971—organized by Ben Caldwell, Owen Meredith, the late Stanley F. Horn, the late Hal R. Swann Jr., and the late Albert W. Hutchison—Tennesseans were well on their way to a better understanding of our material culture. That same year, the Dulin Gallery of Art and the East Tennessee Historical Society in Knoxville presented an exhibition with catalogue entitled *The Arts of East Tennessee in the Nineteenth Century.*

This was followed by *Antiques in Tennessee*, a collection of articles on Tennessee's material culture edited by *The Magazine Antiques* in the early 1970s. Under the editorship of the late Alice Winchester, Wendell Garrett, the late Orrin W. June, and Ellen Beasley, the issue included a series of essays on a range of Tennessee decorative arts subjects.

And finally, there are *The Art and Mystery of Tennessee Furniture*, Nathan Harsh and Derita Coleman Williams's encyclopedic study edited by C. Tracey Parks in 1988; and Namuni Hale Young's exhibition and catalogue, *Art and Furniture of East Tennessee* in 1997. Without any and all of these groundbreaking works and all the work done by the Tennessee State Museum, The Tennessee Historical Society, and the Museum of Early Southern Decorative Arts, we never could have attempted an exhibition of the breadth of *Art of Tennessee.*

The Atlanta Historical Society's 1983 exhibition with catalogue, *Neat Pieces*, discussed furniture forms that were commonly found in the South. The list included the slab, or sideboard-slab, often called a huntboard in the twentieth century; the turn-round or lazy Susan table; the sugar chest; the case and bottles or cellerette on stand; and the hide-bottomed slat-back chair.

All of these have been found in Tennessee, along with our own lowly biscuit rock—a table created with a stone surface for the exclusive purpose of beating biscuit dough. It may speak volumes about frontier culture in the backcountry that all of these early Southern forms were tied to eating and drinking.

Another piece of furniture that would have been commonly found in Tennessee households was the Jackson press. Its origin is as closely tied to Tennessee and the backcountry as probably any form of antebellum furniture

John Rose, *Secretary*, ca. 1833, detail, cat. no. 40

55

other than the sugar chest. Possession of a Jackson press spoke of its owner's lack of pretension, belief in the common man, but above all else, his support of Andrew Jackson. Ironically, Jackson's adopted hometown, Nashville, was a hotbed of Whig opposition. If the voting record of the town is any judge, presses in Nashville should have been called Clay presses, as Henry Clay and his fellow Whigs, more often than not, carried the city. But among the yeoman class on farms throughout rural Tennessee, a population whose vote would eventually carry Jackson all the way to the White House, a Jackson press was right at home.

As the Jackson press was usually found in the dining room or in a passage, it served as an all-purpose case piece with two doors enclosing storage shelves that could be used to hold everything from bed linens and blankets to plates, serving bowls, and platters. Above that space, one or two drawers, side by side, held table linens and cutlery. Two forms of Jackson presses have come down to us from this period. The first has one or two drawers over two doors. It typically has a backsplash at the back of the top or a three-sided splashboard at the back and sides of the top, and frequently rests on turned feet. The second form has the same one or two drawers over two-door construction but lacks the splashboard; instead, it has a stepped-back cupboard sitting on it. As with most other forms of furniture made in Tennessee cabinet shops, cherry or walnut was the primary wood used for a Jackson press.

Most antebellum furniture in Tennessee falls into one of three categories. The first is the large segment of furniture that came out of the cabinet shops that moved ever westward. For almost as soon as the first permanent European settlements popped up in the backcountry, cabinetmakers were arriving via the Shenandoah Valley and Great Wagon Road out of Pennsylvania and Winchester, Virginia.

Many of these artisans had been trained in either the Philadelphia or the Baltimore area or were second-generation Tennessee artisans, having apprenticed under Philadelphia- or Baltimore-trained cabinetmakers. While it may seem like a stretch to link the backcountry of East Tennessee with one of the largest cities in Anglo-America, it is better understood when one follows the path of western migration out of Philadelphia to Winchester, Virginia, where the Great Wagon Road began. Because the Great Wagon Road, which went as far as Salem, North Carolina, was one of the very few passable wagon roads in the West, it became a jumping-off place for settlement into East Tennessee. The result was that cabinetmakers were soon setting up shop in the new towns of Jonesboro, Greenville, Rogersville, Maryville, and Knoxville. Still others crossed over the Great Smoky Mountains from western North Carolina into East Tennessee.

From these new shops came sundry forms of furniture, filling the new homes of Tennessee. More often than not they were scaled down and simpler than their Philadelphia, New York, and Baltimore cousins. One has only to view a piece attributed to the group known as the Winchester, Virginia, School of cabinetmakers working in both East and Middle Tennessee to understand its antecedent in Philadelphia. Likewise, the form of a piece from the William Winchester shop in Sumner County was born out of Baltimore.

These influences were also tempered by the presence of craftsmen who brought with them their own traditions, including English, German, Moravian, Scottish, and Irish. And to add to the difficulty in tracing root influences, cabinetmakers and their apprentices rarely seemed to stay put, as they, like many of their fellow settlers, moved west as the state opened up.

By the second quarter of the nineteenth century, many towns throughout Tennessee, especially in East and Middle Tennessee, had grown to the point that they were capable of sustaining multiple cabinet shops. What emerged with this new civilization was a thriving society that was primarily agrarian, but with strong centers of trade and commerce. Antebellum cabinetmakers prospered as the desire for creature comforts grew. Soon artisans were producing every form of furniture possible, including safes and presses, corner cupboards and clocks, slabs and sideboards, bureaus and chests, beds and chairs, wardrobes and desks and bookcases. All were being churned out in a growing number of cabinet shops throughout Tennessee.

The overwhelming number of documented cabinetmakers during the antebellum period were white. Yet there were both freemen, like Dick Poynor of Williamson County, who owned his own chair factory, and enslaved men who were owned by cabinetmakers or were rented out to cabinetmakers to work and, at times, to run cabinet shops. Unfortunately, most of the history of the role the African community played in the development of cabinet shops in Tennessee has been lost forever.

The backcountry was opened to settlement and trade largely because of the state's extensive network of navigable rivers. Simultaneously, a growing number of passable roads linked port communities and landlocked towns. This must have seemed like a boon for the cabinetmaker, who could now both receive exotic woods like mahogany and more easily move his shop to a new settlement. Cabinetmakers began to advertise that they could produce goods on a par with what could be found in the East, even while competition grew as more cabinetmakers came to the state to ply their trade.

It should not be thought that this growing network of transportation was moving only one way. John Rose from East Tennessee may be one of the better examples of the mobility and skill of the backcountry cabinetmaker. For while he proudly claimed his roots in East

Tennessee, he also asserted that he had mastered carving to equal that of any Philadelphia craftsman. During his career, he traveled back and forth between the two areas, producing handsomely carved furniture for buyers in both markets. The secretary in the exhibition was made during one of the years that Rose was living in Pennsylvania. Yet even then, when he signed his work, he proudly declared that he was from East Tennessee.

Even as the new cabinet shops were establishing themselves, merchants began to use the same transportation system to bring in the furniture that falls into our second category, the imported venture, or speculative sale, furniture of the antebellum years. With prosperity came consumers' desire to have the latest fashion. Tennessee's retailers advertised they had "fashionable" goods for sale, as they referred to the newest styles from the urban East. For most Tennesseans, Philadelphia and New York were the design centers for current fashion. John Overton of Travellers Rest was typical of the Tennesseans who added venture furniture to their homes. During a major redecoration, Overton purchased twelve Philadelphia-made klismos-style chairs from his son-in-law R. H. Barry, a retailer of venture goods in Nashville. As was the custom, the Philadelphia maker numbered each chair under the seat. For whatever reason, six of those numbered chairs ended up at The Hermitage, the home of Overton's friend, political ally, and former law partner, Andrew Jackson. Overton acquired six more chairs to replace those he had given or sold to Jackson. Tradition has held that the additional six chairs were made in Nashville. If so, it is instructive to compare the Philadelphia-made chair with its copy, revealing a high level of craftsmanship that is not always expected from the backcountry furniture maker.

With all the new money in Tennessee, some of the finest furniture of the day was coming from the East by way of the rivers and improving roadways to furnish town houses and plantations alike. The Hermitage may be as good an example as any of how locally made and venture furniture were mixed as Tennesseans decorated their homes at the time. The Hermitage's sofas and beds were made in Philadelphia, but Jackson's desk and bookcase, his bureaus, and his card tables came from a host of Tennessee shops ranging from those that produced Winchester, Virginia, School–type furniture to the Nashville shop of James B. Houston, brother of Tennessee governor Sam Houston.

Philadelphia was not the only source of the furniture coming into the state, as examples of New York–, Pittsburgh–, Baltimore–, and Cincinnati-made furniture have been found all over Tennessee. Labeled Duncan Phyfe sofas from New York have shown up in both Williamson and Maury Counties.

With the influx of venture furniture, it became increasingly difficult for local cabinet shops to compete. Over the years, many of them either moved farther west—to Arkansas and beyond—or became retailers of venture furniture themselves. As for West Tennessee, because of its later development and its accessibility to the Mississippi, venture furniture, most of it from Cincinnati—then the furniture manufacturing capital of America—flooded the market. While there are examples of locally made furniture coming out of areas like Obion, Henry, and Madison Counties, the overwhelming amount of antebellum furniture in West Tennessee is venture trade.

The final, and smallest, category of antebellum furniture is composed of the Tennessee-made furniture that did not come out of a cabinet shop. While there is probably far less of this in Tennessee than in some of her neighboring states, there is, nonetheless, Tennessee-made furniture that was not made by a trained cabinetmaker. All students and collectors of antebellum Tennessee furniture have heard tales of everything from sugar chests to slabs to rope beds being "plantation-made" by a great-great-great-grandfather. Sometimes the story has an "old faithful" slave making the particular piece for someone in the family.

Few plantations had their own full-time cabinet shops, but almost all plantations and yeoman farms did possess all-purpose shops where simple, plain-style furniture was turned out as needed. Possibly the best example in the exhibition is the biscuit rock from Rural Plains, the plantation of Dr. Samuel Henderson, in Williamson County. These objects were practical, utilitarian pieces. They were, more often than not, made with little concern for their visual appeal. Yet in an age during which the simplicity of Shaker and Japanese design is coveted, the lines of these simple, farm shop–made objects have wide appeal.

Antebellum furniture in Tennessee is truly as varied as the world it was created to serve. It reflects both the struggle of those early days and the sudden prosperity of those grown wealthy from Tennessee's fertile soil. Pioneer subsistence had given way to a better life for many of those first European settlers, and with that better life came a more comfortable, beautiful material culture. By the 1840s there was little that New York or Philadelphia had that could not be purchased or ordered in Knoxville, Nashville, or the new towns to the west.

And so neighbors now lived side by side, one surrounded by his simple, plain-style furniture, the other with his mix of matching Quervelle pier tables, his Tennessee-made desk with bookcase possibly made by a cabinetmaker of the Winchester, Virginia, School, and his locally made cherrywood Jackson press. In the end, the one common trait we find in all antebellum furniture in Tennessee may well be the richness of its diversity.

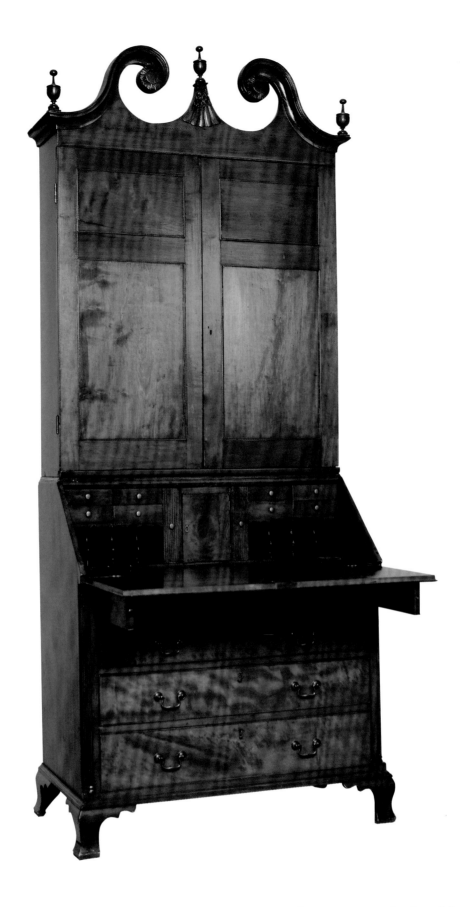

24 · *Desk and Bookcase,* 1797–1815
Knoxville, Tennessee
Cherry, pine, and poplar; 100½ × 43⅛ × 22¾ in.
Calvin M. McClung Historical Collection, Knox
County Public Library

THIS DESK ILLUSTRATES the transmission of style and form from the Delaware Valley to Winchester, Virginia, and finally into East and Middle Tennessee. The shape of the pediment, ogee-shaped feet, and interior drawers are similar to examples found in the Valley of Virginia. The desk's variation on the Rococo style, produced decades after its peak on the East Coast, reveals the migration of popular styles to the Tennessee backcountry. This example is somewhat unusual for a Winchester, Virginia, School piece because it is made of cherry rather than walnut, the more typical primary wood for works produced in the region. KDW

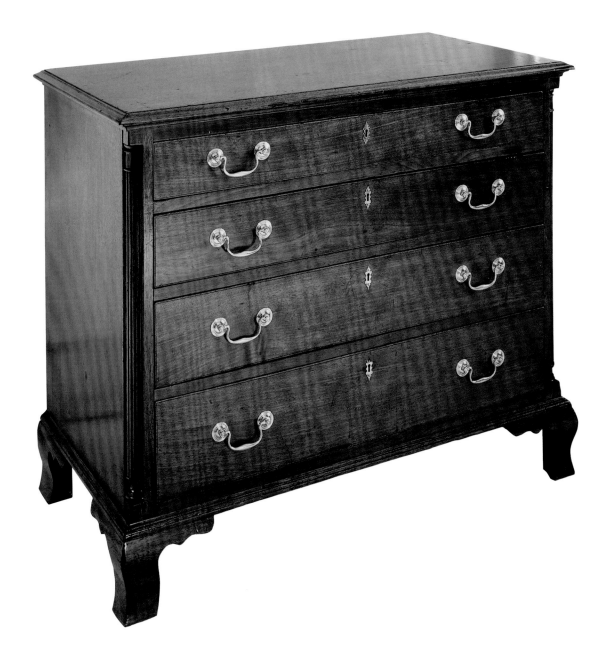

25 · **ATTRIBUTED TO JOSEPH MCBRIDE**
Active in Davidson County, Tennessee

Bureau, ca. 1800–1810
Davidson County, Tennessee
Walnut and tulip poplar; 34½ × 41 × 20⅝ in.
The Hermitage: Home of President Andrew Jackson,
H1898.03.013

THE BUREAU IS FROM THE SAME SHOP that produced both Jackson's desk and bookcase and a desk that has descended in the family of John Donelson Jr. The Donelson desk is signed by Joseph McBride, a cabinetmaker working in Davidson County from about 1801 to 1816. These three are related in form and construction to other pieces coming out of Winchester, Virginia, Knoxville, and Nashville, collectively known as the Winchester, Virginia, School. RH

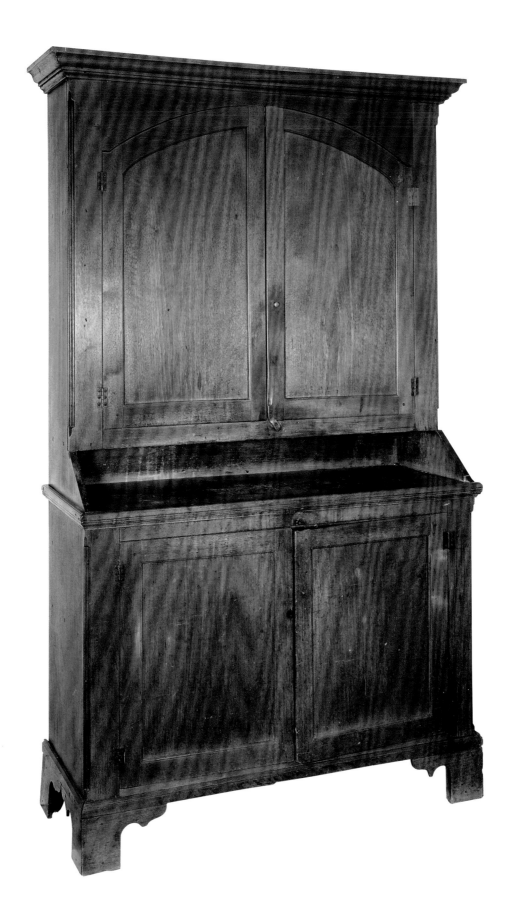

26 · ATTRIBUTED TO JOHN GILLESPIE
b. Rowan County, North Carolina 1773–
d. Sumner County, Tennessee 1868

Cupboard, ca. 1795–1800
Sumner County, Tennessee
Walnut; 96⅝ × 59¼ × 21¼ in.
Collection of Nathan and Jean Harsh
Not in exhibition

NINE CASE PIECES, including two cupboards similar in design to this example, represent Gillespie's identified body of work. A native of Rowan County, North Carolina, Gillespie arrived in Sumner County before the conclusion of the local Indian war in 1795 and took an apprentice in January 1800. In his log shop, he produced furniture, including bureaus and a desk, that deviates little from the work of James Gheen (active 1778–96), a Rowan County cabinetmaker from whom he must have learned the craft. This cupboard descended in Gillespie's family, remaining in his log home until 1971. CTP

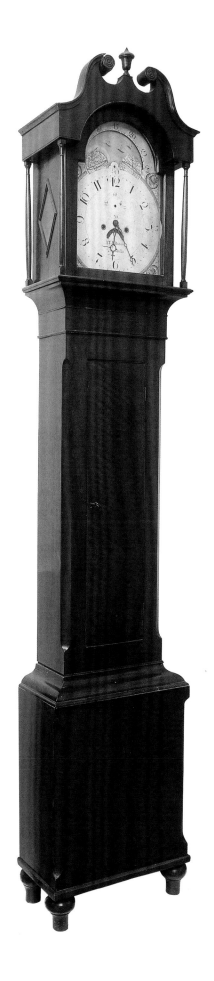

27 · *Clock Case,* ca. 1805–10
Marked "I. T. Elliston, Nashville"
Warranted by Joseph Elliston
Cherry and poplar; 112 × 19 × 7 in.
Collection of Gale Haddock

THE WORKS FOR THIS CLOCK were probably made by Joseph T. Elliston of Nashville, whose signature is on the clock face. The case, with its broken pediment and urn finial, chamfered corners, and bulbous turned feet, is thought to have been crafted by a local maker. BHC

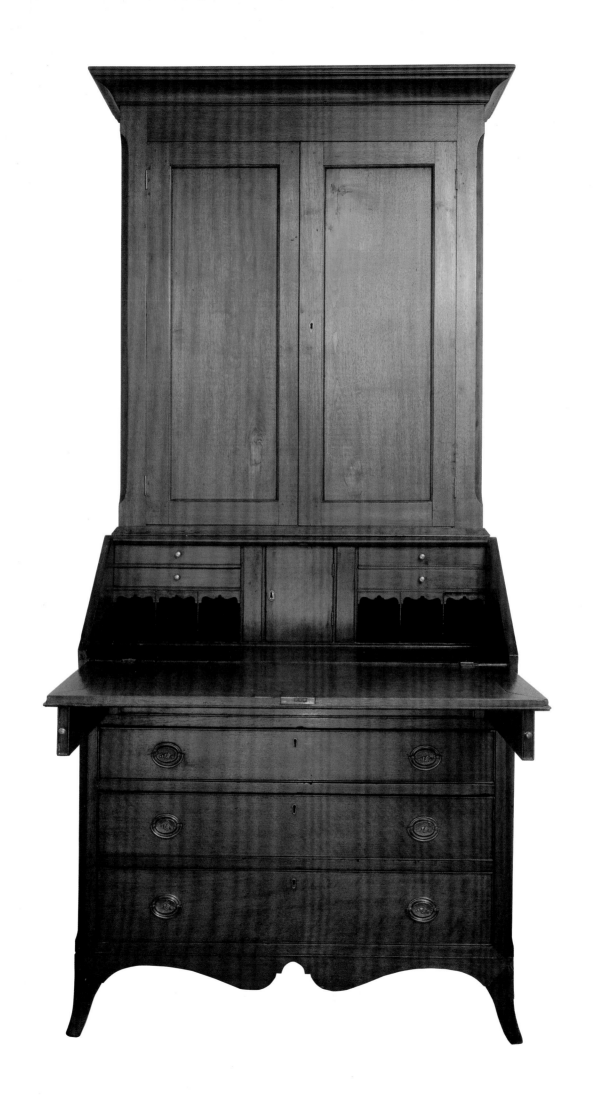

2 8 ᐟ *Desk with Bookcase,* ca. 1790–1810
East Tennessee, possibly Knox County
Cherry, tulip poplar, and original brass;
94 × 42 × 21½ in.
Collection of Ben and Gertrude Caldwell

CHAMFERED CASE CORNERS, strongly splayed French feet connected by a shaped skirt, and the simple linear plan of the desk interior demonstrate the plain style Neo-classicism predominant in Tennessee furniture. Following the American Revolution, pattern books increasingly called for the secretary in place of the old-fashioned slant-front

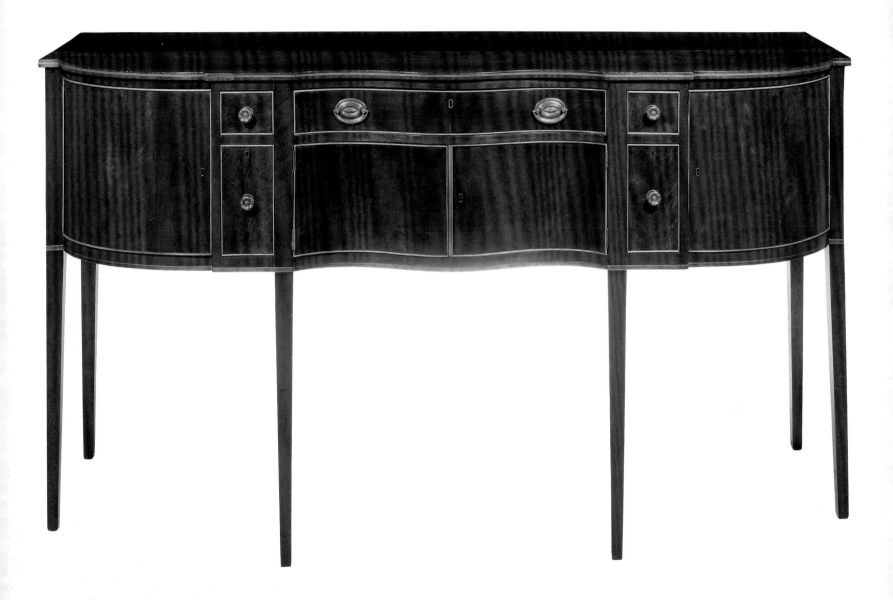

29 · *Sideboard*, ca. 1800–1810
East Tennessee
Cherry, cherry veneer, yellow pine, and tulip poplar;
45 × 80 × 28¾ in.
Collection of Lamar and Honey Alexander

THE COMPLEX PLAN OF THIS SIDEBOARD, with serpentine center section and ovolo-shaped end cupboards, indicates the cabinetmaker's familiarity with urban furniture design. Elements of the design relate to sideboards constructed in New York and Baltimore, but the positioning of drawers to the outside of the interior case legs is a departure from products of these cities and may suggest a central Virginia origin. This sideboard found in Knoxville and a more intricately inlaid mahogany sideboard collected in Hawkins County in the 1920s likely represent products of the same East Tennessee cabinet shop. CTP

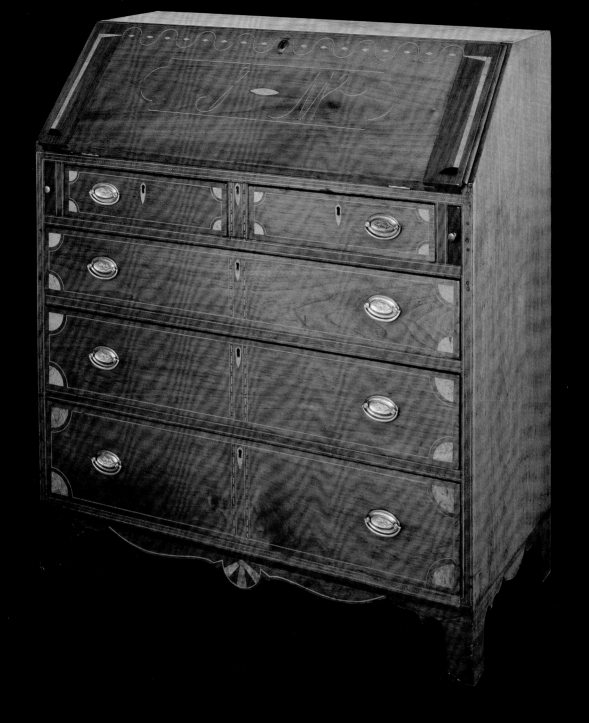

30 · **JAMES OR CAPTAIN JOHN B. QUARLES**
Active Wilson County, Tennessee

Desk, ca. 1814
Walnut, light and dark wood inlay, putty, and tulip
poplar; 45½ × 39¾ × 20¼ in.
Tennessee State Museum Collection, 2002.15

THIS SLANT-FRONT DESK was made for Samuel McAdoo of Wilson County about 1814 by either James Quarles or his son, Captain John B. Quarles. The family moved from Bedford County, Virginia, to Tennessee, as did many skilled artisans of the period. The desk is decorated with elaborate inlay of various geometric motifs as well as the original owner's initials, "S" and "Mc," on the fallboard. The interior of this functional work contains various compartmentalized drawers, pigeonhole spaces, and a door concealing three additional small drawers. KDW

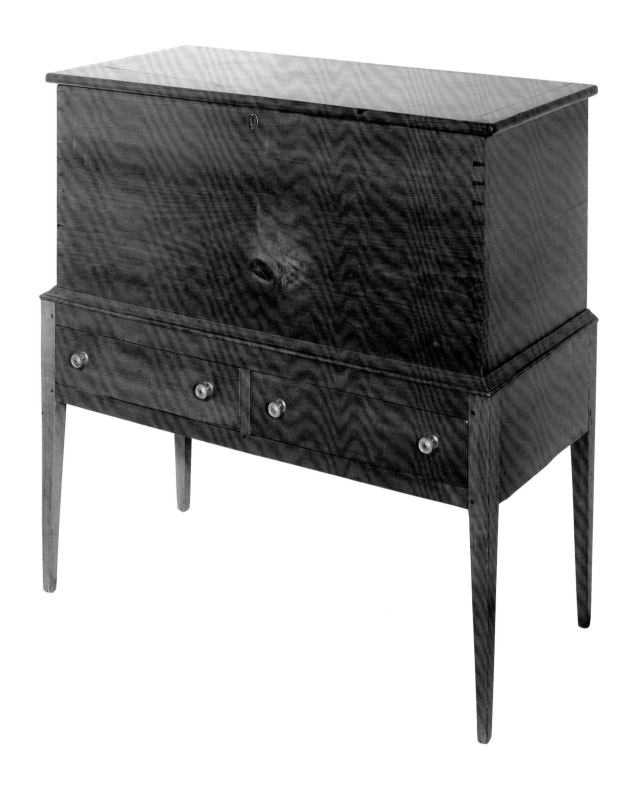

31 ⸱ *Chest,* ca. 1810–20
 Wilson County, Tennessee
 Cherry, tulip poplar, and walnut; 44⅞ × 44⅛ × 21 in.
 Collection of Nathan and Jean Harsh

THE CHEST ON STAND was a popular furniture form in Davidson, Sumner, and Wilson Counties before 1830. Its design source is probably Irish. This chest descended in the Clopton family of Wilson County, who settled south of Lebanon before 1810. CTP

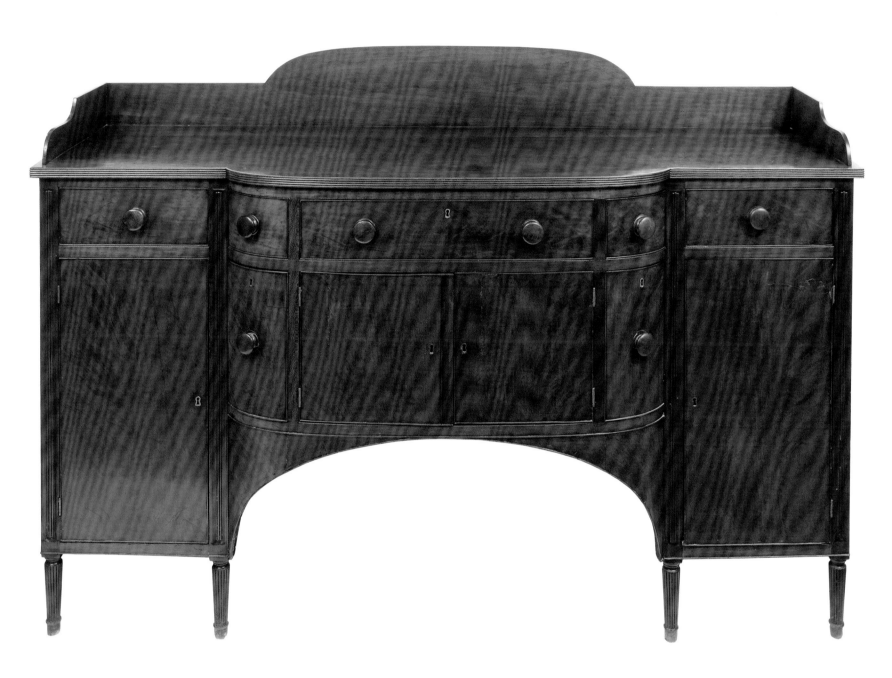

32 · **ATTRIBUTED TO THE SHOP OF**
CAPTAIN JAMES G. HICKS
Davidson County, Tennessee

Sideboard, ca. 1808–14
Cherry, tulip poplar, with cherry veneer; 51½ × 76 × 25 in.
Collection of Robert Hicks

RELATED IN FORM AND CONSTRUCTION to a sideboard identified as having been bought from Captain James G. Hicks, a cabinetmaker working in Nashville from 1812 to 1816, the design of this sideboard is taken from Thomas Sheraton's *The Cabinet-Maker and Upholsterers' Drawing-Book.* Like similar sideboards, cherry veneer on cherry is used instead of mahogany. Of five known related sideboards, this example has the most ornamentation, with reed carving on the body and legs. RH

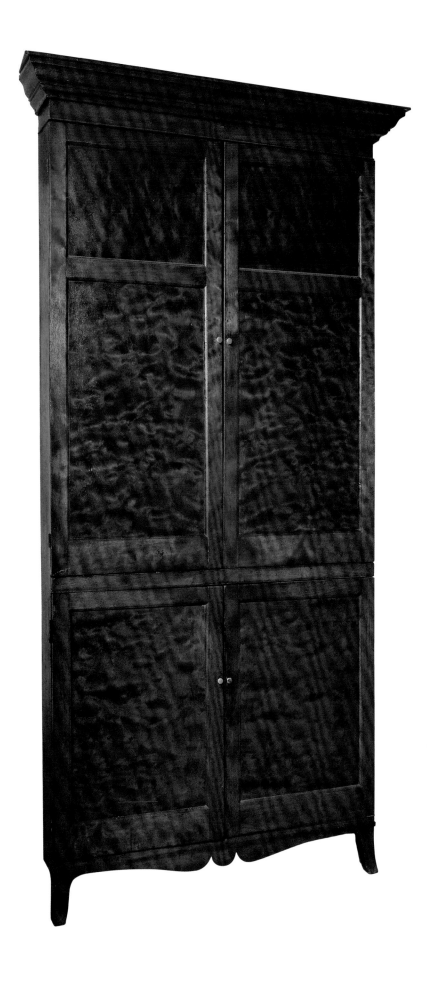

33 · *Corner Cupboard,* ca. 1810–30
Hawkins County, Tennessee
Walnut and yellow pine; 92½ × 47⅜ × 24 in.
Collection of Mary Jo Case

THIS IS ONE OF TWO KNOWN corner cupboards attributed to an unknown cabinet-maker. The use of highly figured walnut in the upper and lower doors is unusual in Tennessee furniture. Its diminutive splayed feet and doors hung flush to the side returns indicate the artisan's exposure to urban cabinetmaking methods. JDC

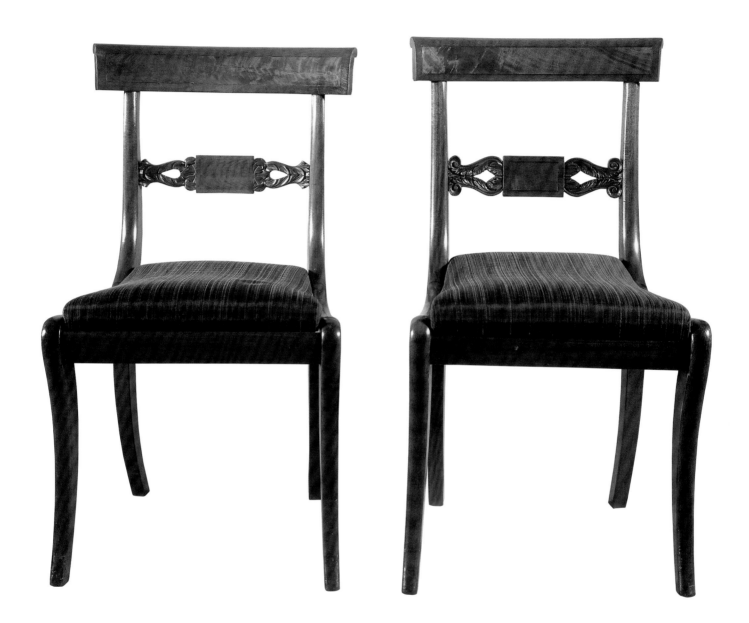

34 · *Side Chair* (klismos style), ca. 1828
Philadelphia, Pennsylvania
Mahogany, tulip poplar, and maple; 32 × 18½ × 20 in.
Travellers Rest Plantation and Museum, 1970.10.12

THIS IS ONE OF A SET OF TWELVE Philadelphia-made "fancy chairs" that John Overton purchased in 1828 from Richard H. Barry & Co., a Nashville retailer of venture goods. These klismos-type mahogany chairs were probably originally stencil-gilded across the upper back support, leading to their being described as "fancy" in the bill of sale. Six of the set of twelve eventually ended up at The Hermitage, home of Overton's partner and ally, Andrew Jackson. RH

35 · *Side Chair* (klismos style), ca. 1830
Davidson County, Tennessee
Mahogany and tulip poplar; 33 × 17½ × 19¾ in.
Travellers Rest Plantation and Museum, 1970.10.6

ACCORDING TO TRADITION, this is one of six chairs that were made in Nashville to replace six Philadelphia-made klismos-style side chairs that John Overton had given to Andrew Jackson. They are one inch taller than the originals and the carving is not as crisp, but they could have easily been mixed with the remaining six chairs in a room. RH

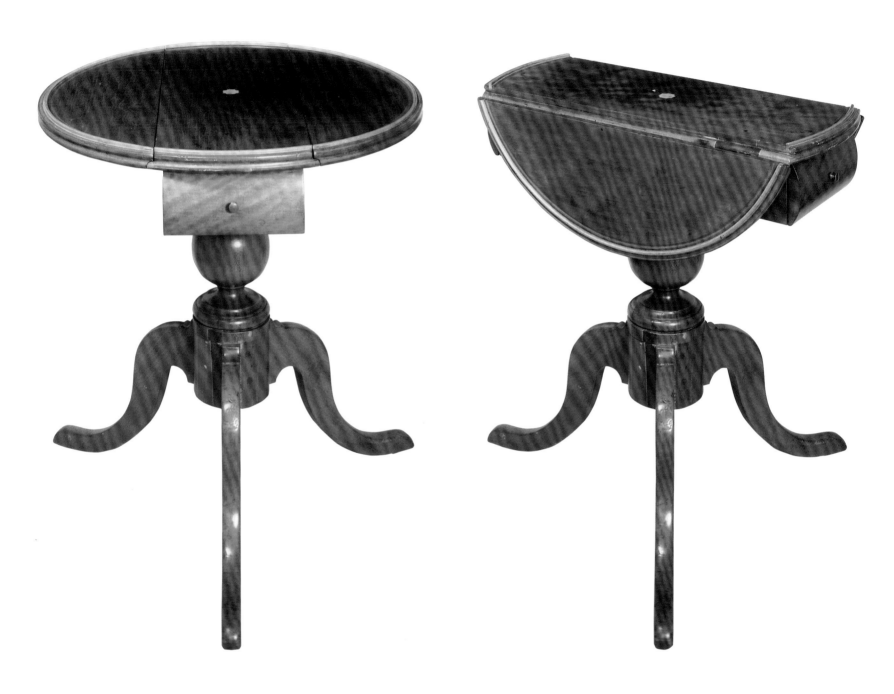

36 · **ATTRIBUTED TO LEVI COCHRAN**
b. Mecklenburg County, North Carolina
1799–d. Marshall County, Tennessee 1885

Table, ca. 1825–35
Good Spring, Bedford County (later Marshall
County), Tennessee
Cherry, undetermined light wood, tulip poplar;
25¼ × 24⅛ in. diam.
Collection of Michael and Mary Jane Boyd

THIS TABLE DESCENDED IN THE FAMILY of Levi Cochran, who began building
furniture in western Bedford (now Marshall) County about 1825. A surviving book of
accounts documents the shop's patronage and output. Bedsteads, tables, chests, bureaus,
and cupboards were predominant products, but on occasion Cochran manufactured hat
blocks, walking canes, and gunstocks as well. CTP

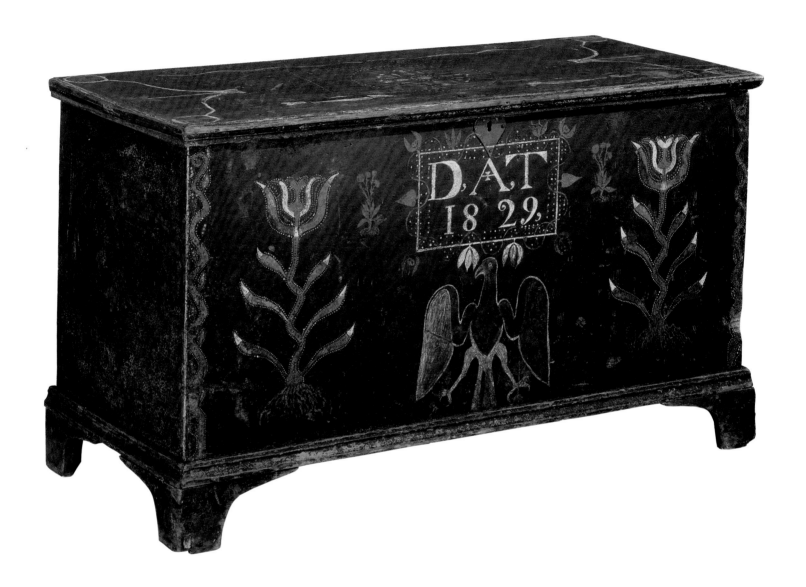

37 · *Chest,* 1829
 Northeast Tennessee
 Inscribed "D,A,T/1829"
 Tulip poplar, yellow pine, and paint;
 27¾ × 48¾ × 22¼ in.
 Abby Aldrich Rockefeller Folk Art Museum,
 Colonial Williamsburg Foundation, 1985.2000.1

FRAGMENTS OF A 1913 KNOXVILLE NEWSPAPER glued to the interior attest to this chest's lengthy presence in East Tennessee, where it was discovered in the Lost Mountain vicinity of Greene County. Paint-decorated chests are often associated with people of Germanic heritage, and the unpotted tulip motif may represent the decorator's suggestion of his own cultural "uprooting" through the process of migration. CTP

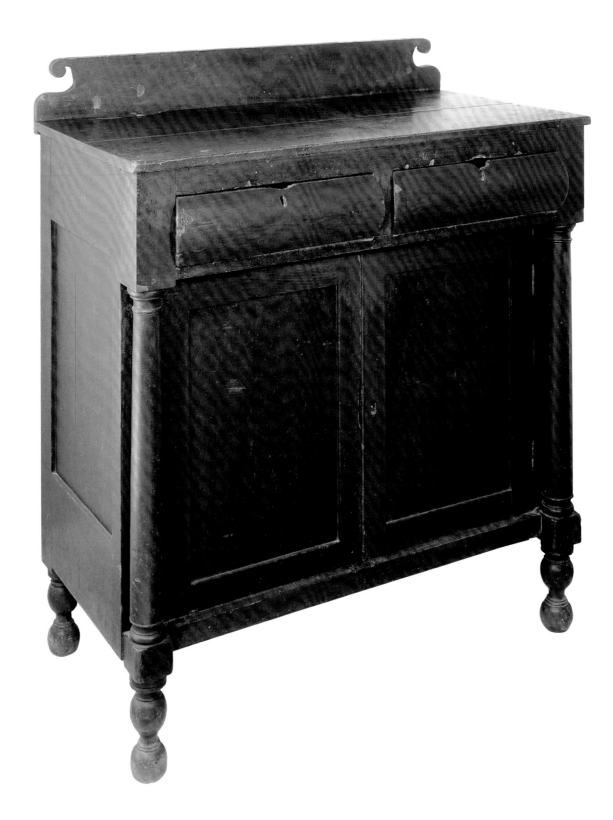

38 · ATTRIBUTED TO MATTHEW LILE MCELROY

b. Prince Edward County, Virginia 1814–
d. Ellis County, Texas 1878

Jackson Press, ca. 1835–40
Rutherford County, Tennessee
Cherry, mahogany veneer, and tulip poplar;
50 × 43¾ × 23¼ in.
Collection of Mr. and Mrs. Henry Brockman

THE VIRGINIA-BORN MCELROY took on the responsibilities of his own cabinet shop about 1838. He produced a variety of forms including bedsteads, bureaus, cupboards, tables, sugar cases, candle stands, wardrobes, work stands, Jackson presses, sideboards, and coffins. Sales were recorded in a surviving account book, which also detailed the cabinetmaker's relocation to Texas in 1856. The classically inspired columns and projecting drawer fronts seen here are features common in his early work. CTP

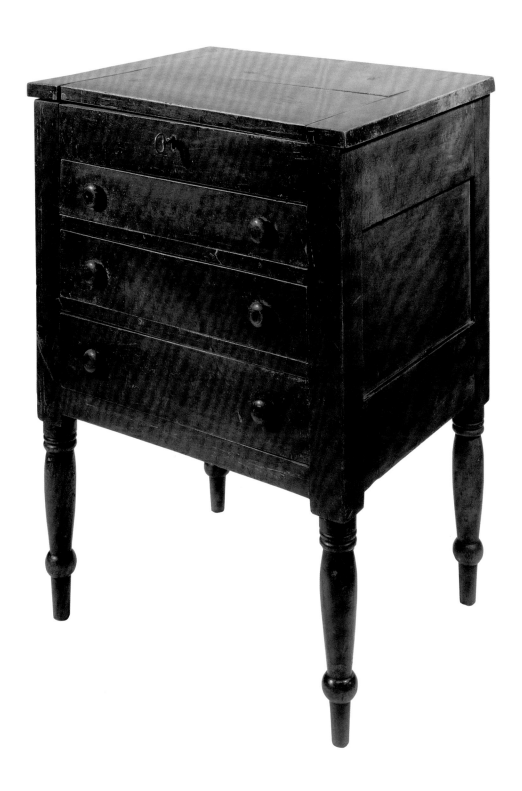

39 · *Ladies' Work Table,* ca. 1830
Northeast Tennessee
Cherry and tulip poplar; 28⅝ × 19⅝ × 15⅞ in.
Collection of Monty and Linda Young

A HINGED TOP CONCEALS a shallow partitioned storage area, which suggests this table's function. Domestic responsibilities in the form of needlework, quilting, garment production, and mending consumed much of a woman's daily routine. Accordingly, Tennessee cabinetmakers' advertisements often include references to "ladies work tables." CTP

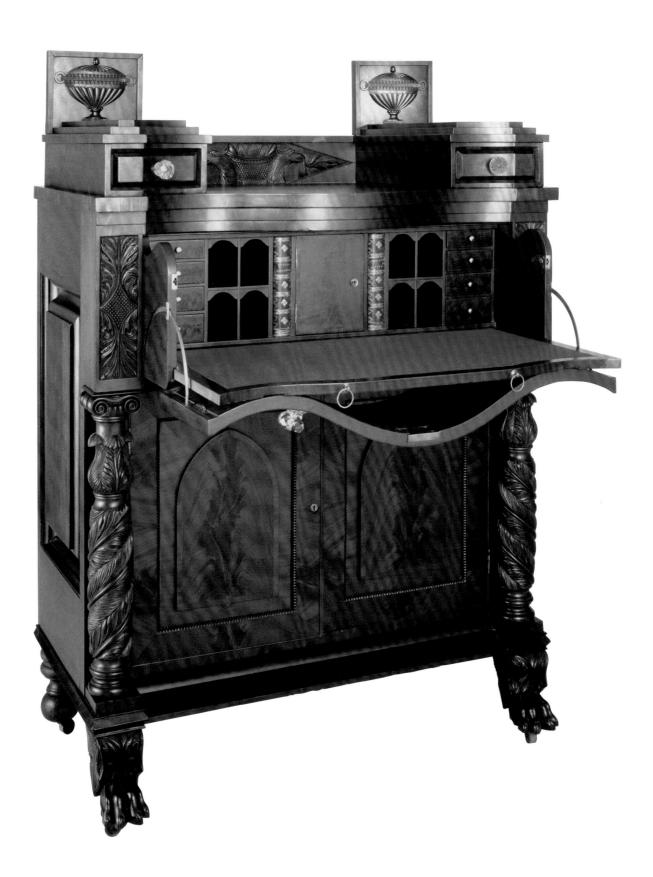

40 · JOHN ROSE

Active Knoxville, Tennessee

Secretary, ca. 1833
Mahogany, tulip poplar, pine, rosewood, and leather;
65 × 45 × 24 in.
Tennessee State Museum Collection, 89.124

THIS SECRETARY IS INSCRIBED "Made by John Erhart Rose from East Tennessee/ Knoxville/July 28th 1833." It is a splendid example of the late Neoclassical, or Grecian, style with classical carved motifs such as animal-paw feet, two lidded urns, acanthus-carved pillars, and a basket of fruit flanked by double eagle heads holding olive branches in their beaks. The carving is deep and crisp, the work of a master craftsman. Rose advertised his carving abilities as he moved back and forth between East Tennessee and Pennsylvania. Rose is known to have been in Philadelphia when this secretary was made. RH

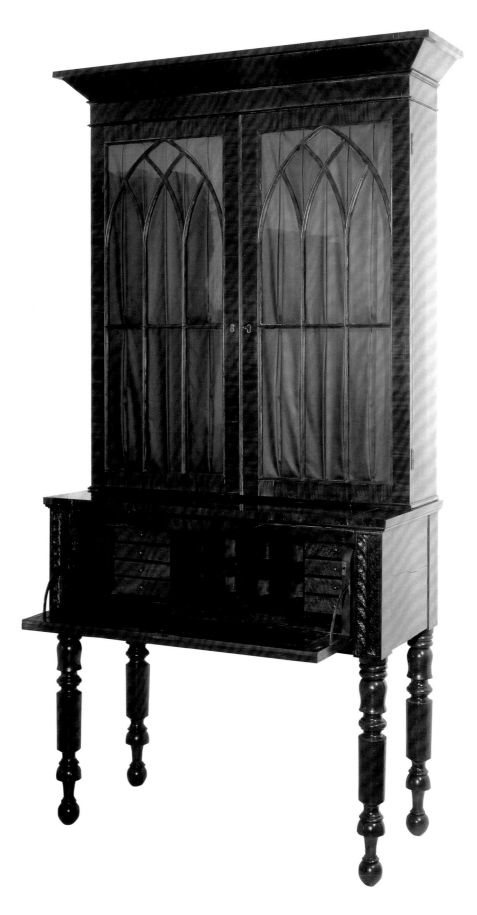

41 · *Secretary with Bookcase,* 1838
Williamson County, Tennessee
Cherry, tulip poplar, mahogany, and bird's-eye
maple veneer; 98 × 54 × 21 in. (closed)
Collection of Robert Hicks

THE SECRETARY WITH BOOKCASE, made for Dr. Hezekiah Oden of Walnut Winds
in Williamson County, demonstrates the influence of New York taste on Tennessee fur-
niture in the nineteenth century. Its form is straight out of Duncan Phyfe's cabinet shop,
while regional adaptation is shown through the use of cherry instead of mahogany as the
primary wood, turned legs instead of Phyfe's reeded legs, and twelve inches added to its
height. RH

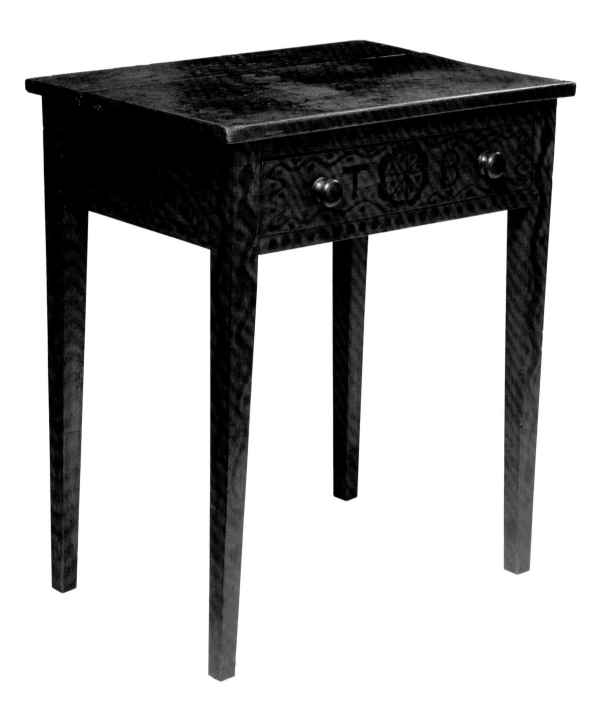

42 · *Table,* ca. 1840–80
Jefferson County, Tennessee
Walnut and yellow pine; 29¾ × 26 × 18¾ in.
Collection of Carole Carpenter Wahler

ABOUNDING WITH LIZARD, FISH, undulating snakes, and other idiosyncratic motifs, the decoration of this table suggests a ceremonial use. The designs were drawn in green ink and later covered with orange shellac. The table descended from an African American family who referred to it as the "Bible table." Family tradition suggests "TB" was the maker of the table. JDC

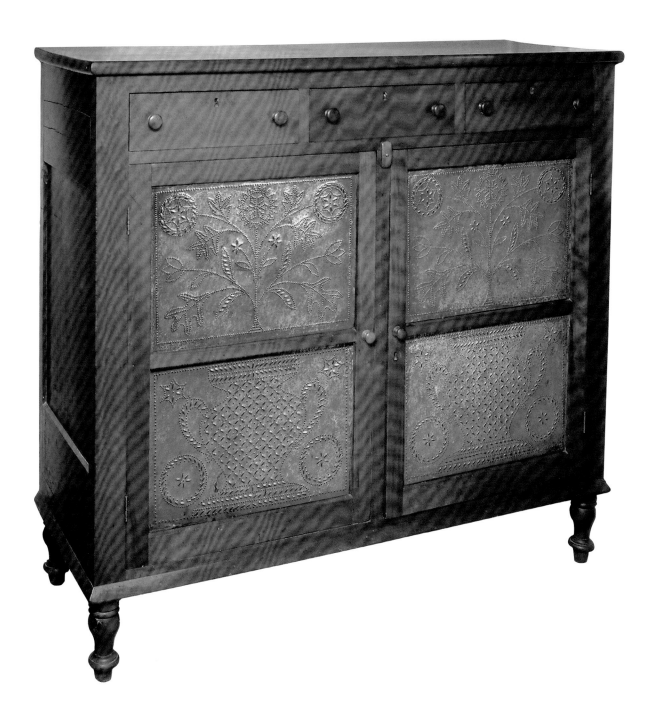

43 ᴬ **ATTRIBUTED TO JOHN WOLFE**
b. 1810–d. 1891; active Sullivan County,
Tennessee 1840–60

Safe, ca. 1840–70
Piney Flats, Tennessee
Cherry, tulip poplar, and tin; 50½ × 54 × 19 in.
Collection of Mary Jo Case

THIS SAFE IS PART OF A GROUP attributed to the cabinetmaker John Wolfe, who worked in the Piney Flats area. Highly stylized tin doors with urns, sprouting flowers, and geometric designs are often found on safes from East Tennessee and southwest Virginia. This artisan typically used these larger doors in combination with the three-drawer case for all his known work. The three-drawer case is unusual compared with other safes from the region and may indicate a more formal use such as a dining room sideboard. JDC

44 · *Biscuit Rock,* mid–19th century
Williamson County, Tennessee
Tulip poplar, pine, and limestone; 37 × 30½ × 26 in.
Collection of Rick Warwick

BISCUIT ROCKS ARE LISTED AMONG kitchen furniture in many county probate records throughout Middle Tennessee during the mid–nineteenth century. Sometimes referred to as a "beatin' biscuit rock," this form was typically composed of a limestone or marble slab that was used as the surface on which dough was worked and a wooden hood that was closed to allow the dough to rise or to cover the surface when not in use. Occasionally examples are found with a thick poplar board in place of a rock slab and a cloth instead of a wooden hood for covering bread. RHW

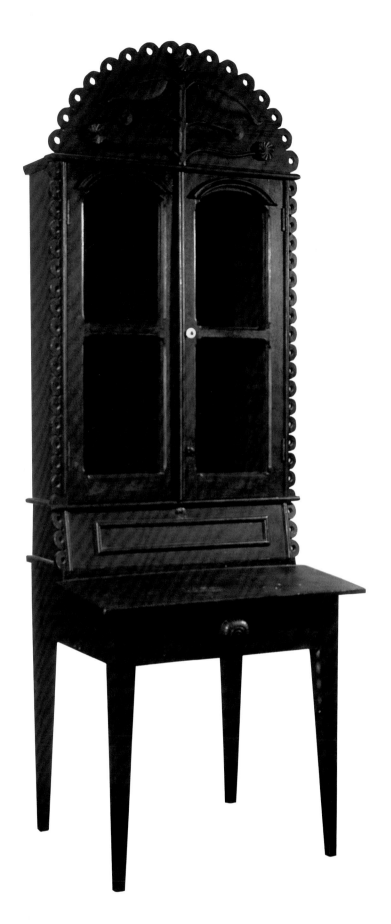

45 · JIM MORRELL
Cowan, Franklin County, Tennessee

Desk and Bookcase, ca. 1875–80
Walnut, tulip poplar, and glass; 88 × 31 × 27 in.
Collection of Monty and Linda Young

AN AFRICAN AMERICAN CONFEDERATE veteran of the Civil War, Jim Morrell made this secretary with bookcase for his own family. Its construction reflects both contemporary taste for factory-made furniture and the idiosyncratic decorative carving that is often a feature of African American furniture. Morrell never had a cabinet shop but worked as a carpenter and house builder through the end of the nineteenth century. It descended with its history through his family to his great-granddaughter, Eleanor Hodge Gray. RH

Benjamin H. Caldwell Jr. and Robert Hicks

Sugar Chests

Within that small group of antebellum furniture that was most common, and at times indigenous to the South, the sugar chest—in its many variations—remains the most coveted among Southern collectors. So dear is the form that siblings have been known to divide into enemy camps when one child, over the others, inherited the "family sugar chest." For, long after the price of sugar had fallen, the preciousness of the sugar chests remained. To understand the strange aura that surrounds the sugar chest, one must first understand a bit of its history and lore.

Throughout the ages, sugar has been prized by civilization. As with most rare and valued commodities, the history of sugar storage is tied to the lock and key. That said, probably no one ever took sugar storage more to heart than those early settlers in the backcountry of the American South. Whether the first white settlers came to flee civilization or to create it anew, sugar was one commodity that few seemed willing to live without. The earliest records of life in Tennessee repeatedly mention the importation of sugar and attempts to manufacture it, along with sugar substitutes like sorghum, locally.

From the late eighteenth century through the first quarter of the nineteenth century, shipments of goods from New Orleans upriver were few and infrequent. Before the advent of the steamboat, it could take as long as a year for a flatboat to travel upstream from New Orleans to Nashville. Regular shipments of sugar, in hard molded cone forms, arrived in Nashville approximately every twelve months. Thus, it is of little wonder that, during the early days, the sugar chest could be found in inventory after inventory throughout the Southern backcountry.

Those early chests are often little more than locked boxes, sometimes with a ledger drawer, for it was said that the good yeoman wife knew to the teaspoon how much sugar was on hand at any given time. And well she should have, considering there was still land in the backcountry that sold more cheaply per acre than a pound of sugar.

It has long been held that the sugar chest was the near exclusive property of the upper and upper-middle classes. Yet in 2003 a survey of sugar chests in Williamson County found ninety-one county-made sugar chests, with the overwhelming majority from yeoman-class homes.

When, during the third decade of the nineteenth century, regular shipments of sugar arrived via steamboat from New Orleans in less than a month, the price of sugar plunged. Yet the tradition of buying sugar in bulk amounts continued through the Civil War. And although the price was only a fraction of the cost that early settlers had paid, it was still high enough to warrant keeping sugar in a secure place.

The most common form of the sugar chest is a dovetailed or post-and-paneled box on legs with a drawer, not too far removed from the earlier "case and bottles" container for liquor storage. Access was from a hinged lid, most often secured with lock and key. The interior could range from a simple undivided space to a space divided into two or three compartments. It is not uncommon to find chests with a dovetailed wooden liner, usually made of poplar, most often the secondary wood for chests made in Tennessee. As with most vernacular furniture of the period in the backcountry, cherry and walnut were the preferred primary woods in sugar chest construction. For many years, the range of forms varied somewhere between the somewhat earlier tapered-leg to the more common turned-leg chests.

Throughout the second quarter of the nineteenth century, cabinetmakers were transforming the lowly sugar box into sugar chests, sugar tables, sideboard sugar chests, sugar desks, combination sugar chest/case and bottles, and in Tennessee, Jackson presses with sugar chests. Only a few sugar desks have been found in Tennessee, while any other forms were traditionally dismissed as imposters. While there is record that the shop of the Nashville cabinetmaker James B. Houston produced a "sideboard sugar chest," evidence of this combined form has been discounted, dismissed, or explained away over the years. Yet, as we surveyed private and public collections for *Art of Tennessee*, we were confronted several times by pieces related in form to both the "sideboard sugar chest" and the "sugar press" described in the book *The Art and Mystery of Tennessee Furniture*.

An interesting problem is presented by the Rutherford County cabinetmaker Matthew Lile McElroy. His daybook, which he kept

from 1838 to 1856, records his making sugar cases and charging $6.00 apiece for them, yet there is no mention of a sugar chest. Since his contemporaries for whom we have records were charging from $5.00 to $9.50 for sugar chests, it is clear that the terminology was not standard. Used throughout much of the South, sugar chests have been found or listed in inventories in every state surrounding Tennessee, with the overwhelming majority being produced in either Tennessee or Kentucky. It is now evident that there is more work to be done on the subject of sugar chests if we are to understand how varied the forms may indeed have been.

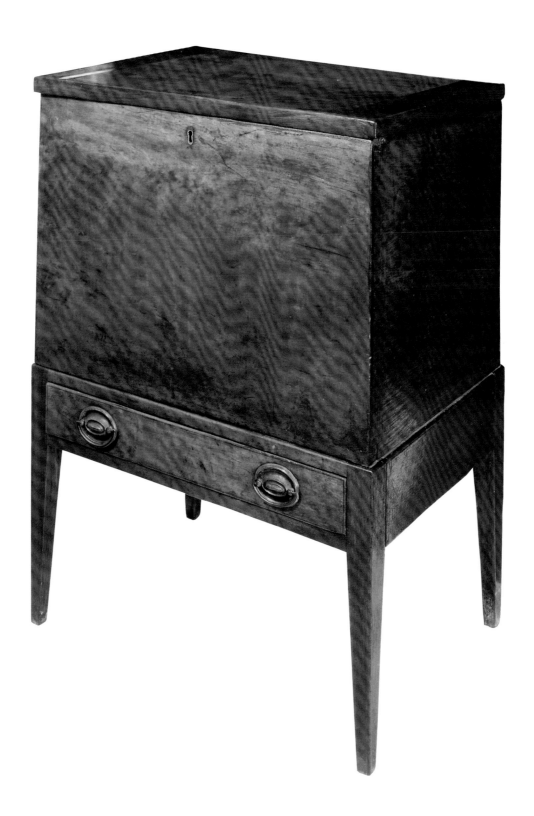

46 · *Sugar Chest,* ca. 1800–1810
Davidson County, Tennessee
Cherry, walnut, tulip poplar, and original brass;
35 × 26 × 18½ in.
Collection of Lucy Scott and Sam Kuykendall

CONSISTENT IN FORM with a small number of early sugar chests made in Davidson and Williamson Counties, this box has retained its original brass. Little is known of its provenance before a Columbia antique dealer purchased it in Davidson County in the late 1960s. It has become one of the icons of Tennessee decorative arts. RH

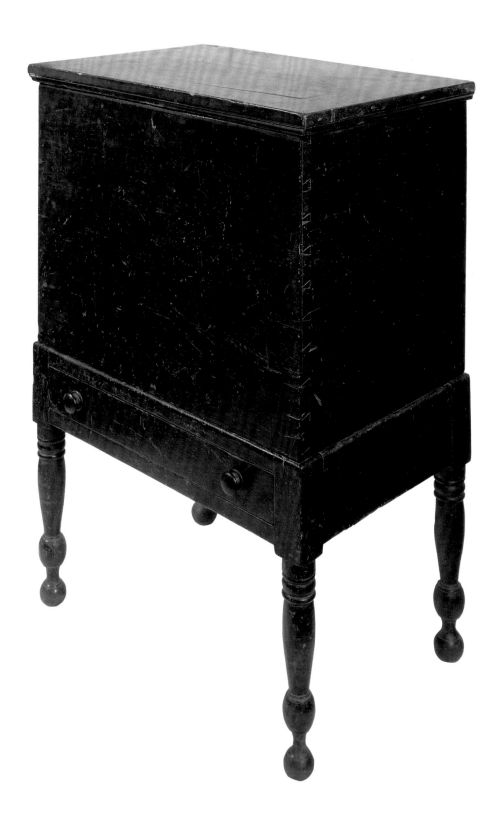

47 · **ATTRIBUTED TO J. W. ALLEN**
Fernvale Community, Williamson County,
Tennessee

Sugar Chest, ca. 1820–25
Cherry and tulip poplar; 36½ × 17 × 25¼ in.
Collection of Monty and Linda Young

TYPICAL OF THE TURN-LEGGED FORM found throughout the backcountry, this dovetailed sugar chest retains its original surface, along with its original brass hinges. The letters "JWA" are chalked on the back. Descending through his family for more than 150 years, it was owned and most likely made by J. W. Allen of the Fernvale Community in Williamson County. The lid is breadboard construction with applied molding. RH

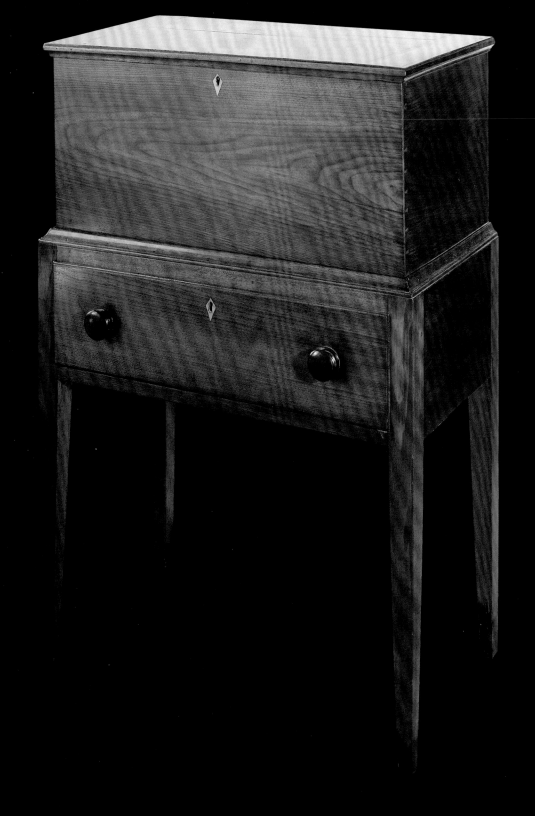

48 · *Case and Bottles,* ca. 1815–25
Middle Tennessee
Walnut, tulip poplar, with light wood escutcheon
inlay; 41½ × 27 × 15 in.
Collection of Jack and Joanne Little

THE DESIGNATION "CASE AND BOTTLES" relates to this piece's exterior, which is
similar to early examples of the form coming out of North Carolina. But instead of being
divided into four or more bottle-size compartments, the interior is divided into two large
compartments in an arrangement often found in sugar chests. This is one of two chests on
stands found in Middle Tennessee that have been identified as from the same unknown

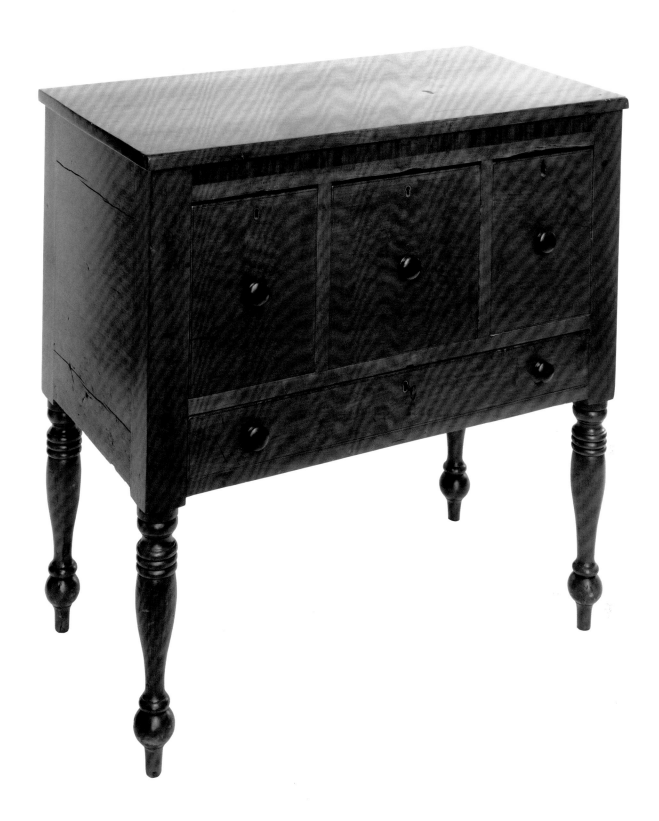

49 · *Sideboard Sugar Chest,* ca. 1820–30
Wilson County, Tennessee
Cherry and tulip poplar, with mahogany veneer;
38⅝ × 38¼ × 20⅜ in.
Collection of Nathan and Jean Harsh

UNTIL NOW, THIS FORM HAS BEEN described as a "sideboard." More than likely it was a hybrid form known as a "sideboard sugar chest." Similar examples have been found in Middle Tennessee. Possibly the three larger drawers were used for storing white sugar, brown sugar, and coffee, while the lower drawer may have held a ledger book to keep track of the chest's costly contents. A sideboard sugar chest is documented as having been produced in the shop of James B. Houston. RH

C. Tracey Parks

William Winchester Jr., Cabinetmaker

Neoclassical design in Tennessee furniture is best represented in the shop production of William Winchester Jr. Working from his uncle's plantation in Sumner County, William produced a large body of work that closely parallels stylish Baltimore furniture of Neoclassical conception, which in turn was primarily influenced by urban British patterns and construction methods.

William was born on September 18, 1781, in Frederick County, Maryland, the sixth child of William and Mary Parks Winchester. He was baptized in December of the following year near Westminster, a town established by his grandfather in 1764. He was the second generation of Maryland-born Winchesters, his namesake grandfather having arrived in Annapolis in 1729 at the age of nineteen.

The specifics of William's early life are not known, but the sophistication of his Tennessee cabinetwork reveals his exposure to and likely training in a Baltimore cabinet shop utilizing urban British cabinetmaking technology. William's father was a prominent Baltimore merchant. Most likely, his son's training resulted from a private contract of apprenticeship between the father and a shop master, perhaps sometime in 1795, when William turned fourteen and the elder Winchester was assuming a director's position at the newly formed Bank of Baltimore.

Apprenticeships traditionally concluded when the apprentice attained his majority of twenty-one, at which time he was free to contract as a journeyman. William turned twenty-one in September 1802, but he had arrived in Tennessee a few months earlier. His presence in Tennessee is first recorded in the minutes of the Sumner County Quarterly Court, where on July 7, 1802, short of his own twenty-first birthday, William took Moses Morrish as an apprentice to "learn the cabbinet [sic] trade."[1]

No doubt William knew much about Tennessee before his arrival. His uncles James and George Winchester had settled in 1785 along Bledsoe's Creek in eastern Davidson County, reorganized into Sumner County by the North Carolina legislature the following year. The Winchester brothers' 228-acre tract was two miles west of Bledsoe's Lick, the easternmost of three permanent settlements begun in 1779 in the Cumberland area.[2] Soon after their arrival, the brothers constructed a mill on the creek flowing past their property. By 1787 the stone improvement was operational and the men produced sawn lumber,

milled flour, and distilled whiskey from the complex. For James Winchester the mill was the first of many commercial endeavors.

Each man assumed important political positions in Sumner County. George was appointed register in 1787, and James served as the first county trustee. The following year James joined other representatives from the Cumberland settlements at Hillsborough, North Carolina, to ratify the new federal constitution. In 1796 he would be elected by his peers to the position of speaker in Tennessee's first senate. James Winchester had served with distinction in the Revolutionary War. Having enlisted in 1776 as a private, he achieved the rank of captain before his discharge at Annapolis at war's end. His combat skills proved useful on the frontier. As an officer in the local militia, Winchester was frequently required to defend the Cumberland settlements from hostile Indian attack, primarily from the Cherokee and Creek who opposed American expansion into their territory. Much blood was shed by both sides and few families escaped its effect. George Winchester was killed in an ambush in July 1794, less than a year before the conflict's resolution. Peace with the Indian tribes coincided with the opening of a wagon road into the Cumberland settlements in the summer of 1795 and the resulting flood of new arrivals. A census of the county that year revealed 6,370 persons in comparison to 3,613 living in Davidson. The end of hostilities left the Cumberland awash in a building boom.

Without the distraction of war, James Winchester began to conceive of a grand stone house for his Sumner County home. He would call it Cragfont, the name he had chosen for the first dwelling built on the property. By 1798, as Winchester family tradition holds, work was under way.[3]

Cragfont was nearing completion late in the summer of 1802. William had been busy at his workbench constructing the house's new furniture since July. In September François André Michaux, a French botanist, left Nashville to visit James Winchester. On his arrival, Michaux found Cragfont to be a two-story "stone house, very elegant for the country," and seems to have been surprised that Winchester had secured carpenters from Baltimore to finish the interior.[4] It is unfortunate that Michaux did not give an account of the furniture then being constructed. No household inventory survives with sufficient detail to determine the quantity of furniture actually produced for Cragfont.

Eleven pieces may be positively attributed to William Winchester Jr., including the looking glass and china press in this exhibition. The looking glass, although with losses to its applied scrolled decoration, maintains its original finish and a history of descent from James Winchester shared by a sideboard, pair of card tables, dining table, breakfast table, tall case clock, bureau, and secretary. All the Cragfont furniture is constructed of cherry with tulip poplar as the predominant secondary wood. Lightwood inlaid stringing is used as decoration on the breakfast table, tall case clock, sideboard, and card tables.

William's use of cherry, rather than mahogany, represents the only significant departure from standard Baltimore work. The half-round shape of his card tables repeats the most popular design produced by Baltimore shops working in the Neoclassical taste. Construction methods for the tables further illustrate the cabinetmaker's almost certain training in that city. Like the majority of half-round card tables constructed in Baltimore, both rear legs of the Cragfont tables are designed to swing open from the stable rear rail and support the open top. When closed, rear legs overlap the ends of the front rail. These features, combined with the "hollow" molded leaf edges and the presence of a medial rail between the front and rear table skirts, clearly demonstrate the cabinetmaker's Baltimore training.[5]

The book-matched cherry cornice frieze veneers and stylish splayed or "French" feet of the china press recall urban patterns as well. Like the bureau and secretaries, the china press has a British-style, fully paneled back. Urban craftsmanship is further evident in the independently constructed and removable cornice and frieze, cabinet doors hung flush with the case sides, and the absence of exposed joining pins at the door corners. As in other case pieces from the group, dovetail joints on the drawers are small and precise and the deep drawer blades are backed up with poplar dustboards extending to the back of the case.

William's patronage beyond Cragfont is represented by a walnut secretary made for another Sumner countian, General Daniel Smith (1748–1818).[6] On Smith's secretary, the cabinetmaker employs his standard base treatment with shaped apron and "French" feet. These elements are also present on the china press, as well as the Cragfont secretary and bureau.

The china press has a history of descent in a Wilson County family from about 1870. Before their ownership, its history is unknown. The china press may represent additional shop patronage beyond William's own family, but it is equally possible the press was part of the original furnishings for Cragfont, which were sold at public auction shortly after the Civil War.

Whatever its history, the press is part of the largest group of Neoclassical furniture attributed to a specific Tennessee cabinetmaker. Collectively, the furniture reflects and documents the early appearance of the most current national fashions on the Tennessee frontier.

In 1804 William Winchester returned to Baltimore, where he lived a long and productive life, but no evidence of his work in the cabinet trade exists beyond his brief time spent in Tennessee.

NOTES

1. Sumner County Quarterly Court Minutes, book 1, p. 346, Gallatin.

2. Walter T. Durham, *The Great Leap Westward: A History of Sumner County, Tennessee, from Its Beginnings to 1805* (Nashville: Sumner County Public Library Board, 1969), 31–33.

3. After the peace, James Winchester turned his attention to building up the frontier. Along with a partner, William Cage Jr., he laid out the new town of Cairo on the north bank of the Cumberland River and began selling lots in February 1800. He was instrumental in the planning and promotion of Memphis. Walter T. Durham, *James Winchester: Tennessee Pioneer* (Gallatin, Tenn.: Sumner County Library Board, 1979), 72–73, 212–23.

4. François André Michaux, *Travels to the Westward of the Alleghany Mountains in the State of Ohio, Kentucky and Tennessee in the Year 1802*, trans. B. Lambert (London, 1805), 254–55.

5. Ronald L. Hurst and Jonathan Prown, *Southern Furniture, 1680–1830: The Colonial Williamsburg Collection* (New York: Harry N. Abrams in association with Colonial Williamsburg Foundation, 1997), 247–50. Hurst and Prown discuss a card table attributed to the shop of the Baltimore cabinetmaker Levin S. Tarr (1772–1821). The Cragfont tables have many features in common with Tarr's work but differ in the shaping and position of glue blocks.

6. The Smith secretary has previously been published, where it was mistakenly attributed to another artisan. See Nathan Harsh and Derita Gleman Williams, *The Art and Mystery of Tennessee Furniture and Its Makers through 1850*, ed. C. Tracey Parks (Nashville: Tennessee Historical Society, Tennessee State Museum Foundation, 1988), 109.

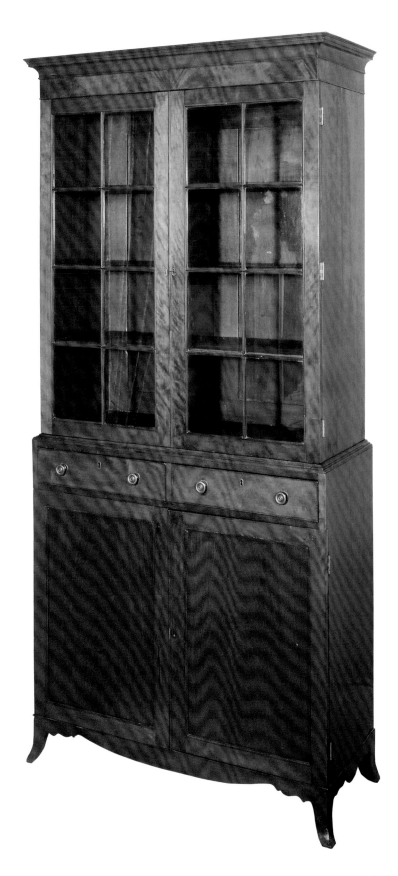

50 · ATTRIBUTED TO WILLIAM WINCHESTER JR.

b. Frederick County, Maryland 1781–
d. Baltimore, Maryland 1864

China Press, ca. 1802–4
Sumner County, Tennessee
Cherry and cherry veneer, tulip poplar, and
walnut; 92¾ × 44 × 19¼ in.
Collection of C. Tracey Parks

FURNITURE PRODUCED AT CRAGFONT by William Winchester Jr. demonstrates the early appearance of Neoclassically inspired urban furniture design in Tennessee. The independently constructed cornice and frieze, flush-hung cabinet doors, and stylish "French" feet of this china press are all urban cabinetmaking traits. This press represents the earliest documented example of a furniture form popular in Sumner and Davidson Counties in the first half of the nineteenth century. CTP

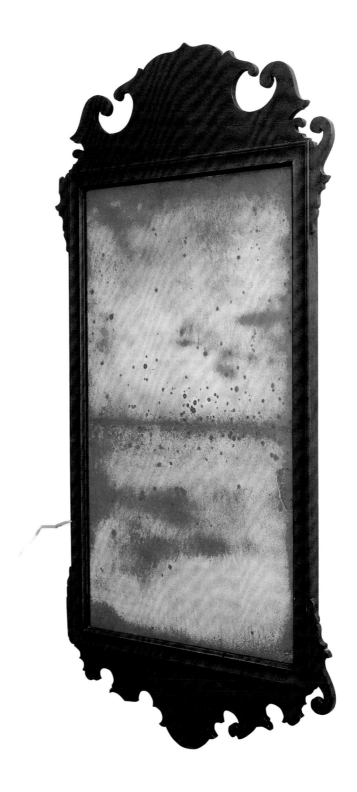

51 · **ATTRIBUTED TO WILLIAM WINCHESTER JR.**
b. Frederick County, Maryland 1781–
d. Baltimore, Maryland 1864

Looking Glass, 1802–4
Sumner County, Tennessee
Inscribed in pencil on back "Col. Winchester"
Cherry, tulip poplar, and silvered glass;
41¾ × 20¾ × 1⅛ in.
Historic Cragfont, Inc.

WOOD-FRAMED MIRRORS WITH INTRICATE scrolled surrounds of this style achieved national popularity in the eighteenth century. This looking glass was made for General James Winchester (1752–1826) of Sumner County and descended in his family. It originally hung in his stone house, Cragfont, which was completed in 1802. CTP

Rick Warwick

Richard "Dick" Poynor

Richard "Dick" Poynor was born a slave in Halifax County, Virginia, on June 22, 1802. He immigrated to Williamson County in 1816 with the Robert Poynor family, settling on the Little Harpeth near the present-day Cool Springs Galleria. The Poynors were well established as craftsmen in the community, as indicated by Robert Poynor's estate inventory of 1848, which included "mechanics' tools, some saddlers' tools, some shoemakers' tools, some blacksmithing tools and some chairmakers' tools." It is assumed that Robert taught his slave, Dick, the art and mystery of chairmaking. On Robert's death, Dick, age forty-six, valued at $450, became the property of Dr. A. B. Poynor, Robert's son, while his children—Catharine, age twenty, valued at $600; Thomas, age nineteen, valued at $650; James, age sixteen, valued at $600; Phillip, age thirteen, valued at $100; Mary, age eleven, valued at $425; and Jane, age six, valued at $425—were divided among the other heirs.

Dick Poynor seemed to enjoy a special status in antebellum Williamson County that few men of color were able to realize. He apparently could read and write; printed in pencil in his family Bible are the words "I purchased this bible for three dollars on May 27, 1835." He recorded the death of his first wife, Loucinda, on February 29, 1840, shortly after the birth of their seventh child. Also listed in the Poynor Bible are the births, deaths, and marriages of his children and grandchildren.

Sometime between 1850 and 1860 Dick obtained his freedom and, if tradition is correct, purchased the freedom of his second wife, Millie. Williamson County court records are silent on the emancipation of Poynor or his wife, but he was listed as posting a bond in 1860, as a freeman of color was required to do, and paying land taxes. By 1851 he had moved from the Robert Poynor farm near Brentwood and was working at his own horse-powered chair factory and hillside farm of 150 acres off Pinewood Road in western Williamson County, twelve miles from Franklin. Dick Poynor, with the help of his son James (1833–1893), produced hundreds of chairs at the factory. The Poynor chair construction was simple. With the knowledge that green wood shrinks as it dries, Poynor drove dry rungs into green posts, assured that the joint would remain tight without nails or glue.

The classic signature of a Poynor chair is found in the gracefully arching mule-eared post secured with a wooden peg in the top slat. Typically, the posts, slats, and rocker arms were made of sugar maple, while the rungs were made of hickory and the rockers of walnut. Dick made armed rocking chairs in several sizes, armless sewing rockers, high chairs for infants, and youth chairs for children. Mostly he made standard straight chairs in three sizes. The Poynor chair could be purchased as a rosewood-grained, yellow-striped "fancy chair" or in the solid hues of red, blue, black, brown, and green, all bottomed in finely woven patterns of white-oak splits. John D. Miller, a merchant on Main Street in Franklin, Tennessee, advertised in that town's *Review and Journal* of April 18, 1861, that he had "Poynor's chairs—kept constantly on hand for sale," a notice that illustrates the large market Poynor enjoyed. Traditionally cherished by many Williamson County families, the Poynor chairs' simple style and famous durability have rendered them highly collectable today.

Dick Poynor the man is as interesting as his famous chair. Despite the racial strife following the Civil War, he remained an honored citizen of the community, as evidenced by his membership from April 1865 until his death on March 27, 1882, in the Leiper's Fork Primitive Baptist Church, a predominantly white congregation. He was buried in the Garrison cemetery near his home, next to his second wife, Millie, and among his white neighbors. His homestead remained in the family until 1976. Though he died more than a century ago, Dick Poynor is still revered as a master craftsman and cherished as part of the history of the Leiper's Fork area.

In 1990 the Tennessee Historical Commission placed a marker near the site of Poynor's home and chair factory in Williamson County. His highest honor and recognition came during the Tennessee Bicentennial (1996), when Sparta Spoke Factory chose to reproduce the Poynor rocker as an example of superior Tennessee craftsmanship. In February 1999 the Tennessee State Museum, as part of its Black History program, exhibited a collection of his chairs to recognize his status as a distinguished African American craftsman.

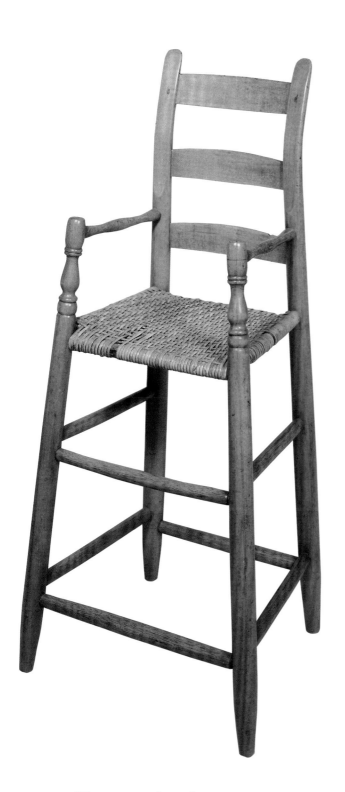

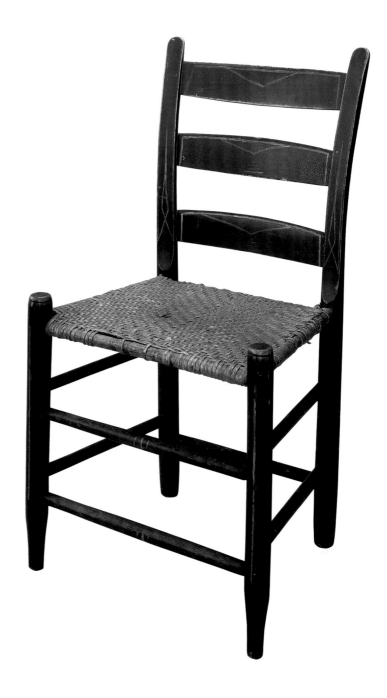

52 · RICHARD "DICK" POYNOR
 b. Halifax County, Virginia 1802–
 d. Williamson County, Tennessee 1882

High Chair, ca. 1850–70
Williamson County, Tennessee
Maple with hickory rungs and arms; 39 × 18 × 11¾ in.
Collection of John and Jane Luna

53 · RICHARD "DICK" POYNOR
 b. Halifax County, Virginia 1802–
 d. Williamson County, Tennessee 1882

Side Chair, ca. 1850–70
Williamson County, Tennessee
Sugar maple, hickory, white oak, rosewood, and paint;
33½ × 18¾ × 15 in.
Collection of Rick Warwick

WORKING AS A CHAIR MAKER in Williamson County, Dick Poynor was one of the countless craftsmen who produced children's furniture for the growing population in the backcountry. Along with high chairs, Poynor made youth chairs—scaled-down side chairs for children who had grown beyond the high chair. Cabinetmakers produced other types of furniture for young people, ranging from cradles and youth beds to children's bureaus and doll furniture. RH

THIS CHAIR WAS ONE OF A SET purchased by Captain John H. Hunter (CSA) of Riversmeet Farm at Leiper's Fork from the local chair maker Dick Poynor and has remained in the family to the present day. RW

Benjamin H. Caldwell Jr.

Silver Production and Importation in Tennessee

The story of the early artisans who made silver in Tennessee begins with William Bean, the first permanent settler in East Tennessee. In 1769 Bean immigrated from Virginia with his son George, a gunmaker who became the state's first silversmith. The family settled on Boone Creek near the Watauga River. Bean advertised his services as goldsmith, jeweler, and gunsmith in 1792 in the *Knoxville Gazette.* His customers were, not the aristocracy, but common people who wore dressed skins for clothing and carried the barest of necessities.

In June 1796 forty-two thousand square miles of territory south of the Ohio River became known as Tennessee. In 1818 Isaac Shelby and Andrew Jackson purchased West Tennessee from the Chickasaw Indians, establishing Tennessee's present borders. The history of silversmithing in Tennessee parallels the migration to and settlement of these geographic areas. The first period follows the transition from territory to statehood and lasts until 1820, when the steamboat started plying the Mississippi, Ohio, Cumberland, and Tennessee Rivers, bringing finished products to those who settled the land. The second period lasts from about 1820 to 1840, a time when Tennessee grew to be the fifth most populous state in the union, and when many silversmiths moved into the state. People were now looking for a better way of life with some of the amenities found in places such as New York, Boston, Charleston, Philadelphia, and Cincinnati. The third period encompasses the importation of silver made in the Northeast by manufacturers who used the new tools of the industrial revolution to make their silverware, which was frequently stamped with the name of a local Tennessee retailer. These pieces, even when made elsewhere, tell the story of the tastes of the citizens of Tennessee just prior to the Civil War. In this period of developing rail travel, electroplating technology imported from the East was used by silversmiths as they sought to expand their sales throughout the region.

Two of our earliest silversmiths, Joseph T. Elliston and Thomas Deaderick of Nashville, used lotteries advertised in local newspapers to encourage business. This gave the early settlers a chance to win anything from silver teaspoons and silver buttons to gold watches. The purchase of a lottery ticket for acquisition of niceties seemed more acceptable to these frontiersmen whose inventories reveal a paucity of possessions—often just an iron kettle, a quilt or down mattress and bed, and perhaps a horse. Later inventories begin to reveal silverware—spoons, predominantly—then an occasional ladle or a few beakers.

Like earlier silversmiths in the colonies, Tennessee smiths continued the tradition of hiring apprentices to carry on their trade. Some never finished their apprenticeships, though they had successful careers as silversmiths. Many of them combined silver production with watch- and clockmaking, even though most just retailed watches made predominantly in England. They put their names on the watches and clocks mainly as a guarantee that they would stand behind the workmanship of the goods they sold.

A review of the 1820 federal manufacturers' census reveals that silversmiths lived in at least seven counties in Tennessee—Bedford, Davidson, Green, Hawkins, Maury, Rutherford, and Smith. From other research we know that Knox, Madison, and Shelby Counties also had silversmiths. According to the survey, they made clocks and watches, gold- and silverware, and jewelry. They used Spanish milled dollars as a source of silver (rather than American coins, which were rare).

From 1820 to 1840 the state matured rapidly. Tennessee, particularly Middle Tennessee, became a significant producer of agricultural products. Steamboats made a great savings in time and in the cost of shipping. A trip by flatboat to New Orleans and return by keelboat or by overland route might have taken a year, whereas a steamboat could reach New Orleans from Nashville in a week and return in seventeen days. Steamboats made it easy to send wares to market, thereby increasing personal wealth as well as enabling the importation of competing products, particularly silver and furniture from Philadelphia and New York. Many silversmiths stocked imported jewelry and silver work, which often bore the marks of its manufacturer as well as the mark of the local supplier. The latter was the guarantor of quality. It takes study and handling of many pieces to determine where the silver was made, and it is still difficult always to be certain whether the mark is that of the retailer or the maker.

On Christmas 1836 the Association of Watchmakers, Silversmiths, and Jewelers of Nashville "established a bill of rates on all watch repair work and manufacture of silver spoons, cups, ladles, etc....," confirming that some silver was actually produced at that time by these eight men and not just retailed by them. This rare document is the first record of a silversmith guild found in the South. The members' agreement to adhere to uniform prices was probably forced on them by the situation created when President Andrew Jackson closed the banks as well as by competition from local retailers, two of whom, Thomas Gowdey and W. H. Calhoun did not attend this meeting. Rather than put their money in unsafe banks, people like Jackson invested in silver, which was easily identified by seller and often bore the initials of the owner. The group faced fierce competition in the following two decades from the combined forces of mechanized silver manufacture and the ease of importing silver products manufactured out of state. Many tradesmen left Tennessee for Arkansas, Kentucky, Indiana, Mississippi, Alabama, and Texas.

Some silver was produced by hand in Tennessee probably into the 1870s, but the interruption caused by the Civil War as well as the industrialization of the South following the war sounded the death knell for the handmade silver of Tennessee.

After the Civil War, the importation of richly patterned machine-made silver flourished, and handmade silver slowly ceased to be produced. There were sporadic makers, usually associated with a fine arts program at a university, who continued throughout the twentieth century, but silversmithing as it was formerly practiced never occurred again in Tennessee.

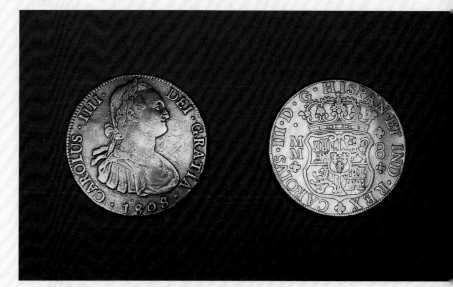

Spanish milled dollar, 1808. Early Tennessee silversmiths used the Spanish dollar, called "coin silver," as raw material because of its high silver content (approximately 90 percent).

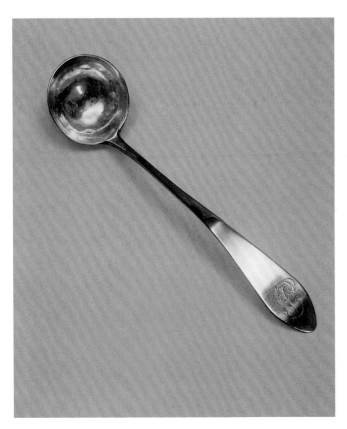

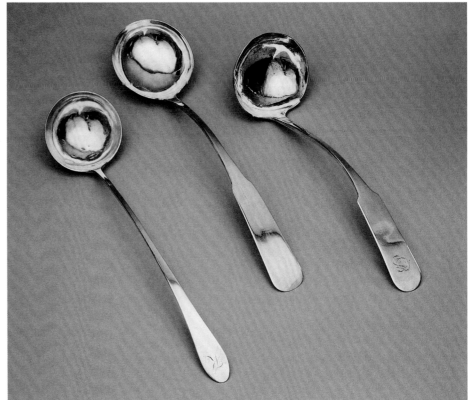

54 · **JOSEPH THORP ELLISTON**

b. Culpeper, Virginia 1779–d. Nashville, Tennessee 1856

Sauce Ladle, ca. 1797
Engraved "P"; marked "J. T. Elliston"
Coin silver; 5⅞ × 1⅜ in.
Collection of Ben and Gertrude Caldwell

THE EARLIEST KNOWN PIECE of Tennessee silver, this ladle was made by Joseph Thorp Elliston, who in 1797 established himself as Nashville's first silversmith and clockmaker. Soon after his nephew John Elliston joined him in his shop in 1809, Elliston turned his interests to civic responsibilities, serving as one of Nashville's five incorporators, an alderman, and mayor from 1814 to 1816. BHC

55 · **ISAAC MARTIN**

Active Nashville, Tennessee ca. 1800–1810

Punch Ladle, 1800
Engraved "R"; marked "IM" (twice) and "C"
Coin silver; 13½ × 3¼ in.
Collection of Ben and Gertrude Caldwell

IN AUGUST 1808 ISAAC MARTIN offered for sale an assortment of jewelry and spectacles "at the cheapest rates" at Winn's Inn, Nashville. In the same month Martin sold tickets for a lottery in which he intended to dispose of watches and jewelry. This ladle is attributed to him because of the mark "IM." BHC

56 · **JOSEPH THORP ELLISTON**

b. Culpeper, Virginia 1779–d. Nashville, Tennessee 1856

Punch Ladle, 1800–1820
Marked "ITE"
Coin silver; 14¼ × 3½ in.
Collection of Ben and Gertrude Caldwell

THE MARK ON THIS LADLE uses the Old English "J," which looks like an "I." There is no known Elliston whose first initial was I. BHC

57 · **EDWARD RAWORTH**

d. 1835; active Nashville, Tennessee 1808–20

Punch Ladle, ca. 1810
Engraved "B"; marked "E. RAWORTH"
Coin silver; 12¾ × 3⅝ in.
Collection of Ben and Gertrude Caldwell

THIS LADLE'S MARKS INDICATE that its maker was Edward Raworth, one of Davidson County's earliest silversmiths. Raworth advertised for an apprentice in 1808, but by 1820 warned his customers that he was "removing to the country" and requested that they pick up their orders at his dwelling on Cherry Street. BHC

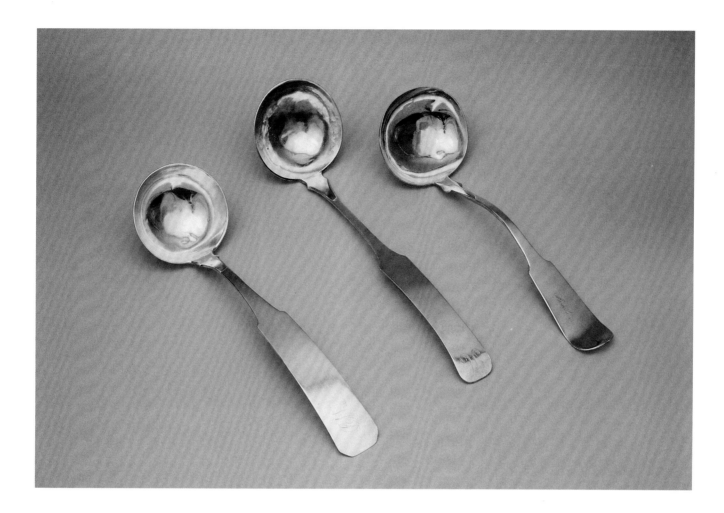

58 · BARTON RICHMOND

b. Boston, Massachusetts–active Nashville,
Tennessee 1816–40

F. P. FLINT

b. Boston, Massachusetts–d. Nashville,
Tennessee 1823

Punch Ladle, ca. 1820
Engraved "WD"; marked "RICHMOND & FLINT"
Coin silver; 13 × 3¾ in.
Collection of Ben and Gertrude Caldwell

THIS LADLE, ENGRAVED "WD," was owned by William Donelson, brother-in-law of Andrew Jackson. It was made by the former Bostonians Richmond and Flint, who established their silversmith firm in 1816 on Market Street in Nashville, selling watches, jewelry, silver spoons, and military goods. Soon after the establishment of steamboat services to Nashville, they advertised a variety of silverplated ware and Britannia ware, imported from Boston, Providence, and Baltimore. BHC

59 · JOHN CAMPBELL

b. Scotland 1803–d. Franklin, Tennessee 1875

Punch Ladle, ca. 1845
Engraved "Mentlo"; marked "J. CAMPBELL"
Coin silver; 13⅛ × 4¼ in.
Collection of Ben and Gertrude Caldwell

DR. MENTLO OF SUMNER COUNTY, physician to Andrew Jackson, owned this ladle. It was made by John Campbell, born in Scotland in 1803. Campbell served an apprenticeship in Fayetteville, North Carolina, before moving to Nashville in 1836. Besides working as a silversmith, Campbell served as secretary of the Association of Watchmakers, Silversmiths, and Jewelers of Nashville, a guild that established price guidelines. BHC

60 · JAMES HODGE

b. Tennessee 1800 or 1804–d. Columbia,
Tennessee 1887

Punch Ladle, ca. 1825
Engraved "H"; marked "J. HODGE" and an encircled
"Columbia T"
Coin silver; 14¼ × 3⅞ in.
Collection of Ben and Gertrude Caldwell

THIS LADLE WAS MADE BY THE SILVERSMITH James Hodge and was found in Columbia, Tennessee, where Hodge began his career as an apprentice to his brother-in-law Samuel Northern. Hodge became one of Maury County's wealthiest citzens and for more than fifty years rarely missed a day at the shop. He is buried at Rose Hall in Columbia. BHC

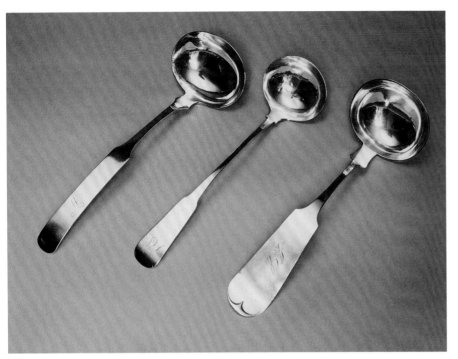

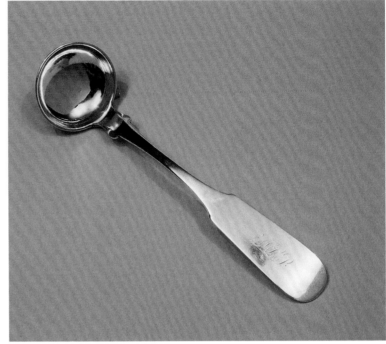

61 · THOMAS MCCOWAT

b. Virginia 1783–active Nashville, Tennessee
1823 and Jackson, Tennessee 1838–53

Punch Ladle, ca. 1835
Engraved "SAL"; marked "MCCOWAT"
Coin silver; 13 × 3½ in.
Collection of Ben and Gertrude Caldwell

THIS FIDDLE-STYLE LADLE is thought to have been made in Nashville, where it was found. Thomas McCowat moved from Virginia to Nashville by 1824, the year he advertised his shop in the *Nashville Whig.* By 1838 McCowat had moved to Jackson, Tennessee, and continued to work there until his death. BHC

62 · JOHN M. SMITH

Active Nashville

Punch Ladle, 1835
Engraved "W"; marked "J. M. SMITH" with a reverse "S"
Coin silver; 13 × 4⅜ in.
Collection of Mrs. Thomas Connor

THE ONLY REFERENCE TO JOHN M. SMITH is an advertisement in the June 19, 1835, issue of the *Nashville Union* announcing the sale of his jewelry store to Daniel Webb and John S. Britain. His trade history, like that of many other Tennessee silversmiths, is documented solely in the silver that he produced, and verified in newspaper ads and census records. Note the mark on this ladle has a reversed "S," which could have been a mistake or might indicate the silversmith was either dyslexic or uneducated. BHC

63 · ERNEST WIGGERS

b. Hanover Kingdom, Germany ca. 1836;
active Nashville ca. 1866

Punch Ladle, ca. 1866
Engraved "J.Y."; marked "E. Wiggers"
Coin silver; 13⅜ × 4⅛ in.
Collection of Ben and Gertrude Caldwell

DOCUMENTATION OF ERNEST WIGGERS'S presence in Nashville before 1866 has not been found. His surviving work looks to be handmade, using old techniques, unlike the mechanically produced silverware that appeared more often after the Civil War. BHC

64 · SAMUEL BELL

b. Washington County, Pennsylvania 1798–
d. San Antonio, Texas 1881

Gravy Ladle, ca. 1820–50
Engraved "MLP"; marked "S. BELL"
Silver; 6¾ × 1¾ in.
Collection of Robert Hicks

THIS GRAVY LADLE WAS MADE BY Samuel Bell, Knoxville's best-known silversmith and its mayor in the 1840s. In 1852 Bell sold his business and moved his family to San Antonio, Texas, where he established himself as a "jeweler and silversmith," specializing in Bowie-style knives. BHC

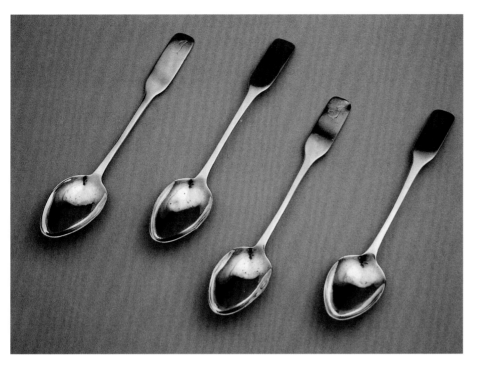

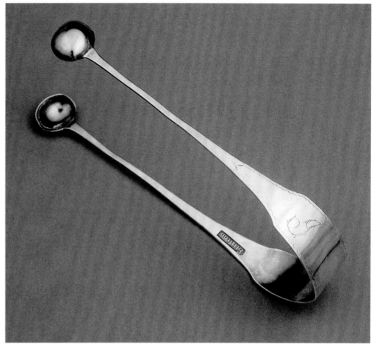

65 · **JOSEPH THORP ELLISTON**
b. Culpeper, Virginia 1779–d. Nashville,
Tennessee 1856

Teaspoons, 1800–1810
Engraved "J"; marked "J. T. Elliston"
Silver; 7 × 1 in.
The Hermitage: Home of President Andrew Jackson,
H1985.07.029–.032

THESE TEASPOONS BEAR the earliest mark of Joseph Thorp Elliston, Nashville's first silversmith. BHC

66 · **JOSEPH THORP ELLISTON**
b. Culpeper, Virginia 1779–d. Nashville,
Tennessee 1856

Sugar Tongs, ca. 1810
Engraved "J"; marked "Elliston"
Silver; 2½ × 6½ in.
The Hermitage: Home of President Andrew Jackson,
H1925.05.039

THESE SUGAR TONGS BEAR the "Elliston" mark that was used after Joseph T. Elliston and his nephew John formed a partnership in 1809. The tongs are in the very early fiddle style and are enhanced with a bright-cut border. BHC

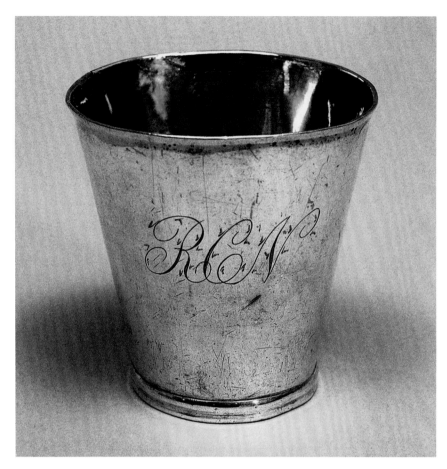

67 · **BARTON RICHMOND**
b. Boston, Massachusetts–active Nashville, Tennessee 1816–40

F. P. FLINT
b. Boston, Massachusetts–d. Nashville, Tennessee 1823

Beaker, ca. 1815–20
Engraved "RCN"; marked "RICHMOND & FLINT"
Coin silver; 3¼ × 3⅛ in.
Collection of Ben and Gertrude Caldwell

THIS IS THE EARLIEST KNOWN PIECE of Tennessee holloware. The beaker is made in the late-eighteenth-century style, which is more flared toward the lip than the more common form of Tennessee beakers or julep cups. BHC

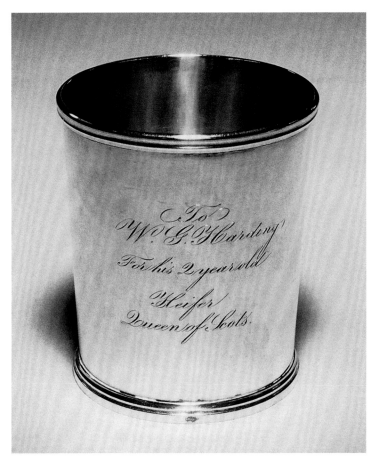

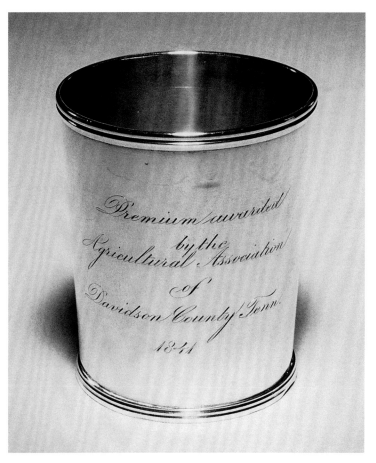

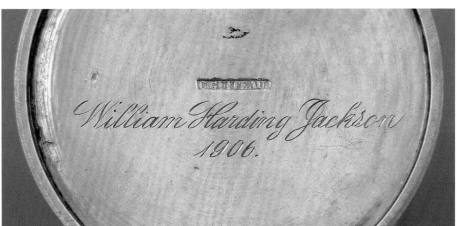

68 · **C. GUITEAU**
Active Nashville, Tennessee 1836–45

Beaker, 1841
Intaglio-marked "C. Guiteau"
Engraved "To W. G. Harding for his 2 year old Heifer,
'Queen of Scots.'"
Coin silver; 3½ × 3 in.
Belle Meade Plantation, Nashville Chapter Associa-
tion for the Preservation of Tennessee Antiquities,
72.3.18

THIS CUP, SHOWN FROM TWO SIDES, was one of two awarded in 1841 to William Giles Harding by the Agricultural Association of Davidson County for his prize livestock. The silversmith, C. Guiteau, was also a watchmaker, jeweler, and engraver. At one time he was in partnership with John Peabody, but he was on his own by the time this cup was made. Harding's grandson William Harding Jackson inherited the beaker in 1906. JH

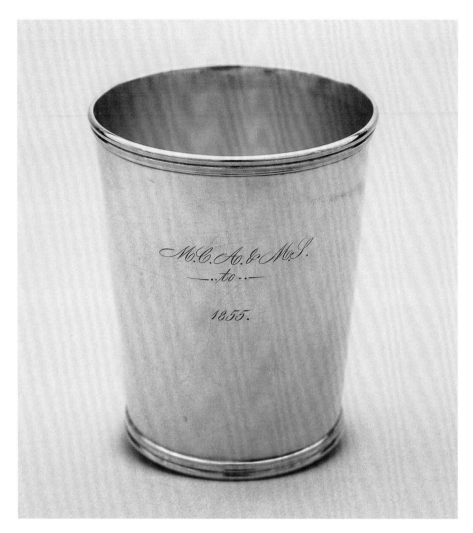

69 · **JOHN CAMPBELL**
b. Scotland–d. Franklin, Tennessee 1875

GEORGE WASHINGTON DONIGAN
b. New York, New York ca. 1824–d. 1864

Beaker, 1855
Engraved "M.C.A.&M.S./to/Castor/1855"; marked
"C & D" and "Campbell and Donigan" with elephant
hallmark
Coin silver; 3½ × 3 in.
Belle Meade Plantation, Nashville Chapter
Association for the Preservation of Tennessee
Antiquities, 72.3.19

GENERAL WILLIAM GILES HARDING of Belle Meade Plantation won this trophy for his horse, Castor, at the Maury County Agricultural and Mechanical Society Fair in 1855. Trophies were often functional items in the nineteenth century, so this mint julep cup was also used to hold drinks. Campbell and Donigan were located at the corner of College and Union Streets in Nashville from 1853 to 1855. John Campbell was a Scottish immigrant who had apprenticed in Fayetteville, North Carolina, and George Washington Donigan came from New York. JH

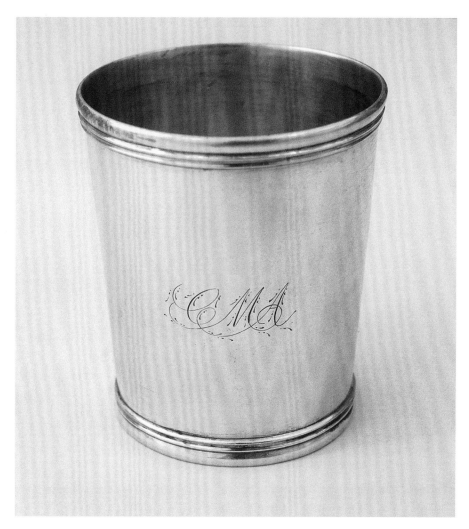

70 · **FREDERICK HARVEY CLARK**
b. Danbury, Connecticut 1811–d. Memphis, Tennessee 1866

Beaker, ca. 1840–60
Engraved "CMA"; marked "F. H. CLARK & CO."
Coin silver; 3½ × 3 in.
Tennessee State Museum Collection, 82.171a

FREDERICK HARVEY CLARK worked as both a jeweler and a dentist in Murfreesboro in 1838 before moving to Memphis in 1841. The mark on this cup bears the name of his firm, which sold watches, jewelry, and silverware, repaired timepieces, and made daguerreotypes—all activities typical of the large jewelry stores and silversmith shops of its time. BHC

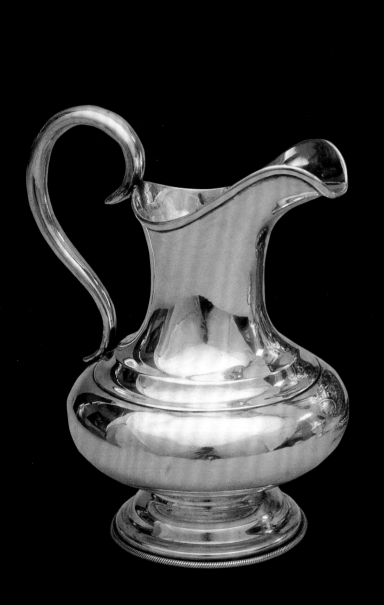
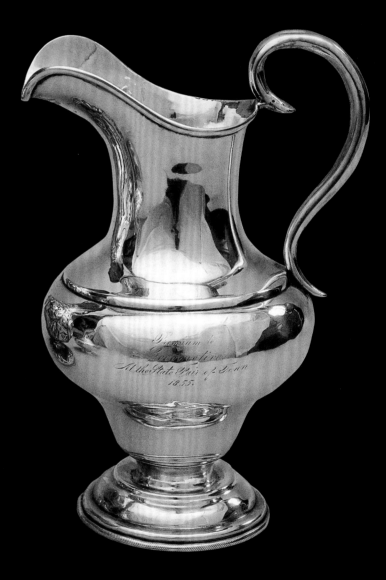

71 ⸳ **JOHN CAMPBELL**
b. Scotland 1803–d. Franklin, Tennessee 1875
GEORGE WASHINGTON DONIGAN
b. New York, New York ca. 1824–d. 1864

Small Pitcher, ca. 1855
Engraved "premium to Locomotive at the State
Fair of Tenn/1855"; marked "C&D"
Coin silver; 6⅝ × 4⅞ × 3⅝ in.
Collection of Ben and Gertrude Caldwell

THE ENGRAVING ON THIS PITCHER indicates that it was awarded to Locomotive, a prize bull from southern Kentucky. Campbell and Donigan worked in Nashville from 1853 to 1855 at the corner of College and Union Streets. There they produced and probably imported a quantity of silver identifiable by an unusual elephant hallmark as well as a "C&D" (Campbell and Donigan) mark similar to that found on Bailey and Co. silver of Philadelphia. BHC

72 ⸳ **JOHN CAMPBELL**
b. Scotland 1803–d. Franklin, Tennessee 1875
GEORGE WASHINGTON DONIGAN
b. New York, New York ca. 1824–d. 1864

Trophy Milk Pitcher, ca. 1855
Engraved "D.C.A.&M.A. to Castor, 1855";
marked "CAMPBELL & DONIGAN"
Coin silver; 5⅜ × 4½ × 3¼ in.
Collection of Ben and Gertrude Caldwell

THE ENGRAVING "D.C.A.&M.A. to Castor, 1855" on this trophy milk pitcher refers to the Davidson County Agricultural and Mechanical Association. The pitcher is also marked with two elephant hallmarks. BHC

Premium
awarded at the
Tennessee State Fair,
to
Alex. I. Porter,
for
Trotting Brood Mare,
1856.

73 · JONES, SHREVE, AND BROWN

Presentation Ewer, 1856
Engraved "Premium awarded at the Tennessee State
Fair to Alex. J. Porter, for Trotting Brood Mare, 1856";
marked "JONES, SHREVE, BROWN & CO., BOSTON"
Coin silver; 10¼ in.
Collection of Robert Hicks

THIS NEO-GRECIAN EWER sports a bulbous urn-shaped body, flared spout, simple
S-scroll handle, and decorative border. It originally belonged to Alexander J. Porter,
owner of the horse for whom the trophy was awarded. A prominent Tennessean, Porter
served as an adjutant general in the Confederacy and chancellor of the old University
of Nashville. BHC

74 · *Tea Service,* 1855
Engraved "J. F. Lanier"; marked "W. H. CALHOUN"
Silver; sugar bowl, 8 × 9 × 5 in.; teapot,
9½ × 11½ × 6 in.; creamer, 7 × 7 × 4¼ in.
Tennessee State Museum Collection, 82.118a–c

THIS IS ONE OF THE FEW Tennessee-marked coin silver tea services. The set is in the Rococo revival style popular in the 1850s, but the strawberry finial gives it a Tennessee touch. The creamer has a covered spout, a unique design element usually found on Southern tea services, perhaps to discourage insects. BHC

75 · **WILLIAM HENRY CALHOUN**

 b. Pennsylvania ca. 1815–d. Nashville,
Tennessee 1865

Goblet, 1855
Engraved "To Castor 2nd Division Fair Tenn, &
3rd SA & MS/1855"
Coin silver; 5 × 3 in.
Belle Meade Plantation, Nashville Chapter
Association for the Preservation of Tennessee
Antiquities, 72.3.41

THESE GOBLETS, WHICH HAVE BEADED rims and Greek key bands around their
bases, were awarded to William Giles Harding for two horses in 1855. William H. Calhoun
trained in Philadelphia before opening a jewelry store in Nashville in 1835. He sold wares
from New York and Philadelphia as well as the items that he and his journeymen made.
His silver is intaglio-marked "W. H. Calhoun" or "W. H. Calhoun Nashville T." JH

76 · **WILLIAM HENRY CALHOUN**

 b. Pennsylvania ca. 1815–d. Nashville,
Tennessee 1865

Goblet, 1855
Engraved "To Epsilon 2nd Division Fair in Tenn &
3rd SA & MS/1855"
Coin silver; 5 × 3 in.
Belle Meade Plantation, Nashville Chapter
Association for the Preservation of Tennessee
Antiquities, 72.3.39

77 · **WILLIAM HENRY CALHOUN**
b. Pennsylvania ca. 1815–d. Nashville,
Tennessee 1865

Pitcher, 1865
Engraved "to Mrs. H. Bruner, 1865"; marked
"W.H. Calhoun, Tenn"
Coin silver; 8⅜ × 6⅜ × 4½ in.
Collection of Ben and Gertrude Caldwell

THIS PITCHER WAS PROBABLY made in Philadelphia or New York and sold by Calhoun in his successful Nashville retail business, which he operated for many years under his motto "Small profits and quick sales." BHC

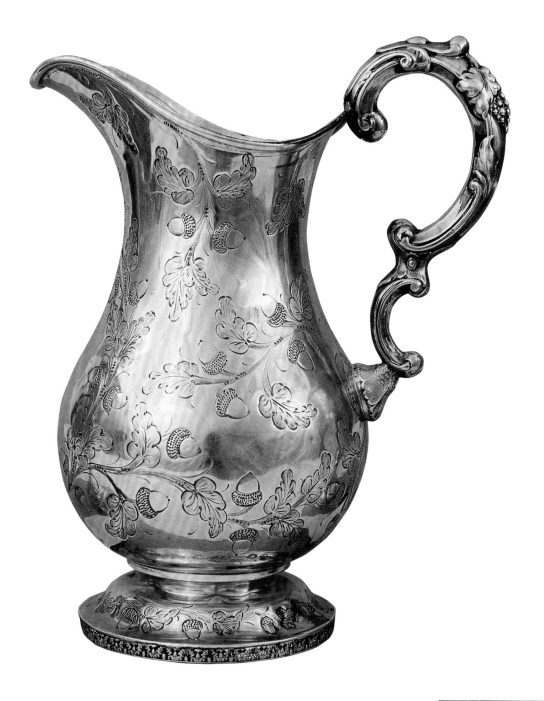

78 · *Pitcher,* 1855
Engraved "Betty M. Woods Jan. 6, 1855";
marked "T. Gowdy"
Coin silver; 9⅜ × 4½ × 7⅞ in.
Tennessee State Museum Collection, 82.11.6

THIS PITCHER BELONGED TO Betty Woods, the niece of William Edward West, a Tennessee and Kentucky portrait artist. The misspelling of the silversmith's name—Thomas Gowdey—gives evidence that after 1835–40, most silver sold in Tennessee was probably made in the Northeast, retailed locally, and stamped with the retailer's name, not the actual maker's mark. BHC

Stephen T. Rogers and Samuel D. Smith

Pottery

There were prehistoric Native American potters for at least two thousand years before the first Europeans arrived in what is now Tennessee, but pottery making as a regional historic-period craft dates from the late 1700s. Since that time Tennessee-made pottery has played a sometimes subtle but always continuous role in the lives of the state's Euro American and African American inhabitants. This overview of the history of the craft discusses the several phases of change and development that occurred from the late eighteenth into the twentieth century. Our understanding of these phases derives from a study of Tennessee potters and their wares that has been ongoing since the late 1970s.[1]

It is assumed that a few potters came into the state along with the first waves of Euro American settlers, soon after 1770. Archaeological information from some of the state's earliest historic-period sites suggests that local wares were being produced at least by the early 1790s. The two earliest Tennessee potteries with clear historical documentation were operating in 1799 in Middle Tennessee and by 1808 in East Tennessee. By 1820 a special Federal census recorded the existence of eight Tennessee potteries, one in Middle Tennessee and seven in East Tennessee, but there were certainly others that were too small to qualify for inclusion in this census.

These earliest Tennessee potteries were family-based operations that made lead-glazed earthenware jars, jugs, pitchers, dishes, and a variety of other utilitarian forms. The production of glazed earthenware was common in East Tennessee and to a lesser extent in Middle Tennessee until about the time of the Civil War but was rare after the 1860s. Toward the end of this period, some of the potters in upper East Tennessee produced earthenwares that are notable for their decorative embellishments, such as multicolored slips under the glaze and geometric stamps applied to vessel walls and handles. Some of the better-known pottery family names during this phase are Bohannon, Cain, Click, Harmon, Haun, Hinshaw, Mottern, and Vestal in East Tennessee and the Cobles in Middle Tennessee. Tennessee's earthenware pottery seems to reflect a blending of influences from traditions prevalent in Virginia and North Carolina.[2]

In the 1820s a more durable, high-fired ware called stoneware began to be produced in Tennessee and soon spread to pottery centers all across the state. Early Tennessee stoneware was commonly glazed by introducing salt into the kiln at the hottest stage of firing. Vessels were sometimes marked with incised or stamped maker's names and gallon capacity numbers, and there was some use of cobalt slips to apply dark blue gallon capacity numbers or decorative designs. After the Civil War, it was common to coat the interiors of salt-glazed vessels with a brown clay slip, and later there was a general sequence of stoneware glazing that progressed from all brown, to brown and white, to all white. Stoneware forms were utilitarian in nature and were similar to those of the earthenware tradition, but the making of stoneware dishes was rare even though stoneware churns were ubiquitous. Except for the relatively rare use of a glazing technique referred to as alkaline glaze, early Tennessee stonewares are similar to those documented for North Carolina and Georgia.[3] Common family names associated with the production of Tennessee stoneware include Decker, Floyd, Grindstaff, Harmon, Love, Smith, and Weaver in East Tennessee; Barr, Cole, Collier, Dunn, Elrod, Hitchcock (Hedgecough), LaFever, Roberts, and Spears in Middle Tennessee; and Connor, Craven, Fesmire, Garner, Keller, Reevely, Russell, Smyth, Ussery, Yeager, and Weist in West Tennessee.

In the late 1800s these family-based potteries began to be replaced by stoneware factories. An evolving railroad network made it feasible to bring clay and other raw materials to urban centers where labor was concentrated and to transport the finished wares to widespread markets. Mechanization evolving out of the industrial revolution also affected the manner and rapidity with which wares could now be produced. Toward the end of the nineteenth century the most common stoneware vessels produced in Tennessee were whiskey jugs. Competition from the glass container industry and Prohibition, which began in Tennessee in 1910, effectively ended Tennessee's functional stoneware pottery industry by the early 1900s.

From about 1880 to about 1920, there was a nationwide movement focused on the production of handmade artistic wares, commonly

called art pottery.[4] This had some influence in Tennessee, and it appears that the first examples produced were by Elizabeth J. Scovel, who started the Nashville Art Pottery as part of the Nashville School of Art. This operation lasted from 1884 until about 1889. Another Tennessee art pottery that has received a considerable amount of recognition was the Nonconnah Pottery near Memphis. This pottery was started by Nellie R. Stephen and her son Walter B. Stephen and was in production from about 1903 to 1912, making wares with unusual glazes and raised, decorative appliqués. In 1913 Walter Stephen moved to North Carolina, where he started a second Nonconnah pottery that lasted until 1918 (it was replaced by the Pisgah Forest Pottery).[5]

While these were the widespread general trends, there were exceptions to all phases. A very few traditional earthenware potteries, which were mostly extinct by the 1860s, lasted until about 1900 in rural areas of upper East Tennessee. Traditional, family-run stoneware potteries mostly disappeared by the late 1800s, but a few were still operating in eastern Middle Tennessee until the 1930s. While most of the factory stoneware potteries became extinct by about 1910, there were one or two later ones that produced utilitarian wares in combination with wares of an artistic nature. An exception to all of this was the Southern Potteries at Erwin in East Tennessee. Here, from 1917 until 1957, millions of pieces of hand-painted, white-bodied plates and other dinnerware were produced and distributed to consumers all over the eastern United States.

By the late 1950s pottery making of any kind had become rare in Tennessee. However, this void eventually began to be filled by the studio pottery movement, which seems to date from the 1960s. The Tennessee Association of Craft Artists was founded in 1965 and included at least two potters. Its members now include more than 130 studio potters, some of whom follow handmade ceramic traditions not too far removed from those employed by Tennessee's early potters.

NOTES

1. Samuel D. Smith and Stephen T. Rogers, *A Survey of Historic Pottery Making in Tennessee*, Research Series No. 3 (Nashville: Tennessee Division of Archaeology, 1979). Work is progressing on a major revision of this publication, which will discuss the people and wares associated with about 200 pottery-making operations that formerly existed in Tennessee.

2. Comparative examples can be found in works by H. E. Comstock, *The Pottery of the Shenandoah Valley Region* (Winston-Salem, N.C.: The Museum of Early Southern Decorative Arts, 1994), and John Bivins Jr., *The Moravian Potters in North Carolina* (Chapel Hill: University of North Carolina Press, 1972).

3. Charles G. Zug III, *Turners and Burners: The Folk Potters of North Carolina* (Chapel Hill: University of North Carolina Press, 1986), and John A. Burrison, *Brothers in Clay: The Story of Georgia Folk Pottery* (Athens: University of Georgia Press, 1983).

4. Paul Evans, *Art Pottery of the United States* (New York: Charles Scribner's Sons, 1974).

5. Rodney H. Leftwich, "The Nonconnah Pottery of Tennessee and Western North Carolina," in *May We All Remember Well* (Asheville, N.C.: Robert S. Brunk Auction Services, 2001), vol. 2, 70–90.

79 · **ATTRIBUTED TO THE CAIN POTTERY**
Sullivan County, Tennessee

Jar, ca. 1840–80
Earthenware, lead glaze, and manganese decoration;
13¼ × 11¼ in.
Collection of Mary Jo Case

THE DISTINCTIVE COMBINATION OF JAR FORM, rolled open-loop handles, and haphazardly brushed manganese decoration identifies the jar as being from the upper East Tennessee–southwestern Virginia region. Large jars such as this were used for food storage. They continued to be produced and used in East Tennessee long after other areas of the state had switched to stoneware to avoid the dangers of lead poisoning. CCW

80 · **ATTRIBUTED TO THE CAIN POTTERY**
Sullivan County, Tennessee

Jar, ca. 1820–80
Earthenware, lead glaze, and manganese decoration;
9 × 9 in.
Collection of Carole Carpenter Wahler

THIS EYE-PLEASING PIECE was created by a talented potter. His attempt at systematic decoration enhances its appeal. When found in the early 1970s in upper East Tennessee, it was thought to have been produced in Pennsylvania or Connecticut and therefore was sold out of the region. By 1980, when a collector returned it to Tennessee, a number of related examples had surfaced. A "C" in glaze is on the bottom of the piece. CCW

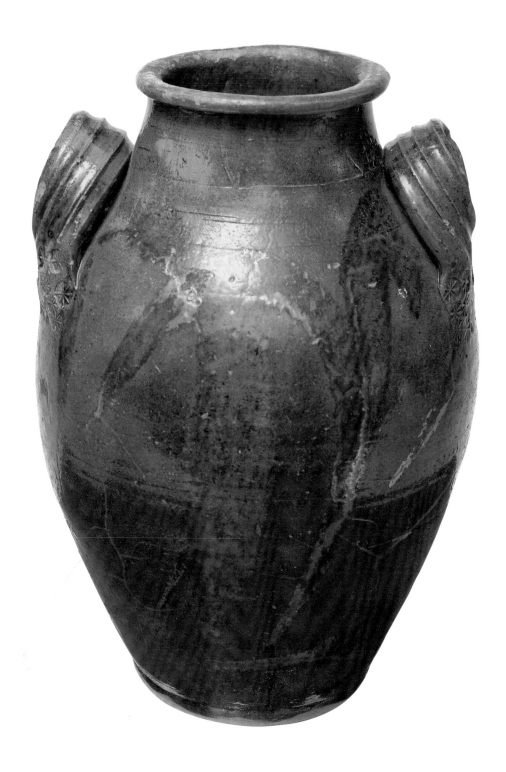

81 · HAUN POTTERY
Greene County, Tennessee

Jar, ca. 1840–60
Earthenware, lead glaze, and colored glaze
decoration; 13¼ × 9¾ in.
Collection of Carole Carpenter Wahler

THE NAME "HAUN" IS INCLUDED in the raised, decorative coggling surrounding the shoulder. Wheel-like stamps cover the terminals of the extruded lug handles. The color of the brushed decoration was likely achieved by a combination of iron oxide and manganese. The pseudo-crawling of the glaze was probably due to the addition of starch as a binder. Close inspection reveals differences in potting skills and decoration between this storage jar and the similarly glazed C. A. Haun jar (see next entry). CCW

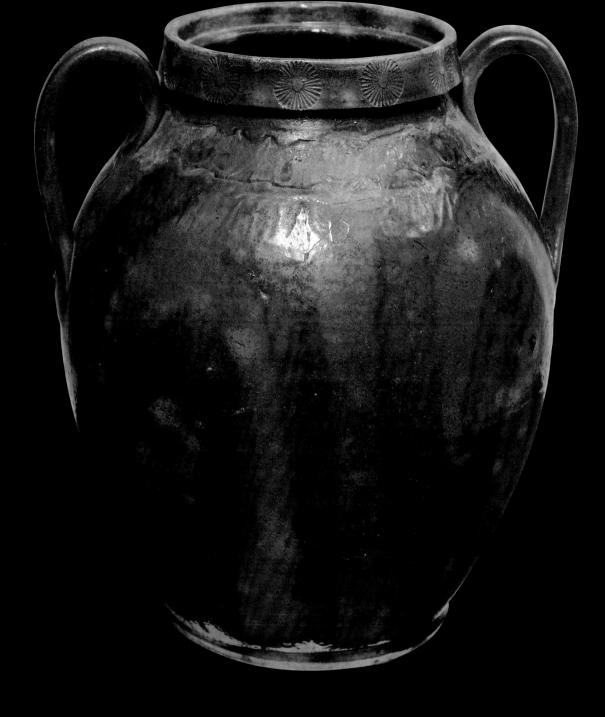

82 · C. A. HAUN

b. 1821–d. 1861

Greene County, Tennessee

Jar, ca. 1840–60

Earthenware, lead glaze, and colored glaze
decoration; 9⁷⁄₈ × 9¹⁄₂ in.

Collection of Mary Jo Case

TWO ROWS OF "C. A. HAUN & CO NO 1" are coggled around the shoulder. Large, delicate, wheel-like stamps surround the rim and decorate the handle terminals. Artistically brushed colored glaze covers the body. Marked similarities are seen between this jar and the "Haun" jar (see previous entry); however, some significant differences suggest two Hauns potting side by side. C. A. Haun was one of five East Tennessee "bridge burners" who were hanged by the Confederate forces in 1861. These pro-Union men considered burning the Lick Creek railroad trestle a patriotic act. CCW

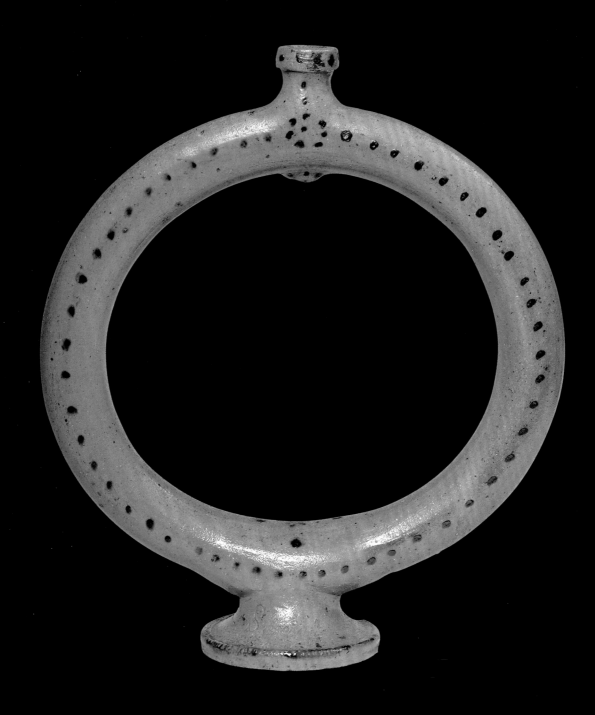

83 · **DECKER POTTERY**
Washington County, Tennessee

Ring Bottle, 1896
Stoneware, salt glaze, and cobalt decoration;
15³⁄₄ × 14¹⁄₂ × 5¹⁄₂ in.
Collection of Dr. Jerry E. Waters

THIS FORM WAS PRESUMABLY made so that a man could carry it over his shoulder while working in the fields or riding horseback. The size, base, decoration, and inscription, however, indicate that this bottle was made as a presentation piece. Cobalt dots and a flower decorate the ring and neck; the foot is outlined in cobalt. "Samuel Davault" and "June 26, 1896" are incised on the base. The Devault family has been in Tennessee since the eighteenth century. CCW

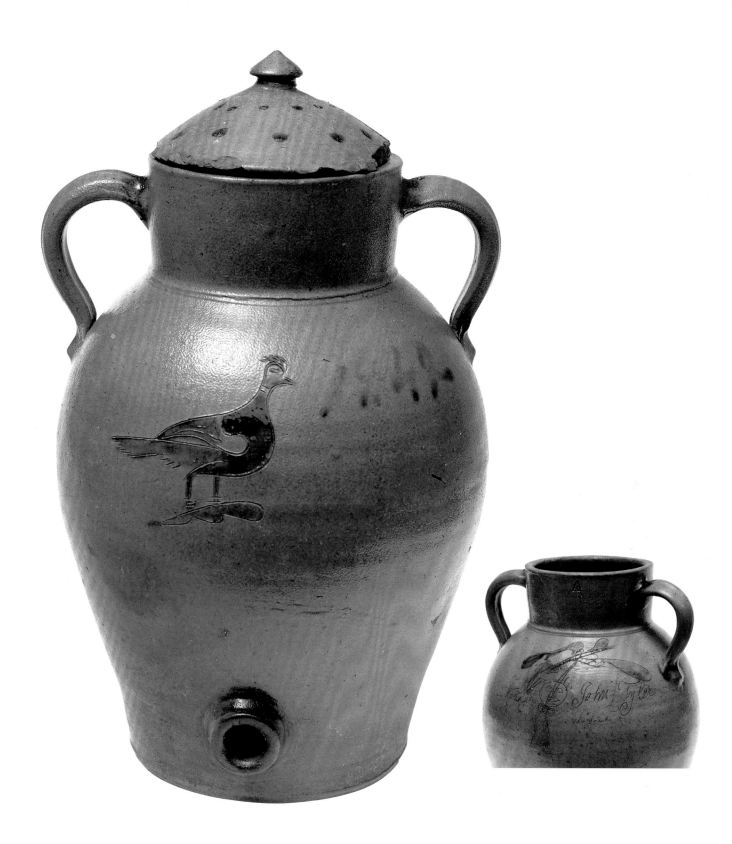

84 · ATTRIBUTED TO JOHN FLOYD
b. 1804–d. 1887

Graves Pottery, Knox County, Tennessee

Water Cooler, 1842
Stoneware, salt glaze, and incised and brushed
cobalt decoration; 17 × 12 in.
Collection of Carole Carpenter Wahler

A PEAFOWL AND "1842" DECORATE the front of this piece, and dots cover the domed lid. The decoration on the back is partially obscured by a crude drawing of a man hanging from the barrel of a gun, and "John Tyler Vetoes Nobody" is incised in script. It is fair to assume that the potter was disturbed by President Tyler's 1842 tariff vetoes. This piece of pottery descended in the family of James Madison Carter, who drove a stage-coach between Nashville and New York. CCW

85 · **WILLIAM GRINDSTAFF**
b. 1847–d. ca. 1898
Knox County, Tennessee

Figural Jug, ca. 1890
Stoneware, dark slip, and salt glaze; 14 × 7½ × 8½ in.
Collection of Carole Carpenter Wahler

THIS FIGURAL VESSEL was created by attaching a head to the top of a jug and adding clay for ears, eyes, forehead, nose, lips, arms, and a collar. Tiny white teeth were made from broken pieces of china. Four small, semicircular "Knoxville, Tenn." stamps surround a deep impression where the collar meets. "W GRINSTAFF" [*sic*] is impressed on the front. This piece descended in the family who owned the Patrick Sullivan Saloon in Knoxville. CCW

86 · GEORGE HEDGECOUGH FAMILY
b. 1881

Putnam County, Tennessee

Grave Marker, 1927
Stoneware; 31½ × 9½ × 11¼ in.
Tennessee State Museum Collection, 87.67.3

THIS VESSEL WAS MADE to commemorate the life and death of infant Aubrey D. Sherrell by his uncle George Hedgecough, descendant of the LeFever family of potters. An inscription on the marker reads "Bud on earth to bloom in heaven." Grave markers are rare in American pottery, and few survive breakage and theft. For unknown reasons, this marker was never placed on the grave but kept at home by the family until 1987. NFC

87 · *Jar*, ca. 1860–80
Putnam County, Tennessee
Stoneware, dark slip, and salt glaze; 12 × 13½ in.
Collection of Carole Carpenter Wahler

THIS VICTORIAN-LOOKING JAR was created by a utilitarian potter as a purely decorative object. Similar jars have the thin, ruffled rim and distinctive handles. Clay was shaped by hand and applied to the jar to create the roping, heart, and diamond designs. Matching sherds have been found at a Putnam County pottery site. However, since many men worked at that site through the years, the potter of this piece is still unknown. CCW

88 · **DUNN POTTERY**
Smithville, DeKalb County, Tennessee

Compote, 1887
Stoneware, dark slip, and salt glaze; 5⅞ × 6¼ in.
Collection of Carole Carpenter Wahler

THIS WELL-TURNED SMALL COMPOTE was undoubtedly intended as a presentation piece. It is incised "Smithvill, DDklb Millard J Dunn 1887 Miss Dunn." The possibility exists that a Dunn other than Millard made it because, based on current knowledge, he is not listed as having been a potter. The Dunns potted in DeKalb, White, and Putnam Counties. They were related by marriage to the Lafevers, as were most of the potters in the region. CCW

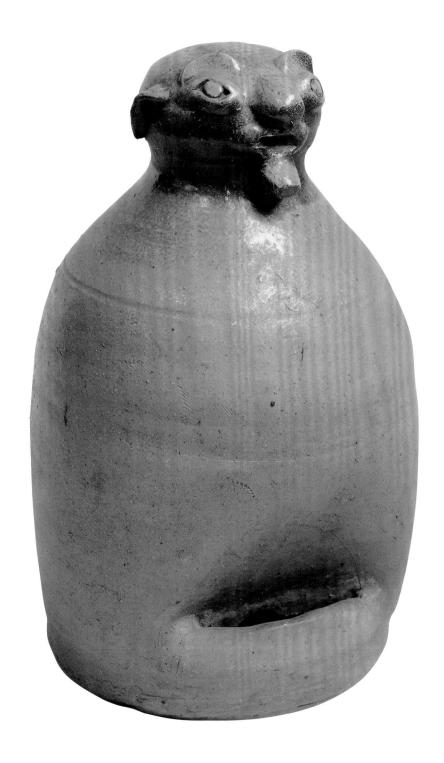

89 · **RILEY LAFEVER**
b. 1912–d. 1993

Figural Chicken Waterer, ca. 1930–40
Putnam County, Tennessee
Stoneware, dark slip, and salt glaze; 11¾ × 7¼ in.
Collection of Museum of Appalachia, Norris,
Tennessee

To make this piece, the potter essentially turned a closed jug and formed a head on top. Clay was added for ears, beard, and facial features. An opening was cut and a trough formed near the base. The outer wall of the trough was pulled higher than the inner so that a vacuum was formed when the vessel was filled. As the chickens consumed the water, an equivalent amount would be released from the jug. Riley was a sixth-generation LaFever potter in Tennessee. CCW

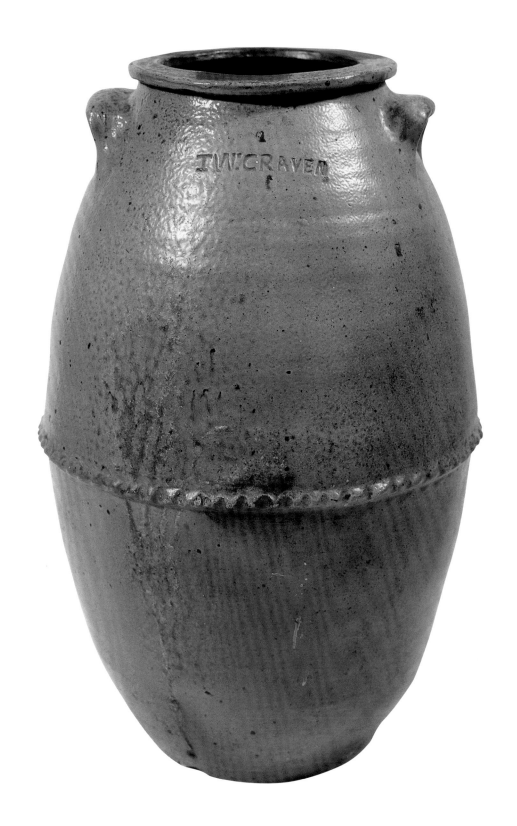

90 · **T. W. CRAVEN**
b. 1804–d. 1860
Henderson County, Tennessee

Jar, ca. 1840–60
Stoneware, local slip, and salt glaze; 21½ × 12 in.
Collection of Monty and Linda Young

THE DISTINCTIVE FORM OF THIS JAR identifies it as a Craven piece of pottery made in Tennessee. It was turned in two sections and joined. The juncture is concealed on both the interior and exterior with bands of clay. The exterior band is decorative and the interior is smooth. "T.W:CRAVEN" is impressed on one side and an "X" is impressed on top of a freehand "X" on the other. The Cravens moved to Tennessee from North Carolina in 1829. CCW

91 · WALTER B. STEPHEN

b. 1876–d. 1961

Nonconnah Pottery, Shelby County,
Tennessee

Vase, ca. 1901–10
Art pottery and slip glaze; 5 × 6½ in.
Collection of Stephen T. Rogers

AFTER BEING MOLDED BY HAND from local clay, the vase was covered with multiple coats of matte green slip on the exterior and brown on the interior. The floral design was then laboriously created by applying layers of liquid clay with an artist's brush. "NONCONNAH" was printed on the bottom using the same technique. This early Southern art pottery was established in the Memphis area and named for a nearby stream. It was moved to the mountains of North Carolina by 1913 and ultimately renamed Pisgah Forest Pottery. CCW

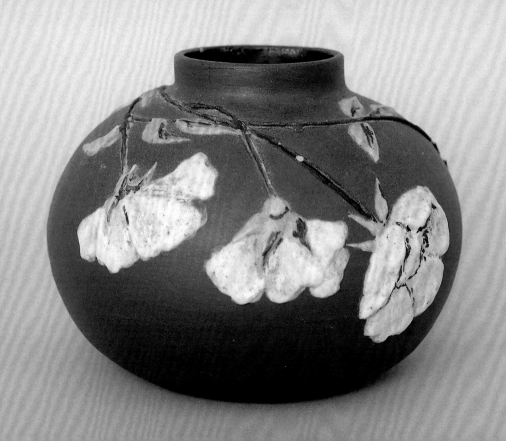

Bets Ramsey

Nineteenth-Century Quiltmaking in Tennessee

Until the advent of early industrialization in 1790, textiles in colonial America were produced primarily from flax and wool spun and woven at home or hired out to loom. Quiltmaking was limited to households with the means to purchase costly imported fabrics (unless one chose to use locally produced cloth)[1] until domestic manufacture began to expand rapidly with the establishment of the first spinning mills in 1790 and the power loom in 1815.[2]

Cloth was readily available by the time Tennessee was attracting a growing population in the early nineteenth century. Even though less time was required to weave a blanket or coverlet, quiltmaking by hand[3] was being practiced in the majority of homes. It was a rewarding process with a wide range of styles, from the simple utility scrap quilt to the most intricate, elaborately quilted masterpiece quilt, and there was a quilt for every level of proficiency and budget.

In the nineteenth century a woman may have had no other opportunity for self-expression than through her quilts. Her joys and sorrows, her longings and passions were messages stitched into cloth with needle and thread. "But is it Art?" the critics ask. Even an ordinary utilitarian object can be categorized as "Art" when it meets the criteria employed in judging any artwork: its composition, color, design, craftsmanship, originality, and *possession of a certain unique quality*. The historical significance, the quilt's "story," is an added consideration when selecting work for inclusion in an exhibition or a piece of writing.

It is obvious that the makers of the Trentham quilt lavished attention on every detail of its fabrication. Composed of nine rondels, possibly derived from the Pineapple or Chestnut Bud pattern, units were pieced and then appliquéd to a quilt top of three lengthwise panels seamed together. The richly quilted layers of cloth are further defined by extra cotton stuffed into the motifs from the underside of the quilt. It was made by Mary Trentham and her sister-in-law Nancy Jane Trentham in Rhea County, a locale singled out for the extraordinarily handsome quilting and stuffing practiced there, a tradition that continued until the end of the nineteenth century.[4]

Asymmetry in art and the impetus for the crazy quilt fad are attributed to a growing awareness of Asian styles, especially after Japanese artifacts were displayed at the Centennial Exposition in Philadelphia in 1876.[5] Crazy quilts became a vehicle for displaying luxurious fabrics, exemplary needlework skills, and collected souvenir items and were more likely to be found on parlor furniture than on beds. Designs and transfer patterns were available to incorporate in one's work. An excess of richness and fashion may compensate for less strong elements of design, as seen in Amy Terrass Johnson's crazy quilt made when she was twenty years old. The shops of Chattanooga supplied the fancy goods she needed for the blocks and the three-dimensional "dolls of the world" that add unexpected delight to the ornate surface of the composition.

The quality of Amy Johnson's quilt indicates something of her social and economic position, as does the crazy quilt made by Eunice Whitfield and Marianne Dudley, African American cousins who lived in a rural area near Clarksville, Tennessee. Less ornate, the quilt is made of scraps obtained by a relative who worked in a Chicago hotel adjacent to a millinery shop. Their own ingenuity and concept of embellishment demonstrate the cousins' awareness of the styles current at the turn of the century.

According to the Tennessee quilt survey, pieced quilts far outnumbered all other categories of quilts made in the state prior to 1930.[6] The pieced Milky Way quilt, however, is considered atypical for several reasons. The rather complicated piecing of hexagonal blocks is a variation of the square-block Log Cabin pattern. Unlike many pieced quilts made of scraps, it was made of all-new material purchased in Paris, Tennessee. Each block was finished and joined alternately with a plain block that was quilted on the sewing machine, an unusual innovation by these mother and daughter quilters.

While this is a limited selection of the quiltmaker's art, in each case the maker or makers were consciously creating a nonutilitarian object whose function was adornment of the home, to bring pleasure to the eye, in the name of Art.

Notes

1. Sally Garoutte, "Early Colonial Quilts in a Bedding Context," in *Uncoverings 1980* (Mill Valley, Calif.: American Quilt Study Group, 1981), 18–25. In her survey of colonial household inventories, Garoutte finds quilts were a luxury item comprising less than 2 percent of bedding.

2. Linda Welters and Margaret T. Ordonez, *Down by the Old Mill Stream: Quilts in Rhode Island* (Kent, Ohio: Kent State University Press, 2000), 51–52.

3. Suellen Meyer, "Early Influences of the Sewing Machine and Visible Machine Stitching in Nineteenth-Century Quilts," in *Uncoverings 1989* (San Francisco: American Quilt Study Group, 1990), 39.

4. Bets Ramsey, "Stuffing, Stippling, and Pieces of Roses," in *What's American about American Quilts?* (Washington, D.C.: Smithsonian Institution, 1995), session 2, 22–23.

5. Penny McMorris, *Crazy Quilts* (New York: E. P. Dutton, 1984), 12–13.

6. Bets Ramsey and Merikay Waldvogel, *The Quilts of Tennessee: Images of Domestic Life prior to 1930* (Nashville: Rutledge Hill Press, 1986), 45.

92 · **MARY ANN WALKER TRENTHAM**
 b. Spring City, Rhea County, Tennessee 1857–
 d. Spring City, Rhea County, Tennessee 1920

NANCY JANE TRENTHAM

Nanny's Quilt, 1880
Cotton; 89½ × 73¼ in.
Collection of Randy and Margaret Trentham

MARY TRENTHAM DESIGNED a complicated motif to piece then appliqué to a plain background. With the help of her sister-in-law Nancy Jane Trentham, she completed the top, and they quilted it in elaborate designs of wreaths, garlands, flowers, and grapes. When one-year-old Nanny wanted attention, they would trace around her hand and quilt the outline into the background. Later extra bits of homegrown cotton were pushed into the quilted designs from the underside. The quilt was always called *Nanny's Quilt* because of the handprints. BR

NANCY JANE PATTERSON COPE
b. Palestine Community, Henry County,
Tennessee 1847–d. Palestine Community,
Henry County, Tennessee 1921

SUSIE DRUCILLA GREER COPE
b. Palestine Community, Henry County,
Tennessee 1865–d. Palestine Community,
Henry County, Tennessee 1935

Milky Way Quilt, ca. 1880
Cotton; 95 × 80 in.
Collection of Emily Daniel Cox, granddaughter
and great-granddaughter

NANCY JANE COPE and her daughter-in-law Susie lived together for many years, sharing household duties and quiltmaking. They made dozens of quilts as they challenged each other to try new patterns and unusual colors. *Milky Way* is noteworthy for its machine quilting and joining of prefinished hexagonal blocks, a variation of the Log Cabin design. BR

94 · **AMY TERRASS JOHNSON**
b. Chattanooga, Tennessee 1863

Crazy Quilt, 1883
Silk, velvet, and dolls; 73¼ × 71 in.
Tennessee State Museum Collection, 85.64

AMY JOHNSON'S CRAZY QUILT demonstrates her proficiency with needle and thread and her discriminating taste for elegance, desirable attributes when selecting a wife who would make her home a sheltering haven of beauty for her family. She showed an awareness of other cultures by adding sixteen international dolls to the quilt's surface. BR

95 · **EUNICE WHITFIELD AND MARIANNE DUDLEY**
Active Preacher's Mill, Tennessee

Crazy Quilt, ca. 1900
Silk, and silk and cotton velvet; 84 × 60 in.
From the collection of the Customs House Museum and Cultural Center, Clarksville, Tennessee

COLLECTING UNUSUAL FABRICS was one of the challenges in making a crazy quilt, and Eunice Whitfield and Marianne Dudley were fortunate. A cousin of Marianne's husband was a porter in a Chicago hotel next to a hat shop. From the shop he acquired leftover millinery scraps to send to the Tennessee cousins. They were thrilled to have such fashionable fabric. Before moving into a nursing home, Eunice gave the quilt to a neighbor who later gave it to the Customs House Museum. BR

Candace J. Adelson

Textile Art in Tennessee through the Early Twentieth Century

Tennessee's textile art, like the state's other creative disciplines, explores forms and styles seen across the nation, with local touches inspired by place, period, available raw materials, and climate. In fineness of craft and beauty of design, the traditional arts of quilting and weaving blankets and coverlets can soar to the same heights as in better-known and better-studied centers. Children's embroidered samplers, although less common than northeastern ones, are similar to them in type and in purpose.

Textile art has been primarily, though not uniquely, a woman's province in the home. This is where the quilts, handwoven blankets, and many of the overshot coverlets of Tennessee were made. Although many quilts, and most blankets, were created for practical use, particularly prized items were brought out only on special occasions. This is evident from interviews collected by historians, as well as from the amazing state of preservation of examples like the Amy Terrass Johnson crazy quilt. Their makers considered them artistic expressions, to brighten a home in the same way a painting does. Few Tennesseans had paintings, but they had many beautiful textiles. They knew the dangers of exposure to dust, light, and wear, and proudly and carefully protected works that were deemed worthy of becoming heirlooms. In fact, that word, from the same root (*lome*, meaning "implement") as the loom used in weaving, indicates the central place textiles have been accorded in societies through the ages.

Blankets, though utilitarian, were one of the few joyful everyday adornments of a simple Tennessee home during the early years of settlement and the antebellum period. Stripes and checks, in a variety of combinations of bright red, yellow, rose, blue green, gray, browns, and blues, were favored because these designs could be produced on a relatively simple loom, the same loom that made plain cloth for clothing and sheets. Still, hand spinning, coloring the yarns with vegetable dyes, and weaving took many hours, so blankets were valued possessions, carefully stored for the summer in cedar chests or with tobacco or other herbs, to preserve them from insect damage.

Overshot coverlets are to early American hand-weaving what jazz is to music. Their many classic base designs, as well as the endless variations that can be elaborated from them, require a slightly more elaborate loom than the one used for blankets. To create an overshot pattern, the yarns of one direction skip, or "float," over two or more crossing yarns (instead of just one, as in plain cloth and blankets). The pattern instructions were intricate. A weaver had to be skilled to produce such coverlets and even more gifted to invent new patterns. The art was passed down in families, and these beautiful bedspreads were in demand. Some were made, mainly by women, in the home for family use; some were by professional weavers (both men and women, especially widows) either resident or moving from town to town; still others can be considered semiprofessional work, by homesteaders (primarily women) who sold them for extra income. Weavers shared copies of their paper "drafts" (weaving patterns) with family and friends near and far. The basic designs found in Tennessee coverlets occur up and down the eastern United States under different names. The cotton and wool coverlet displayed here was woven probably in Carroll County in the 1860s for John Norman, who served in the thirty-third through thirty-fifth Tennessee General Assemblies. Its psychedelic effect is achieved in part by pattern and in part by selection of color and is a variation on a popular base pattern that had many different names. Eliza Hall, writing the first book on American coverlets in 1912, when overshot weaving was still widely produced in the South, found it called Double Bow Knot in Rhode Island and in Kentucky (where it was also called Blooming Leaf); in Georgia it was Muscadine Hulls; in Mississippi, Double Muscadine Hulls; in North Carolina, Hickory Leaf; and in unspecified other areas, Lemon Leaf or Olive Leaf, the name associated with this coverlet when it entered the Tennessee State Museum's collection in 1972.

Both men and women worked in Tennessee textile factories, which had begun to spread in the 1850s and became an important part of Southern life after the Civil War. The Jacquard loom mechanism, invented in France in 1804, made weaving pictorial designs more time- and cost-effective. Its technology, based on a series of punched cards that determined the intertwinings of the warp and weft, was the forerunner of the modern computer. The Maryville Woolen Mills (Blount County, in operation from 1874 to 1901) was one of several

Tennessee manufacturers of decorative coverlets woven on Jacquard looms. Others were in Montgomery and Claiborne Counties. The eagles in the corners of this signature pattern tie it to the patriotic designs so beloved in the Jacquard coverlets of the northern United States, which tend to be earlier in date. It has no center seam, indicating that it was woven on a wide, water- or steam-driven power loom; however, the cotton and wool threads were handspun, probably locally.

By the time of Tennessee's settlement, samplers were a form of schooling for children about five to seventeen years old. Some were made at elite girls' schools, others under the tutelage of a mother, relative, or governess. Samplers by boys, by slave children, and by girls in Indian reservation schools have also been documented in the South. While creating samplers, children learned needlework, written alphabet and number recognition, and often also moral or religious concepts, as in the inscriptions on the two presented here. The layout and motifs of both of these are closely linked to the style found up and down the Appalachian corridor. The alphabet letters resemble those in hundreds of other examples, and the zigzag with florets around Sarah Ann Brown's piece is a traditional frame motif. Floral borders like Nancy Hendrix's were popular in the first half of the nineteenth century, but the bright colors in these and other Tennessee pieces are unusual. They are achieved with wool yarns, which dye more easily and darker than silk. Wool is uncommon in samplers from the Eastern Seaboard, where imported silk flosses were preferred. In agricultural Tennessee, however, expensive silk floss was used sparingly. Sheep were homegrown and plentiful, and children learned the useful art of processing wool for weaving as they helped prepare their embroidery yarns.

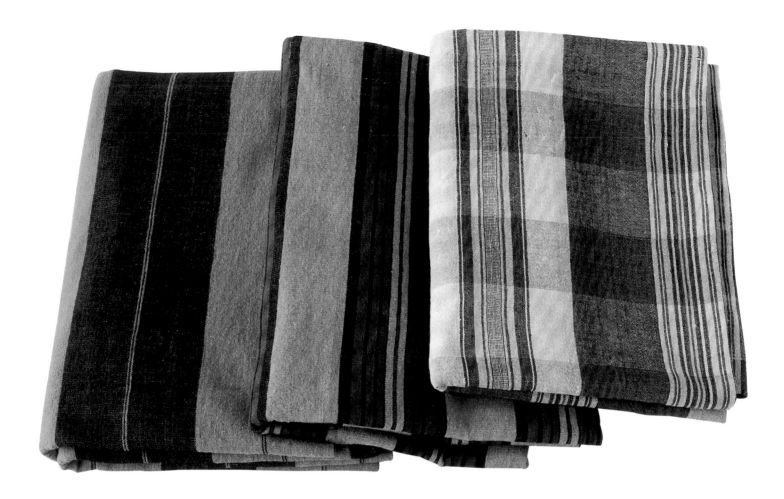

96 · **ATTRIBUTED TO ELLEN
CATHERINE ROGERS DYCUS**

b. 1859–d. 1925; active Jackson County,
Tennessee

Blanket (green with black and red stripes),

ca. 1890–1925
Cotton and wool; 88⅝ × 72½ in.
Collection of C. Tracey Parks

97 · **ATTRIBUTED TO ELLEN
CATHERINE ROGERS DYCUS**

b. 1859–d. 1925; active Jackson County,
Tennessee

Blanket (green and black stripes),

ca. 1890–1925
Cotton and wool; 87 × 72⅝ in.
Collection of C. Tracey Parks

98 · *Blanket* (olive green, red, brown, pink,
and yellow plaid), second half of the

19th century
Probably Clay County, Tennessee
Wool; 80 × 67⅜ in.
Collection of C. Tracey Parks

THE TWO STRIPED BLANKETS come from the collection of Hallie Green and may have been made by her mother, Ellen Catherine Rogers Dycus. Dycus was a gifted weaver who made overshot coverlets and rugs as well as blankets. All the yarns for her work were produced on the Dycus family farm in Jackson County, Tennessee, using cotton from the fields and wool from the sheep. The plaid blanket, purchased in Hermitage Springs, Tennessee, is unusually thin because both its warp and weft are of handspun wool. CJA

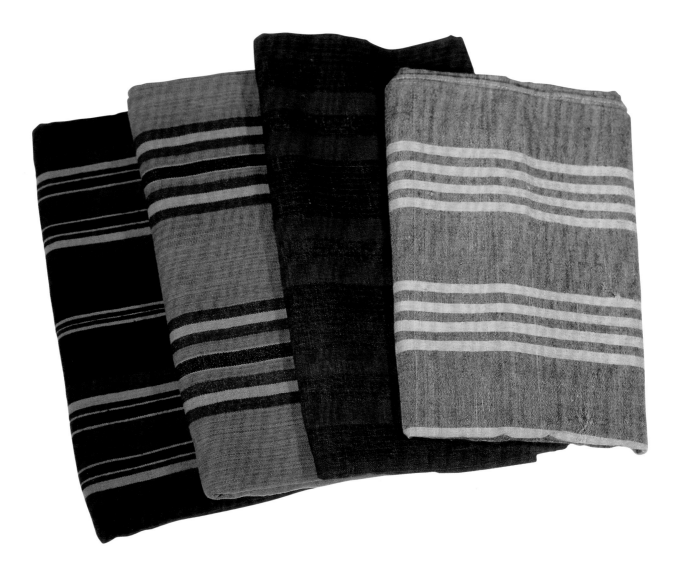

99 ^ *Blanket* (black with red and green
stripes)
Marshall or Giles County, Tennessee
Cotton and wool; 86 × 69 in.
Collection of Monty and Linda Young

100 ^ *Blanket* (red and yellow stripes)
Rutherford County, Tennessee
Cotton and wool; 77½ × 68½ in.
Collection of Monty and Linda Young

101 ^ *Blanket* (black with red and blue
stripes)
Smith County, Tennessee
Cotton and wool; 92½ × 75 in.
Collection of Monty and Linda Young

102 ^ *Blanket* (lavender with red, black,
and green stripes)
DeKalb County, Tennessee
Cotton and wool; 86 × 66 in.
Collection of Monty and Linda Young

THERE ARE TECHNOLOGICAL REASONS behind the choice of lively stripes for early
Tennessee blankets. The warps, the first yarns threaded onto the loom, were constantly
under tension. The wool yarns of the time could not take such strain in a heavy blanket
weave, so cotton was used. But cotton was difficult to color with most natural plant dyes.
Soft wool dyed more easily and so was chosen for the weft, which ran back and forth across
the loom, almost entirely covering the warps. Changes in the weft color produced stripes,
which were thus the easiest design to execute on a simple loom. CJA

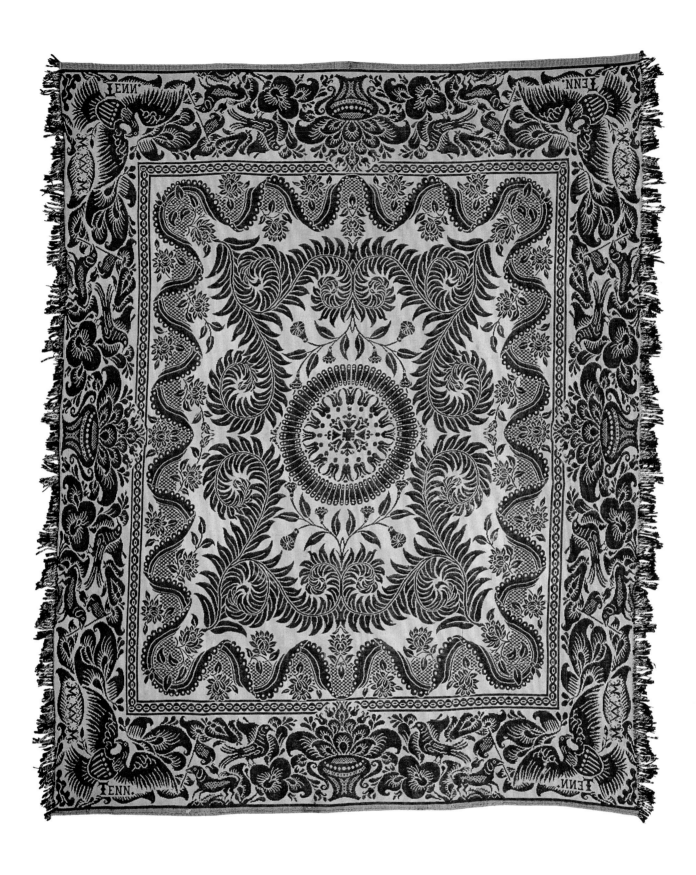

103 · MARYVILLE WOOLEN MILLS

Blount County, Tennessee, 1874–1901

Coverlet, ca. 1876–1900
Cotton and wool; 86 × 69 in.
Tennessee State Museum Collection, 95.67.1

THE MARYVILLE WOOLEN MILLS, founded on Pistol Creek in Maryville in 1874 with three water-powered Jacquard looms, eventually grew to fifty steam-powered looms and sixty employees. The Jacquard punch-card system was the forerunner of the modern computer and permitted complex designs to be woven easily. This pattern, with American eagles in the corners, may have been inspired by the United States Centennial in 1876 and was woven for many years. Examples are known in blue, red, green, aqua, khaki, and brown (probably all colors achieved with synthetic, aniline dyes). CJA

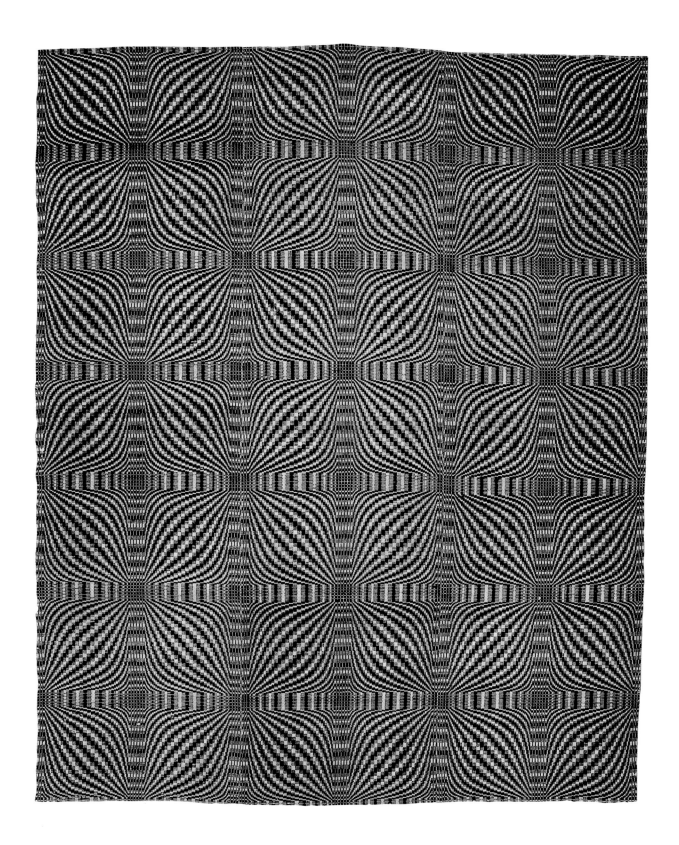

104 · *Coverlet,* ca. 1830s–60s
Probably Rutherford, Carroll, or Davidson
County, Tennessee
Cotton and wool; 101 × 82 in.
Tennessee State Museum Collection, 72.13

JOHN NORMAN, CARROLL COUNTY REPRESENTATIVE and then senator in the thirty-third through thirty-fifth Tennessee General Assemblies (1859–69), owned this coverlet. It is unusually wide, made from three carefully matched widths of overshot weave (the colored wefts skip over more than one warp at predetermined intervals to create the pattern). An enlarged variation on the Double Bow Knot or Olive Leaf pattern, the design has psychedelic effects, achieved by placing only one huge blue and white "bow knot" on each fabric width and limiting the touches of red. CJA

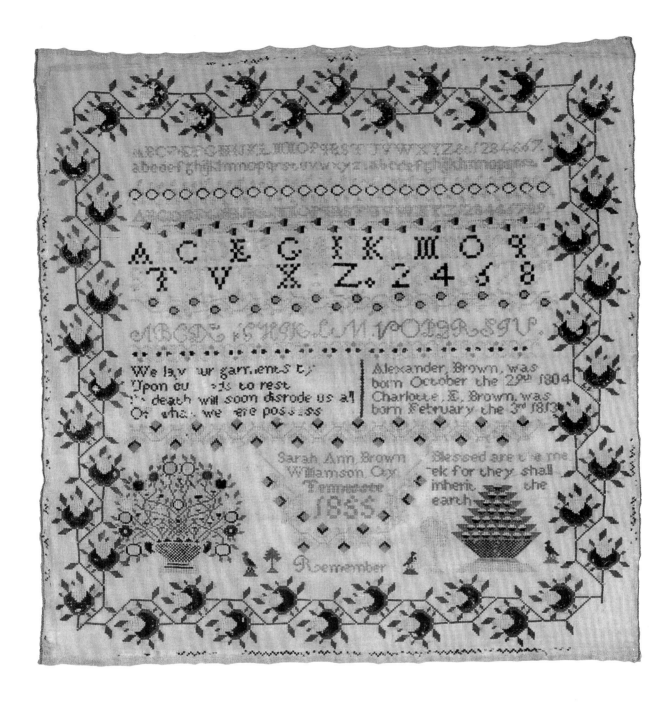

105 · SARAH ANN BROWN

b. 1843–active Williamson County, Tennessee

Sampler, 1855
Colored wool and natural linen canvas;
22⅞ × 22⅝ in.
Tennessee State Museum Collection, 85.106.1

THREE BROWN BROTHERS came from North Carolina to settle west of Franklin in Williamson County. Alexander (Sandy) and his wife, Charlotte Claud, bought Hamilton Place, where their twelve-year-old daughter Sarah Ann made this sampler in 1855. Like many schoolgirl samplers, it includes the alphabet in several different scripts, numbers, her parents' names and birth dates, and moralizing inscriptions. The zigzagging frame with florets was also common. The somewhat damaged quotations read: "We lay our garments by/Upon our beds to rest/So death will soon disrobe us all/Of what we here possess" and "Blessed are the me/ek for they shall/inherit the/earth." CJA

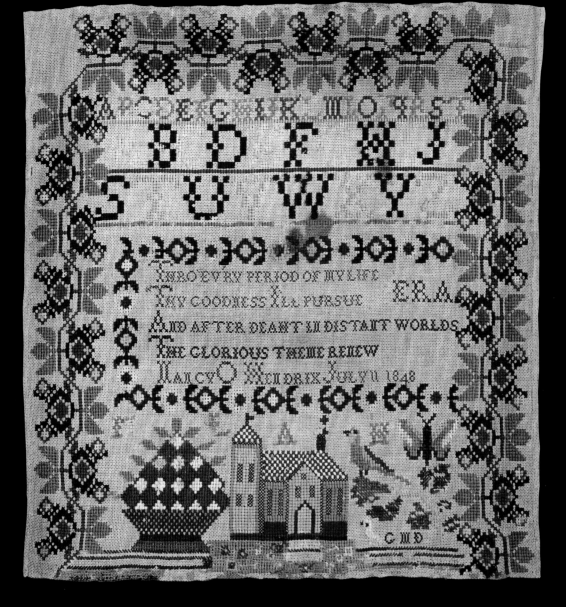

NANCY O. HENDRIX

Sampler, July 11, 1848

Colored wool, silk, and natural linen canvas;
19⁵⁄₈ × 18¹⁄₈ in.

Tennessee State Museum Collection, 1999.16

THE HENDRIX FAMILY lived in Eagleville, which before the Civil War was in William-son County but is now in Rutherford County. A very similar sampler still belongs to the descendants of the Richard Sutton family, which owned a large farm in the same area. According to Rick Warwick, a Williamson County historian, the Hendrix family lived next door and Mr. Hendrix tutored the Sutton children. The verse reads: "THRO EVRY PERIOD OF MY LIFE/THY GOODNESS I'LL PURSUE/AND AFTER DEAHT IN DISTANT WORLDS/THE GLORIOUS THEME RENEW." CJA

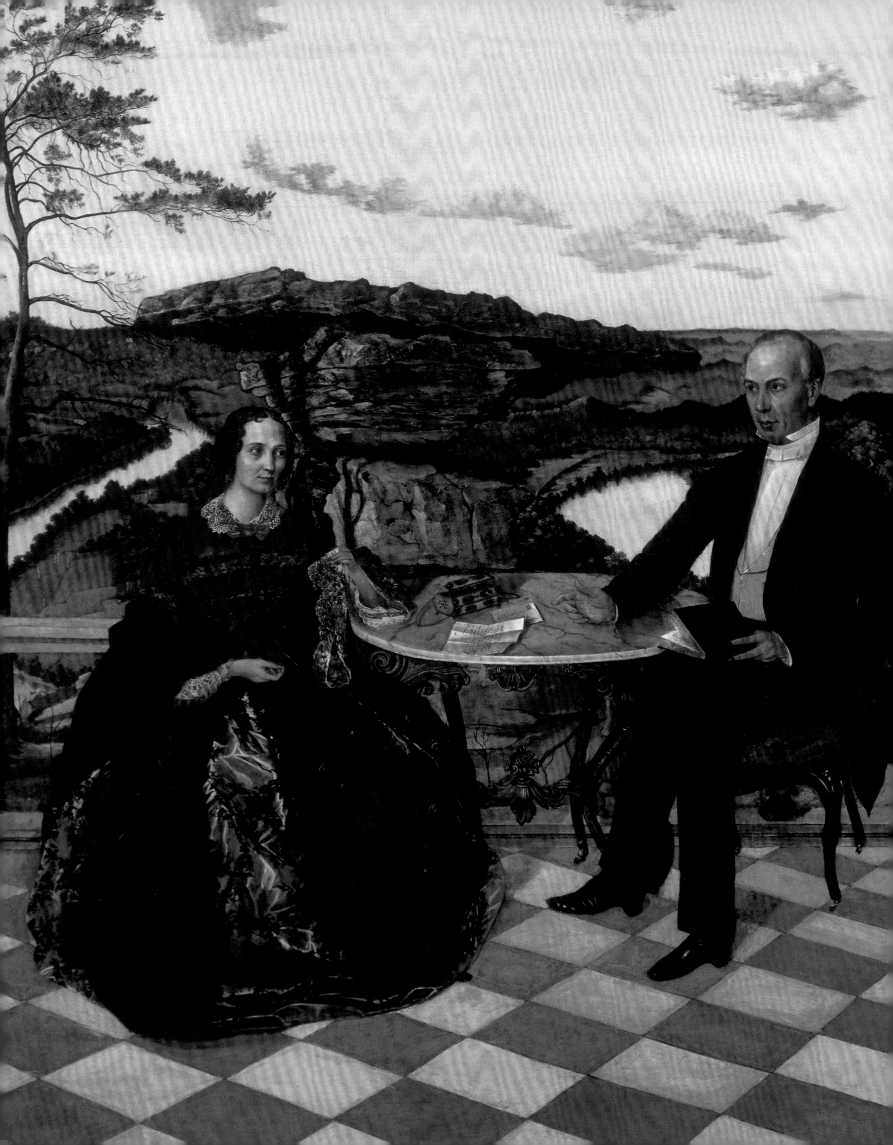

James A. Hoobler

ANTEBELLUM PAINTING

ART IS NOT PRODUCED IN A VACUUM. IT IS BOTH A REFLECTION OF THE TIME AND PLACE in which it is created and a part of a larger continuum. As visitors enter the Tennessee State Capitol, the Greek Revival crown jewel of William Strickland's architectural career, they are greeted by a frescoed ceiling in the entrance lobby. This mural depicts the concept of Manifest Destiny, the taking away from Native Americans of the continent by settlers and soldiers of European and African descent. In the corners are depictions of four of the arts: painting, sculpture, music, and literature. Tennesseans were bringing Western European civilization with them as they took possession of this new frontier. As European civilization cherished the arts, Tennesseans, as a part of that civilization, did, too.

Probably the first paintings made in Tennessee are the overmantel board paintings in the Carter House at Elizabethton, which date to about 1780. One depicts a classical temple on a hilltop, with two men in eighteenth-century suits standing at the base of the hill. Both the paneled room and the painting represent an attempt to bring the tidewater Virginia world of the Carter family into Tennessee. Another early work shows us how this appreciation of art was transmitted to the next generation. Rebecca Chester created the earliest dated nonarchitectural painting in Tennessee, dating to about 1810. Made for the family of David Deadrick Anderson, whose house and store can be seen in it, the painting depicts Deadrick's Hill in Jonesboro, Tennessee. By commissioning the painting, the family had a tangible keepsake of their home and their position within the community. Most of the art created in Tennessee throughout the nineteenth century was similarly commissioned, although usually these works were portraits of the patron.

The first professional artist to work in Tennessee was Ralph E. W. Earl. The son of the Connecticut artist Ralph Earl, he studied with his father, who was a portraitist. While in Paris in 1815, the younger Earl copied a portrait of Napoleon Bonaparte. Two years later he visited Nashville, intent on painting a life-size portrait of General Andrew Jackson, the recent hero of the Battle of New Orleans. He may have brought Napoleon's portrait with him to Nashville as the bait to lure Jackson into sitting for a portrait, a bait that Jackson took. Both paintings were placed in the first museum in Nashville, which Earl opened on the Public Square in 1818, and both are now in the Tennessee State Museum. Other significant portraits by Earl include that of the Ephraim Hubbard Foster family and a series of portraits of Jackson, most notably the equestrian portrait at The Hermitage and the so-called National Picture at the Smithsonian.

Earl is an example of an artist who sought success in the expanding frontier. Other such artists are James Cameron, a Scotsman, who immigrated to the United States as a very young man; John Wood Dodge, a New Yorker; Edward Troye, a Swiss native who trained in England and specialized in portraits of thoroughbred race-horses; George Dury, a Bavarian who had worked in the circle of the Wittelsbach court in Munich as a portraitist; and Thomas Waterman Wood, a native of Vermont, who briefly worked in Nashville doing genre paintings and portraits.

Washington Bogart Cooper was the first Tennessee-born painter of consequence. He and his brother William, also a portraitist, worked in the state from the 1830s into the 1880s. Both artists were much in demand, helping to establish painting as a viable occupation in Nashville.

James Cameron, *Colonel and Mrs. James A. Whiteside, Son Charles, and Servants,* 1858–59, detail, cat. no. 117

Another skilled artist working in Tennessee prior to the Civil War was the miniaturist John Wood Dodge. This talented New York artist moved to the South for health reasons and painted in the Nashville area from 1840 until the outbreak of the Civil War. One particularly poignant portrait is that of Felix Grundy Eakin, the son of Felicia Grundy and William Eakin. The child died at age three; this portrait was painted posthumously. Beside him are symbols of a young life cut short: tools laid down, wilted flowers, a broken toy, a climbing rose, and an urn.

Dodge's medium was competing with a new technological invention—photography. To adapt to the changing times, he also hand-colored photographs. The portraits of William Giles Harding and Elizabeth McGavock Harding are examples of this practice.

Two areas that were becoming more acceptable as subjects for painting were landscape and genre. One way to entice the public to pay for something other than a portrait was to combine elements of two or more subjects. James Cameron's portrait of Colonel James and Harriet Whiteside put all three types together. It is a portrait of the colonel, his wife, Harriet, their son Charles, and two house slaves. But it shows them all interacting, as in a genre scene, and in a most implausible location. An Italian loggia has been placed on the lip of Lookout Mountain, with Umbrella Rock and Chattanooga in the background. The loggia did not exist, but there was a hotel on the mountaintop, and the Whitesides owned both the hotel and the top of the mountain. Cameron prospered in his profession and was able to purchase a hill near the center of Chattanooga, which is still known as Cameron's Hill. With the outbreak of the war he left the area, returning after its end, to find the beautiful landscape that he had celebrated in his paintings devastated by the war. Heartbroken, he gave up painting, became a Presbyterian minister, and moved to Oakland, California.

Thomas Waterman Wood worked primarily as a portrait artist in Nashville for a brief period prior to the Civil War. One of these works is his portrait of Della Callender. As a New England native, he may have sensed the growing regional rift, although his majestic portrayal of slaves in *Southern Cornfield, Nashville, Tennessee* (1861) gives no hint of his political views. In it he shows a group of seven African Americans resting from their labors in a cornfield; it is an unsentimental, positive portrayal free of racial judgments. As such, it is an unusual depiction for that time and place.

An unidentified artist painted a portrait of Adelicia and Joseph Acklen's summer estate, Belmont, in about 1860. This was the most impressive estate in Tennessee from about 1855 to 1885. It contained a private art museum, a bowling alley, zoo, two stables, a glass house, five cast-iron gazebos, the largest formal garden in the state, an artificial lake, and a five-story water tower. Belmont's lush landscaped park—with sculpture in cast iron and marble, summerhouses, and all of the other appurtenances evident in the painting—was remarkable in Tennessee, especially for a home that was primarily a summer retreat! It reminded a Northern soldier who saw it during the Federal occupation of Nashville during the Civil War of a "first-class cemetery." His comments are worth quoting:

> Acklin's [*sic*] premises . . . are rather a speciality in the way of extravagance. . . . His buildings are gothic-ified and starched and bedizened to perfection. Serpentine walks, shrubbery, and all of that sort of thing, abound in great quantity and profusion. A tower, one hundred and five feet high, is built near a spring a fourth of a mile distant from the buildings, and a steam-engine within its base forces water to its top, whence it is piped in every direction over the grounds. The improvements cost over a quarter of a million dollars. Looking over upon it from adjacent high grounds, the white marble fountains, emblems, and statues cause the place to resemble somewhat a fashionable first-class cemetery.[1]

Tennessee's population rose from 422,823 in 1820 to 1,109,801 in 1860. The state experienced dramatic increases in immigrant populations during this period, and Irish, German, and Jewish communities developed across the state, enlivening the Scots-Irish, English, and African American mixture from the earliest settlement period. The number of artists in the state similarly increased. When Ralph E. W. Earl came to Tennessee in 1817, it was still a frontier state. John Grimes and William Henry Baker painted in Nashville soon after. In East Tennessee Samuel M. Shaver painted portraits, in which landscapes relevant to the sitters were frequently included. William Edward West came down from Kentucky and practiced here as a portrait painter. William Thruston Black, who had exhibited in New York and Philadelphia, moved to Nashville, where he, too, established a portrait studio. Robert Loftin Newman and William S. Shackelford, both from Clarksville, became portrait painters. Newman moved north following service in the Confederate Army and eventually painted landscape, biblical, and genre scenes reminiscent of those of Albert Pinkham Ryder and Ralph Blakelock. William Browning Cooper, so as not to compete with his brother Washington Bogart Cooper, moved to Memphis and painted portraits there prior to the Civil War.

By 1860 Tennessee's major urban centers provided many opportunities for artists to pursue their careers. The progress that had occurred during the antebellum period, however, was interrupted by the Civil War, when little painting of significance issued from

Tennessee's artists. In the last decades of the nineteenth century, painting, and the influences and career paths of individual artists, displayed an increasing awareness of new artistic styles emanating from cities Back East and in Europe.

NOTE
1. Albert W. Wardin Jr., *Belmont Mansion: The Home of Joseph and Adelicia Acklen* (Nashville: Belmont Mansion Association, 1989), 20.

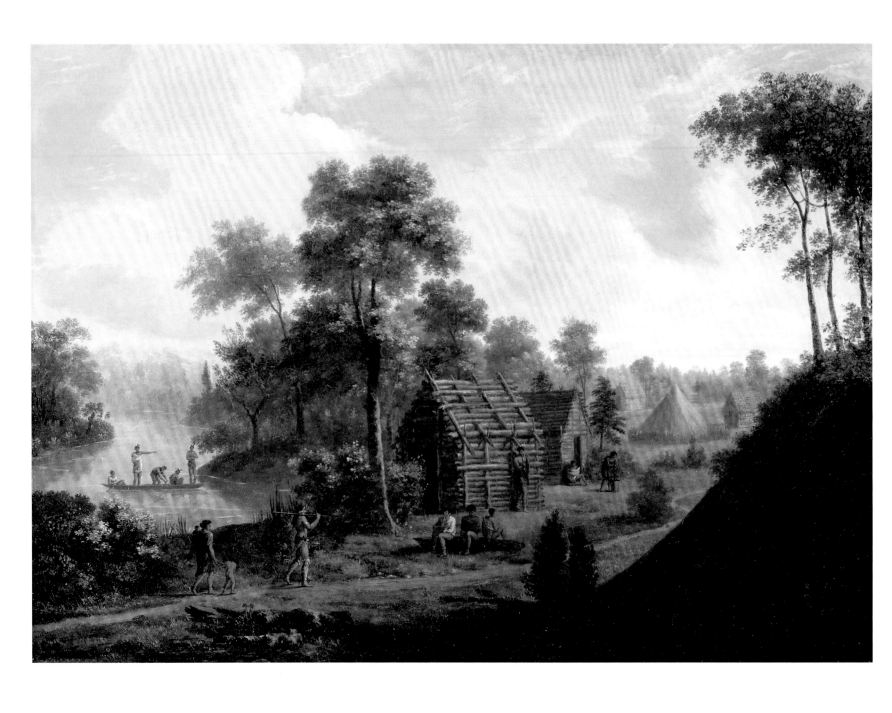

**107 · FÉLIX MARIE FERDINAND
STORELLI**
b. Italy 1778–d. France (?) 1854

Souvenir de Tokouo, 1819
Oil on canvas; 21¾ × 29¾ in.
Collection of Mr. and Mrs. Ridley Wills II

THIS PAINTING DEPICTS TOQUA ("Tokouo" in French), a Cherokee village in south-
eastern Tennessee. The work is based on a now-lost composition made by the French
nobleman Antoine-Philippe d'Orléans while he was touring the United States during a
period of voluntary exile with his two brothers, one of whom was the future king of France,
Louis-Philippe. Although the image is fairly precise in its depiction of the horizontal log
dwelling and Little Tennessee River, the idealized appearance of the village's inhabitants
reflects a common European view of Native Americans as noble savages living in perfect
harmony with nature. KDW

108 · JOHN JAMES AUDUBON
b. Les Cayes, Haiti 1785–d. New York,
New York 1851

Tennessee Warbler, 1832
From *The Birds of America*
Hand-tinted engraving on paper; 19½ × 12½ in.
Collection of Lucy Scott and Sam Kuykendall

THE TENNESSEE WARBLER was one of 497 birds that Audubon painted for his book
The Birds of America. This little warbler must have been migrating from Central America
when Audubon spotted it in Louisiana in 1821. As was his practice, he observed the bird—
"Nature must be seen first alive and well studied before attempts are made at representing
it"—before he shot and then mounted the male specimen. By the spring of 1826 Audubon
took his portfolio of watercolors to London to be engraved by Robert Havell Jr. In 1838
approximately 200 bound sets of 435 plates were sold for $1,000 per set. LK

109 · **SAMUEL M. SHAVER**
b. Sullivan County, Tennessee 1816–
d. Jerseyville, Illinois 1878

Double Portrait
Oil on canvas; 32 × 42½ in.
Collection of Mary Jo Case

FOR MORE THAN TWENTY-FIVE YEARS, Samuel M. Shaver was East Tennessee's most sought-after portraitist, working in Rogersville, Greeneville, Russellville, and Knoxville. The unidealized portrayal of this stoic and humble couple is typical of Shaver's early method of painting his sitters. This style was common throughout many parts of antebellum rural Tennessee, in which sitters generally rejected elaborate fabrics and accessories, or even a painted background; they simply wanted an accurate record of their appearance. KDW

110 · **WILLIAM STAMMS SHACKELFORD**
b. Fleming County, Kentucky ca. 1814–
d. Missouri ca. 1878

James O. Shackelford, Jr., 1857
Oil on canvas; 46¾ × 39 in.
Tennessee State Museum Collection, 76.190

SOMETIME IN THE 1850S William Shackelford moved from Kentucky, where he had received some training as an artist under the sculptor Joel Hart, to Clarksville, Tennessee. This work is one of a series of six portraits painted in Clarksville—all owned by the Tennessee State Museum—of his cousin James O. Shackelford, his wife, Sabina, and their four children. The children are all shown outdoors, with romanticized landscapes as a background. This depiction of the artist's ten-year-old nephew shows a ruined church with a graveyard on the opposite side of a stream. JAH

111 ^ JOHN WOOD DODGE
 b. New York, New York 1807–d. Pomona,
 Tennessee 1893

 Portrait of Mary Eliza Washington,
 1842
 Watercolor on ivory; 2½ × 2 in.
 Collection of Raymond and Linda White

DODGE WORKED IN AND AROUND Nashville from 1840 until 1861. He painted in miniature the cream of Middle Tennessee's society. Mary Eliza was a daughter of the Nashville banker Thomas Washington. As was the case with many miniatures of children, this portrait was painted after the little girl's death. It displays Dodge's fine technique and his most dramatic background—blue sky with pink clouds. The child's cropped hair and the dark circles under her eyes are emblematic of the illness that caused her death. RDW

112 · JOHN WOOD DODGE

b. New York, New York 1807–d. Pomona,
Tennessee 1893

*Posthumous Likeness of Felix Grundy
Eakin,* 1846

Oil on ivory; 6 × 5 in.
Collection of the Cheekwood Museum of Art,
Nashville, Tennessee, Transfer from the Nashville
Museum of Art, Gift of Mrs. Nannie Eakin Steger
in memory of her daughter Felicia Steger Gibson,
1960.2.72

POSTHUMOUS (OR MEMORIAL) portraits were common in the antebellum South,
where child mortality rates were quite high. When young Felix Grundy Eakin died at the
age of three, his parents commissioned Dodge—already well known in Nashville for his
miniature portraits—to create a likeness of their son. The artist meticulously painted the
child's features as well as the details of the objects that surround him: an urn, wilted flow-
ers, and broken toys, all sad symbols and reminders of death. CMA

113 · JOHN WOOD DODGE

 b. New York, New York 1807–d. Pomona,
 Tennessee 1893

 Portrait of General William Giles
 Harding, 1857

 Albumen photograph, hand-tinted; 8½ × 6½ in.
 Belle Meade Plantation, Nashville Chapter
 Association for the Preservation of Tennessee
 Antiquities, 87.14

JOHN WOOD DODGE spent most of his career as an itinerant painter in the South. Although known for his miniatures, he also painted large portraits, still lifes, and dioramas —scenes painted on transparent cloth giving the illusion of three dimensions. Dodge was largely self-taught. In 1840 he came to Nashville, where he painted off and on until 1861. When photography began to compete with his business, Dodge started creating tinted photographs such as this pair of the Hardings. JH

114 · JOHN WOOD DODGE
b. New York, New York 1807–d. Pomona,
Tennessee 1893

Portrait of Elizabeth McGavock
Harding, 1857
Albumen photograph, hand-tinted; 8½ × 6½ in.
Belle Meade Plantation, Nashville Chapter
Association for the Preservation of Tennessee
Antiquities, 86.38.4

JOHN WOOD DODGE

b. New York, New York 1807–d. Pomona,
Tennessee 1893

Portrait of Mrs. Arena P. Whitlock,
1840

Watercolor on ivory; 2½ × 2 in.

Collection of Raymond and Linda White

ALTHOUGH SHE APPEARS hardly more than a child herself, Arena Whitlock was
the mother of a two year old when this miniature was completed on November 24, 1840.
Dodge painted this portrait, a portrait of her husband, R. E. Whitlock, and a portrait of
their child as payment of rent for the painting rooms in downtown Nashville that Dodge
rented from Whitlock. RDW

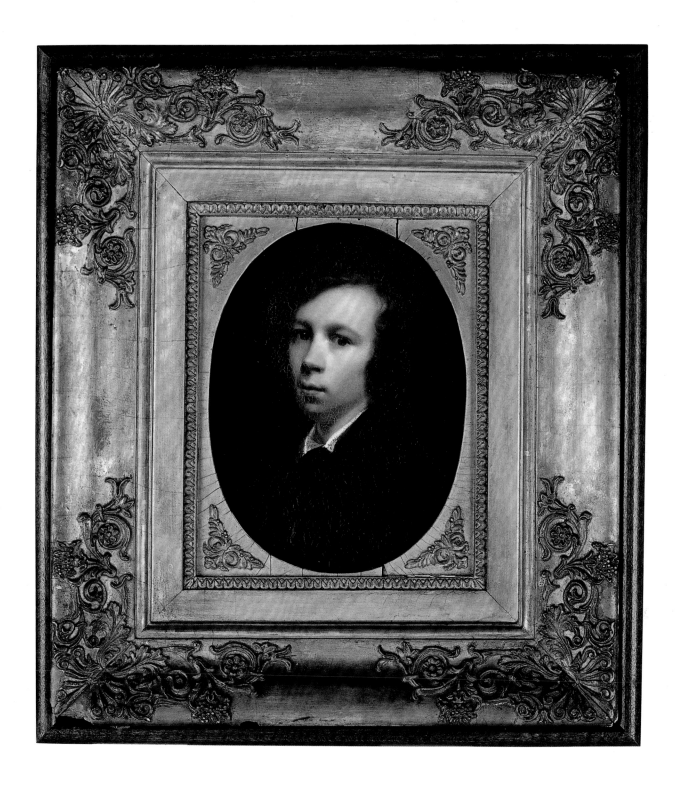

116 · **GEORGE DURY**

b. Würzburg, Bavaria 1817–d. Nashville,
Tennessee 1894

Self-Portrait, ca. 1835
Oil on panel; 10 × 9 in.
Tennessee State Museum, Tennessee Historical
Society Collection, 81.106.2

THIS SELF-PORTRAIT AT AGE eighteen was created in Bavaria before Dury and his wife emigrated to Wartburg, a German and Swiss colony in the Cumberland Mountains of East Tennessee, in 1849. By 1850 the couple had moved to the more cosmopolitan city of Nashville so that George could reestablish his career in painting. Due to the enthusiastic endorsement of prominent families such as the McGavocks, Dury quickly rivaled the already established portraitist Washington Bogart Cooper for important commissions. KDW

117 · JAMES CAMERON

b. Grennock, Scotland 1817–d. Oakland,
California 1882

*Colonel and Mrs. James A. Whiteside,
Son Charles, and Servants,* 1858–59

Oil on canvas; 53 × 75 in.
Hunter Museum of American Art, Chattanooga,
Tennessee, Gift of Mr. and Mrs. Thomas B.
Whiteside, HMAA.1975.7

AFTER STUDYING ART IN Philadelphia and Italy, James Cameron arrived in Nash-
ville in the early 1850s. He was almost immediately enticed to Chattanooga, however, by
the railroad entrepreneur Colonel James A. Whiteside, who provided him with lodging
and studio space. This large-scale painting depicts the colonel with his wife, son, and
two slaves relaxing on an Italianate marble patio perched above a panoramic view of the
city, which includes the Moccasin Bend of the Tennessee River. Cameron preferred land-
scape painting over portraiture and often included landscapes in his portraits, as he did
here. KDW

118 · **JAMES CAMERON**
b. Grennock, Scotland 1817–d. Oakland, California 1882

Belle Isle from Lyon's View, 1861
Oil on canvas; 30 × 41 in.
Tennessee State Museum Collection, 1.835

ALTHOUGH CAMERON ESTABLISHED a successful business in Chattanooga as a portraitist, he preferred to paint landscapes, especially of the area around Chattanooga. In fact, Cameron was so disappointed at the devastation of the countryside after the Civil War that he abandoned painting to become a minister and moved to California. Cameron's sensitivity and attachment to the land are visible in this tree-lined view of the Tennessee River surrounding Belle Isle in Knox County. Like the painters working in the Hudson River area of New York, Cameron saw the land as a pure and spiritual place. KDW

119 · *Belmont,* ca. 1859–60

Oil on canvas; 40¼ × 54¼ in.
Collection of the Cheekwood Museum of Art,
Nashville, Tennessee, Gift of Naomi M. Kanaf in
Memory of her husband Max Tendle, 1978.3.13

THIS PAINTING IS A VISUAL document of the house and grounds at Belmont, the summer home of Joseph and Adelicia Acklen. The painting shows the artist's technical skill in rendering details, but with a curiously distorted sense of proportion and perspective. A giant fieldworker, emerging from a thicket of stalks, towers over two gentlemen on horseback, while flagrantly enlarged fruit grows in the lush, green fields in front of the elegant Italianate mansion perched on a hilltop. KDW

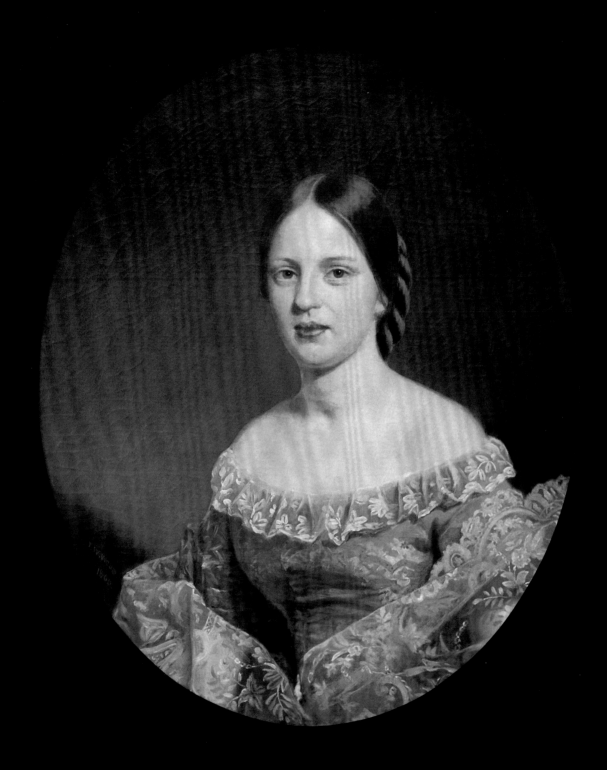

120 · THOMAS WATERMAN WOOD
b. Montpelier, Vermont 1823–d. New York,
New York 1903

Portrait of Della Callender, ca. 1860
Oil on canvas; 30 × 25 in.
Collection of Ann (Callender) Sharp Street

DURING THOMAS WATERMAN WOOD'S brief stay in Nashville from 1859 to 1862,
the city was considered, with the exception of New Orleans, the most cosmopolitan city
in the South. Wood was a successful portrait painter in the region, receiving commissions
from such prominent figures as Dr. John Hill Callender and his wife, Della. In this oval
portrait, Wood has captured the beauty of this fair young woman as well as the intricacy
of the lace adorning her blue gown. KDW

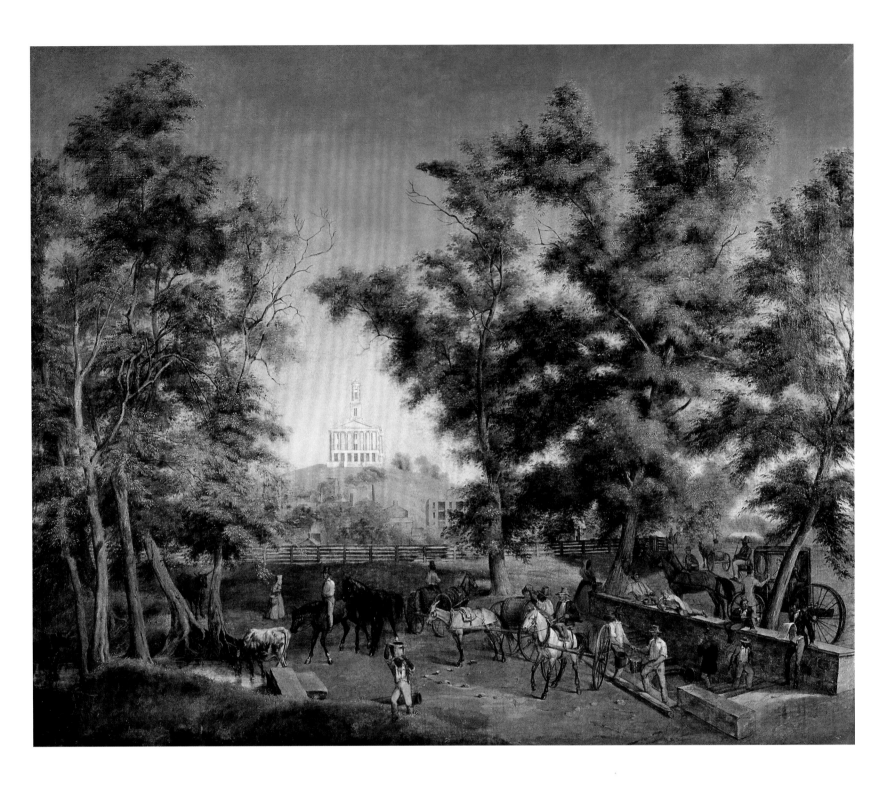

121 ᴬ **ATTRIBUTED TO JAMES E. WAGNER**

Active Nashville, Tennessee ca. 1840–60

Tennessee State Capitol from Morgan Park, ca. 1857–60

Oil on canvas; 35⅜ × 43⅜ in.
First Tennessee Heritage Collection

Tʜɪs ʟᴀɴᴅsᴄᴀᴘᴇ ᴀɴᴅ ɢᴇɴʀᴇ ᴘᴀɪɴᴛɪɴɢ shows the new Tennessee State Capitol building as seen from the popular mineral spring in Morgan Park, where people drank the sulphur water for its supposed medical benefits. The painting does not show the Roman Catholic Church of the Holy Rosary, which was removed in 1857, indicating that it was created sometime between then and 1860, when Wagner left the state. This is essentially the same view that people can see today from the Tennessee Bicentennial Capitol Mall. JAH

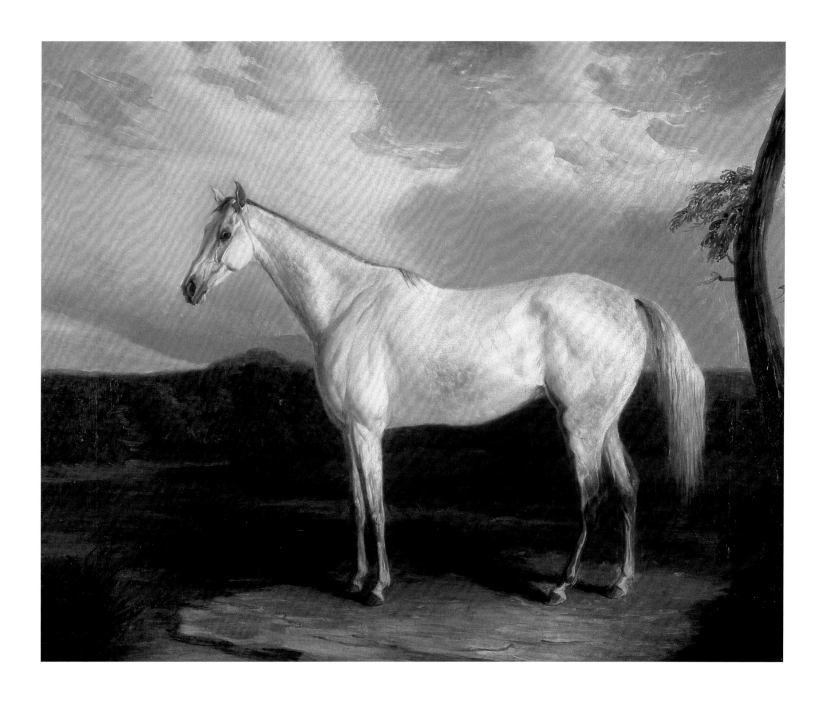

122 · **EDWARD TROYE**

b. Lausanne, Switzerland 1808–
d. Georgetown, Kentucky 1874

Gamma, 1843

Oil on canvas; 22 × 27⅛ in.
Belle Meade Plantation, Nashville Chapter
Association for the Preservation of Tennessee
Antiquities, 72.3.42

EDWARD TROYE STUDIED ART in England before coming to the United States. One of the first artists in America to specialize in animal subjects, he became the foremost mid-nineteenth-century painter of horses. Troye settled in Scott County, Kentucky, after he married in 1839 and traveled from there to Virginia, Tennessee, South Carolina, and Alabama to paint. This portrait of Gamma is one of several he painted of the famous thoroughbreds at Belle Meade Plantation. JH

SOUTHERN CORNFIELD WAS COMPLETED in 1861 and first exhibited at the National Academy of Design, in New York. Thomas Waterman Wood was greatly impressed with the art he had seen on two previous trips to Europe, and one can clearly see the influence of religious and allegorical imagery in this work. The two main figures are placed in a manner reminiscent of depictions of Joseph and Mary at the birth of Christ, with a younger figure kneeling and offering a gift of water like a supplicant shepherd. Although this was the work of an artist who was not well known at the time, *Southern Cornfield* has become the most frequently exhibited painting in his body of work. JM

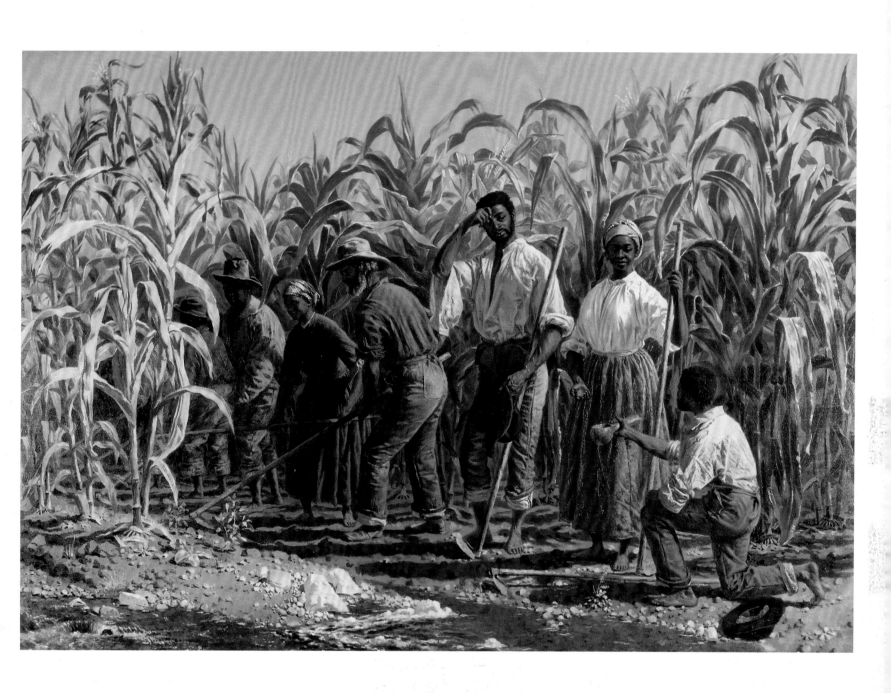

Estill Curtis Pennington

Ralph E. W. Earl

Ralph E. W. Earl was born into a family of painters that included his father, Ralph Earl (1751–1801), and his uncle James Earl (1761–1796). His father was quite a character, an unrelenting loyalist during the American Revolution and reputedly fond of his drink, an affection that ultimately killed him. At odds with revolt, he retreated to England in 1777. "About 1784" he married Ann Whiteside there, repatriating his young family to Boston in 1785.[1]

When the younger Earl determined to be a painter, he, like other American artists of the Federal era, traveled to London, seeking those lessons in likeness that the American expatriate Benjamin West (1738–1820) dispensed so generously. While in England, from 1809 to 1810, Earl is reputed to have lived with members of his mother's family in Norwich, where he is said to have enjoyed the patronage of a local worthy, General John Money. The Norwich School, a group of local artists organized in 1805, was flourishing at this time, creating art whose simplicity of design and earnest appreciation for atmospherics were not unlike those of his father's efforts in Connecticut.

Earl returned to America in 1815, fired by an idea to create a series of "history" paintings based on episodes from the Battle of New Orleans. History painting, or the re-creation of actual events on monumental canvases for extended public display, was the ultimate goal of all ambitious painters at this time. To fulfill his promise, Earl made various excursions through the deep South in search of living participants, and it was this quest that brought him into contact with Andrew Jackson in Nashville, in 1817. It was to be a fortuitous meeting for Earl, resulting in a series of portraits of Jackson and marriage to a Jackson relation, Rachel Jackson's niece, Jane Caffrey.

After Jane Earl's death in 1819, Ralph E. W. Earl seems to have become a fixture in the Jackson household for the rest of his life, residing with the presidential family in Washington, D.C., and at The Hermitage, where he died and is buried. Earl's admiration for Jackson was profound. He is said to have found the stalwart warrior to be "the most amiable man … I ever saw, and a most perfect gentleman … he is a strong friend … and a formidable enemy," characterizations that certainly ring true with the legend of Old Hickory.[2]

At the same time Earl continued an active career as an artist-entrepreneur, opening a "museum of curiosities" in Nashville in 1819, where, among other objects, he exhibited a full-length portrait of then General Jackson. The origins of the Tennessee State Museum are said to have sprung from this endeavor.

While he did function as a "court painter" to Jackson, Earl also painted other subjects in a refreshingly personal style, significant to the history of Southern portraiture of the period. His sources are clear. From his father he absorbed that painterly attention to strong, flat lines, sharp focus, and occasional panoramic perspective that has been called "plain painting."[3] Although the senior Earl's style evolved during his stay in England, he never adopted the Neoclassical sophistication sought by Benjamin West, John Singleton Copley (1738–1815), or Gilbert Stuart (1755–1828), an inclination favored by his son.

Earl created one of the more remarkable family group portraits in the history of painting in the South. The family of Ephraim Hubbard Foster is posed on either side of an open window. In the window, precariously held aloft by her parents, is a child in fancy dress. The highly ambitious composition, augmented by the vivid coloration, opens out to an expansive horizontal space. The attention to detail is also a rich catalogue of the period's material culture.

This strong coloration has little to do with the prevailing affection for Romantic atmospherics then being promoted in England by Thomas Lawrence (1769–1830) and practiced most perfectly in America by Thomas Sully (1783–1872). Rather, it calls to mind certain developments in Northern European painting, especially the Baltic basin, where sharply focused works in strong contrasting colors renewed an affection for forthright display devoid of trompe-l'oeil excess.

Earl's role in aiding the development of Jackson's taste is an intriguing subject for speculation. Earl was present when The Hermitage was begun in 1819 and when it suffered a damaging fire in 1834, resulting in its being rebuilt in the Greek Revival style, complete with extraordinary wallpaper in the French Empire taste. Was

Earl responsible for the introduction of this paper, whose vivid tints recall something of his own sharp coloration?

Critics who have referred to Earl's work as "wooden" miss something of his charm.[4] He painted at a time when distinctions between an American style and the European manner were of great concern. Like his father, he can be admired for that "unadorned directness in the American character that the more academic point of view tends to idealize out of existence."[5] Certainly, like Jackson, he was the man for the times.

NOTES

1. See William Benton Museum of Art, *The American Earls: Ralph Earl, James Earl, Ralph E. W. Earl* (Storrs: University of Connecticut, 1972).

2. Emma Look Scott, "Ralph Earl: Painter to Andrew Jackson," *Taylor Trotwood Magazine* 7 (April 1908): 30.

3. See John Michael Vlach, *Plain Painters: Making Sense of American Folk Art* (Washington, D.C.: Smithsonian Institution Press, 1988).

4. Fred Voss, Portraits of the Presidents, *www.npg.si.edu.*

5. Marvin Sadik, "Heroes for a New Nation," in *American Portraiture in the Grand Manner: 1720–1920,* exh. cat. (Los Angeles: Los Angeles County Museum of Art, 1981), 25.

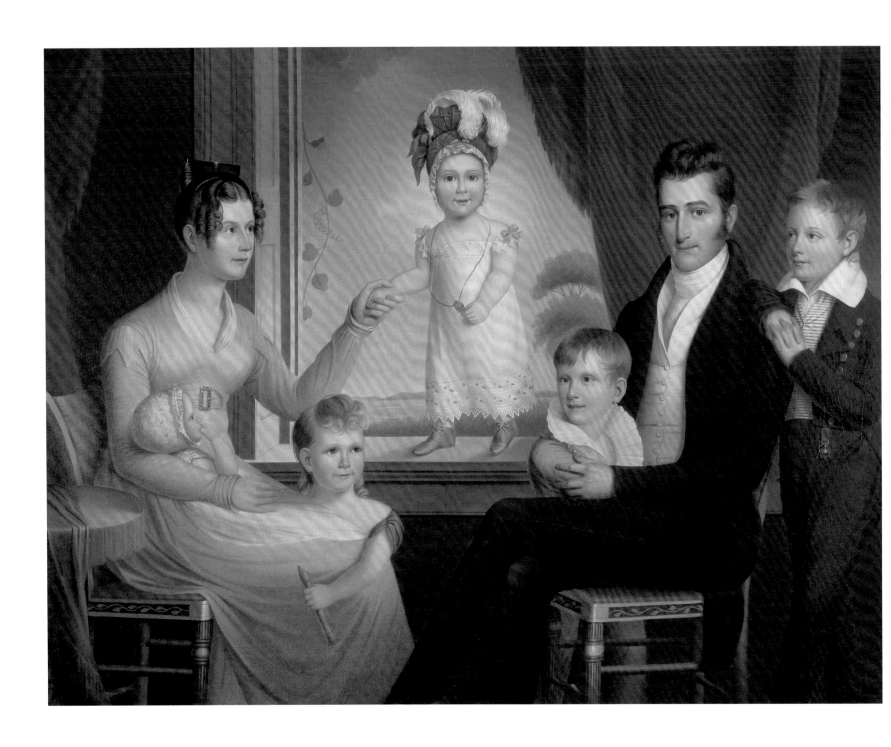

124 · **RALPH E. W. EARL**

b. Norwich, England 1785–d. The Hermitage, Nashville, Tennessee 1839

The Ephraim Hubbard Foster Family, 1824

Oil on mattress ticking; 53⅛ × 70 in.
Collection of the Cheekwood Museum of Art, Nashville, Tennessee, Gift of Mrs. Josephus Daniels, 1969.2

THIS GROUP PORTRAIT DEPICTS Ephraim Hubbard Foster, a Nashville lawyer, colonel, and senator, surrounded by his wife and five children. Earl portrays the Fosters as a well-to-do family dressed in expensive apparel and surrounded by elegant furnishings, quite atypical accoutrements for Nashville at the time. Yet he made the family real to the viewer by adding personal touches such as the pennywhistle in the young girl's hand and the outrageous hat worn by the daughter standing in the window. This is a warmly sentimental portrait in which all members of the family are embracing, holding, or touching each other. CW

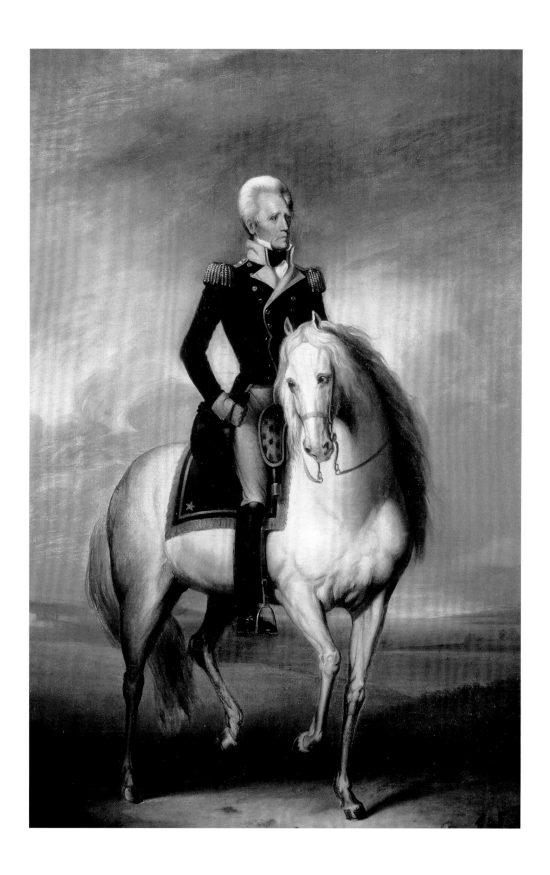

125 · **RALPH E. W. EARL**

b. Norwich, England 1785–d. The Hermitage, Nashville, Tennessee 1838

Equestrian Portrait of Andrew Jackson,
ca. 1833
Oil on canvas; 31⅛ × 21¾ in.
The Hermitage: Home of President Andrew Jackson, H1906.04.001A

IN THIS IMAGE OF JACKSON astride his horse, Earl used a muted background and barely discernible horizon to focus attention on the figure. The *Nashville Republican* wrote of the painting, "The dignified bearing of the General, and his habit of command, tell with fine effect in the upright figure and firm countenance, every line of which the painter has made alive with expression." JCK

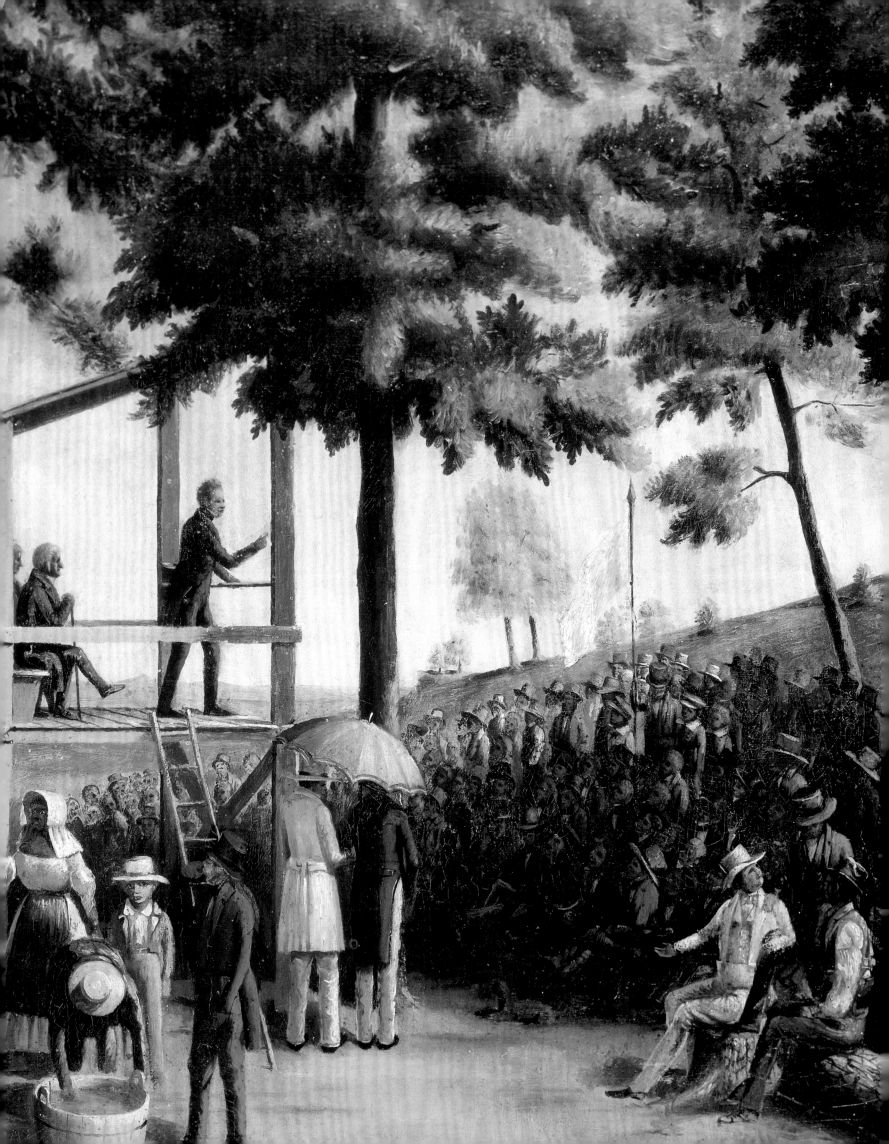

James C. Kelly

TENNESSEANS ON THE
NATIONAL STAGE

THE PERIOD OF TENNESSEE'S GREATEST NATIONAL INFLUENCE WAS THE FORTY YEARS AFTER Andrew Jackson's first presidential bid in 1824. Tennessee was then a quintessentially American place, one being democratized but coexisting with slavery; a raw society but no longer a frontier; religiously observant but highly materialistic; anti-intellectual yet reformist; well integrated into a market economy; and, above all, dynamic and optimistic. What made Tennessee special, however, was its continuous cast of important political leaders, including three presidents of the United States. The democratization of politics would have happened even without the foremost of them, Andrew Jackson, but it was a force he channeled into a great political party, while reinventing the presidency.

This entirely self-made man was an American success story. Arriving in Nashville just after its founding, Jackson became a locally successful lawyer and judge, then a national hero with his victories at Horseshoe Bend and, especially, at New Orleans. His overarching political credo was a hatred of monopoly and special privilege. No radical egalitarian, he sought to preserve equality of opportunity, so men like himself could rise above their origins. At The Hermitage, he lived like a biblical patriarch with his bondmen and bondwomen, his flocks and his herds. Though he was no longer a common man himself, ordinary people nonetheless saw in him their champion.

As few voters ever would see the candidate in the flesh, Jackson sat for many artists whose works—usually in the form of prints—disseminated his likeness to the mass of newly enfranchised white men. Jackson sat for the nation's leading artists, but none of them was a Tennessean. Political leadership does not always parallel artistic ascendancy, and Tennessee's raw vitality was still unequal to patronizing the arts at the highest level. More than two dozen portraits of Jackson were painted by a transplanted New Englander, Ralph E. W. Earl, who came to Nashville in 1817 to paint Old Hickory's portrait, married Mrs. Jackson's niece, and for the rest of his life lived with Andrew Jackson at The Hermitage and in the White House. The most widely reproduced of Earl's images—in the form of a print—shows General Jackson in full military dress riding Sam Patch, a favorite horse given to him by the citizens of Philadelphia in 1833. The upper half of the figure is taken from Earl's conventional half-lengths of Jackson. The *Nashville Republican* quickly spotted that "the charger has been copied from the celebrated model to successive artists in Van Dyck's Charles I [British Royal Collection]."[1]

The painting Earl considered his masterpiece, however, was a full-length, simplified, republican version of the Baroque state portrait of the sixteenth and seventeenth centuries. With seeming finality he called it "The National Picture," and it was completed near the end of Jackson's presidency, so that one observer saw in it the "autumnal sunset emblematic of his bright and glorious official retirement."[2] One Jackson confidant said the president's back was turned on Congress as a snub, which was certainly possible with Jackson, but probably the pose was dictated by aesthetic considerations, the capitol being included in the distance to complete the republican ensemble and to provide a focal point for Earl's well-executed perspective. The *Boston Statesman* declared that the picture "combines the qualities of a portrait, a landscape, and a historical painting."[3]

As Earl was completing "The National Picture," the capitol in its background was being adorned with statuary of statesmen. In hope of gaining commissions for such statues, the Dresden-born sculptor Ferdinand Pettrich came to America. Although there is no documentary proof that he was granted sittings by President Jackson, two

J. K. Polk Stump Speaking, ca. 1840–50, detail, cat. no. 132

167

circumstances suggest that he did, probably in April 1836. First, a letter of introduction for Pettrich was sent by the Philadelphia painter Thomas Sully to Ralph E. W. Earl, presumably to request sittings for the sculptor. Second, there is the success of the marble itself, which is a palpable likeness that captures Jackson's most distinguished feature—his long, narrow face. There are at least six replicas, one of which is shown here, all by or after Pettrich, and in the replicas even greater emphasis is given to another of Jackson's features—the still-luxuriant head of hair of the sixty-nine-year-old president. Nonetheless, Pettrich did not succeed in obtaining the commissions he sought, in part because the deepening nationalism that Jackson so assiduously promoted led to a movement to employ only American artists.[4]

Although Thomas Jefferson called him a barbarian, it seems that Jackson's tastes were merely conventional. None of the White House furniture he ordered was custom-made, and what was supplied would not have been out of place in the home of a prosperous saloon keeper.[5] Much better than those pieces is a mahogany veneer and cherry bowfront chest of drawers in the Federal style, the American name for Neoclassicism, which a receipt of 1816 indicates was purchased by Jackson for $55 from the cabinetmaker James Houston, the older brother of Sam Houston, Jackson's political protégé.[6] This political connection may have influenced General Jackson in the purchase. With brass hardware gleaming against the rich color of the expensive, imported mahogany, the chest is nearly identical to Philadelphia examples of the period. Few pieces of Tennessee furniture of this quality survive from so early a date.

In 1844

A number of Gen. Jackson's old neighbors and political friends . . . determined to have made for the purpose, and to present to him an Arm Chair, so constructed as to render it peculiarly convenient for an invalid whose habits were necessarily sedentary. The chair itself is a plain, wood, republican piece of furniture—just as it was known would be most acceptable to the time honored veteran for whose use it was intended.[7]

This mechanical reclining chair reflects the decisive change of taste that occurred after 1830, inspired by the publication of the final volumes of James Stuart and Nicholas Revett's *The Antiquities of Athens*. What we call the Empire style was then called the Grecian or modern style. Compared with Federal furniture, Empire was less delicate, more monumental, and often featured bold, heavy scrolls that could be cut on a bandsaw. In this chair, the back, arm supports, and even the feet tucked beneath are scrolls. This "plain Grecian" style was principally American and, as Jackson's presenters noted, was deemed appropriately republican.

By a tradition in the family of Andrew Jackson Donelson, Jackson's nephew by marriage, a pair of unmarked silver candelabra was given to Jackson in 1831 by Tammany Hall, New York City's Democratic Party organization. Lacking the appropriate hallmarks, they are probably not English, despite the use of masks as decorative devices on the bases. Presumably, Tammany would have presented an American piece. Jackson had a liking for silver, at least for the status it conveyed, and as president he doubled the amount of White House silver by purchasing French serving pieces from a former Russian minister to Washington. However, at the White House Jackson found that candlesticks and oil lamps were liable to be overturned by his raucous supporters, so chandeliers came to be preferred.[8] This may account for the repatriation of the candelabra to Nashville.

Sam Houston, the younger brother of James the cabinetmaker, served under Jackson in the Creek War, came to Nashville afterward, and served in Congress as Jackson's protégé. As a congressman, Houston sat in 1826 for a portrait miniature by Joseph Wood. In 1827 Houston was elected governor of Tennessee, but in April 1829 he resigned without explanation, probably because he had separated from his wife of just three months. He went to live among the Cherokee and posed for a miniature in Indian dress. Considering himself in political exile, he had John Grimes of Nashville paint a full-length portrait of him as Marius, a famous exile from ancient Rome, among the ruins of Carthage. Within a few years, however, Houston had begun a second career, in Texas.

Ephraim Hubbard Foster was another of Jackson's young followers. He was Old Hickory's secretary in the Creek War and his color bearer at New Orleans. Late in 1824 Ralph E. W. Earl painted an entirely domestic image of Foster and his family.

In 1835 Foster broke with Jackson, who governed as president just as he had commanded as a general, expecting unquestioning obedience. It never occurred to Jackson that anyone could honestly disagree with him; such dissenting persons must be wicked. Beyond his hatred of privilege, Jackson's policy decisions were whimsical and often based on personal animosities, as he was a good hater. In his insistence that the Indians be expelled from American territory, he flagrantly violated federal treaties with the Indians and ignored Supreme Court decisions. Foster was not the only person to protest Jackson's autocratic rule. The Whig Party was formed to oppose Jackson, and Foster was quick to join.

Congressman David Crockett of West Tennessee called Jackson's Indian removal policy "infamous" and was thanked for his futile opposition by the Cherokee chief John Ross. Crockett, too, was welcomed into the Whig Party, which recognized his colorful vernacular speech and humor as potentially powerful weapons. In 1834

Crockett made a tour of eastern cities that some thought was a prelude to a run for the presidency in 1836.

After completing the tour, Crockett gave portrait sittings to the Virginia-born artist John Gadsby Chapman (1808–1889), best known for his mural *The Baptism of Pocahontas* in the rotunda of the U.S. Capitol. Disdaining Chapman's bust portrait as making him appear "a cross between a clean-shirted Member of Congress and a Methodist Preacher," Crockett proposed instead a full-length depiction of him as a bear hunter. Approving Chapman's subsequent design, Crockett said, "Go ahead," an abbreviation of his motto, which appeared in his autobiography as "Be always sure you're right, then go ahead." The final pose, however, was chosen when Crockett entered the studio one day, lifted his broad-brimmed hat, and gave a shout as if urging dogs to the hunt.

The resulting portrait was exhibited at the National Academy of Design in 1835 and, again in New York, at the Apollo Association in 1838. An engraver named C. Stuart, affiliated with the latter institution, produced a mezzotint that was published by James Herring in 1839. The oil painting was sold to the new Republic of Texas but perished by fire in 1881. A small replica that Chapman kept was sold by his son in 1906 to the Daughters of the Republic of Texas, who operate the Alamo.[9]

The acclaim garnered on his national tour did Crockett no good at home, where he was defeated for reelection by the peg-legged Jacksonian Democrat Adam Huntsman. Half-jestingly, Crockett told a Memphis audience, "Since you have chosen a man with a timber toe, you may go to hell and I will go to Texas."[10]

Although Davy Crockett and 180 others died at the Alamo the following March, their sacrifice was not in vain, as it gave Sam Houston time to assemble and train the army that won Texas's independence the next month. James K. Polk was then speaker of the United States House of Representatives. An ardent expansionist, he longed to see Texas added to the United States. Called Young Hickory, Polk won the governorship of Tennessee for the Democrats in 1839. The following year he stumped for his party's presidential nominee, Martin Van Buren of New York, delivering a speech in Knoxville on July 4. That may be the occasion represented in a painting inscribed on the reverse, "JK Polk 1840/Knoxville, Tenn." The artist is unknown, but a view of the state capitol from the south, probably done in the 1850s judging from the near-completeness of the building, seems to be by the same hand, probably an artist residing in the state.

At the July 4 rally, Polk also announced his intention to seek reelection. He was defeated, however, by James C. "Lean Jimmy" Jones, not only in 1841 but again in 1843. The latter victory seemed to forecast success for the Whig Party's prospective presidential standard-bearer in 1844, Henry Clay of Kentucky. The Whigs of Philadelphia pre-sented Governor Jones a magnificent silver ewer (pitcher) to mark the occasion. The maker was Osmon Reed of Philadelphia, who proudly marked it with his name five times. Reed's inspiration was a ewer made in 1780 by Vincenzo Belli for Cardinal Francesco Antamois. Although the ewer as a form dated to antiquity, the elaborate repoussé decoration of Reed's ewer departed from the chaste Neoclassicism of the early 1800s and heralded the arrival of the Rococo Revival, soon to be reflected by such furniture makers as John Henry Belter.[11]

The ewer is chased with a scene of a figure, presumably Lean Jimmy himself, stumping to a crowd. A banner borne by an eagle reads "POST PRAELIA PRAEMIA" (After the battle come rewards), a sentiment that undoubtedly excited Whig Party patronage job seekers. On the opposite side of the ewer, a cartouche of shell (*rocaille*, hence Rococo) scrollwork encloses a chased scene identified by a banner as "ASHLAND," Henry Clay's Kentucky home named for his Virginia birthplace. Rose and dogwood blossoms common to Tennessee further embellish the ewer.

The hopes raised by Lean Jimmy's victory were dashed. Despite losing Tennessee, James K. Polk edged Clay in New York and thus won the presidency in 1844. Young Hickory's victory was enormously gratifying to the aging Old Hickory. In April 1845 the French king Louis-Philippe summoned the American artist George Peter Alexander Healy, who was supplying portraits of famous men for the immense historical picture galleries the king had created at Versailles. "Mr. Healy," said the king, "It seems that General Jackson is very ill. I must have his portrait. Can you start at once for The Hermitage?" Arriving in Nashville some weeks later, Healy copied a portrait of Jackson by Ralph E. W. Earl in case he could not gain sittings with Jackson, who initially said he could not sit again "for all the kings in Christendom." His daughter-in-law changed his mind, however, and Healy was afforded access to the sickroom for several weeks. On viewing the completed work at the end of May, the dying man pronounced it "the best that has been taken." The family agreed, and desired another for themselves, which Healy had to execute hastily as Jackson was now near death. Consequently, the replica is a shade inferior to the original masterpiece now at the Musée du Château du Blérancourt. The art historian James Barber writes of the eyes, "In the French version they are heavier, evoking a profound melancholy. In the American twin, they are merely sad."[12]

Louis-Philippe's quest for portraits of American statesmen led Healy to President Polk. Jefferson Davis's wife, Varina, pronounced Polk "an insignificant looking little man."[13] The Davises attached great importance to outward appearances, and in the portrait shown here, despite Healy's skill, Polk is rather unprepossessing. According to Polk, "Mr. Healy, the artist" also asked him to pose with his cabinet for a daguerreotype in June 1846. Encountering Dolley Madison and

the cabinet wives in the adjoining parlor, "Three attempts were made to take the likenesses of myself, the Cabinet & the ladies in a group, all of which failed." The final, successful effort excluded the women. Also absent was secretary of state James Buchanan. Healy himself was probably not the daguerreotypist, but rather John Plumbe Jr., of Washington, D.C.[14] The previous year, Plumbe had exhibited a composite portrait of the Senate and House of Representatives consisting of hundreds of individual daguerreotypes.

Polk was methodical where Jackson had been mercurial, but Young Hickory internalized the pressures that Old Hickory had freely vented. In a single term, Polk accomplished all of his major objectives, especially acquiring Oregon and conquering California and New Mexico, but he worked himself to death, dying at fifty-three, just months after completing his presidency.

The third of Tennessee's presidential triumvirate was Andrew Johnson. The onetime tailor became alderman, then mayor of Greeneville, state representative and state senator, congressman, governor, United States senator, vice president, president, then a United States senator again until his death in 1875. In 1856, as governor, he sat for a portrait by the artist William Browning Cooper who, with his brother Washington, "commenced our artistic careers in circumstances most unfavorable to artistic culture, no schools of art, no pictures, nothing to stimulate us in our chosen pursuit."[15] With help from his already established brother, William Cooper was able to attend the National Academy of Design in New York City and study in France and Italy. About 1840 he returned and settled in Memphis, presumably because Nashville was his brother's territory. By 1854, however, both brothers were working in the capital city, though not exclusively. Cooper's portrait of Andrew Johnson did not provide psychological insight into the sitter, which in any case was not expected, but he did furnish a good likeness, which was. The column, drapery, and massive "state" chair had been commonplaces of state portraiture since the sixteenth and seventeenth centuries. The book in Johnson's hand may have been intended to allay fears that he was uneducated, when actually he was self-educated. Cooper's bold use of outline divides the composition into blocks of clear, separate colors. This portrait became part of a set of the governors of Tennessee, mostly executed by Washington Cooper. The series was exhibited at the state capitol from September 22 to October 16, 1858, and an admission charge, coupled with steep discounting of the price to $500, enabled the Tennessee Historical Society to buy the set in 1859.[16]

The building in which the exhibition was held was then nearing completion after fourteen years of construction. In 1845 the architect William Strickland had promised "an Athenian building" for the Campbell's Hill site selected by the Capitol Building Commis-

sion. It was to be "surmounted by a Corinthian tower," namely, "the Choragic Monument of Lysicrates of Athens."[17] Strickland had previously placed such a tower, drawn from Stuart and Revett's *The Antiquities of Athens*, atop his Philadelphia Merchants' Exchange in 1834. To acquaint his clients with the form, he produced a wooden model that still survives. The Greek Revival style was especially popular in the American South because ancient Athens had been a democracy with slaves, and the Choragic Monument was commonly known as the Lantern or Candlestick of Demosthenes, the famed orator. Indeed, it did prove to be the capitol's crowning glory.

Soon after the capitol's completion, as Tennesseans voted in February 1861 against calling a secession convention, the Yankee artist Thomas Waterman Wood was finishing an ambitious genre painting in his Nashville studio. The Vermont native had come to Nashville following European study. Although of necessity Wood mostly painted portraits in Nashville, including several with the new capitol in the background, in January 1861 he engaged African American models who may have been free or slaves on hire. The completed work, called *Southern Cornfield, Nashville, Tennessee,* was sent for exhibition to the National Academy of Design (cat. no. 123).[18] The painting is an honest, nonstereotypical depiction of real African American men and women at work. The cornfield itself had probably been sketched the preceding summer. The kneeling figure offering a gourd of water had many antecedents in Christian art and also had recently been featured in Junius Brutus Stearns's 1851 work *Washington as a Farmer at Mount Vernon. Southern Cornfield* is a nonideological picture. There is no hint of censure of slavery, the issue then tearing the country apart. In June 1861 Tennesseans voted to leave the Union, but, curiously, Wood remained in the South. He left for Louisville only in 1862, some months after Nashville had been occupied by the Union Army. There he executed the series *A Bit of War History: The Contraband,* documenting the transformation of an escaped slave into a recruit and, finally, a wounded veteran.

In February 1862 Nashville was stunned by the sudden defeats at Fort Henry and Fort Donelson and the evacuation of the city by the Confederate commander Albert Sidney Johnston. Later that year, an obscure artist named Alexander Ransom painted a scene of federal troops camped along the Cumberland River near Fort Donelson. The fighting has moved on and stillness pervades the scene. Light reflects off the water and there is a coruscating twilight sky.

For the next three years, the state capitol was occupied by Military Governor Andrew Johnson, who, like most East Tennesseans, loathed secession. After the bulk of the Union army departed Nashville to seek the enemy in the field, Johnson was left with two thousand troops to defend Nashville against recapture. The capitol was dubbed Fort Johnson, and in the view of the main or east facade in

1864 by the photographer George N. Barnard, one sees tents, brush arbors, and fortifications in the yard built by conscripted black labor. In Barnard's view from the east facade, parrot guns are trained in the direction of the distant Cumberland River.[19]

When General Don Carlos Buell recommended abandoning Nashville to the enemy, Governor Johnson said he would sooner burn it down. In October 1862 a relief force under General William Rosecrans secured the city. Rosecrans went on to a tactical draw but strategic victory at Murfreesboro and advanced on Chattanooga. Defeated at Chickamauga, he was relieved of command by Ulysses S. Grant, whose troops led by "Fighting Joe" Hooker promptly carried Lookout Mountain by assault. In reality, Lookout Mountain was but the first step in the campaign for the main Confederate position on Missionary Ridge, but it captured the imagination of artists as "The Battle above the Clouds." Even scenes of Union soldiers clambering up Lookout Mountain after the victory were popular.

The South sought meaning for its vain sacrifice, and in this quest artists played a part. The cult of the Lost Cause was the result, and the romantic aura that often settles over lost causes drew in even Northern-born artists such as William Gilbert Gaul, although it should be said that his mother was a Tennessean. In 1881 he moved to Tennessee to take up an inheritance. Too young to have participated in the Civil War, he made its depiction on canvas the focus of his artistic endeavors.

With few exceptions, Gaul did not depict specific battles or actual episodes, nor were his works done to illustrate texts. Generally, he portrayed types of wartime experiences, especially those of the common soldier. The scene shown in his romantic painting *Following the Guidon* could have occurred anywhere, anytime during the war. The abstracted background gives no hint of place. *Waiting for Dawn* is a much less heroic image. The bodies of the dead lie unattended by the survivors of battle, the latter too numbed by cold to stir. To us, this is an antiwar picture. To Gaul, however, it honored sacrifice, but it did begin to move away from the nineteenth-century notion that pictures should be both beautiful and ennobling. Nonetheless, it was part of a larger series intended to "crystallize on canvas the magnificent deeds of daring and love which distinguished the Confederate soldier."[20]

Tennesseans made much of their being last out and first back into the Union, but Tennessee nonetheless experienced the next hundred years as a Southern society and culture, no longer as a quintessential American place. Although Andrew Johnson was president until 1869, he represented neither majority opinion in Tennessee during the war nor majority national sentiment afterward. Essentially, from the moment in June 1861 when Tennesseans decided they were more Southern than American, Tennessee's time of national political preeminence was over.

NOTES

1. *Nashville Republican*, December 22, 1835, quoted in James G. Barber, *Andrew Jackson, a Portrait Study* (Seattle and London: University of Washington Press, 1991), 144.

2. *Boston Statesman*, February 25, 1837, quoted in Barber, *Andrew Jackson*, 146.

3. Ibid.

4. Barber, *Andrew Jackson*, 126–27, and telephone conversation with James Barber, April 30, 2003.

5. William Seale, *The President's House*, 2 vols. (Washington, D.C.: White House Historical Association, 1986), vol. 1, 186.

6. Information kindly provided to the author, February 2003, by Marsha Mullin, director of museum services, The Hermitage.

7. "General Jackson and His Neighbors," *Nashville Union*, September 16, 1844, kindly provided by Marsha Mullin, director of museum services, The Hermitage.

8. Seale, *The President's House*, vol. 1, 195, 173–74.

9. The preceding paragraphs are taken from Curtis Carroll David, ed., "A Legend at Full Length: Mr. Chapman Paints Colonel Crockett—and Tells about It," *Proceedings of the American Antiquarian Society* 69 (1960, for the year 1959): 155–74.

10. James C. Kelly and Frederick S. Voss, *Davy Crockett, Gentleman from the Cane: An Exhibition Commemorating Crockett's Life and Legend on the 200th Anniversary of His Birth*, exh. cat. (Washington, D.C.: Smithsonian Institution Press; Nashville: Tennessee State Museum, 1986), 31.

11. *Philadelphia: Three Centuries of American Art*, exh. cat. (Philadelphia: Philadelphia Museum of Art, 1976), 319, cat. no. 273.

12. Marie DeMare, *G. P. A. Healy, American Artist* (New York: McKay, 1954), 118–28; G. P. A. Healy, *Reminiscences of a Portrait Painter* (Chicago: A. C. McClurg and Co., 1894), 144, 149; Barber, *Andrew Jackson*, 197–98.

13. Quoted in Margaret C. S. Christman, *1846, Portrait of the Nation*, exh. cat. (Washington, D.C., and London: Smithsonian Institution Press, 1996), 28.

14. Ibid., 27.

15. "Monograph by William Cooper," Tennessee State Library and Archives, Box C-2 no. 142 1/2, cited in James C. Kelly, "Portrait Painting in Tennessee," *Tennessee Historical Quarterly* 46 (winter 1987): 199.

16. Kelly, "Portrait Painting in Tennessee," 201–2.

17. Jessie Poesch, *The Art of the Old South* (New York: Alfred A. Knopf, 1983), 229–31.

18. James C. Kelly, "Landscape and Genre Painting in Tennessee, 1810–1985," *Tennessee Historical Quarterly* 45 (summer 1985): 42.

19. James A. Hoobler, *Cities under the Gun* (Nashville: Rutledge Hill Press, 1986), 31, 35.

20. *Confederate Veteran*, May 1907, quoted in James A. Hoobler, introduction to *Gilbert Gaul, American Realist*, exh. cat. (Nashville, Tenn.: Tennessee State Museum, 1992), 5.

126 · **RALPH E. W. EARL**

b. Norwich, England 1785–d. The Hermit-
age, Nashville, Tennessee 1838

Andrew Jackson

Oil on canvas; 126 × 93 in.
Smithsonian American Art Museum, Transfer
from the U.S. District Court for the District of
Columbia, 1954.11.12

EARL CONSIDERED THIS WORK to be the most significant of his depictions of
Jackson, and so dubbed it "The National Picture." The president is in civilian clothes, but
the scarlet-lined military cape recalls his martial achievements. The motif of a statesman
posed next to a classical column was popular in American political imagery, the aim of
which was to cast the leader as heir to the democratic traditions of ancient Greece. JCK

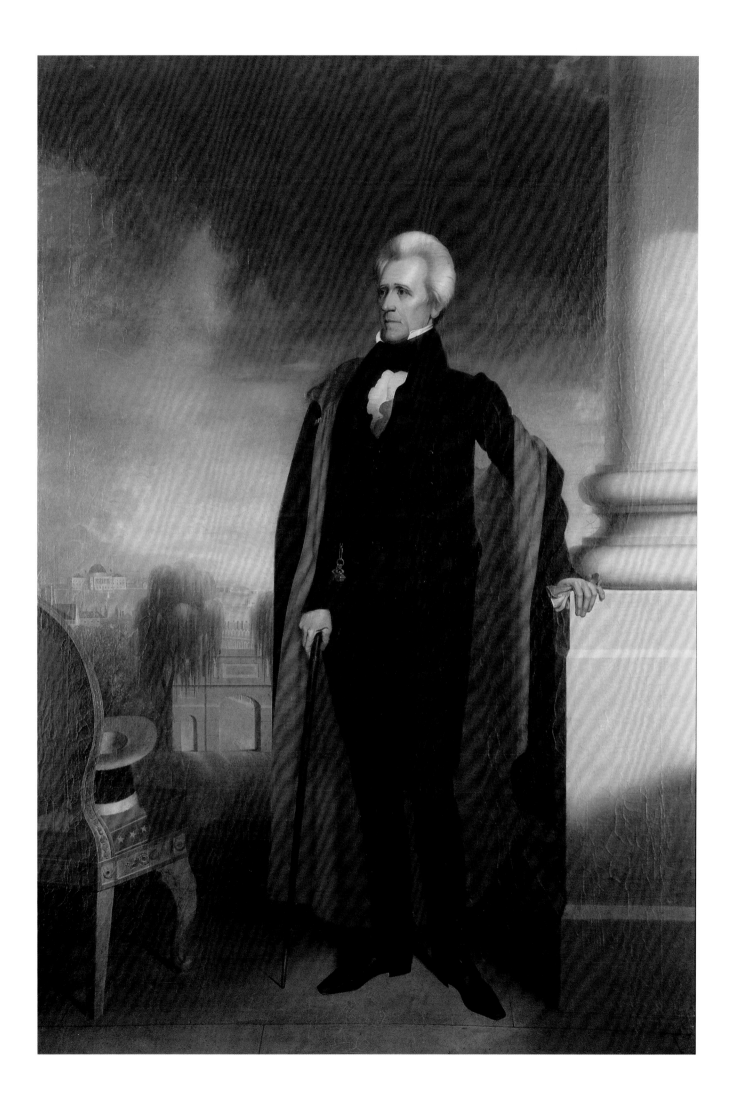

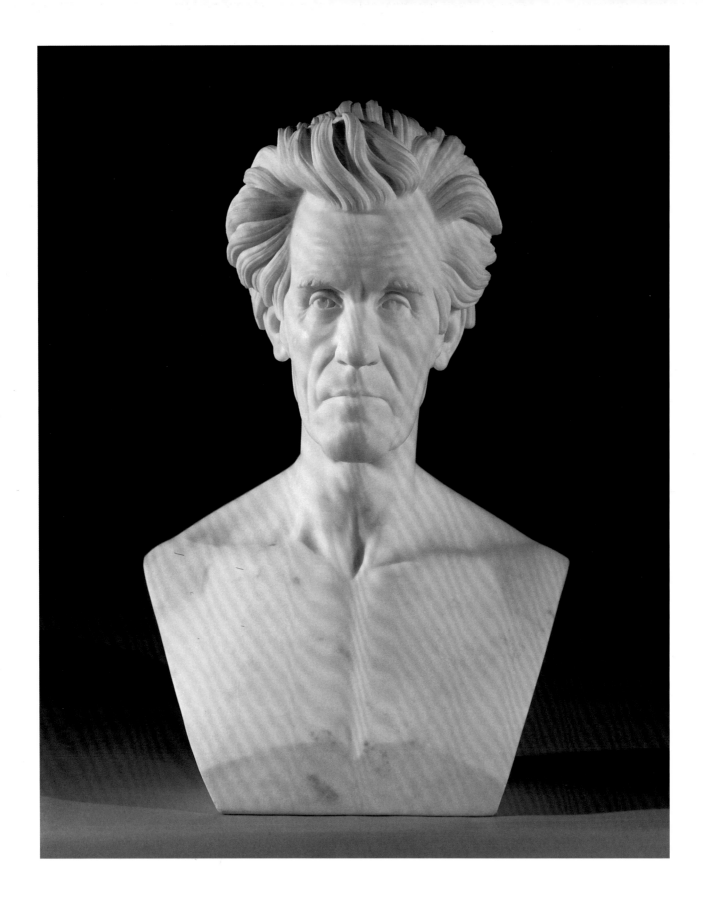

127 · **FERDINAND PETTRICH**
b. Dresden, Germany 1798–d. Rome, Italy 1872

Bust of Andrew Jackson, 1836
Marble, replica of 1836 original; 25 × 16½ × 11 in. National Portrait Gallery, Smithsonian Institution, NPG.91.45

FERDINAND PETTRICH WAS THE SON of the court sculptor to the king of Saxony, and while he was in Rome, he was a pupil of the Danish sculptor Bertel Thorwaldsen. The Philadelphia painter Thomas Sully praised Pettrich as excelling in "works of magnitude," perhaps alluding to the sculptor's hope of being commissioned to do full-length statues. Even in the smaller bust format, however, Pettrich produced a memorable likeness of Jackson. JCK

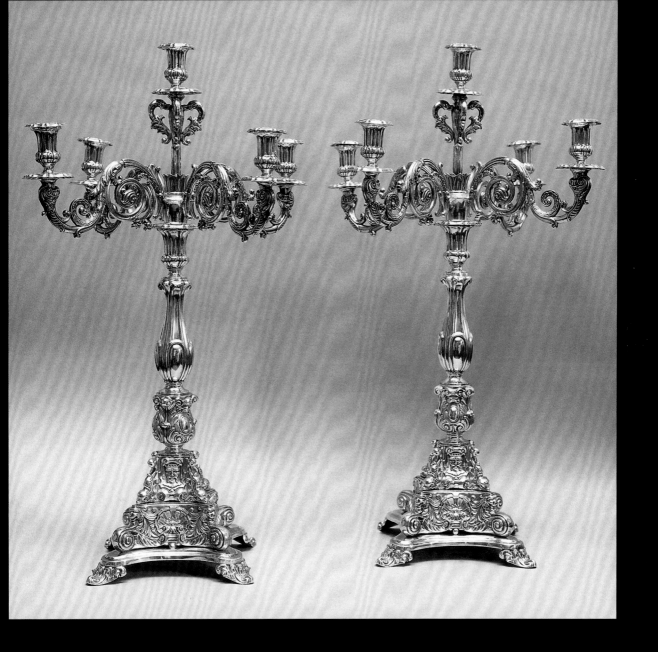

128 ⸱ *Pair of Silver Candelabra (Jackson's Candelabra)*, ca. 1830
Unmarked
Coin silver; 29¾ × 18¾ × 18¾ in.
Collection of Ben and Gertrude Caldwell from the Stanley Horn Collection

THESE SILVER CANDELABRA were given to Andrew Jackson by Tammany Hall in 1831 and used by Jackson while he was in the White House. After he completed his second term, Jackson gave the candelabra and a pair of wine coolers to Andrew Jackson Donelson, who had been his secretary while Jackson was president. Probably made by a New York silversmith, the candelabra are in the English style, but are raised rather than cast. BHC

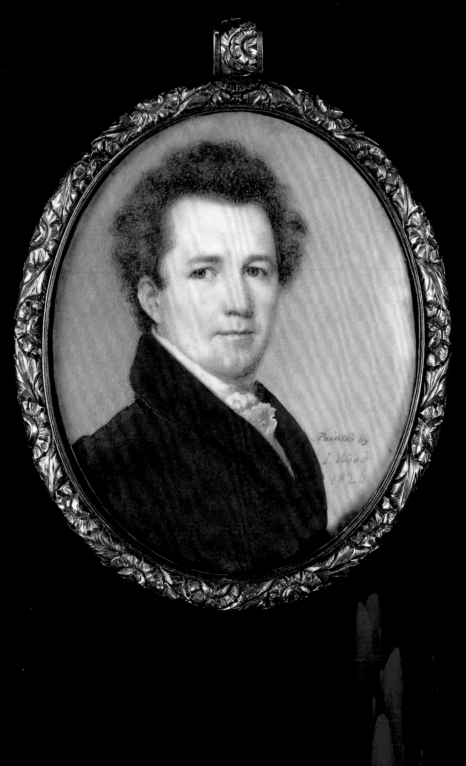

129 · JOSEPH WOOD
b. ca. 1778–d. 1830

Portrait of Sam Houston, 1826
Watercolor on ivory; 4 × 3 in.
San Jacinto Museum of History,
Houston, Texas

A CLOSE FRIEND OF THE ARTIST JOSEPH WOOD recalled that Wood's "company was courted by the first men of the nation." He settled in Washington, D.C., because every military or naval officer, legislator, judge, and government official thought himself worthy of a fine portrait. Congressman Sam Houston of Tennessee was thirty-three years old when he sat for this likeness. The 18-karat gold frame is original; the ring at top would allow the portrait to be worn as a pendant. JCK

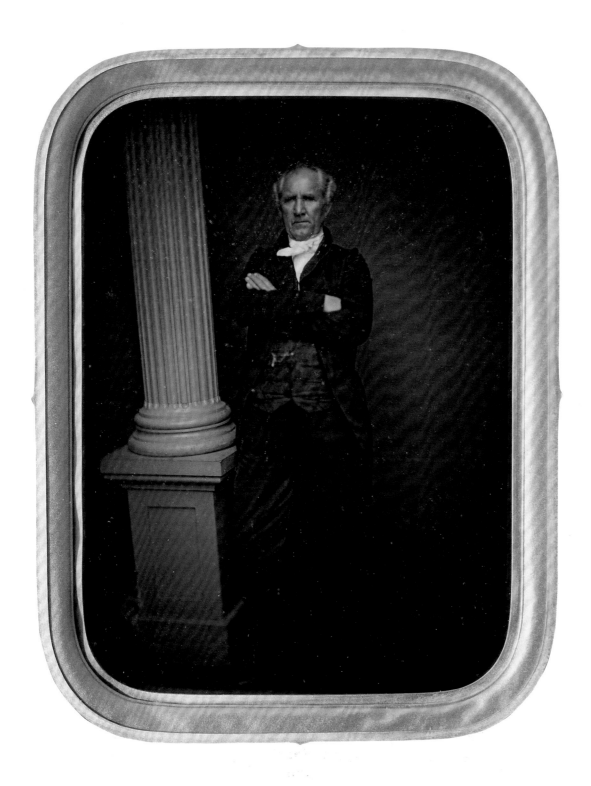

130 · **MEADE BROTHERS**
Active New York, New York 1842–63
CHARLES R. MEADE
d. St. Augustine, Florida 1858
HENRY W. M. MEADE
d. 1865

Samuel Houston, 1851
Daguerreotype; 8 × 5¼ in.
The Museum of Fine Arts, Houston; Gift of
Vinson & Elkins L.L.P. in honor of the Firm's
seventy-fifth anniversary

THIS IMAGE SHOWS THE COMMANDING bearing of Sam Houston, former governor of Tennessee who led the Texas armies in the Battle of San Jacinto that secured Texas's independence from Mexico. The daguerreotype was taken in 1851 while Houston was serving as a United States senator from Texas, probably in the New York studio of the brothers Charles and Henry Meade. It is extraordinary both for its full-plate size and for the full-length portrait stance of the six-foot two-inch Houston. NFC

131 · C. STUART

Active ca. 1840

David Crockett, 1839
Engraving on paper, 18⅛ × 13 in.
First Tennessee Heritage Collection

IN LATE MAY OR JUNE 1834 David Crockett posed as a bear hunter for the Alexandria, Virginia, artist John Gadsby Chapman. Crockett procured the fringed hunting shirt, leggings, and moccasins in the capital city, while a Virginia neighbor of Chapman's supplied the powder horn, pouch, and an unornamented rifle on which the subject insisted the artist paint "Go ahead," Crockett's motto. This engraving is based on Chapman's painting. JCK

132 ᴬ *J. K. Polk Stump Speaking,* ca. 1840–50
Inscribed "JK Polk 1840/Knoxville, Tenn."
Oil on canvas; 15¼ × 23¼ in.
Tennessee State Museum Collection, 10.270

ALTHOUGH ONCE BELIEVED TO BE a depiction of an early-nineteenth-century religious revival meeting, scholars now believe that this painting depicts James K. Polk, then governor of Tennessee, addressing a group gathered on a hill near Knoxville on July 4, 1840, on behalf of the presidential candidate and fellow Democrat Martin Van Buren. Whereas a revival would have included entire families, virtually no women are visible among the group in this painting, which was created at a time when they were denied the right to participate in politics. The presence of the well-dressed African American family in the lower left corner remains unexplained, since they, too, could not vote. KDW

133 · **OSMON REED**
Active Philadelphia 1833–63

Presentation Ewer, 1843
Engraved "Presented by the Whigs of the City
and County of Philadelphia to the Hon. James C.
Jones Governor of Tennessee As a token of their
admiration for his gallant success in the Guber-
natorial canvass of 1843 which resulted in the
establishment of Whig principles and opened the
Presidential Campaign with sure harbingers of
the triumphant election of Henry Clay in 1844."
Silver; 18 × 10⅝ × 7½ in.
Philadelphia Museum of Art: Purchased with
the Joseph E. Temple Fund, 1902

THE WHIG PARTY OF PHILADELPHIA presented this ewer to Tennessee governor
James C. Jones, whose election the Whigs took as a sign of success for Whig candidate
Henry Clay's presidential bid in 1844 (an election won by James K. Polk). Decorated with
repoussé and engraved motifs, the ewer reflects the high, ornate style popular in Philadel-
phia in the 1840s. BHC

134 • **THOMAS GOWDEY**
b. Castlewellan, Ireland 1795–
d. Nashville, Tennessee 1863

JOHN PEABODY
d. Nashville, Tennessee 1850

Presentation Urn, 1846
Engraved "Presented to Henry Clay, the gallant champion
of the Whig cause by the Whig ladies of Tennessee/a
testimonial of their respect for his character, of their
gratitude for his patriotism, and public service, and
their admiration for his talents and his high and noble
bearing under all trying circumstances of his eventful
life. The historic muse will cherish, defend, and perpetrate
his reputation/Detor digniori"; marked "G and H"
Silver; 22⅝ × 19 × 11¾ in.
Tennessee State Museum Collection, 83.15

THIS URN WAS PRESENTED to Henry Clay by the Whig ladies of Tennessee in appre-
ciation of his leadership of the Whig Party during his unsuccessful bid for the presidency
against James K. Polk in 1844. The inscription on the urn shows the loyalty of Clay sup-
porters despite his defeat. Although the urn was marked by Gowdey and Peabody, both
Nashville silversmiths, the "G and H" mark indicates that it was manufactured by Gale
and Hayden of New York City. BHC

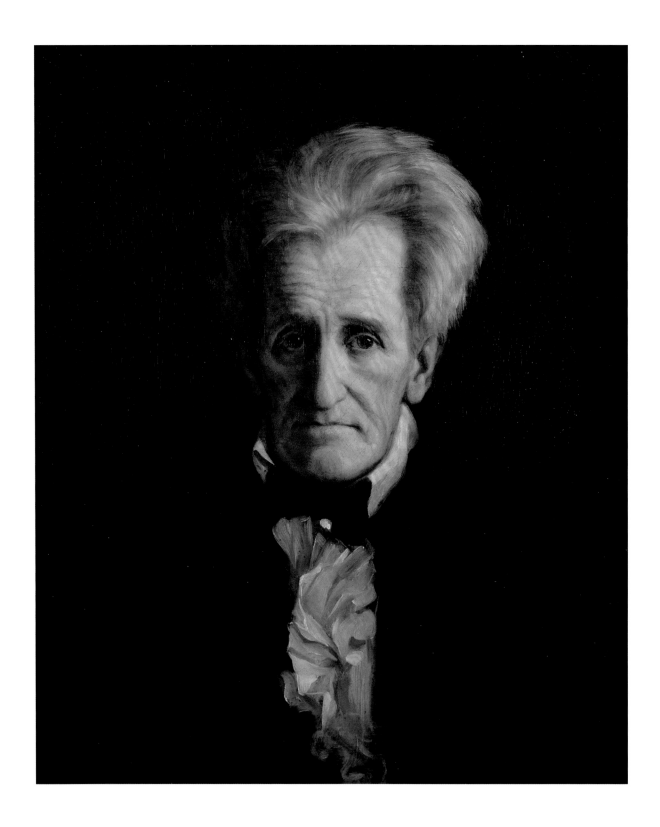

135 · **GEORGE PETER ALEXANDER HEALY**
 b. Boston, Massachusetts 1813–
 d. Chicago, Illinois 1894

 Portrait of Andrew Jackson, 1845
 Oil on canvas; 24 × 20 in.
 The Hermitage: Home of President Andrew
 Jackson, H1905.02.001A

OF THIS PORTRAIT, JACKSON SAID, "If I may be allowed to judge my own likeness, I can safely concur in the opinion of my family that it is the best that has been taken." When, a few days later, Jackson died, the portrait was exhibited at the Nashville home of United States Supreme Court Justice John Catron. The *Politician* observed that "It represented him, indeed, at the verge of existence." JCK

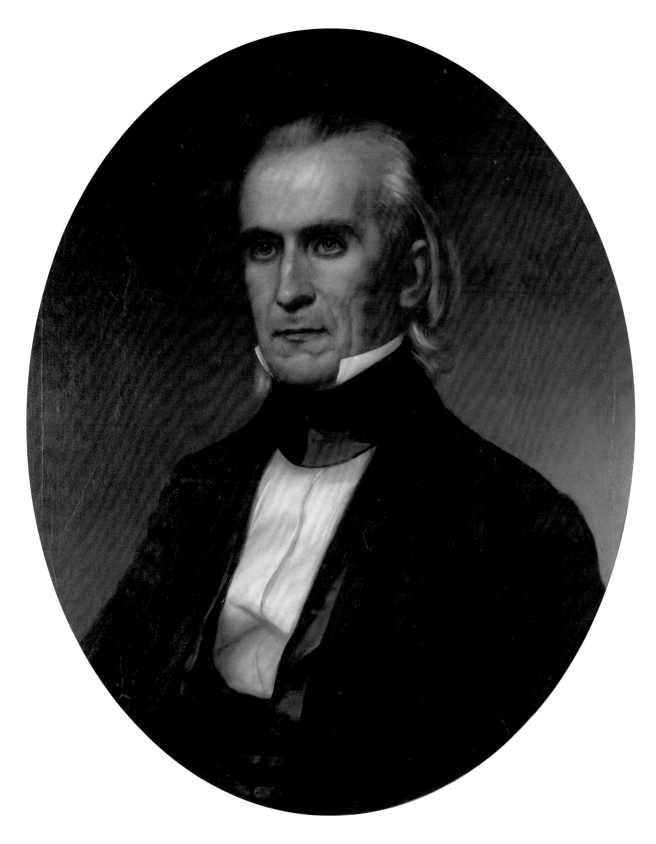

136 · **GEORGE PETER ALEXANDER HEALY**
 b. Boston, Massachusetts 1813–
 d. Chicago, Illinois 1894

Portrait of James K. Polk, 1848
Oil on canvas; 34 × 22 in.
James K. Polk Ancestral Home, Columbia,
Tennessee

GEORGE PETER ALEXANDER HEALY painted at least five separate portraits of
James K. Polk. Polk recorded in his diary that the lengthy sittings were "irksome and
fatiguing," taking too much time away from his schedule. This represents the final portrait
of Polk, just months before his death. It depicts the youngest president up to the time
looking far older than his fifty-three years. TP

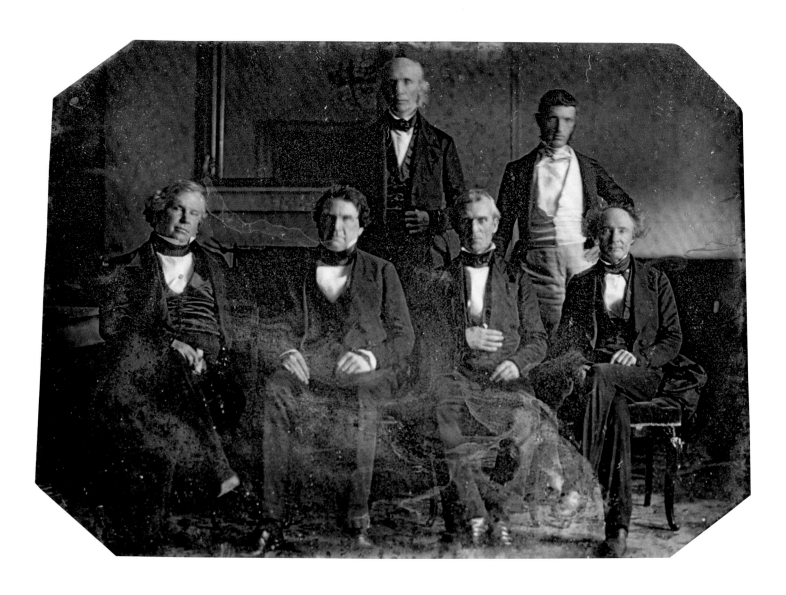

137 · JOHN PLUMBE JR.
b. Wales 1809–d. Dubuque, Iowa 1857

James K. Polk and His Cabinet, 1845
Daguerreotype; 4½ × 6 × ½ in.
James K. Polk Ancestral Home, Columbia,
Tennessee

THIS DAGUERREOTYPE of President James K. Polk and his cabinet by John Plumbe Jr. is important for the firsts it represents. It is the first image of a president and his cabinet together. It is also the first surviving image of the interior of the White House. Seated left to right are Attorney General John Y. Mason, War Secretary William L. Marcy, President Polk, and Treasury Secretary Robert J. Walker. Standing left to right are Postmaster General Cave Johnson and Navy Secretary George Bancroft. Secretary of State James Buchanan is not in the photograph. TP

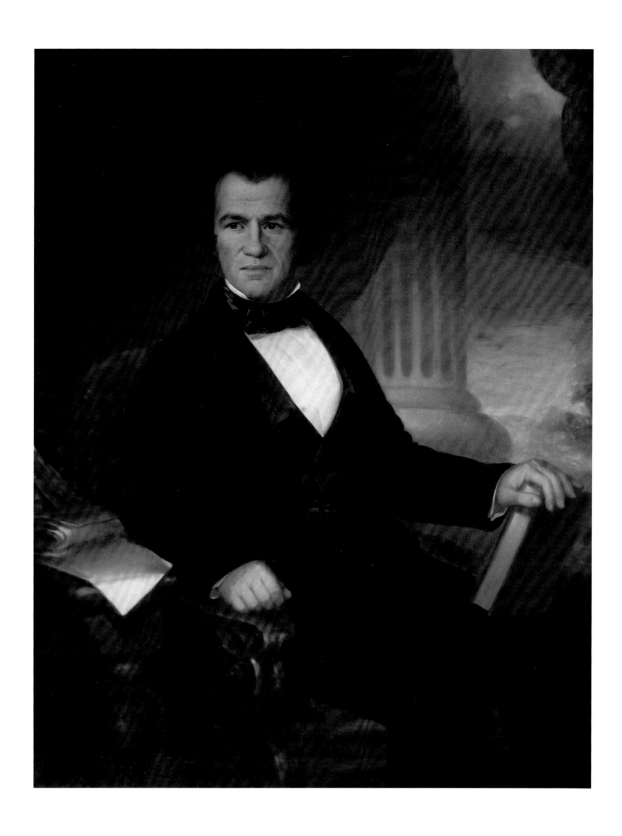

138 · **WILLIAM BROWNING COOPER**
b. Smith County, Tennessee 1811–
d. Chattanooga, Tennessee 1900

Andrew Johnson, 1856
Oil on canvas; 50 × 40 in.
Tennessee State Museum Collection, 1.885

THIS STATELY PORTRAIT of Andrew Johnson seated in front of a classical fluted column and red curtain, surrounded by books and papers, is fairly typical of the pose and props used in nineteenth-century depictions of public servants. Johnson served as the mayor of Greeneville, Tennessee, state representative, state senator, United States congressman, governor, United States senator, and vice president, before becoming president of the United States on April 15, 1865, following the assassination of Abraham Lincoln. He did not secure the Democratic nomination for president in 1868 but returned to the Senate in 1874, the only former president to serve in the Senate. KDW

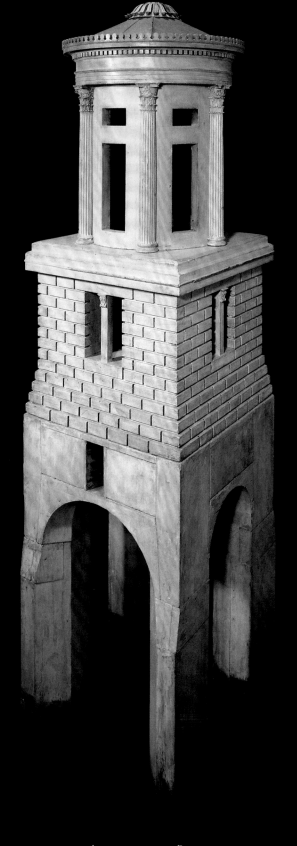

WILLIAM STRICKLAND
b. Navesink, New Jersey 1788–
d. Nashville, Tennessee 1854

*Model of the Tennessee State Capitol
Tower (Cupola),* 1845
Pine; 139¾ × 28⅝ × 26¾ in.

A RENOWNED PHILADELPHIA ARCHITECT, William Strickland apprenticed to
Benjamin Henry Latrobe, who once described the "Lanthorn of Demosthenes," otherwise
called the Choragic Monument of Lysicrates, as "that than which nothing of the kind can
be more beautiful." Strickland modeled his cupola for the state capitol on the Choragic
Monument Latrobe so admired. The building was constructed between 1845 and 1859. Its
northeast cornerstone covers the entombed body of Strickland, who died in 1854. JCK

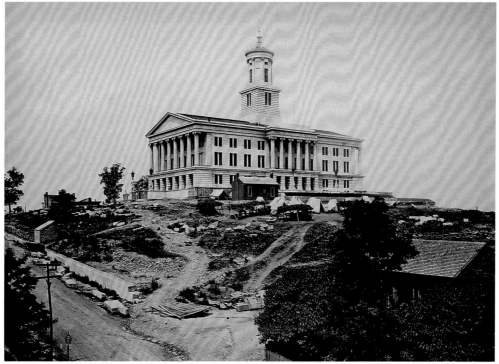

140 · **GEORGE N. BARNARD**
b. Coventry, Connecticut 1819–
d. Onondaga, New York 1902

Nashville from the Capitol, 1864
Albumen print; 9⅞ × 14⅛ in.
Gift of the Roger Houston Ogden Collection,
The Ogden Museum of Southern Art, University
of New Orleans

IN 1864 GEORGE BARNARD, working as the official photographer for the United States Army, documented General William Tecumseh Sherman's famous march from Tennessee to the Carolinas. These photographs were published in his 1866 book, *Photographic Views of Sherman's Campaign.* The third plate in the book, *Nashville from the Capitol,* shows a view looking out over the front steps of William Strickland's state capitol building, with Union cannons overlooking the occupied city. BC

141 · **GEORGE N. BARNARD**
b. Coventry, Connecticut 1819–
d. Onondaga, New York 1902

Tennessee State Capitol, 1864
Albumen print; 16 × 20⅛ in.
Tennessee State Museum, Tennessee Historical
Society Collection, 95.103

BARNARD WORKED WITH SUCH significant photographers as Alexander Gardner and Timothy O'Sullivan on Mathew Brady's Civil War photographic crew, documenting the historic battlegrounds and cities along Sherman's route. Because its many educational institutions made it a center of learning, nineteenth-century Nashville styled itself "the Athens of the South." This view of Strickland's capitol building shows such Neoclassical elements as fluted columns and the elegant cupola, which Strickland modeled after the Choragic Monument of Lysicrates, in Athens, Greece. BC

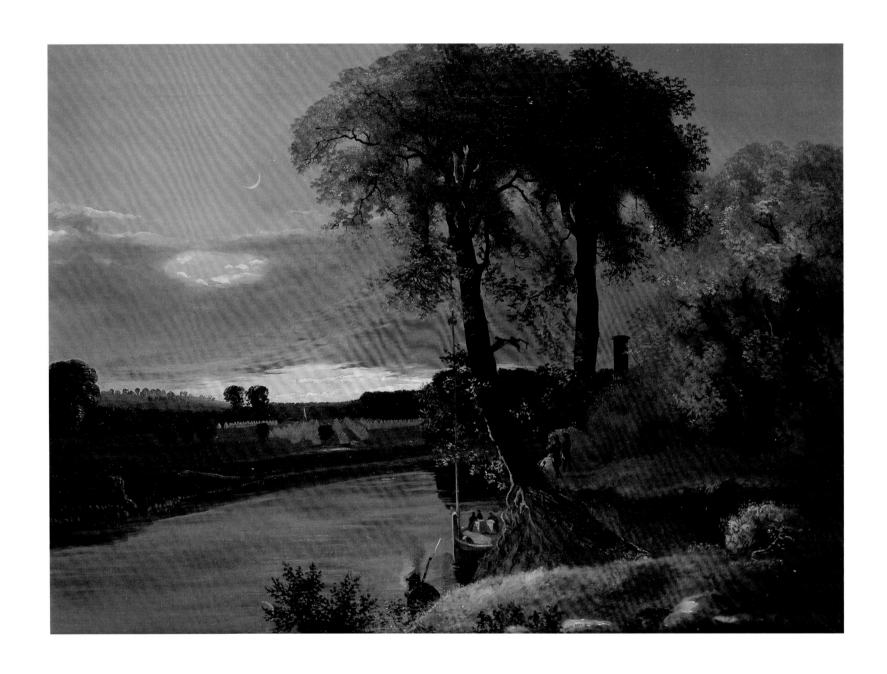

142 · **ALEXANDER RANSOM**

Active 1840–65

Near Fort Donelson, 1862
Oil on canvas; 22¼ × 30¼ in.
Tennessee State Museum Collection, 82.4

IN THIS PAINTING, a military camp is shown on one side of the Cumberland River, while on the near bank a single soldier smoking a pipe sits with his rifle leaning against his shoulder while his two companions gaze over the water. The golden foliage of the trees and red hue of the sky's clouds suggest that the painting was created in the fall. As the artist has inscribed on a rock in the foreground, the scene was painted near Fort Donelson, a garrison captured by Ulysses S. Grant in February 1862 in what proved to be a major victory for the North. KDW

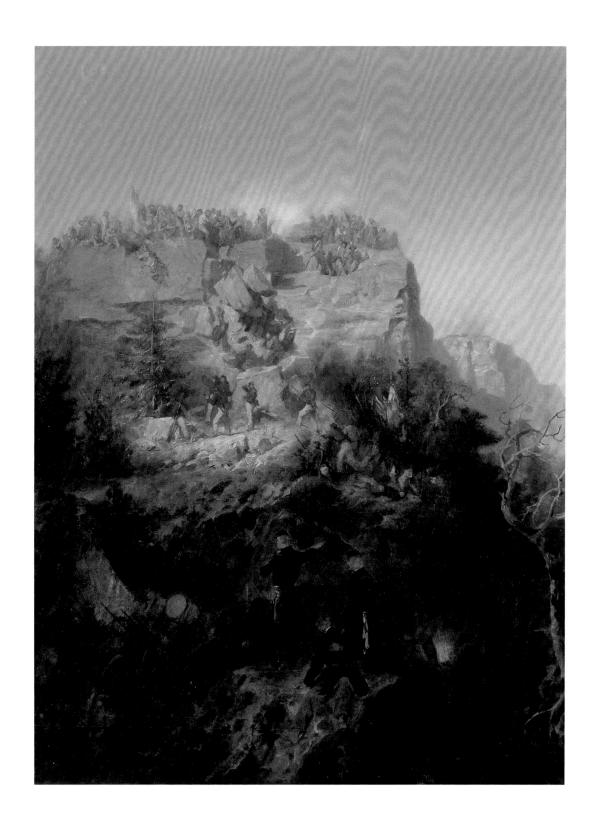

143 · *Skirmish on Lookout Mountain,*
ca. 1880s
Oil on canvas; 22½ × 18½ in.
Tennessee State Museum Collection, 1997.93

THIS PAINTING BY AN UNIDENTIFIED ARTIST depicts a skirmish on Lookout Mountain during the fighting around Chattanooga in the fall of 1863. This engagement in the larger campaign is sometimes called the Battle above the Clouds. During the fighting, the heavy fog and smoke obscured visibility. This postwar memorial to the battle is thought to be a work of the imagination and memory rather than an accurate description of the battle. JAH

Marsha Mullin

Decorative Arts at The Hermitage

Andrew Jackson purchased the Hermitage property in 1804 and lived there until his death in 1845, and members of his family continued to reside there until 1893. Jackson lived in two different residences on the property; the original log farmhouse of about 1800 and the brick Hermitage mansion built and remodeled twice between 1819 and 1837. The Jacksons' furnishings, like those of most families, represent acquisitions made over a long period.

Jackson probably bought some of the earliest pieces of silver when he served as Tennessee's first congressional representative in the United States capital, then located in Philadelphia, in 1796. Jackson also made many purchases from Tennessee artisans during the seventeen years he and his family lived in the two-story log farmhouse. Receipts, as well as attributed pieces of furniture, identify the craftsmen patronized by the Jacksons, including the cabinetmakers William Winchester, Joseph McBride, Ward and Paxton, J. B. Houston, and Richard Smith. Tennessee-made pieces from this early period still exhibited in the Hermitage mansion are a sugar chest, a desk-bookcase, a pair of card tables, and two chests of drawers. These furnishings are high style and the best that could be purchased in the Nashville area. They suggest that the log farmhouse could never have been described as a log "cabin," as the family acquired high-post beds, dressing tables, dining tables, a sideboard, and an elegant lady's workstand fitted with green silk trimmings. In addition to furniture, Andrew and Rachel Jackson purchased silver, furnishing chintz, and mirrors. The Nashville silversmiths Joseph and John Elliston, Richmond and Flint, and William H. Calhoun provided goods to the Jacksons; marked pieces from all of them are in the Hermitage collection. The artist Ralph E. W. Earl painted his first portraits of Jackson while the family lived in the log farmhouse.

After moving to the brick mansion in 1821, the Jacksons made most of their purchases in New Orleans and Philadelphia rather than Nashville. Jackson's improved financial status and the coming of steamboats that made shipping large, bulky goods easier contributed to this quest for goods farther afield. In the fall of 1834, a fire heavily damaged the mansion, resulting in its second remodeling and the purchase of numerous new furnishings. Most of the goods came from Philadelphia, the birthplace of Andrew Jackson's daughter-in-law Sarah Yorke Jackson. Sarah was responsible for most of the furnishing purchases after the fire, although Andrew Jackson did make suggestions. The Hermitage during those years was a strong statement of the Greek Revival and Neoclassical taste. In addition to the Philadelphia furnishings, the house included such reflections of the growing global economy as French wallpaper and Chinese silk. Despite the numbers of furnishings from eastern or even foreign makers, the family continued to use Tennessee-made furniture, silver, works of art, and other objects throughout their residence at The Hermitage. Nashville cabinetmakers provided a few of the new pieces, although the only identified maker is McCombs and Robinson, who made a hall tree and repaired a number of older items. The makers of Jackson's set of four bookcases and the reclining invalid chair presented by his Nashville political friends are unknown.

In 1850, five years after Andrew Jackson's death, his adopted son and daughter-in-law chose some new furnishings for their home. These selections were in the early Victorian Rococo style and were again interspersed with the older pieces. Most of them seemed to be for the parlors, the most important public rooms in the house. Changing finances dictated that these were the last extensive furnishings purchased for the remainder of the time the Jacksons lived at The Hermitage. The Victorian furniture is no longer on exhibition. In the 1990s the Ladies' Hermitage Association (LHA) restored the interior of the mansion to correspond to the way the house appeared during Andrew Jackson's retirement years just after the remodeling occasioned by the fire of 1834.

The State of Tennessee chartered the Ladies' Hermitage Association to operate The Hermitage as a public museum in 1889. At that time, Andrew Jackson III and his family still lived in the mansion, surrounded by the furnishings purchased by Andrew and Rachel Jackson as well as by later family members. After the Jacksons moved away from The Hermitage in 1893, the LHA was able to acquire nearly all the furnishings from the family in a series of acquisitions beginning in 1897. Today The Hermitage contains the largest number of original furnishings of any of the homes of the early American presidents.

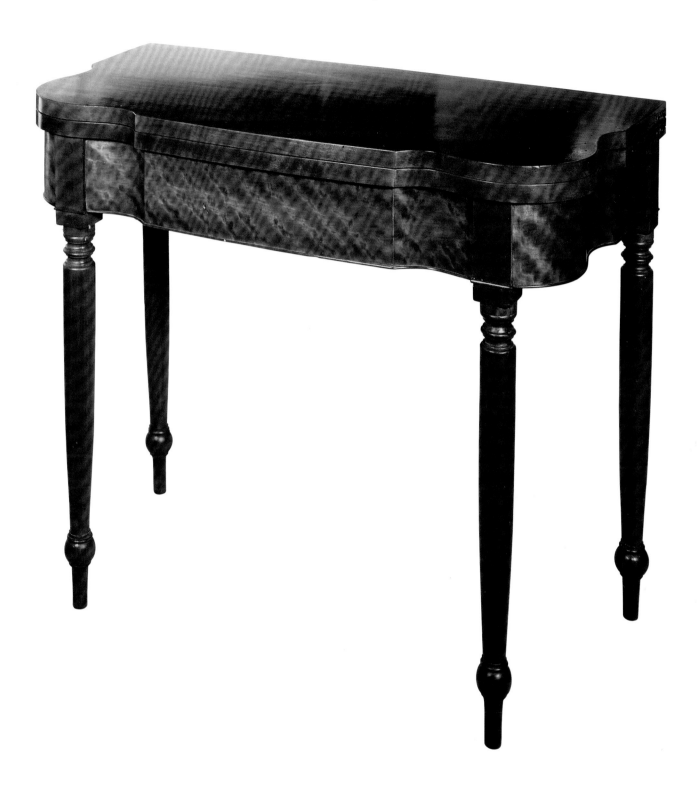

144 · **ATTRIBUTED TO JAMES B. HOUSTON**
b. Rockbridge County, Virginia–d. Davidson
County, Tennessee 1824

Card Table, ca. 1816–20
Cherry and mahogany; 28¾ × 36 × 18¾ in. (closed)
The Hermitage: Home of President Andrew Jackson,
H1965.51.001

THIS IS ONE OF A PAIR OF CARD TABLES at The Hermitage that are believed to have been purchased by Andrew Jackson from the Davidson County cabinetmaker James B. Houston in 1816. Standing on turned legs with brass casters, the serpentine apron has a conforming folding top. Like so many pieces reinterpreted by cabinetmakers in Tennessee, the design has been scaled down from related forms made Back East. RH

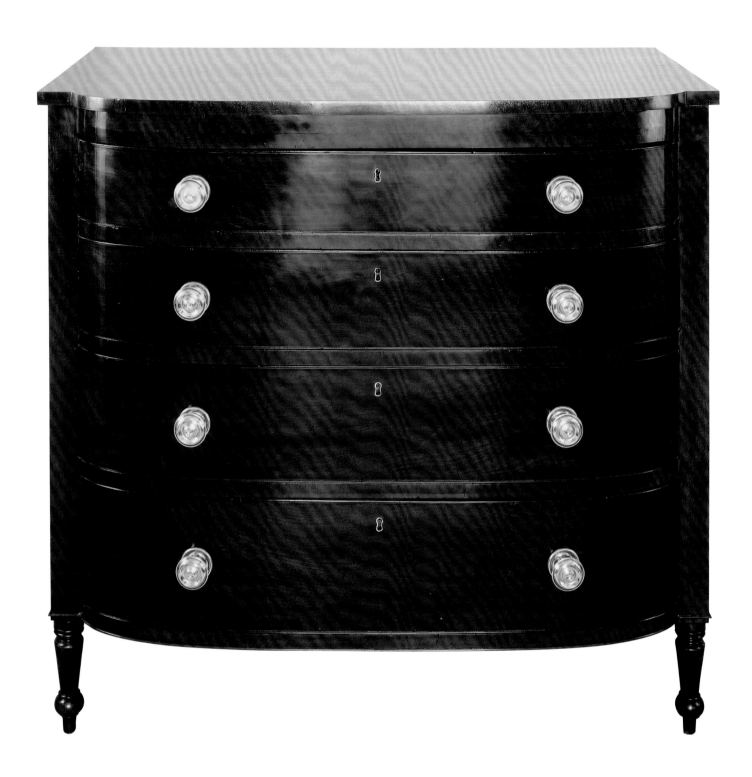

145 · JAMES B. HOUSTON
b. Rockbridge County, Virginia–
d. Davidson County, Tennessee 1824

Bureau, ca. 1816
Cherry, tulip poplar, with mahogany veneer;
40¾ × 43⅛ × 24¼ in.
The Hermitage: Home of President Andrew
Jackson, H1894.02.002

DESCENDING THROUGH THE JACKSON FAMILY, this bureau is attributed to James B. Houston, a Davidson County cabinetmaker and elder brother of Tennessee and Texas governor Sam Houston, by a bill of sale that lists an "Eliptic [*sic*] Bureau," which Houston sold to Jackson. The four graduated-height drawers form the elliptical D-shaped front of the bureau. James Houston claimed to have worked in Philadelphia, Baltimore, Norfolk, and Charleston, before setting up business in Knoxville in 1810 and Nashville in 1814. RH/JCK

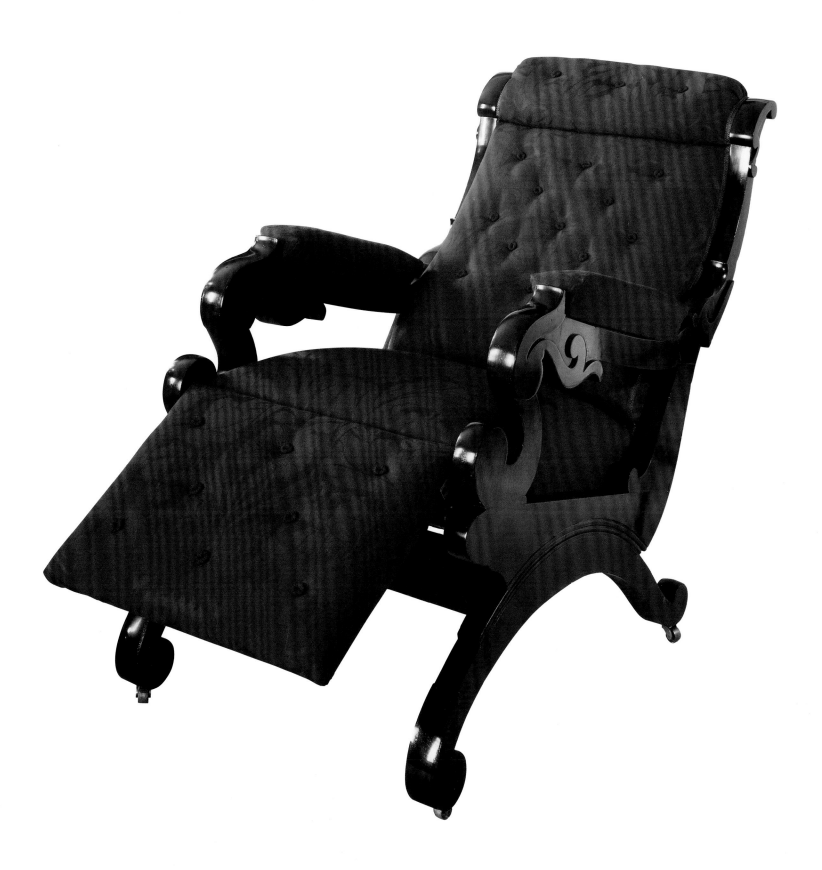

146 · *Upholstered Reclining Chair,* 1844
Davidson County, Tennessee
Mahogany, tulip poplar, damask, forged iron,
and brass; 37¾ × 27 × 54 in.
The Hermitage: Home of President Andrew
Jackson, H1901.03.001

GIVEN TO JACKSON IN 1844 by "his Nashville political friends," this upholstered reclining chair was described as a "chair suitable for invalids." Originally upholstered in tufted red wool damask, the chair is related in style to reclining chairs that had been coming out of Baltimore and Philadelphia for almost twenty years. By oral tradition, the chair was made for Jackson at a cabinet shop in Nashville, although the identity of the shop remains unknown. RH

Dan E. Pomeroy

"Holding the Line": William Gilbert Gaul as a Military Artist

When a writer visited the New York studio of William Gilbert Gaul in 1898, she discovered a place filled with uniforms and an assembly of swords crossed over the mantelpiece, while the dining room ceiling was dominated by a circle of muskets.[1] This martial display would have surprised no one familiar with Gaul's reputation, which rested on art portraying military glory and sentimentality. More particularly, the American Civil War was at center stage in his military art, and he seemed to have a special sympathy for those who struggled for the Lost Cause of the South. Gaul was, as one critic observed in the 1980s, "one of those artists caught up in a desire to recall what to him had been the region's greatest glory."[2]

The man whose brush treated the Lost Cause with such tenderness was born in New Jersey, in 1855, six years before the Civil War began. As a child he must have been transfixed by a romantic fascination with "the war," and his Tennessean mother's affection for the Confederacy undoubtedly had an effect on him.[3] All of this must have been pivotal in his decision to enter Claverack Military Academy with hopes of pursuing a naval career. His fragile health, however, soon discouraged him from that ambition.

Gaul turned his considerable talents to art, and well before the age of thirty he had established himself as one of America's premier military artists. He was trained in his craft at the National Academy of Design, where he was elected to full academician standing in 1882, the youngest member ever to achieve this coveted status. During these early years he produced his share of sentimental genre paintings, but it is not surprising that his three submissions to the academy at the time of his election were all Civil War works. *Charging the Battery* was sold for a record price of $1,500, while *The Stragglers* and *News from Home* were acquired for the permanent collection of the academy. In that same year he was awarded the gold medal from the American Art Association for *Holding the Line at All Hazards*, a tribute to the tenacious commitment of the Confederate soldier.

Ironically, while Gaul was achieving his greatest success in New York, he was taking up residence in the backwoods of Tennessee. He had inherited some land in Van Buren County from an uncle, but the uncle had stipulated that Gaul must live on the land for four years

to gain title to the property. Gaul and his wife gamely moved into a crude log cabin, far from the conveniences of any city, and from 1881 to 1885 an outbuilding served as his studio. As soon as his required tenure in Van Buren County was over, Gaul and his wife moved back to New York, but he would return to Tennessee, first from 1891 to 1894 and again from 1904 to 1910.

When he arrived back in New York in 1885, Gaul found a steady demand for his military art, and his reputation continued to flower. His work was used to illustrate a series of articles on the Civil War in *Century Magazine*, and three of his paintings were engraved as frontispieces when the three-volume *Battles and Leaders of the Civil War* was published in 1887. During this time Gaul himself was traveling throughout the West, probably seeking solace after his wife died in a tragic accident in New York. He lived among the Sioux and on army bases, experiences that resulted in a number of canvases sympathetic to the Indians. In 1889 he won another medal at the Paris Universal Exposition for *Charging the Battery*.

His return to Tennessee in 1891 again coincided with a highlight of his career. He was awarded a bronze medal at Chicago's World's Columbian Exposition in 1893 on the strength of two entries, the already well-received *Charging the Battery* and *Silenced*. The quality of the competition reflects well on Gaul, since his work was pitted against more than a thousand other paintings from more than two hundred artists, including Thomas Moran, James McNeill Whistler, Louis Tiffany, Winslow Homer, William Merritt Chase, and Childe Hassam. The next year, in 1894, he again left Tennessee for New York, but he found it difficult to support himself through his art because the buying public was increasingly attracted to other artists and movements.

Gaul sought refuge in Tennessee, arriving about 1904, accompanied by a new wife who reflected his lifelong affinity for the military. She was the daughter of a vice admiral in the British Navy, and she later served as a model for the mother in two of his most famous Civil War paintings, *Leaving Home* and *Tidings from the Front*. Gaul divided these Tennessee years between Van Buren County and downtown Nashville, where he set up a studio and gave art lessons.

Despite the fact that Gaul's public popularity was declining, this period is associated with some of his most significant Civil War art. In 1907 *Confederate Veteran* magazine announced that a group of Nashvillians had formed a company and commissioned Gaul to produce a series of paintings depicting "the courage, sacrifice, sufferings, and home life of the Confederate soldier," and then to sell prints of the works.[4] Among the twelve major canvases that resulted are *Waiting for Dawn, Glorious Fighting,* and *Nearing the End.* In one, *Between the Lines,* Gaul painted himself as a Union soldier trading with Confederates.

The plan to sell prints met with little success, and the project seems to have been abandoned. In 1910 Gaul left Tennessee for the final time, leaving his twelve paintings in Nashville and eventually selling them to the owner of the Hermitage Hotel. Gaul himself continued to work, but with less and less public acceptance, it was a struggle to make ends meet. He died of tuberculosis in New Jersey in 1919.

It would be a disservice to remember Gaul only as a Civil War artist. Even his interest in militaria was not confined to the Civil War and, in addition to his works on the Native American, he was an illustrator, genre painter, and landscapist. There are modern critics who believe that his Barbizon-style landscapes represent his finest work.[5] But Gaul's fame will probably continue to rest primarily on the strength of his military art and, more precisely, on his efforts to capture the heroism and pathos of the American Civil War.

NOTES

1. Jeanette L. Gilder, writing for *The New Outlook* in 1898, as cited in Josephine Murphy, "Gilbert Gaul in Tennessee," *Nashville Tennessean Magazine,* September 4, 1949, 12.

2. Rick Stewart, "Toward a New South: The Regionalist Approach, 1900 to 1950," in *Painting in the South, 1564–1980,* ed. Ella-Prince Knox, exh. cat. (Richmond: Virginia Museum of Fine Arts, 1983), 107.

3. Louise Davis, "Rare Paintings Back 'Home' at Cheekwood," *The Tennessean,* October 23, 1983, F-1.

4. Murphy, "Gilbert Gaul in Tennessee," 13.

5. Estill Curtis Pennington, *Look Away: Reality and Sentiment in Southern Art* (Spartanburg, S.C.: Saraland Press, 1989), 27, and James Hoobler, *Gilbert Gaul: American Realist,* exh. cat. (Nashville: Tennessee State Museum, 1992), 6.

147 · **WILLIAM GILBERT GAUL**
 b. Jersey City, New Jersey 1855–
 d. Ridgefield Park, New Jersey 1919

 Following the Guidon, 1898
 Oil on board; 18⅛ × 13¾ in.
 First Tennessee Heritage Collection

ALTHOUGH HE WORKED DECADES after the Civil War, William Gilbert Gaul is best known for his images depicting scenes, mostly imaginary, from the conflict. This painting—executed *en grisaille,* a method of painting only in shades of gray—depicts a young soldier on horseback bravely holding up the standard, leading the way as the battle rages on. A casualty of the conflict lies in the lower right corner of the picture. KDW

148 · **WILLIAM GILBERT GAUL**
b. Jersey City, New Jersey 1855–
d. Ridgefield Park, New Jersey 1919

Waiting for Dawn, 1903
Oil on canvas; 32 × 44 in.
Birmingham Museum of Art; Gift of John Meyer

WAITING FOR DAWN is one of a series of twelve paintings commissioned by Nash-villians that "[depicts] the courage, sacrifice, heroism, sufferings, and home life of the Con-federate soldier during the Civil War." The painting's limited color palette—punctuated only by red blankets and the orange glow of campfires and a house burning in the distance—and spare composition create a somber aura that may reflect the soldiers' growing sense of hopelessness after a harrowing battle. KDW

Jack Becker

PAINTING IN TENNESSEE, 1865–1920

BETWEEN 1865 AND 1920 AN INCREASING NUMBER OF TENNESSEANS PURSUED PAINTING as a vocation, and a number of institutions were formed that fostered the creative spirit of the state and its residents. Instruction in the fine arts had been limited in the state until the dawn of the twentieth century, when there were more opportunities for fledgling artists. For example, the Newman School of Art and the Watkins Institute in Nashville as well as the University of Tennessee offered instruction for amateurs and professionals during this period. Expositions, such as the Tennessee Centennial of 1897 in Nashville and the Appalachian Exposition of 1910 and 1911 in Knoxville, included fine arts displays that introduced the latest aesthetic trends to audiences across the state. Simultaneously several organizations that encouraged the arts were established, among them the Knoxville Art Circle (1898, later the Nicholson Art League), the Nashville Art Association (1883), the Centennial Club (1894), the Art Study Club in Chattanooga (1913), and the Memphis Art Association (1914). In May 1916 the Memphis Memorial Art Gallery opened, and other museums across the state would soon follow. It comes as no surprise that painting blossomed in the state with the development of an educational and support system for the visual arts.

The range of styles and subjects pursued by artists in Tennessee of the late nineteenth and early twentieth centuries reflects the broader development of American art and culture. During this period American painting underwent dramatic and profound changes. For example, increasing numbers of Americans studied abroad in the academies and ateliers of Paris and other European cities. Those who would emerge as the leading painters in Tennessee at the end of the nineteenth century benefited from European sojourns, which provided them with solid training as well as an introduction to world-class art collections. Many painters turned to landscape for inspiration, but the close observation of nature favored by midcentury artists began to fade. Instead, radical attitudes toward landscape painting, first from the French Barbizon painters and later from the Impressionists, revitalized how American artists depicted the natural world. Those artists engaged with figurative subjects presented a range of approaches as well. Some took their subjects from religious or classical themes, working in an academic tradition, whereas others were inclined to depict scenes of everyday life here in Tennessee, treating them in a style inspired by French Realist painters. Still others turned to the time-honored subject of still life. Although abstraction became a viable means of expression for many avant-garde American artists of the early twentieth century, it had little impact on painters here. Instead, artists worked in a modified Impressionist style experimenting with the effects of color and light.

Regardless of the decade, or the style, several artists turned to the natural beauty of Tennessee for inspiration. One of the state's most dramatic regions, where the Tennessee River cuts through the Cumberland Mountains, was the subject of the most significant Tennessee landscape painting of the nineteenth century. Although the artist Alexander Helwig Wyant would become best known for his late landscapes characterized by somber tones, heavily layered paint, expressive brushwork, and an introspective view of nature, his 1866 *Tennessee* represents an important benchmark in his career. Inspired by the artist's firsthand account of this location, Wyant executed the painting while in Europe as a student under the tutelage of the Norwegian painter Hans Fredrik Gude. Wyant had visited the region outside Chattanooga in the 1850s or 1860s while spending time in Frankfort, Kentucky, and must have taken sketches from America with him to Europe. Gude's teaching paralleled midcentury taste,

John Stokes, *Wedding in the Big Smokies, Tennessee*, 1872, detail, cat. no. 150

199

and he stressed a style that fastidiously depicted the facts of the natural world in a large panoramic format. Wyant's expansive landscape emphasizes the deep gorge produced by the river passing through the Cumberland range. Elder Mountain is to the right of the river gap and Signal Mountain to the left. Rejected from an exhibition in London, the painting was displayed at the 1866 spring annual of the National Academy of Design in New York, but it met with little critical success. For many, panoramic views of an abundant, peaceful landscape no longer represented America in the aftermath of the Civil War. New attitudes toward painting and the representation of nature would inform future generations of landscape artists in Tennessee.

Although Wyant drew his inspiration from the beauty of the Tennessee landscape, his career was centered in New York City, and he had little impact on painting in the state, leaving it to others to define Tennessee's artistic legacy during the nineteenth century. Born in Jonesboro, Washington Bogart Cooper, for example, became one of the most prolific Tennessee artists of that century. With few educational opportunities available for an aspiring artist in Tennessee, Cooper, like others who would follow him, went elsewhere for study, spending a year in Philadelphia under the instruction of John Inman. Returning to Nashville in the 1830s, Cooper applied his craft to capturing the likeness of the gentry and elite of Tennessee for fifty years. His 1878 portrait of Ellen Thomas (the daughter of John W. Thomas, president of the Nashville, Chattanooga, and St. Louis Railroad) characterizes his work. Cooper portrays his model in a brightly colored dress set against a stock architectural backdrop complete with flowers and an urn. The fecundity of the setting, and the fact that Ellen holds a flower in her left hand, strikes a chord with the viewer, when it is realized that this is a posthumous portrait, probably created as a reminder for the family of the daughter who passed away while still young.

Portraits were not limited to family members, and several artists documented captains of industry and civic pride. The Memphis-born artist Charles Pinkney Stewart depicted four leaders of Memphis during the 1880s as well as the construction of a new post office in the city as seen from the intersection of Main and Madison Streets. In *Four Men on a Corner,* Stewart rendered the likeness of David Park Hadden, at the far left, who was de facto mayor of the city; Napoleon Hill, to the right, made a fortune in business and was among the founders of Union Planters National Bank. Next to Hill stands Henry Arthur Montgomery, who was involved in the cotton business and established the city's first power plant, and at the far right is Archibald Wright, an attorney who served on the Tennessee Supreme Court. Although lacking the finesse of an academically trained artist, Stewart captured the likeness of four influential civic citizens at an important time in the history of Memphis.

The next generation of painters in the state benefited from formal training in the art academies of leading American and European cities. Like Americans from other parts of the nation, these young artists headed to New York, Philadelphia, Paris, and other cities in search of training and exposure to the latest trends and great art collections. The Tennessee native Adelia Lutz, for example, studied at the Corcoran Gallery in Washington, D.C., the Pennsylvania Academy of the Fine Arts in Philadelphia, and in France before returning to Knoxville, where she became director of the Knoxville Art Club. Lutz was known for her flower studies, landscapes, and portraits such as that of a girl with a black ribbon. At the other end of the state, Memphis's most noted nineteenth-century artist was Carl Gutherz, who spent the majority of his career in France. After studying at the École des Beaux-Arts in Paris and other European academies, Gutherz discovered in the early 1870s that he was unable to make a living in Memphis. He taught in St. Louis before returning to Paris to live the life of an expatriate artist. His 1888 *Light of the Incarnation,* created in Paris, exemplifies his academic training and his interest in Symbolist imagery. Allegorical subjects like this did not find favor in Tennessee, and Gutherz would have to look for support in Paris or other major cities during his career.

Robert Loftin Newman shared Gutherz's fascination with historical and religious subjects, but he pursued them in a dramatically different and highly individualistic manner. Newman grew up in Clarksville, where he began painting in the 1840s, and few paintings from his years in Tennessee survive. He is best known today for his small-scale works that frequently explore religious subjects, such as *Mother and Child.* Newman had the opportunity to study with several leading French painters including Thomas Couture and Jean-François Millet. During his lifetime, Newman's work was appreciated and supported by a small circle of friends and admirers, many of whom helped the artist financially. In *Mother and Child* and other paintings, Newman achieved remarkable color effects, defining his forms vaguely and working in a loose technique. Like his contemporary Albert Pinkham Ryder, Newman stood outside the mainstream of American art of the late nineteenth century.

Other artists interested in figurative themes discovered subjects closer to home in Tennessee rather than in the pages of history books or the Bible. For example, the painting *Women at Work* by Lloyd Branson demonstrates an approach to a figurative subject radically different from that of Gutherz or Newman. Branson chose as his theme common labor and imparted a dignity to the strain of these working women. During his career in East Tennessee, Branson pursued local subjects such as this one that were depicted in a manner influenced by the French Realist painter Gustave Courbet and others. One of the earliest artists to study at the National Academy of Design in New

York in the early 1870s, Branson received an award that enabled him to travel to Europe. While in France he saw the work of French Realist painters and the work of the Barbizon School, a group of French painters who depicted the rural landscape close to Paris. One of the most significant Tennessee artists of this period, Branson made other valuable contributions to the arts of the state through his leadership of the Nicholson Art League in Knoxville and his teaching of several artists including Catherine Wiley and Adelia Lutz. Another artist, George Chambers, also studied in Europe but, like Branson, drew his inspiration from the rural agricultural traditions of the South. Chambers discovered a distinctly American scene in the countryside of Tennessee, depicting an elderly woman standing in a cabbage patch in his *In the Tennessee Mountains.*

In Nashville, Gilbert Gaul also turned to subjects suggestive of everyday labor in Middle Tennessee. An artist of national stature, Gaul first came to Tennessee in 1881 after inheriting a small farm in Van Buren County. He would eventually teach at the Watkins Institute and would frequently depict scenes of historical importance and local interest, such as *Rafting on the Cumberland River.* Gaul illustrates logs tied together as a raft floating downriver to lumber mills, and in doing so celebrates Nashville's predominance as a center for hardwood lumber.

Although many artists chose to paint landscape and figurative scenes, frequently they turned to still life or other genres. Such is the case with Willie Betty Newman, an artist closely connected with Nashville who had a far-reaching reputation during her lifetime as a painter of many subjects. Originally from Murfreesboro, Newman studied in Cincinnati, Ohio, before attending the Académie Julian in Paris, a school popular with Americans. Like others of her generation, Newman was smitten with French culture, that of Brittany in particular, and drew heavily on her knowledge of this region for her figurative subjects. She received recognition in the 1890s and exhibited several times at the Paris Salon. Newman painted the elegant *Still Life: Pewter Pitcher and Cherries* while in France. In 1912 she returned to the United States and settled in Nashville, where she eventually opened her own art school.

Artists in Tennessee, as in other regions of the country, were affected by the rise of Impressionism and plein-air painting, that is, painting out-of-doors directly in front of nature. Although artists had sketched in the open air before, greater emphasis was placed on completing an entire painting while outside, and in the belief that these works were the equal of landscapes and figure subjects produced in the studio. Instead of the smooth surfaces and firm outlines employed by an earlier generation of painters, those artists inspired by Impressionism used, to varying extents, pure, prismatic colors unmixed on the palette and laid directly on the canvas, creating thick,

impasto-laden surfaces. While depicting everyday subjects, these artists employed intense color and active brushwork to give the illusion of flickering light and atmosphere in their paintings.

One of the finest Tennessee artists to work in an Impressionist style was Anna Catherine Wiley. Raised in Knoxville, Wiley left her hometown in 1903 for study at the Art Students League of New York. By 1905 she had returned to Knoxville to teach art in the Home Economics Department of the University of Tennessee. Wiley continued her education by enrolling in summer courses in the East with Robert Reid and other noted painters who introduced her to Impressionism. The garden, with its bright and varied palette and dappled sunlight, became a standard subject for Impressionist painters including Wiley, who captured a mother and child amid flowers on a sunny day. Domestic subjects were popular with many Impressionist artists such as the little-known James Harry Goodrich, who also rendered an intimate moment of a mother reading to her child. Goodrich had studied in Chicago and at Harvard University and would later teach at Fisk University in Nashville.

Painting appears to have come naturally to Ella Sophonisba Hergesheimer, a descendant of one of the nation's earliest and most influential artists, Charles Willson Peale. Her studies at the Pennsylvania Academy of the Fine Arts with Cecilia Beaux and the American Impressionist William Merritt Chase led to her being awarded a Cresson fellowship for study in Europe. In 1907 Hergesheimer received a commission in Nashville to paint the portrait of Bishop Holland M. McTyeire, the Methodist clergyman who had persuaded Cornelius Vanderbilt to endow the school that would become Vanderbilt University. Finding that she enjoyed Nashville, she established residence in the city and over the next three decades painted many leading citizens as well as landscapes and still lifes. In *Redbud Time at Olde Belle Meade Mansion,* she portrays the vivid colors of spring at one of the most important historic homes in Nashville.

Reflecting on painting in Tennessee between the years 1865 and 1920 provides an opportunity to consider the transformation of the visual arts in the cultural life of the state and its residents. Painters in Tennessee depicted a variety of subjects in a range of styles, from landscape to portraiture and from historical themes to scenes of everyday life. During this period a large number of artists benefited from the growing educational system in the United States and the opportunity of foreign study. From their study, artists gained insights into new attitudes toward subject matter and the latest stylistic trends. Although Tennessee painters reflected the larger currents of American art and culture, certain paintings illustrate landscapes, themes, and individuals that are distinctive to the state. In their depictions of Tennessee, these painters contributed to a rich artistic legacy for Tennesseans to celebrate a century later.

149 · **ALEXANDER HELWIG WYANT**
b. Tuscarawas County, Ohio 1836–
d. New York, New York 1892

Tennessee, 1866
Oil on canvas; 34¾ × 53¾ in.
The Metropolitan Museum of Art, Gift of
Mrs. George E. Schanck in memory of her
brother Arthur Hoppock Hearn, 1913 (13.53)

THIS PAINTING DEPICTS "the Grand Canyon of the Tennessee," where the Tennessee River cuts through the Cumberland Mountains. Visible in the distance is the gap between Signal Mountain and Elder Mountain and, farther beyond, the Chattanooga Valley. As in the paintings of the Hudson River School artists working in New York State, the details are sharply defined and the style highly finished, but the subdued coloration and atmosphere resemble the pictures of the French Barbizon painters. It is not known when Alexander Wyant was in Tennessee, but he worked in Kentucky in the 1850s and early 1860s. KDW

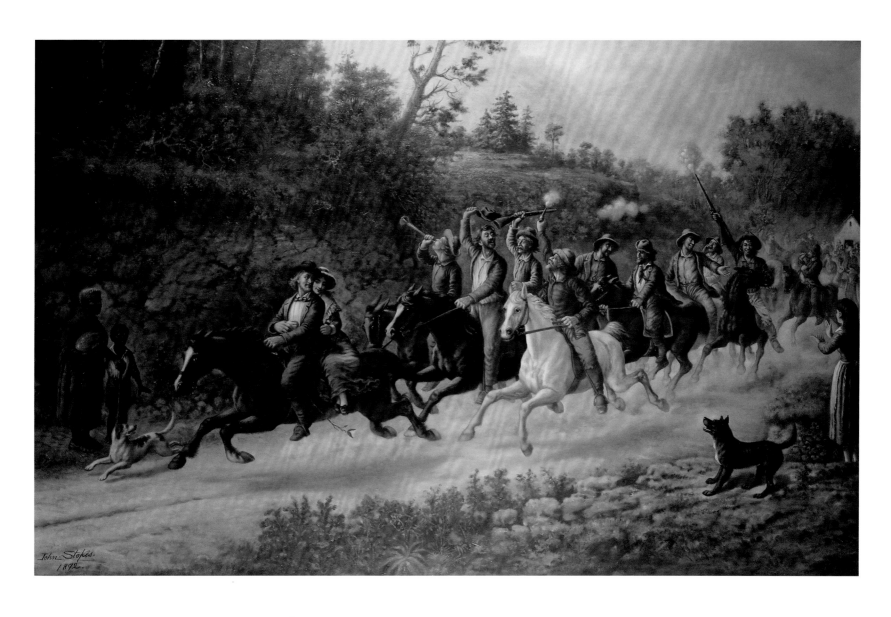

150 · JOHN STOKES

Active 1864–81

Wedding in the Big Smokies, Tennessee,
1872
Oil on canvas; 33 × 53 in.
Tennessee State Museum Collection, 83.75

THIS PAINTING DEPICTS a shivaree, an old mountain custom that took place immediately after a wedding ceremony. The celebrants would pursue the bride and groom, making every conceivable manner of noise—shouting, banging pots, firing guns, ringing bells, and so forth—until the bride and groom bought off the noisy serenaders by providing food and drink. TSM

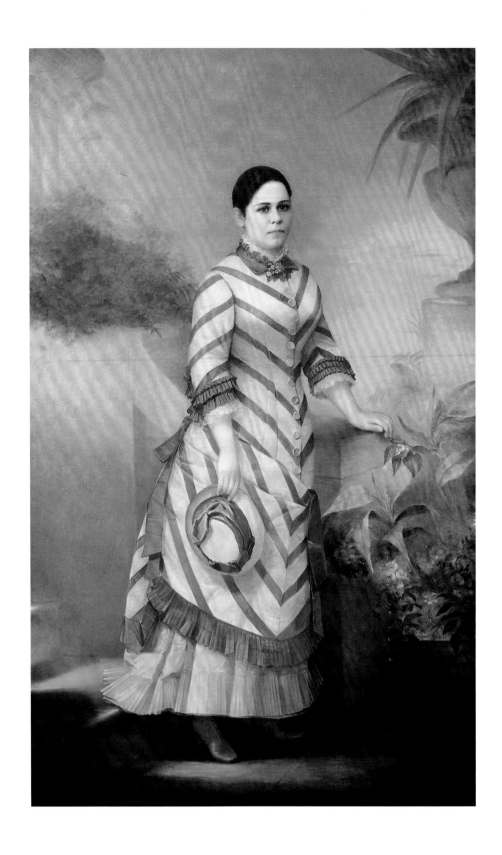

151 · **WASHINGTON BOGART COOPER**
 b. Washington County, Tennessee 1802–
 d. Nashville, Tennessee 1888

Portrait of Ellen Thomas, 1878
Oil on canvas; 78½ × 47 in.
Private Collection

THIS LATER WORK BY the well-known Nashville portraitist Washington Bogart Cooper depicts the daughter of Elizabeth and John W. Thomas, president of the Nashville, Chattanooga, and St. Louis Railroad. The family's wealth is reflected in Ellen's fashionable dress, hat, and shoes. Sadly, Ellen died in October 1878 at the age of sixteen, and this portrait was painted posthumously as a memorial to the young girl. KDW

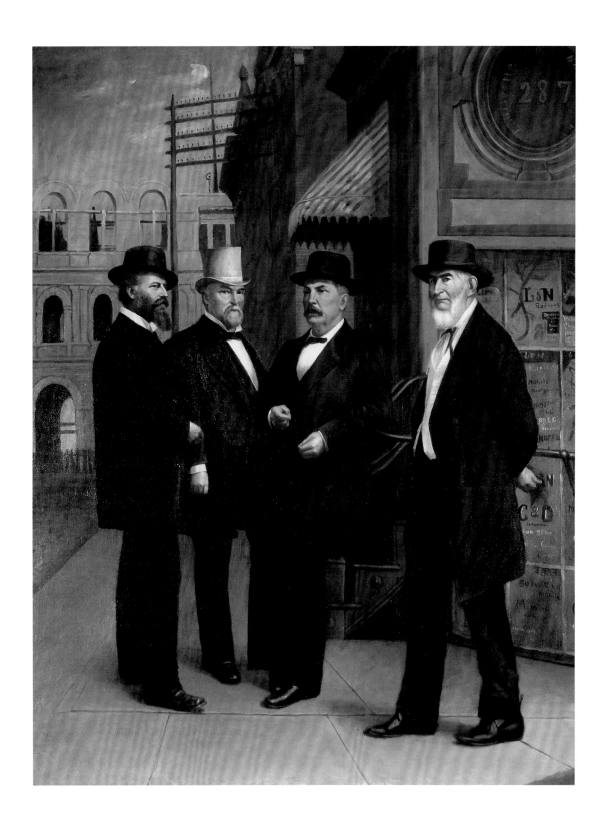

152 · CHARLES PINKNEY STEWART
b. Memphis, Tennessee 1849 or 1850–
d. Memphis, Tennessee 1892

Four Men on a Corner, ca. 1880
Oil on canvas; 52 × 41½ in.
Association for the Preservation of Tennessee
Antiquities, Woodruff-Fontaine House

IT IS NOT KNOWN WHETHER Charles Stewart received formal artistic training, although one account states that he may have studied under George Caleb Bingham in Missouri. From 1880 to 1890 Stewart was listed as a painter in the Memphis city directory. Four prominent Memphis businessmen are depicted in this painting: David Park Hadden, a former mayor of the city; Napoleon Hill, one of the founders of Union Planters National Bank; Henry Arthur Montgomery, owner of several cotton compresses and founder of Montgomery Park, now the site of the Memphis Fairgrounds; and Archibald Wright, an attorney who served on the Tennessee Supreme Court. The men are depicted standing at the intersection of Main and Madison Streets looking toward the new post office. KDW

153 · **ROBERT LOFTIN NEWMAN**
b. Richmond, Virginia 1827–d. New York,
New York 1912

Mother and Child, 1890
Oil on canvas; 12¾ × 10¼ in.
Collection of the Cheekwood Museum of Art,
Nashville, Tennessee, Gift of Mrs. Walter Sharp,
1974.7.18

ROBERT LOFTIN NEWMAN began his career as a self-taught portraitist in Clarksville, Tennessee. His later works, though, focus on mythological and biblical subject matter in a style that is often compared with the moody Gothic symbolism employed by his friend Albert Pinkham Ryder. In this mystical image of Mary holding the Christ child, the figures appear to float in a spiritual place, the colors glowing in the darkness. The Virgin's shimmering red dress and the child's golden halo seem to emit their own light within the surrounding darkness. KDW

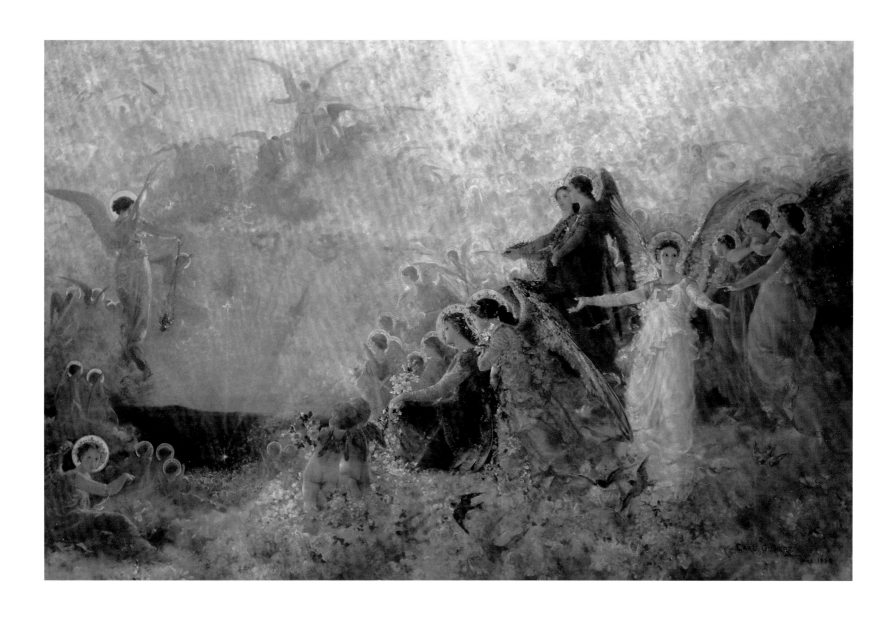

154 · **CARL GUTHERZ**
 b. Switzerland 1844–d. Philadelphia,
Pennsylvania 1907

Light of the Incarnation, 1888
Oil on canvas; 77 × 114 in.
Memphis Brooks Museum of Art, Memphis,
Tennessee; Gift of Mr. and Mrs. Marshall F.
Goodheart, 68.11.1

THE SWISS NATIVE CARL GUTHERZ moved to Memphis with his family in about 1860, when he was sixteen. While studying art on a return trip to Europe, Gutherz became inspired by works from the High Renaissance. Gutherz combined Christian concepts with allegorical imagery to depict the moment of the birth of Christ. The religious, mystical quality of the painting reflects the nineteenth-century Symbolist aesthetic, which promoted a spiritual approach in art—the primacy of the soul and imagination over the empirical world. MBM

155 **ANN ADELIA ARMSTRONG LUTZ**
 b. Jefferson County, Tennessee 1859–
 d. Knoxville, Tennessee 1931

Untitled, 1890
Oil on canvas; 11⅝ × 9⅝ in.
Diana and Robert Samples Collection

AFTER STUDYING at Miss Pegram's School in Baltimore, Mary Baldwin's College in Virginia, the Corcoran Gallery in Washington, and the Pennsylvania Academy of the Fine Arts in Philadelphia, Adelia Lutz returned to Knoxville in 1887 and became a successful artist and leader in the arts community. As was typical of many of Lutz's portraits, the languid pose and dreamy expression of the young woman seen here create a poetic image of reverie rather than an actual likeness of a particular individual. KDW

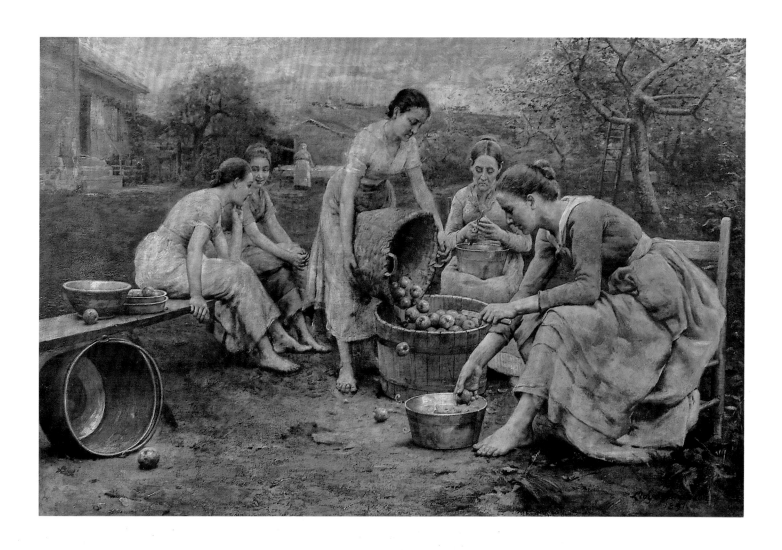

156 · **LLOYD BRANSON**
b. Union County, Tennessee 1854–
d. Knoxville, Tennessee 1925

Women at Work, 1891
Oil on canvas; 29½ × 44½ in.
Collection of Namuni Hale Young

LLOYD BRANSON STUDIED ART outside the state, first in New York City at the National Academy of Design and then in Europe. This scene was painted when he returned to Tennessee, and it demonstrates the influence on Branson of the Barbizon School, a group of artists in France that specialized in landscapes and pastoral genre scenes. Three barefooted farm women are preparing the apples, while two younger girls appear distracted from the task at hand, lost in their whispers and laughs. KDW

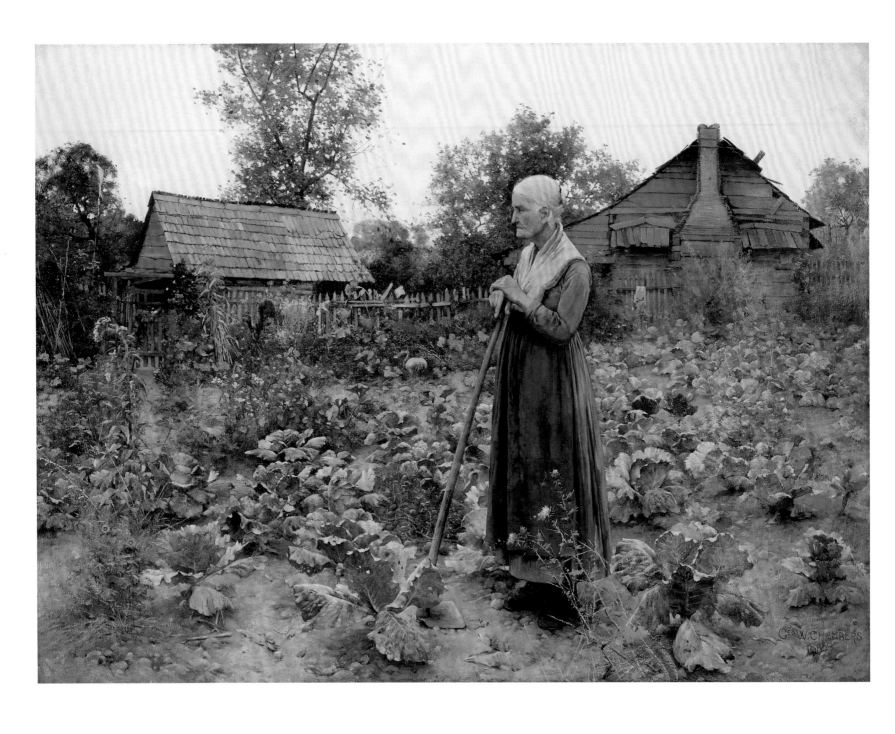

157 · **GEORGE W. CHAMBERS**
b. St. Louis, Missouri; active 1880s–90s

In the Tennessee Mountains, 1887
Oil on canvas; 47 × 63 in.
Tennessee State Museum Collection, 89.108

ALTHOUGH GEORGE CHAMBERS STUDIED under such masters as Jean-Léon Gérôme and Jules Dupré in Paris, he later drew his inspiration from agricultural traditions found in the post–Civil War Southern countryside. This work, probably painted near Monteagle, depicts an elderly woman pausing as she hoes a cabbage patch. A run-down cabin and shack stand behind the weary worker, yet one senses her pride in the land and her labor. *In the Tennessee Mountains* was exhibited at the Art Institute of Chicago's Second Annual Exhibition of Paintings in 1889, where it was awarded second prize, and at the Pennsylvania Academy of the Fine Arts in 1891. KDW

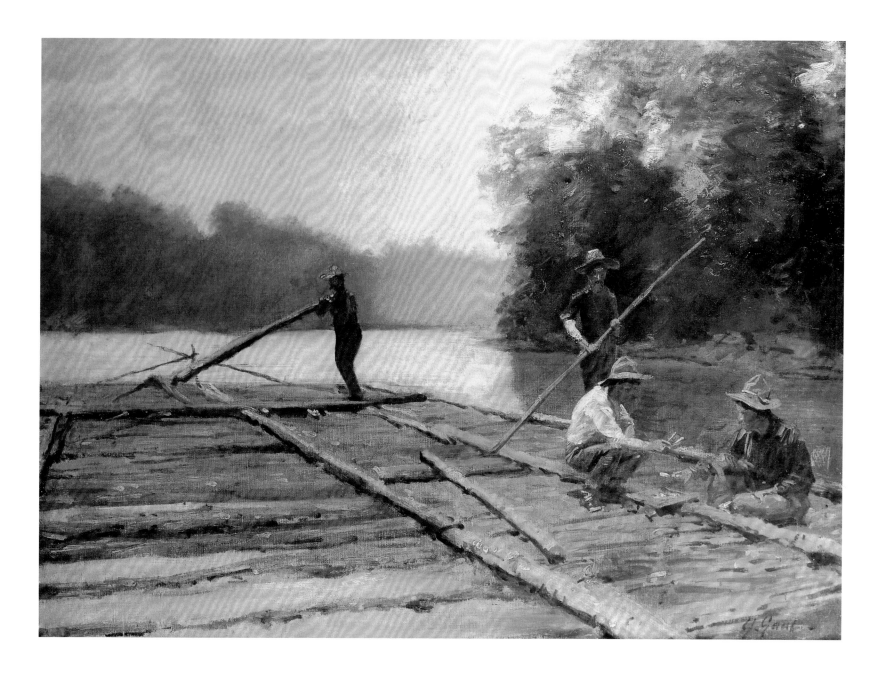

158 · **WILLIAM GILBERT GAUL**
 b. Jersey City, New Jersey 1855–
 d. Ridgefield Park, New Jersey 1919

 Rafting on the Cumberland River,
 ca. 1905–10
 Oil on canvas; 18 × 24 in.
 Tennessee State Museum Collection, 82.142.6

THIS PICTURESQUE, MARK TWAIN–LIKE scene depicts an aspect of the logging industry on the Cumberland River at the turn of the last century, a period in which Middle Tennessee was considered the hardwood capital of the world. To transport the fallen trees to the lumber mills, logs were often tied together, forming rafts that could easily be floated downriver. Here Gaul depicts two standing men steering the vessel while two younger workers are seated, engrossed in a game. KDW

159 · **CORNELIUS HALY HANKINS**
b. Guntown, Mississippi 1863–
d. Nashville, Tennessee 1946

Still Life with Onions, 1902
Oil on canvas; 20¼ × 28 in.
Collection of Cooper, Love & Jackson, Inc.,
courtesy of Stanford Fine Art

CORNELIUS HANKINS STUDIED ART in St. Louis with the leader of the Ashcan School, Robert Henri, and in New York with William Merritt Chase. Their influence is evident in Hankins's visible brushwork and the sense of dignity he gave to everyday, humble subject matter. Hankins moved to Nashville in 1904 and supported himself primarily through commissioned portraits. However, his skill in depicting the layered skin of these onions and the soft light that falls over the dark pantry attests to his sensitivity to a variety of subjects. KDW

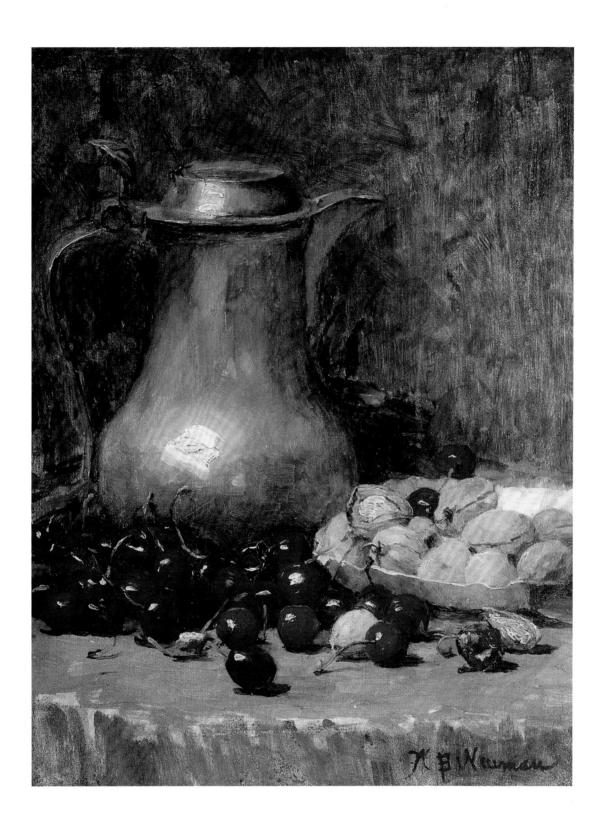

160 · **WILLIE BETTY NEWMAN**

b. Murfreesboro, Tennessee 1863–
d. Nashville, Tennessee 1935

Still Life: Pewter Pitcher and Cherries,
ca. 1890s
Oil on panel; 15⅜ × 12 in.
Collection of Ben and Gertrude Caldwell

AFTER ATTENDING ART SCHOOL in Cincinnati, Willie Betty Newman was awarded a scholarship to the Académie Julian, in Paris. She remained in Paris for twelve years, during which time she exhibited eight paintings at the Paris Salon, a testament to her skill as an artist as well as her determination to succeed as a woman in the male-dominated art establishments. Her paintings, influenced by French academic painting and, to a lesser extent, Impressionism, often show scenes of everyday life, as in this still-life painting of a modest pewter tankard surrounded by cherries and pecans. Newman moved to Nashville permanently in 1902. With few opportunities for artists in the postwar South, she relied on portrait painting for the remainder of her career. SS/KDW

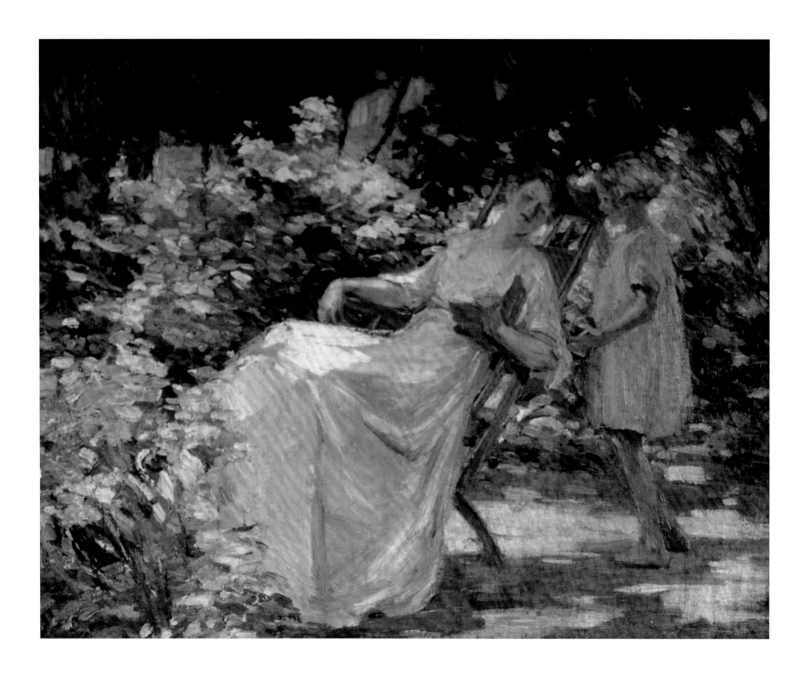

161 · **ANNA CATHERINE WILEY**
 b. Coal Creek (now Lake City), Tennessee
 1879–d. Philadelphia, Pennsylvania 1958

Mother and Daughter in Garden
Oil on canvas; 23½ × 29½ in.
Calvin M. McClung Historical Collection,
Knox County Public Library

IN 1903 ANNA CATHERINE WILEY left Tennessee to study at the Art Students League in New York. Although she returned to Knoxville in 1905 to teach, she later took summer classes with Robert Reid, an Impressionist renowned for his use of brilliant color. As did many other American Impressionists, Wiley favored genteel subjects, such as women, with or without children, in softly lit interiors or lush, flower-filled gardens. This work shows Wiley's sensitivity to the nuance of atmosphere as a reflection of mood, as the patches of light imbue the subjects with a warm glow, but one tempered with a feeling of melancholy. MWS

162 · **JAMES HARRY GOODRICH**
b. Colon, Michigan 1878–d. date unknown

Mother and Child
Oil on canvas; 27¼ × 19½ in.
Collection of Stanford Fine Art

LITTLE IS KNOWN ABOUT the Michigan-born painter James Harry Goodrich other than that he studied in Detroit, Chicago, and Cambridge, Massachusetts, and that he taught at Fisk University for a time. In this lovely painting, a mother and child sit quietly reading in a lush garden. The bright colors, loose brushwork, and sensitive lighting indicate that Goodrich was influenced by Impressionism. KDW

163 · **ELLA SOPHONISBA HERGESHEIMER**

b. Allentown, Pennsylvania 1873–
d. Nashville, Tennessee 1943

Redbud Time at Olde Belle Meade Mansion, Nashville

Oil on canvas; 28 × 38 in.
Collection of Cooper, Love & Jackson, Inc.,
courtesy of Stanford Fine Art

ELLA HERGESHEIMER WAS THE great-great-granddaughter of the accomplished Philadelphia artist Charles Willson Peale, who founded the Pennsylvania Academy of the Fine Arts. In 1907 she was commissioned to paint a portrait of Bishop Holland M. McTyeire, the man who had convinced Cornelius Vanderbilt to endow the school that became Vanderbilt University. Hergesheimer settled in Nashville, and she painted many still lifes and landscapes there—such as this impressionistic view of the stately Belle Meade Mansion on Harding Road—in addition to portraits. KDW

164 · **RUDOLPH INGERLE**
 b. Vienna, Austria 1879–d. Highland Park,
 Illinois 1950

 October in the Smokies
 Oil on canvas; 20 × 24 in.
 Collection of Cooper, Love & Jackson, Inc.,
 courtesy of Stanford Fine Art

RUDOLPH INGERLE MOVED to the United States in 1891 and began to study at the Art Institute of Chicago in 1895. Although he is well known as an Illinois landscape painter, he also painted in the Missouri Ozarks, Brown County, Indiana, and the Smoky Mountains of Tennessee. As the title of this painting suggests, Ingerle has skillfully captured the warm sunlight and golden foliage of a fall afternoon in the Smokies. The reflection of the tree-covered mountain in the still water of a pond reinforces the mood of reverie. KDW

Celia Walker

TWENTIETH-CENTURY FIGURATIVE AND NARRATIVE ART

As I write now, painting movements, aesthetic attitudes in the colleges, and critical rationalizations in the press, along with collectors' interests, are even more tied to Parisian turn-of-the-century thinking than they were before Wood, Curry, and I came to our American positions. Our influence on the young is negligible. An imported 'aesthetic' is, at least for the moment, again very generally a mere imitative manifestation in America.

—*Thomas Hart Benton*

As the great Regionalist painter and teacher Thomas Hart Benton stated in 1969, America's love for figurative art ebbed and flowed throughout the twentieth century. However, representational art has never lost its power to inspire Tennessee's artists. Southern artists frequently have a strong connection to their home state that is detectable in their work. In the first quarter of the twentieth century, figurative art began to free itself from the nineteenth-century tradition of academic Realism taught in the country's art institutions. Inspired by the examples of modern European art during this period, Americans broke slowly with Realism and developed a looser brushstroke and brighter palette. But if European avant-garde art inspired many of America's painters to explore different painting techniques, the connection to place characterizes the artists of Tennessee.

A great contributor to the outpouring of narrative art in the 1930s was the Works Progress Administration (WPA) and other government-sponsored art programs. Figurative art, particularly in the form of Regionalism (the celebration of distinct regional characteristics), found a powerful patron in the Roosevelt administration. This movement's nostalgic view of life in rural America became a propagandistic tool in the hands of government programs like the WPA that were designed to advance art appreciation and provide jobs during the Great Depression. Work shown in the 1939 New York World's Fair, such as Meyer Wolfe's lithograph *The Conversation* (which is related to the painting of the same name in this exhibition), were depictions of regional genre that were chosen to represent the individual states.

Social Realism, a critical examination of the lower classes and the social conditions that led to the perceived decay of their environment, also gained recognition in the 1930s. Although painted in the 1950s, Avery Handly's *The Segregationist Motorcade Stops at the Marmaduke Café in Winchester,* which relates to a Ku Klux Klan march in Pulaski, is a good example of Social Realism, while Lewis Hine's *A Group of Nashville Newsies* is an important precedent. During the Depression, many of the principal figurative painters of the 1920s and 1930s were teaching in the country's art schools. Thomas Hart Benton, John Sloan, Grant Wood, and others encouraged young artists like Joseph Delaney and Avery Handly to look to their own homes when choosing their subjects. Benton's *The Sources of Country Music* (1975), which tells the story of traditional Southern music, is an excellent, if much later, example of the expressive narrative painting that these young artists would see in the classrooms of schools like the Art Students League in New York, where Benton taught for nine years and where many of the South's painters studied.[1]

As abstraction became popular in the late 1940s and 1950s, artists felt pressure to stop creating work in what was progressively viewed as an outdated style. Art critics, art historians, and museum professionals actively

Carroll Cloar, *Where the Southern Cross the Yellow Dog,* 1965, cat. no. 172

219

encouraged artists to reject figurative art as a style that had lost its significance in the modern age. A number of painters who attempted to reconcile the values of modern art within the figurative tradition were at times reviled or applauded for their efforts. Some, like Handly, married Cubist technique with narrative subjects to create a uniquely crystallized composition. Others, like Carroll Cloar, combined formal interpretation and flatly painted figurative subjects to create striking juxtapositions and surreal, dreamlike images. Often, these hybridized canvases were grouped under the rubric Expressive Figuration. Occasionally, they were defined as Magic Realism, a combination of Surrealism and photographic Realism.

Cloar achieved national acclaim for his paintings that combined an experimental painting technique (many of Cloar's paintings make use of small dots of paint in a technique akin to Pointillism; others juxtapose areas of flat paint to give the disjointed feeling of collage) and traditional subject matter. Yet even Cloar's hybridized narrative was too traditional for some. In 1968 the New York critic John Canaday blasted Cloar for his use of what he termed "picturesque genre": "Picturesque genre is doubly taboo and, to make things even worse yet, this painter lives down in Tennessee where what used to be thought of as picturesque is now seen as evidence of American society's social cancer."[2] Canaday rejected Cloar's Surrealist technique as an attempt to make genre palatable to sophisticated audiences in the 1960s. Few understood the difficulties of working with an approach that was considered outdated. As the Memphis critic Guy Northrop wrote, "Perhaps it took courage for [Jackson] Pollock to break away from tradition. Today it requires equal courage for men like Cloar to hold to tradition while building on it."[3]

Another artist who juxtaposed flat and expressive brushstrokes to achieve an unsettling Surrealism was William Sawyer. Sawyer was a highly successful artist during the 1960s who abandoned painting in the 1970s to pursue other interests. During his brief career as a painter, Sawyer produced a number of small, detailed paintings that focus on life in Nashville, of which *Kelly's Barber Shop* is an example. Sawyer's technique combined intricate foreground brushwork, often in the bricks and boards that made up the neighborhood buildings, with a rich, mottled background. Together, the two styles created a surreal character, in much the way that Cloar's flat and patterned brushwork did.

A few years his senior was Werner Wildner, whose surreal and precise compositions became increasingly macabre as the years progressed. Although Wildner has worked in Tennessee for most of his life, his art has drawn inspiration from his place of birth, in Witten, Germany. Even though the works in this exhibition reflect Wildner's ability as a Magic Realist, his work frequently veers into the grotesque, earning him comparison with the sixteenth-century artist Hieronymus Bosch, whose scenes of hell and of life gone awry are memorable for their precise detail and vivid imagery. "I've always liked the grotesque and the erotic, the odd and the horrible. I just got a pencil and out it came."[4]

The figurative tradition has remained strong in American sculpture, experiencing a peak in the years following the Civil War, when many sculptors were commissioned to represent war heroes, to the period of the Vietnam War, and it has recently seen a revival of interest among proponents, albeit with mixed results. Philbrick McLeod Crouch worked in Tennessee but drew his inspiration from outside the state. Crouch was one of a handful of Tennessee artists who produced figurative sculpture in the twentieth century and one of the very few to cast his work in bronze. Crouch's subjects were typically birds and figures, such as *Prelude*, which was exhibited in the 1941 Whitney Annual Exhibition of Contemporary American Sculpture, Watercolors, Drawings and Prints, although he also worked in a non-objective format.

If Crouch's muse originated in modern aesthetics, Avery Handly Jr. was inspired by the contemporaneous literary movements of his native Nashville. Handly was a gifted artist stimulated by his home state and the literature of the Southern Agrarians to paint bold narrative scenes of life in and around his home in Winchester, Tennessee. After graduating from Vanderbilt University, Handly studied under two of the most important Regionalist painters of the century, first under Thomas Hart Benton at the Kansas City Art Institute, then with Grant Wood at the University of Iowa. Their belief in the value of regional genre reinforced the Agrarian theory that Handly had learned as an undergraduate.

Handly painted and exhibited throughout the 1940s and until his death in 1958. But Regionalism fell out of favor in the major art centers in the late 1940s and 1950s, and Handly felt that figurative painting was being marginalized. As he wrote to his friend the artist Gus Baker, "The very fact that in between the fluctuations of aesthetic entities such as: cubism, dadaism, expressionism, etc. as they replace each other on the public walls a short run of realism is in order to keep the others furnished with just enough material to maintain a status of revolt."[5]

The careers of two brothers raised in Knoxville represent the struggle of competing styles. Joseph and Beauford Delaney took different paths in their art, one working as a figurative painter, the other gradually working toward complete abstraction. Their successes and failures reflect the pressure to assimilate in a time when art was seen as developing on a linear path from Realism to Abstraction.

Born in Knoxville, Joseph Delaney studied with Alexander Brooke, George Bridgeman, and Thomas Hart Benton at the Art Students League in New York between 1930 and 1933. Benton's fierce independence and love of the American scene, his expressive drawing and bright palette, influenced Delaney: "Somehow Benton's influence and my own background merged.... I was interested in preserving my religious background and also maybe just New York City itself."[6] Benton encouraged Delaney to paint his own environment, and Delaney took the message to heart, devoting a sixty-year career to the depiction of life in America.

The artist made occasional visits home over the years and was celebrated with a retrospective exhibition at the Ewing Gallery of Art and Architecture at the University of Tennessee, Knoxville, in 1986. But he never achieved the international fame of his older brother, Beauford, whose mature work was based in abstraction.

Beauford Delaney left Knoxville and, following studies in Boston, moved to New York City in 1929 at the beginning of the Great Depression. There he studied at the Art Students League under John Sloan and Thomas Hart Benton. Sloan had a studio in Greenwich Village, an area where Delaney would eventually establish residence, and he was working in an experimental technique in his etchings, characterized by patterns of lines that echoed the shapes of his subjects. This modernist device relates to the brushstroke patterns of Delaney's later paintings, such as his 1964 portrait of the photographer Ahmed Bioud. The art critic Jean Guichard-Melli described this technique as "movements of internal convection."[7]

Delaney arrived in New York during the years of the Harlem Renaissance, when government funding and private philanthropic organizations like the Harmon Foundation were actively sponsoring African American artists. But although Delaney was involved in these activities, working with Charles Alston on the WPA-sponsored *Negroes in Medicine* mural at Harlem Hospital (1936) and exhibiting at the Harmon shows (1933–35), his modernist paintings were out of step with the prevailing scenes of African American life of the 1930s and 1940s.[8] He left on vacation for Paris in 1953 in an attempt to experience the cultural life that generated the Cubists and Post-Impressionists and did not return for twenty-six years. It was in Paris that Delaney felt the freedom to paint, as the city was open to African Americans. There he mingled freely with French artists as well as with the many Americans, like the Tennessee photographer Ed Clark, who spent time in Paris. Beauford Delaney's late work became increasingly abstract, and today he is well known for his lyrical abstraction, while his brother Joseph has yet to receive national attention.

New York and Paris have been the inspiration for another Tennessean, Red Grooms. Grooms's watercolor *Times Square in the Rain* shows with expressive wit the vibrant energy of central Manhattan, while *Dans les Metro* is a sympathetic portrayal in three dimensions of a spry Frenchwoman on the subway. Born and raised in Nashville, Grooms moved to New York City, which would become a primary focus of his career in such multimedia installations as *Ruckus Manhattan*. Whether his subject is Manhattan or Paris, Grooms brings to his caricatural work warmth, humor, and empathy that are never cynical or cruel. Perhaps Grooms has the advantage of being always the outsider, the Southerner who can look at his subjects with an objective eye.

Like Grooms, Meyer R. Wolfe was raised in Tennessee, and he spent a large part of his adult life in New York. He studied in New York City at the Art Students League, where he worked under the urban realist John Sloan. Wolfe later commented, "Without doubt John Sloan was the most inspired and inspiring artist with whom I have ever had any contact."[9] Sloan's enthusiasm for urban life and his love of teaching made him an ideal mentor for the young Wolfe. Like Sloan, who had started out as a newspaper illustrator, Wolfe worked for the newspapers while studying in New York. Wolfe and his wife, the photographer Louise Dahl-Wolfe, settled in New York about 1930, and Meyer spent the next fifty years exhibiting his paintings, prints, and drawings around the world. He frequently returned to Nashville to paint and exhibit his work. His preference for African American subjects, as seen in *The Conversation*, was unusual for the period. Most white artists who were painting blacks in the 1930s and 1940s were using servants as models. Racial caricatures were still commonly found in the country's newspaper and magazine illustrations. Wolfe painted African Americans with sensitivity and as real people involved in the daily life of the city.

It was Wolfe's insider's viewpoint that allowed him to create powerful images of all aspects of life in Nashville at midcentury, a role often taken by photography. But most of the photographers in this exhibition were not from the South, and they brought an outsider's view to their depictions of the region. Photographers like Lewis Hine and Ben Shahn inventoried the South like ethnographers tracking a dying species. It would only be later, in the images of Ed Clark and William Eggleston, that the photographic story of the South would be told from the insider's perspective.

Sense of place is a critical factor in the works in this exhibition. Some artists, like Red Grooms and Joseph Delaney, were Southern outsiders looking into another region or country. This viewpoint gave them an objectivity that allowed them a different perspective on narrative interpretation. Others, like Avery Handly, Carroll Cloar, Bill

Sawyer, and Meyer Wolfe, looked into their own region and produced highly individual canvases that combine universal themes with unique perspectives. Still other figurative artists—Philbrick Crouch, Werner Wildner, and Beauford Delaney—drew inspiration from an international perspective. Like Benton, they worked within a tradition that was often reviled as outdated and unsophisticated. However, all treated their subjects with respect in a way that was not always visible in the work of their more avant-garde contemporaries.

Notes

Epigraph: Thomas Hart Benton, *An American in Art: A Professional and Technical Autobiography* (Lawrence: The University Press of Kansas, 1969), 174–75.

1. Rick Stewart, "Toward a New South: The Regionalist Approach, 1900 to 1950," in *Painting in the South, 1564–1980,* ed. Ella-Prince Knox, exh. cat. (Richmond: Virginia Museum of Fine Arts, 1983), 121.

2. John Canaday, "Art: Serene and Tortured TV," *New York Times,* April 20, 1968, 29.

3. Guy Northrop, "Carroll Cloar's Show at Brooks Displays Belief in Art with Ideas," *The Commercial Appeal,* undated, from "Cloar, Carroll," Tennessee State Museum Artist Files.

4. Alan Bostick, "Inside the World of Werner Wildner," *The Tennessean,* June 3, 2001, 4.

5. Gus Baker, ed., *Avery Handly Memorial Exhibition of Paintings,* exh. cat. (Nashville: The Parthenon, 1960), 26.

6. Sam Yates, *Joseph Delaney: Retrospective Exhibition,* exh. cat. (Knoxville: University of Tennessee Ewing Gallery of Art, 1986), n.p.

7. As quoted in David Lemming, "Beauford, Abstraction, and Light," *Beauford Delaney: Liquid Light: Abstractions, 1954–1970,* exh. cat. (New York: Michael Rosenfeld Gallery, 1999), 7.

8. Ibid., 5.

9. Clara Hieronymus, "Meyer Wolfe Returns 'Home' in Show," *The Tennessean,* November 18, 1979, 1E, 4E.

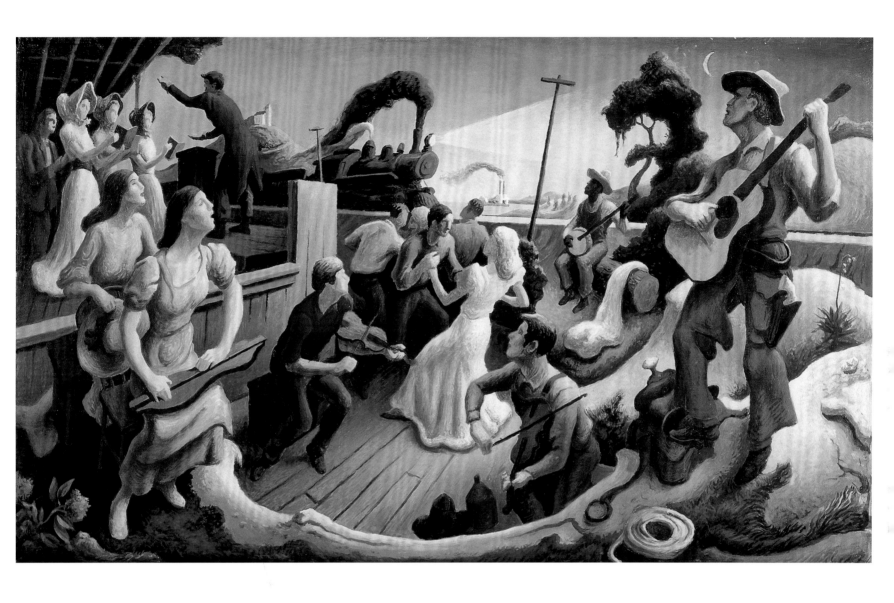

165 · THOMAS HART BENTON

b. Neosho, Missouri 1899–d. Kansas City,
Missouri 1975

*Study for "The Sources of Country
Music,"* 1973–74

Oil on panel; 14¾ × 24¼ in.
Country Music Hall of Fame and Museum,
88.59.10. © T. H. Benton and R. P. Benton
Testamentary Trusts/Licensed by VAGA,
New York, NY

IN 1974 THE COUNTRY MUSIC FOUNDATION commissioned the noted Regionalist painter Thomas Hart Benton to create a large-scale mural for display in the Country Music Hall of Fame and Museum. Benton drafted numerous pencil sketches, detailed studies, and even a three-dimensional maquette of the scene in preparation for this important—and what would turn out to be his last—project. This study is the closest one to the final work and includes all of the characters that Benton chose to represent the origins of country music: a church choir, singing cowboy, dulcimer player, square dancers, and African American banjo player. KDW

166 · **MEYER WOLFE**

b. Louisville, Kentucky 1897–
d. Nashville, Tennessee 1985

The Conversation, ca. 1930s
Oil on panel; 19½ × 23 in.
Collection of Dr. and Mrs. Lawrence K. Wolfe

MEYER WOLFE'S EXPERIENCE as a newspaper illustrator in New York in the 1920s seems to inform his painting *The Conversation,* because its narrative context is not readily apparent, the work could easily be a visual accompaniment to a story. The artist depicts two African American women deeply engrossed in a discussion of a topic unknown to the viewer. The disturbed facial expression of the woman on the left, the withdrawn postures of both women, and the dark palette contribute to the ominous mood of the scene, implying that the women's conversation concerns something portentous. The influence of Wolfe's teacher John Sloan, a member of the Ashcan School, which is known for exploring urban genre painting in the twentieth century, is evident here. LT

167 · **AVERY HANDLY JR.**

b. Nashville, Tennessee 1913–
d. Winchester, Tennessee 1958

The Segregationist Motorcade Stops at
the Marmaduke Café in Winchester,
1955
Oil on canvas; 35¼ × 44½ in.
Collection of Walter and Sarah Knestrick

IF AVERY HANDLY JR. was stimulated by the philosophy of the Agrarians who championed the South in poetry and prose, he was staunchly opposed to the segregationism that remained prevalent in the South throughout the 1950s and into the 1960s. With its bright palette and caricature-like imagery, this depiction of a motorcade of segregationists eating at the Marmaduke Café in Winchester, Tennessee, en route to a rally is a sardonic commentary on the life of John Kasper, a leader of the Ku Klux Klan who was tried and convicted of sedition in 1956 in Clinton, Tennessee. CW

168 · **BEAUFORD DELANEY**

b. Knoxville, Tennessee 1901–d. Paris,
France 1979

Portrait of Ahmed Bioud, 1964
Oil on canvas; 39¼ × 32 in.
Courtesy of Michael Rosenfeld Gallery,
New York, New York

BEAUFORD DELANEY EARNED an international reputation for his expressive por-
traits, vibrant scenes of New York street life, and luminous abstractions. By 1964 the art-
ist was battling a form of mental illness in which he was haunted by voices. In response,
Delaney explored with a growing urgency what he saw as the healing power of pure color,
especially yellow. As his condition worsened, the artist's dense, swirling veils of brilliant,
often volcanic, color began to consume all references to the natural world. SW

169 · **JOSEPH DELANEY**
 b. Knoxville, Tennessee 1904–
 d. Knoxville, Tennessee 1991

Macy's Day Parade, 1974–75
Acrylic and mixed media on canvas;
81½ × 121⅛ in.
Knoxville Museum of Art, Knoxville,
Tennessee

LIKE HIS OLDER BROTHER BEAUFORD, Joseph Delaney found inspiration in Manhattan's bohemian climate. The lure of abstraction, however, was never strong enough to draw him away from his passion for the human figure and bustling scenes of street life. This work is characteristic of the artist's carefully observed, animated compositions made up of thinly applied, bright pigment brushed over loose underdrawing. The skull-like head of the central balloon and a group of unsavory-looking police officers introduce a sinister tone to the otherwise festive scene. SW

170 · PHILBRICK MCLEOD CROUCH
b. Burwin, Illinois 1911–d. Nashville, Tennessee 1999

Prelude, ca. 1940
Bronze; 30¾ × 16 × 17½ in.
Collection of Ned and Jacqueline Crouch

PHILBRICK CROUCH STUDIED SCULPTURE at the Beaux-Arts Institute of Design and the Art Students League in New York in the 1930s. Until World War II he created life-size bronze figures for several parks and gardens in New York. Crouch moved to Nashville in 1947 to work at the Children's Museum, serving as director from 1953 to 1970. *Prelude,* a sculpture in which the human form seems perfectly balanced and graceful, was included in an exhibition at the Whitney Museum of American Art in 1941. KDW

171 · **PURYEAR MIMS**

b. Nashville, Tennessee 1906–
d. Nashville, Tennessee 1975

Hertha, ca. 1962
Limestone; 31 × 11¾ × 8 in.
Collection of William Baucom and
Susan Spurgeon

AN ART PROFESSOR at Vanderbilt University from 1948 to 1972, Mims was influenced by the American modernist sculptor William Zorach, who created monumentally simple and blocky generalizations of the human figure. With bachelor's and master's degrees in literature, Mims often based his sculptures on characters found in a wide array of literary sources, including the Bible and mythology. Hertha is an ancient German name for Mother Earth. A primeval and constant being from which all existence sprang, this goddess is given voice in the first lines of Algernon Charles Swinburne's poem "Hertha," which read, "I am that which began; Out of me the years roll; Out of me God and man; I am equal and whole; God changes, and man, and the form of them bodily; I am the soul." MWS

172 · CARROLL CLOAR
b. Earle, Arkansas 1913–d. Memphis,
Tennessee 1993

*Where the Southern Cross the Yellow
Dog,* 1965
Casein tempera on Masonite; 23 × 33¾ in.
Memphis Brooks Museum of Art, Memphis,
Tennessee; Brooks Fine Arts Foundation
Purchase, 65.17. © Carroll Cloar Estate,
Patricia S. Cloar

THE TITLE OF THIS PAINTING comes from "Yellow Dog Blues," a song by the African American composer W. C. Handy, whose last line is "he's gone where the Southern cross the Yellow Dog." The "yellow dog" was another name for the Yazoo and Mississippi Valley Railroad. Even though it crosses the Southern Railroad in Morehead, Mississippi, this scene could be of any small town in the mid-South. Using bright colors, flat forms, and decorative patterns, Cloar created scenes like this, which capture memories of his Southern delta childhood. MBM

CARROLL CLOAR'S NARRATIVE PAINTINGS summarize life in the rural South. While demonstrating the reality of his own childhood, his paintings also have widespread, universal appeal. In this composition of delicate colors, set against the gray skies and the leafless trees of an early winter afternoon, a lone goose herder gathers and directs his flock at the end of the day—a scene probably witnessed numerous times by Cloar. DH-B

174 · **WERNER WILDNER**
b. Witten, Germany 1925–
lives Nashville, Tennessee

Man with Umbrella, ca. 1950–60
Oil on board; 13½ × 11 in.
Collection of Trudy and Will Byrd

WERNER WILDNER SETTLED IN NASHVILLE in the late 1940s and worked as a commercial artist before devoting his full efforts to fine art in the mid-1950s, about the time that this painting was created. The subject's gray trousers and hidden face suggest an anonymous businessman, quietly reminiscent of the subjects of René Magritte. CW

175 ^ **WERNER WILDNER**
b. Witten, Germany 1925–
lives Nashville, Tennessee

Nude with Rose, ca. 1962
Oil on board; 22 × 18 in.
Private Collection

NUDE WITH ROSE was exhibited in Wildner's 1962 two-person exhibition at the Tennessee Fine Arts Center at Cheekwood. Wildner left the background empty and black, which lends an air of mystery to the subject. Its bust-length format, though unusual to the modern eye, is reminiscent of Renaissance painting. The delicacy and transparency of the subject's veil attest to Wildner's skillful brushwork. CW

176 · RED GROOMS

b. Nashville, Tennessee 1937–
lives New York, New York

Dans les Metro, 1977
Gouache on paper; 37½ × 26 × 12 in.
Collection of Walter and Sarah Knestrick

RED GROOMS IS INTERNATIONALLY renowned for his expressive caricatures of people, usually depicted in their natural urban habitats. Among his most ambitious works are rollicking, giant, three-dimensional installations such as his 1975 *Ruckus Manhattan,* as well as the Tennessee Foxtrot Carousel in downtown Nashville. Here focused on one central figure, *Dans les Metro* is a sympathetic image of a fur-collared grande dame clutching her purse while riding the Paris subway. Constructed of paper painted with the delicate medium of gouache, the work has a lightness in keeping with Grooms's gentle humor. MWS

177 · **RED GROOMS**

b. Nashville, Tennessee 1937–
lives New York, New York

Times Square in the Rain, 1976
Gouache and watercolor on paper; 38 × 50 in.
Collection of Walter and Sarah Knestrick

OF ALL HIS SUBJECTS, the city and its inhabitants are favorites of Red Grooms's. With a populist style that evokes the cartoon illustrations of such artists as Saul Steinberg and R. Crumb, Grooms's expressive graphic distortions are well suited to convey the chaotic environment of New York, where he has lived since 1957. This densely rendered scene captures the constant movement of cabs as they twist and flow between the flashing neon signs in a rain-soaked Times Square. The painting was made especially for the Nashvillian Walter Knestrick, whose support had enabled Grooms to complete his oversize installation *Ruckus Manhattan.* MWS

178 · WILLIAM SAWYER
b. Nashville, Tennessee 1936–
lives Nashville, Tennessee

Kelly's Barber Shop, ca. 1970
Tempera on board; 14⅛ × 18⅛ in.
Collection of Mr. and Mrs. Charles W. Cook Jr.

THE SELF-TRAINED ARTIST Bill Sawyer began painting as a way to pass the time while serving overseas in the army. *Kelly's Barber Shop,* a scene from his hometown of Nashville, is typical of Sawyer's work, views of towns in which the details of buildings, streets, and sidewalks are precisely rendered. A dreamlike sense of stillness and abandonment arises from the presence of very few figures, in this case a disproportionately small black girl walking her pink pet. KDW

Katie Delmez Welborn

Celebrating the Human Spirit:
Nashville Murals by Aaron Douglas,
Ben Shahn, and Thomas Hart Benton

Throughout the *Art of Tennessee* exhibition are works produced by artists from outside the state who were drawn to Tennessee in pursuit of personal and professional opportunities—Ralph E. W. Earl from New England, George Dury from Bavaria, James Cameron from Scotland, and Lewis Hine from New York, among many others. Tennessee would be culturally diminished without the influence and contribution of these artists who brought with them new ideas and distinctive styles.

During the middle years of the twentieth century, three of America's most acclaimed artists—the Harlem Renaissance pioneer Aaron Douglas, the Social Realist Ben Shahn, and the Regionalist Thomas Hart Benton—were commissioned by civic and educational leaders in Nashville to create significant works of public art, in the belief that such projects would lend meaning and value to the texture of life in Middle Tennessee. Although not a part of this exhibition because of their permanent installation in buildings, these works occupy an important place in any discussion of Tennessee's artistic tapestry.

Aaron Douglas came to Tennessee at the behest of his friend and mentor, Charles S. Johnson, a major leader of the Harlem Renaissance. Johnson, extremely well connected within the national African American community, had been asked by the president of Fisk University, Thomas E. Jones, to recommend an artist for the creation of a series of murals for a new library building on campus. Johnson proposed Douglas, and in the summer of 1930 the already highly regarded illustrator and painter moved into the president's house to begin the monumental task, the first of many such public murals he would create. Douglas chose as his subject the history of African Americans in the New World. He hoped his murals would express and promote black identity and dignity, particularly within the young men and women—the future of the black community—who were seeking advancement through education.

The series begins in Africa, the ancestral homeland, and continues with scenes of captivity, slavery, emancipation, and eventual freedom. Advocating the importance of education, Douglas also depicted aspects of the liberal arts—poetry, philosophy, drama, music,

science—as well as classical representations of Night and Day. All of the scenes are painted in Douglas's signature style: silhouetted figures, flat forms, and radiating bands of light. Although today portions of the murals are no longer visible in what is now an administrative building, they continue to serve as both a tribute to this important individual—who returned to Fisk University to found the fine arts department, which he chaired from 1939 to 1966—and a source of pride in black heritage to all who view them.

Also situated in Nashville are several major works by Ben Shahn, an artist of international stature whose work is best known for its social commentary. In 1965 the George Peabody College for Teachers began planning the Human Development Laboratory as part of the new John F. Kennedy Center for Research on Education and Human Development. Dr. Susan Gray, a noted psychologist and chairperson of the building committee, believed that the laboratory should house an important work of art that would remind the faculty and students of the interconnectedness of all aspects of life. Gray stated: "In working with human development, we inevitably tend to study man by segments, and sometimes … forget the organic whole.… We must always remember our basic aim is to restore man to his totality."[1] Aware of Shahn's reputation as an artist committed to improving the condition of humanity through the visual arts, Gray was convinced he was the right artist for the project.

Shahn was familiar with Tennessee, having already created mosaics for the Congregation Oheb Shalom in Nashville (1959) and LeMoyne-Owen College in Memphis (1963). During a chance meeting with Gray at a conference and in subsequent visits by Gray to his home in New Jersey, Shahn was introduced to the project, which he enthusiastically accepted. The resulting mosaic mural contains a large golden face with spiraling eyes, tightly pursed lips, and radiating sunlike waves. Flanking this seemingly omniscient godlike force are two figures. One hangs upside down, limbs tangled and trapped within a complex labyrinth, unable to cope with the conditions of existence. The other stands erectly and firmly on a similar maze, demonstrating humanity's ability to conquer the confusing passageways through life.

A third mural in Middle Tennessee by an internationally acclaimed artist is *The Sources of Country Music,* painted by Thomas Hart Benton for the Country Music Hall of Fame and Museum. In 1973, at the suggestion of the songwriter and art collector Joe Allison and his friend the legendary singing cowboy Tex Ritter, the Country Music Foundation decided to commission a major work of art to celebrate the history of country music. Allison, Ritter, and Norman Worrell, executive director of the Tennessee Arts Commission and another contributor to the project, suggested Benton because they were aware of the well-known artist's own musical roots and interests, which are often reflected in his works. Worrell and Ritter described the venture to Benton in his home in Kansas City and, although the artist had given up large-scale murals, he accepted the commission. Benton immediately proposed that the mural depict the origins of the genre, before there were any stars and record deals. The resulting mural is a lively and successful combination of the numerous aspects that helped shape "America's music": a cowboy fiddler, church choir, black banjo player, dulcimer player, and several square dancers. In the distance a train and steamboat represent both the places where the music was originally played and its mode of transmission throughout the region.

Although physically unable to be included in *Art of Tennessee,* these three murals demonstrate that Tennessee was a meeting ground and crossroads for major visual artists. This tradition continues in such commissioned projects as Red Grooms's *Foxtrot Carousel,* completed in 1998 in Nashville's Riverfront Park.

At the dedication of the Shahn mural, a Peabody official stated that the commission had resulted in an "important addition to the cultural and artistic resources of our community."[2] The same sentiment applies to all the great works of public art in Nashville and throughout Tennessee.

NOTES

1. Jim Andrews, "Dr. Gray and the Great Golden Face," *The Nashville Tennessean,* October 5, 1969, 9.

2. Hollis A. Moore Jr., remarks at dedication ceremony for the mosaic, October 5, 1969, courtesy of Professor Vivien Green Fryd.

Aaron Douglas, *Philosopher,* ca. 1930. Section of mural series at Cravath Hall, Fisk University. Oil on canvas; 109 × 87 in.

Ben Shahn, b. Kovno, Lithuania 1898–d. Roosevelt, New Jersey 1969. *Peabody*, 1968. Mosaic; 108 × 144 in. Peabody College, Vanderbilt University, Nashville, Tennessee. © Estate of Ben Shahn/Licensed by VAGA, New York, NY

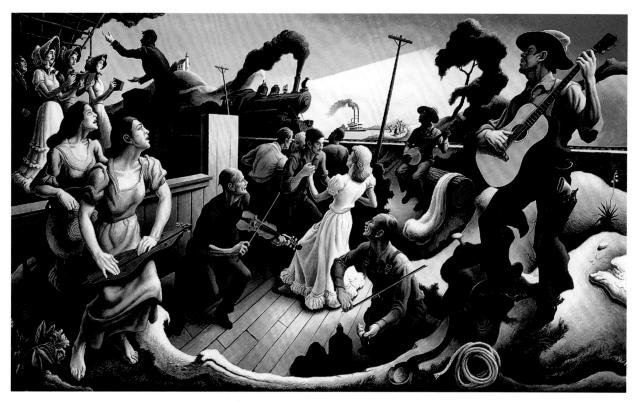

Thomas Hart Benton, *The Sources of Country Music*, 1975. Oil on canvas; 72 × 120 in. Country Music Hall of Fame Museum, Nashville, Tennessee. © T. H. Benton and R. P. Benton Testamentary Trusts/ Licensed by VAGA, New York, NY

John Wood

Structures of Recollection: Tennessee Photography as Document and Art

The photographs in this exhibition catalogue celebrate the medium's dual role as a documentation of particular moments in time and a means of aesthetic contemplation that rises above quotidian description. To best appreciate this integration of functions, it is instructive to consider the novelist Marcel Proust. Much of Proust's greatness derives from a vision of the world that parallels the unique aspects of photography. Proust turned his powers of perception into a complete theory of knowledge, a way of knowing and understanding the world around him. Both he and we, his readers, come to know things based solely on his meticulous watching. There is no moral comment; he is detached; his faith is in observation and description alone. Proust's genius derives from the purity of what he describes. Though his style is highly poetic, even ornate at times, his imagery has the pure, detached clarity of a photograph.

Similarly, photography's great power lies in its ability to document, to record a moment with precision, and then let the viewer "read" it, consider it, and interpret it. The greatest photographers know what to record and how to record it in such a way that mere documentation rises to the level of art. Look at Lewis Hine's *A Group of Nashville Newsies*…. A photographic historian cannot tell you anything about this photograph that you don't immediately see, know, and understand. Here are a bunch of poor, but proud—even cocky—newsboys, and we know that their lives were in many respects wretched. In fact, this was Hine's project—to expose the prevalence and effects of child labor throughout the country. But what is most interesting is how it is possible for us to end up knowing so very much about them and their lives from a single glance! We know because Hine, like Proust, was selective in what he recorded. It is through that selectivity that what might be nothing but documentation rises to the heights of art and grabs a moment from the random flow of time, preserves it, and flings it into the future so that it strikes us with poignancy and meaning. It is about finding what the great French photographer Henri Cartier-Bresson, who also found his way to Tennessee, called "the decisive moment."

Look at Cartier-Bresson's *Tennessee Family*. Again, what could a photographic critic or historian tell anyone about this photograph,

anyone with eyes and any knowledge of what life in the American South was like for black people when this image was made? Cartier-Bresson, again like Proust, caught the decisive moment that revealed everything, that told it all. But more important than merely understanding what *Tennessee Family* says to us is a consideration of what the image makes us feel. We look at those powerful, those enduring, women, we look at their wash on the trees, and we are so touched and moved by such a complex of emotions—pain, regret, guilt, anguish, admiration, and respect—that there is no word to describe it other than *art*.

What does a great work of art do to us but set into motion a flurry of thoughts and feelings? It operates on our mind, of course, but it primarily works on our heart because what it's finally all about is sympathy. Unless we feel that, the art fails. Cartier-Bresson understood that the artist—whether photographer, novelist, or poet—had to catch the instant that engaged the mind and captivated the heart. We can look at George Barnard's beautiful photograph *Nashville from the Capitol* and see that it is carefully and thoughtfully composed (cat. no. 140). The capitol itself on the left of the image occupies nearly a quarter of the photograph; Nashville sprawls out over three-quarters of it, and dead center and perfectly balanced are those enigmatic but grandiose lights. What are they doing there? Why did Barnard put them dead center? They obviously grab our attention, and when it is grabbed, we look more closely. And it is then we see those three cannons—ominous reminders of the lovely picture's real point—a war was ripping the country apart, and it had come home to Nashville.

Though many great photographers have wandered through Tennessee catching decisive moments—and one thinks of Ben Shahn in Tennessee as part of the Farm Security Administration's efforts to document the effects of the Great Depression, or Robert Frank, who came through the state as part of his photographic project that was published as the book *The Americans*—Tennessee has also produced great photographers. William Eggleston is perhaps the most prominent. The featured artist in the first exhibition of color photography at the Museum of Modern Art in New York, Eggleston captured the

life, everyday beauty, and undercurrents of tension of Memphis in the latter half of the twentieth century. Although he was born in Mississippi, Jack Spencer is another of Tennessee's most significant contemporary photographers, whose work is by any measure extraordinarily beautiful. One might ask, "Is a shirtless man, whose head you can't even see, holding a big fish in his hands, beautiful?" That, I guess, depends, but is Jack Spencer's *Man with Fish* beautiful? Yes! Absolutely! But why?

Beauty is a concern in any consideration of art but especially with photographs, because photographs, unlike statues, paintings, or symphonies, are everywhere. We can see hundreds in a single day if we read a newspaper and look at a magazine or two. We take them for granted. So what's beautiful and what's not? The same sympathy that operates on our hearts is still the operative word and is still operating on us but in a slightly different fashion. Sometimes what we are moved by is the content alone—what an image, like *Tennessee Family*, actually says—but at other times we are equally moved by the way in which something is said. One need not be a Puritan—or even a Christian—to be thrilled by John Milton's thundering blank verse in *Paradise Lost*. The *way* an artist speaks can be as powerful as *what* an artist says.

Look at Spencer's print. He achieves effects so rich, so fresh in color and tonality, effects that mix and complement what he has photographed, that *beauty* is the only word for it. I have looked at probably a hundred of Spencer's prints and I don't understand the content of a single one of them in the same way I understand it in photographs by Hine, Cartier-Bresson, or Barnard. But I have never seen one that did not excite my eye simply because of the way it was made, the way Spencer composed it and printed it.

A headless man might seem like a strange composition, but what if Spencer had shown us the man's head? His face would immediately have become the center of our focus and attention, not the bright, shimmering fish against the black body, not the mix of colors and tones. Spencer's message is of a different order from Hine's, Cartier-Bresson's, or Barnard's. It can't be neatly packed into a few words because his message is simply the photograph's beauty, the pure visual delight it gives us. He and many photographers like him are also voyeurs, but the decisive moment they are seeing and capturing is a moment of sheer visual joy, a moment that also speaks to our hearts, but through our eyes alone.

What both kinds of artists finally do, however, is something quite similar. Proust described it in *Du côté de chez Swann:*

When from a long-distant past nothing subsists, after the people are dead, after the things are broken and scattered, still alone, more fragile, more unsubstantial, the smell and taste of things remain poised a long time—faithful, persistent, vital— like souls amid the ruins waiting and hoping for their moment, souls in whose tiny, almost impalpable drop of essence beats unfalteringly the vast structure of recollection.

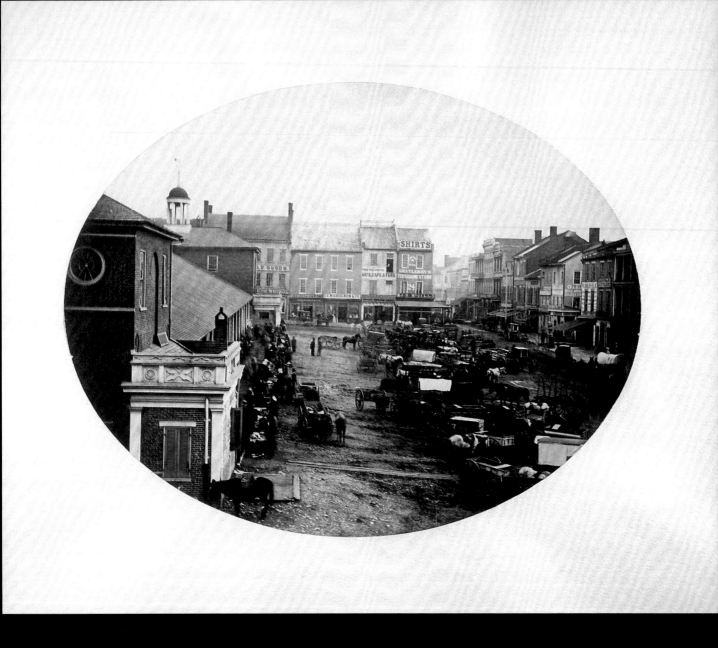

179 · *The Market at Nashville,* 1855
Salt print; 6⅛ × 8 in.
Tennessee State Museum Collection, 94.110

THIS PHOTOGRAPH, taken by an unidentified Belgian railroad entrepreneur who made two visits to North America, is likely the earliest photograph ever taken of a Tennessee city. The view is from the northwestern corner of the Public Square, looking south down College Street, which is now the corner of James Robertson Parkway and Third Avenue North. Built in 1829, the City Hall and Market was perhaps designed by David Morrison, who used domed classical temple forms on the roofs of several buildings in Nashville. The sign of one of Nashville's earliest photographers, Carl C. Giers, is visible on the other side of the market. TSM

180 · **LEWIS HINE**

b. Oshkosh, Wisconsin 1874 – d. Hastings-on-Hudson, New York 1940

A Group of Nashville Newsies. In middle of group is 7-year-old Sam. Smart and profane. He sells nights also. Nashville, Tenn., 11/13/1910, 1910

Gelatin silver print; 5 × 7 in.
National Archives, Washington, District of Columbia

LEWIS HINE TOOK APPROXIMATELY fifty thousand photographs in states from Maine to Texas while employed by the National Child Labor Committee. An educator with the School of Ethical Culture, Hine campaigned tirelessly to expose the industrial revolution's effect on the youth of our country. This photograph shows, with great sympathy and even subtle humor, a common aspect of child labor. Hine believed that hiring children to fill the surplus of jobs hurt the future workforce. Because many children worked from sunrise to sunset, the system endangered their health and deprived them of an education, rendering them useless as future workers. Hine's groundbreaking work played a crucial role in the implementation of child labor laws. BC

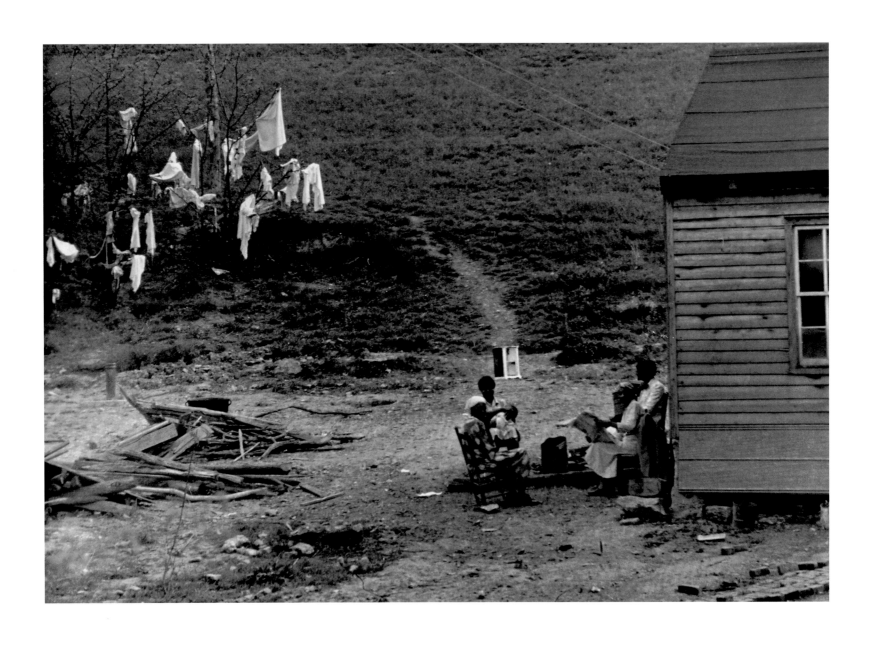

181 · HENRI CARTIER-BRESSON

b. Charteloup, France 1908–
lives Paris, France

Tennessee Family, ca. 1947
Vintage gelatin silver photograph; 6¾ × 9⅞ in.
Gift of the Roger Houston Ogden Collection,
The Ogden Museum of Southern Art, University
of New Orleans

THE PHOTOGRAPHER HENRI CARTIER-BRESSON coined the phrase "the decisive moment." This term refers to the exact moment that the photographer decides to release the shutter and expose the film—the moment when the composition, lighting, and event seem to be in perfect unison. Cartier-Bresson was never interested in photographing the rich or famous. Instead, he focused his attention on the working man, or the beauty and wonder found in everyday life. In *Tennessee Family,* Cartier-Bresson captures a small group of African American women performing the simple but arduous task of doing laundry. BC

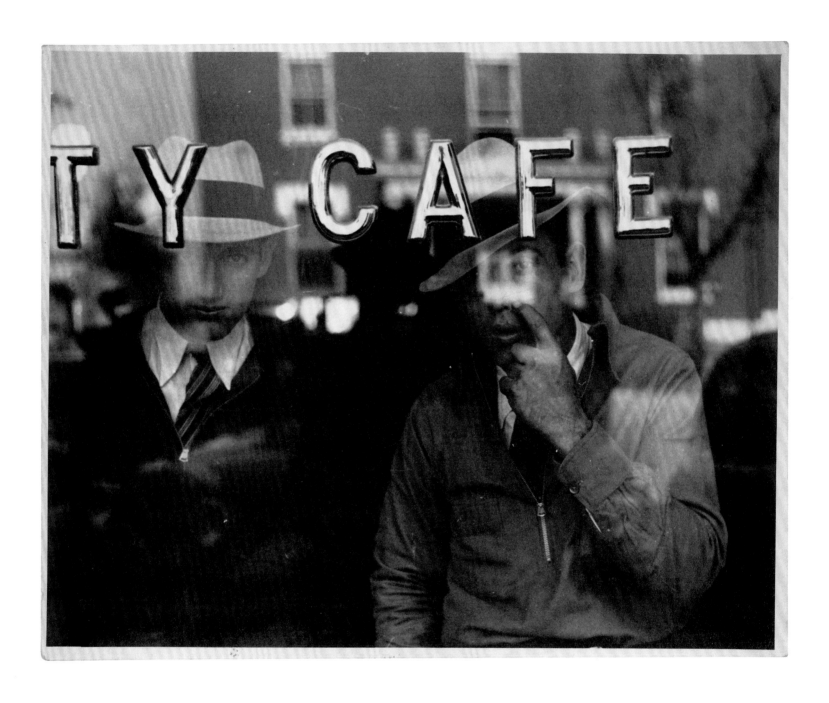

182 · **BEN SHAHN**

b. Kovno, Lithuania 1898–d. Roosevelt,
New Jersey 1969

Untitled (Murfreesboro, Tennessee), 1935
Gelatin silver print; 7⅝ × 9¾ in.
Courtesy of the Fogg Art Museum, Harvard
University Art Museums, Gift of Bernarda
Bryson Shahn, P1970.3121

THE RENOWNED GRAPHIC DESIGNER and painter Ben Shahn initially became interested in photography as a source of subject material for drawings and paintings. When he shared a studio with Walker Evans, the famed documentary photographer both encouraged and instructed Shahn in his study of photography. The child of a socialist Jewish family, Shahn was a political activist who photographed the immigrant population and the working class of a Depression-era America. From 1935 to 1938 he was employed by the Historical Section of the Resettlement Administration/Farm Security Administration. Using the newly popular 35mm Leica camera, he documented the people and places of the Midwest and rural South. BC

183 · ROBERT FRANK

b. Zurich, Switzerland 1924–
lives Mabou, Nova Scotia

Restroom in Memphis, 1955
Gelatin silver print; 8⅝ × 12⅞ in.
The Museum of Fine Arts, Houston; Gift
of Jerry E. and Nanette Finger, 84.129

Image not available for reproduction

A 1955 GUGGENHEIM GRANT enabled the Swiss émigré Robert Frank to travel throughout the United States, creating a photographic essay that still retains a capacity to shock the viewer with its candor. Photographing with a 35mm Leica camera, Frank captured a postwar America with unbiased eyes, documenting a side of the nation that up to that point had not been widely acknowledged. He unflinchingly captured instances of racial and sexual inequality, poverty, and other aspects of America's seamy underside. The photographs were published together in 1958 as the book *The Americans,* with an introduction by the Beat poet Jack Kerouac. Soon after its release, it became the most controversial and popular photography book of all time. BC

184 · DANNY LYON

b. Brooklyn, New York 1942–
lives Clintondale, New York

*Nashville, Tennessee, 1962, Sit-in,
Lester MacKinney, Bernice Reagon
and John O'Neal,* 1962
Gelatin silver print; 9⅛ × 13⅜ in.
The Museum of Fine Arts, Houston; Gift of
Michael and Jeanne Klein in memory of Willie
and Georgia Lindsey, 99.394

WHEN HE WAS STILL a twenty-year-old student at the University of Chicago, Danny Lyon became staff photographer for the Atlanta-based Student Nonviolent Coordinating Committee. Traveling through the South from 1962 to 1964, he captured the drama and emotional intensity of the civil rights movement, including this image of a Nashville sit-in by black activists. Lyon's body of work is widely regarded as the largest single-photographer collection to document the civil rights movement. In later years, he focused his camera on people and events outside mainstream experience, including series on motorcycle gang members, inmates in the Texas penitentiaries, and demolition derby drivers. MWS

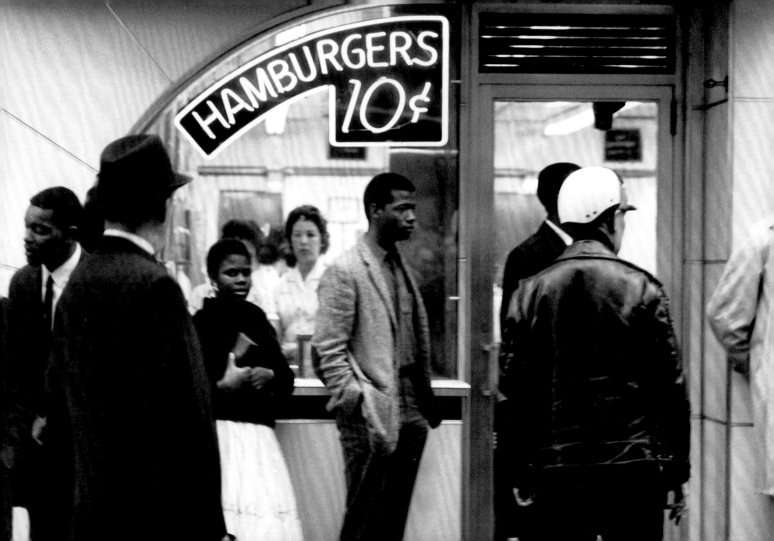

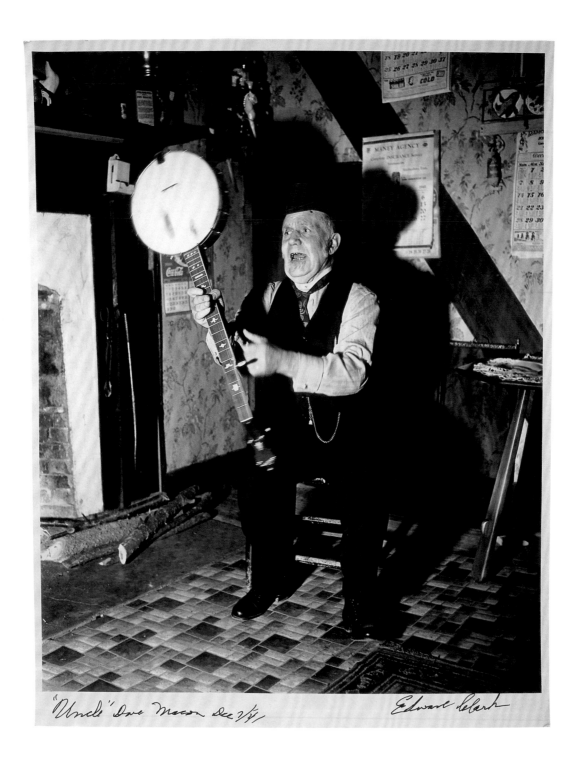

"Uncle" Dave Macon Dec 2/41 Edward Clark

185 · **EDWARD CLARK**
b. Nashville, Tennessee 1911–d. Nashville, Tennessee 2000

Uncle Dave Macon, modern print from 1941 negative
Fiber-based print; 14 × 11 in.
The Arts Company

ONE OF AMERICA'S PREEMINENT photojournalists of the mid–twentieth century, Ed Clark began working for the *Tennessean* newspaper in 1930. He was hired as a staff photographer for the new *Life* magazine in 1943, where he worked until 1962. Throughout his career, Clark created intimate portraits of American presidents and movie stars, memorable postwar series showing the Nuremberg Trials and life in Paris, and, closer to home, images of the stars of the Grand Ole Opry. This photograph of Uncle Dave Macon captures the playful character of the musician as he mugs with his banjo. This candid portrait shows Clark's ability to make his subjects feel comfortable in his presence. MWS

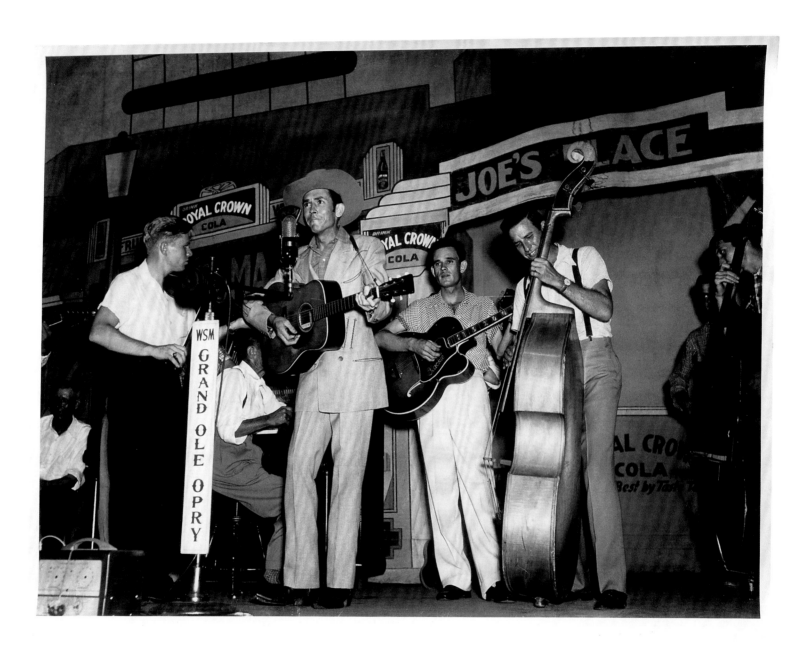

186 · **ROBERT GRANNIS**

b. Nashville, Tennessee 1921–
d. Nashville, Tennessee 1999

Hank Williams at the Grand Ole Opry,
modern print from ca. 1951 negative
Sepia-toned fiber-based print; 10⅞ × 13⅞ in.
The Arts Company

GRANNIS BEGAN HIS CAREER IN 1942, when he was assigned to be a photographer for the United States Army. In 1945 he returned to Nashville, where, for more than fifty years, he photographed visiting celebrities, prominent local citizens and important events, and the stars and performances at the Grand Ole Opry. His photograph of Hank Williams and his band shows the down-home atmosphere (as well as the evidence of Royal Crown Cola's sponsorship) on the stage of the famous Ryman Auditorium, from which performances of the Opry were broadcast across the nation. The famous musician is revealed in the photograph as having a magnetic stage presence equal to the power of his music. MWS

187 · **ERNEST C. WITHERS**
b. Memphis, Tennessee 1922–
lives Memphis, Tennessee

*The Two Kings, Elvis Presley and
B. B. King, Backstage at the WDIA
Goodwill Review, Memphis, Tennessee,*
1957
Gelatin silver print; 18 × 14 in.
Courtesy, Panopticon Gallery, Waltham,
Massachusetts

WITH HIS STUDIO BASED on the legendary Beale Street, the Memphis photographer Ernest Withers photographed the musical icons who lived or performed in his beloved hometown. Withers's images of performers like Ray Charles, Lionel Hampton, and Aretha Franklin captured the excitement of several generations of rhythm and blues, jazz, Motown, and rock musicians. Here we catch a rare glimpse of the two musical kings. In addition to photographing the musicians of the era, Withers is also considered the premier photographer of the civil rights movement. BC

188 · MICHEL ARNAUD

b. Grenoble, France 1944–lives Paris, France; London, United Kingdom; and New York, New York

Afternoon "Blues" at Tootsie's, 1996
C-print photograph; 10½ × 12⅞ in.
Courtesy of the artist

TRAINED IN FRANCE, MICHEL ARNAUD has attained renown as a fashion photographer in both Europe and the United States. From 1995 until 1999 he made more than a dozen trips to Nashville to photograph those he called the "pilgrims of guitar town." This image captures elderly tourists sitting through the parade of wanna-be country singers performing during an early afternoon set at Tootsie's Orchid Lounge on Lower Broadway in Nashville. RH

189 · **LOUISE DAHL-WOLFE**
b. San Francisco, California 1895–
d. Frenchtown, New Jersey 1989

Still Life, 1931
Gelatin silver print; 8 × 11 in.
Collection of Dr. and Mrs. Lawrence K. Wolfe

LOUISE DAHL-WOLFE PIONEERED the use of natural lighting in fashion photography while she was employed by industry giants like *Vogue* and *Harper's Bazaar.* Married to the Nashvillian Meyer Wolfe, Dahl-Wolfe frequently came to the city on visits to her husband's family. While in Nashville, she produced a well-known series of photographs of the folk artist William Edmondson. She also created subtle works like this still life, in which natural lighting from a window both illuminates the scene and creates a grid-like reflection that is a graphic contrast to the apples on the delicate round plate. The monogram on the knife indicates that it belonged to the prominent Nashville resident Elizabeth Lyle Starr. BC

190 ^ **WILLIAM EGGLESTON**
 b. Memphis, Tennessee 1937–
 lives Memphis, Tennessee

Memphis, 1975
Dye transfer print; 12 × 17½ in.
In the Collection of The Corcoran Gallery of Art,
Gift of Mr. Morris R. Garfinkle, 1987.30.3

THE RENOWNED CURATOR and photographic historian John Szarkowski said that the Memphis photographer William Eggleston is the "individual responsible for inventing color photography." Although Eggleston did not truly invent the process, he did elevate it to the status of fine art. The dye-transfer printing process allows Eggleston to achieve the rich, saturated colors that are his trademark. His large-format photographs of commonplace American scenes seem like snapshot views of Southern culture. In *Memphis,* Eggleston angled his camera up at the vibrant red tricycle in the foreground to make the child's toy seem larger than life, dwarfing the suburban homes in the background. BC

191 JACK SPENCER

b. Kosciusko, Mississippi 1951–
lives Nashville, Tennessee

Man with Fish, 1995
Gelatin silver print; 14 × 13½ in.
Collection of Martin and Betty Brown

The Nashville resident Jack Spencer sees his warm, sepia-toned photographs as analogues to short stories. These dramatically lit and minimal narratives are edited and revised primarily using intensive burning and dodging techniques throughout the printing process. *Man with Fish* exemplifies Spencer's austere style. The verticality of the man contrasts with the horizontal lines of the background and the central placement of the fish to create an almost crosslike form. Spencer burned in the man's lower half and dodged the man's hands and the fish to draw attention to the metallic texture of the fish. Bleaching and toning the print intensify the warm glow of the torso and fish scales. BC

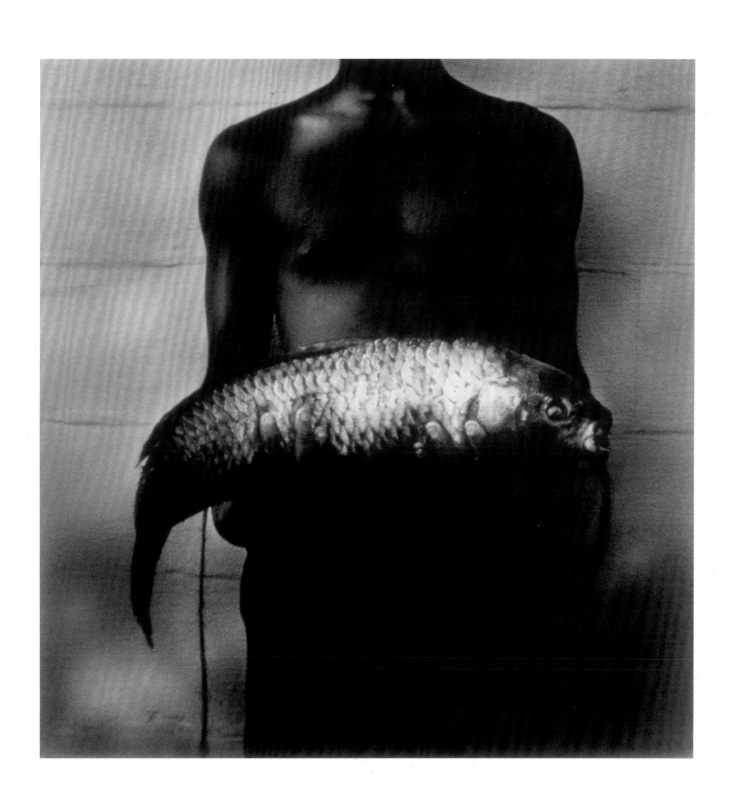

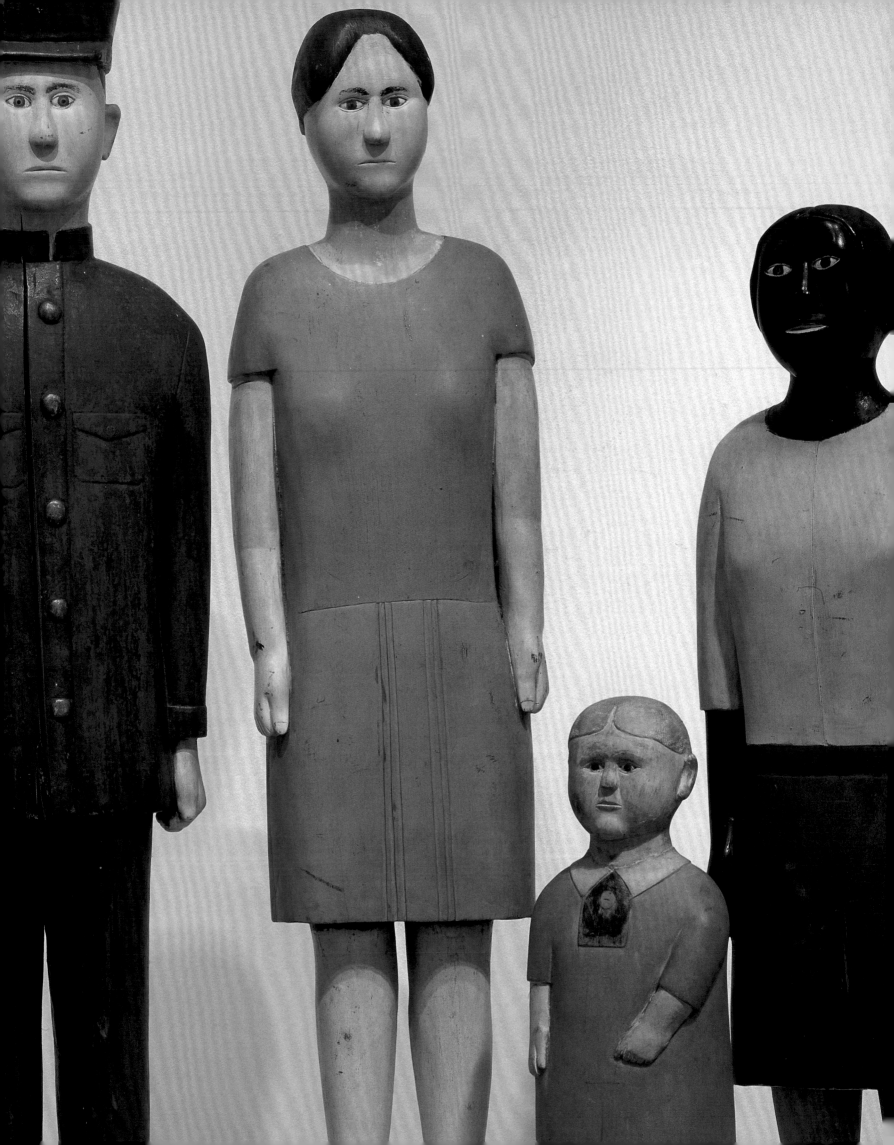

Michael Hall

TENNESSEE FOLK ART

FOLK MUSIC AND FOLK ART HAVE COME TO TRAVEL VERY DIFFERENT ROADS IN THE LIFE of the state of Tennessee. By the middle of the twentieth century, many of Tennessee's country pickers and singers had created highly individualized stage personas inspired and supported by a spate of media-produced folk-culture burlesques, exemplified by the Grand Ole Opry. In contrast, the state's contemporary folk artists found themselves essentially nameless and faceless. The "folk artist cum handicrafter" was typed as an anachronistic throwback, swimming upstream against the tide of industrialized mass production. As a result, the corpus of recognized Tennessee folk art came to include little more than the sturdy split-bottom chairs, funky carved chickens, and rustic apple-head dolls that tourists could buy at roadside souvenir stands throughout the Smoky Mountains.

The time is now ripe to recognize some works of Tennessee folk art as unique fine art productions quite distinct from the things we have categorized as production handcrafts. It would also be timely to acknowledge the makers of these works as real people living in a modern world, and thus to dispel the image of the Southern folk artist as the anonymous pocketknife-wielding cousin of Tennessee's country musicians. Eschewing both the Dogpatch clichés about Southern "folks" and the outdated art canon that myopically defines folk art in terms of the somber portraits of old New England's flinty burghers, we can be free to discover new ways both to understand and to appreciate the cultural identity given voice by the Tennessee folk art in this exhibition. Within the context of a wider survey of the art of Tennessee, this essay examines a few paintings and works of sculpture made by self-taught Tennessee folk artists in the hope of experiencing what the great Canadian regional modernist Emily Carr called "fresh seeing."[1]

Our survey begins appropriately with a contemporary look at some Tennessee folk art produced by artists in the nineteenth century. Born in 1849, Anselmo Harris discovered his passion for making sculpture sometime after middle age. It has long been noted that occasionally ordinary, workaday older people discover a latent creativity within themselves and then find ways to channel this creativity into the production of extraordinary things. Harris's carving entitled *Here Is Where We Play* is one of these things. Confronting Harris's sculpture, we find a discarded tree stump transformed into a fantasy world filled with more than a dozen forest animals cavorting around and through the entwined roots of the overturned stump. On the top, a young boy and girl walk, barefoot, through the scene. Throughout, the sculpture is animated by vines, leaves, flowers, and clusters of grapes all carved in high relief. To complete his creation, Harris polychromed the work and sealed its surface with varnish.

Seeking to connect an artist and his work, we identify Anselmo Harris as a nineteenth-century man moving swiftly toward the modern world of a new century. In a wholly modern way he sent his daughters to college, served the social institutions of his community, and productively exploited the economic opportunities afforded by the times he lived in. Still, his sculpture seems to connect him to another time—a time when frontier children walked barefoot through the woods discovering the vitality and wonder of the natural world. Identifying this world as the place "where we play," Harris most certainly alludes to his own experience of childhood. But more important, by transforming an ordinary tree stump into something we recognize as folk art, Harris gave tangible form to the realm of fantasy and imagination where he himself "played" as an artist—an activity fully consistent with the artistic "play" we now understand as integral to the workings of the creative mind.

Not all speculations on early folk artists are supported by the kind of biographical information available for Anselmo Harris. The three carved walking sticks in this exhibition represent the work of two anonymous late-nineteenth- and early-twentieth-century makers who will probably remain forever unknown. Still, their work captures and holds our attention. Whittling, as a pastime, was very popular in nineteenth-century America—especially in the South, where it is still practiced today. Folk whittlers often fashioned walking sticks for themselves as personal mementos, as presents for friends, or sometimes as tributes to a fraternal association or military unit. The best walking sticks (like the examples here) show the hand of what the early folk art enthusiast Holger Cahill described as "the rare craftsman who is an artist by nature if not by training."[2] A carved walking stick becomes a unique work of folk art when the simple act of whittling results in the production of a significant sculptural form. The walking sticks in this exhibition all demonstrate imaginative approaches to the sculptural issues of composition and design. In addition, they masterfully combine figurative and architectural elements into columnar arrangements that are both representational and abstract. Great folk art walking sticks are more than mere canes created to support the elderly and the infirm. At their best, they become sophisticated works of sculpture—functional, decorative, and self-expressive visions "writ large" within the most restrictive of formats.

The first documented twentieth-century folk work in the exhibition is a sculpture carved by the Tennessean Joe Lee sometime about 1925. Lee is reported to have been a greengrocer who lived in the tiny town of Beaver Hill in Overton County in eastern Tennessee. Entitled *The Buckeye Family*, Lee's sculpture comprises a portrait grouping of four nearly life-size carved and painted figures representing a man, his wife, their small child, and a female black figure presumed to be the child's nurse or nanny. It has been proposed that the group actually portrays the artist and his own household, but no documentation supports this claim. The piece reportedly took Lee three years to complete and became very famous in the environs around Beaver Hill during its maker's lifetime. Proud of his work, Lee kept the figures in his store and relished all opportunities to show them off. According to one account, however, Lee once said that "when art people came to see my figures, I felt small and wanted to crawl under the store, but way before they were gone they made me feel like I am somebody."[3]

What distinguishes *The Buckeye Family* from its nineteenth-century predecessors is its bold self-assertiveness as both a form and a concept. The figures in Lee's group confront the world squarely as working Americans striving for their place in the modern merchant middle class. Lee's is a no-frills—even an "in your face"—approach to image making. The decorative subtleties that impart such charm to much

nineteenth-century folk art are utterly missing in this piece. The bold simplifications in Lee's handling of shapes and colors seem to echo the stylistic abstractions we have learned to admire in the art of many of the trained modernist sculptors who were active in Paris and New York during the very same decade that Joe Lee was fashioning his folk art masterwork in Beaverhill. The emerging modern world saw itself through new eyes, and its artists—both trained and self-taught—gave form to the world's new seeing.

Certainly the Tennessee folk artist most referenced when people talk about artistic seeing is the Nashville sculptor William Edmondson. Untrained as an artist, Edmondson lived his life as a member of Nashville's marginalized black minority. The son of former slaves, Edmondson supported himself for most of his years as a farm laborer and a hospital custodian. About 1934, after receiving several religious visions, Edmondson began carving stone. He quickly produced an array of works including tombstones, angels, animals, figures, and birdbaths—all of which were alleged to have been inspired by his spiritual experiences. Shortly thereafter, the carver and his work were "discovered" by a number of photographers and administrators connected to the Works Progress Administration who in turn passed their discovery on to the director of the Museum of Modern Art in New York. In 1937 Edmondson became the first African American to be given a solo exhibition at the museum.[4] Thirty years after his death, the artist's work became a centerpiece of the landmark exhibition *Black Folk Art in America.* Circulated for two years to major museums all across the United States, this exhibition proclaimed the creativity of the grass-roots segment of the African American community. It also explored the survival of African traditions in the black American experience.

For sixty years, Edmondson's sculpture has meant many things to many people. How should a contemporary audience understand a folk expression contradictorily described as naive, modern, primitive, and visionary; pluralist and universal; provincial and cosmopolitan—an art created by a cultural isolate who also drew paychecks from the Federal Art Project, was sought out by Edward Weston, and showed his work in the Museum of Modern Art? It's not easy. Countrified folk art models and down-home personality-cult stereotypes both fail the challenge here. In truth, Edmondson (more perhaps than any other figure in American folk art) must be understood as a citizen of a complex and changing world. His art is thus best interpreted as a synthetic distillation of the cultural and personal experience of its maker and, as such, can be shown to have much in common with all of the most interesting art of our time. Edmondson's work richly deserves the praise and admiration it has attracted over the years. The carved figures and animals presented in this exhibition hold their own with almost any comparably sized stone sculptures from any

period of history. Direct but subtle, elegant but somehow plain, ambitious and humble at the same time, these carvings find themselves in the center of our Tennessee folk art survey precisely because they so durably enrich the broad landscape of the American imagination.

The question of the impress of popular culture on folk art definitely informs a discussion of three artists in our exhibition. Clarence Stringfield from Nashville found his way into the first important anthology of twentieth-century folk art as the maker of a most delightful (and formidable) polychromed, life-size carving of a bathing beauty.[5] Throughout the early 1970s Stringfield produced a number of smaller versions of his signature carving, one of which is presented here as a kind of latter-day Venus complete with seashell bikini. Born in 1903, Stringfield certainly knew the pin-up movie queens of the World War II era and carved his own buxom goddesses during the very years that *Playboy Magazine* further enshrined curvaceous bathing beauties as American icons. Stringfield's folk art walks in lockstep with the popular culture of his world. In the 1960s he carved a life-size pair of cigar store Indians whose visages seem to jump right off the pages of the decade's popular books on folk art. At the time of his death in 1976, Stringfield was using photographs of various country music performers as source material for a series of portrait busts he carved to honor his favorite hometown Opry stars.

In the 1950s an African American man named J. B. Woodson also shaped and painted his own version of a Venus in the town of Milan. Perched atop a pair of spike-heel shoes, Woodson's dusky, petite, four-foot beauty is fashioned from wood and putty. Decked out in flashy (real) rhinestone earrings, the figure is seductively attired in a painted corset and panty girdle. Suggestive and even erotic, this "dream girl" may be a portrait of someone Woodson knew—or she may simply be a fantasy embodiment of her maker's longings and desires. Woodson himself never offered an interpretation of his fancy lady. It is known that, at one point, she stood in the yard of his Milan home sporting a glittery tiara on her head. Her companion in the yard was another statue Woodson fashioned out of wood and putty, a great bald eagle with spread wings, screaming in triumph over the body of a young pig.[6] Certainly, J. B. Woodson put his own eccentric spin on the popular culture tradition of yard ornamentation.

And last, there's the monumental bird totem made by Homer Green of Beech Grove—a small town situated in Coffee County about fifty miles southeast of Nashville. Born in 1910, Green began making chain-saw sculptures in the early 1980s after a life of hard work as a farmer, carpenter, blacksmith, and factory worker. He began carving small works in cedar and soon realized he could create larger, more ambitious pieces using a chain saw. Soon, the yard of his ridgetop Middle Tennessee home was filled with crudely fashioned

dinosaurs, alligators, giraffes, turkeys, and totem poles—all garishly painted in polka-dot patterns with leftover house paint. According to Green: "I was sitting around here retired and doing nothing. I can't sit around doing nothing. . . . I got tired of whittling, decided I'd try a chain saw. Wore out about five of them."[7] The monumental bird totem in the exhibition bespeaks its maker's great energy, and his lively and whimsical spirit. By the time Homer Green died in 2002, the chain-saw menagerie of spotted birds and "critters" he had carved for twenty years had found a secure place in the popular culture history of American roadside folk art.

The first folk artist in the exhibition who could be classified as a painter in the easel painting tradition is Charles Moore of Nashville. A barber by profession, Moore was a hobby painter in the 1950s; little else is known about him. The few works by Moore that survive, however, compare well with the best-known works of such twentieth-century folk art masters as John Kane, Lawrence Lebduska, Horace Pippin, and Grandma Moses. The painting of a black horse presented in this exhibition speaks eloquently to the modernist notion of a place where the "primitive" and the modern conjoin. Post-Impressionist painters such as Vincent van Gogh and Paul Gauguin admired the art of self-taught artists. They perceived the flat, decorative, abstract "folk art" style as exuding a kind of "primitive" directness and eloquence—qualities they sought to achieve in their own pictures.

Moore's compositional arrangement is simple and decorative. The space of the field around his horse is flat—wholly lacking the illusion of perspective. The shapes representing the fences and trees in the field become abstract forms creating a bold pattern of lines and shapes around the silhouette of the toylike animal. Though Charles Moore made several other paintings of horses, *Black Horse* is his best-known work. Other paintings by him possibly await discovery. One collector who visited Moore in his home recalls seeing a large painting of the Crucifixion hanging in the artist's living room. Behind the foreground image of Christ on the cross, Moore had carefully inserted a panoramic vista reproducing the skyline of Nashville.[8] Sometime in the late 1950s Moore died or moved away. His *Crucifixion* disappeared with him. Nonetheless, his few extant works substantially enrich the story of Tennessee folk art. Depicting the local world of his own experience in a richly patterned, graphic style, Charles Moore was a "classic" folk painter whose work (like that of Edmondson) has earned broad and growing admiration far beyond the borders of the State of Tennessee.

The second easel painter in the exhibition is Paul Lancaster of Nashville. In many ways, Lancaster is hard to classify as a folk artist. For almost thirty years he worked as a picture framer in a prominent Nashville art gallery, retiring in 1995. While in the gallery's employ,

Lancaster was exposed to thousands of works of art and could certainly have gained a sophisticated insight into the workings of the contemporary art world. Can a painter with such an exposure retain the naïveté and innocence presumed to be the hallmarks of an authentic "primitive"? Can works produced by an artist privy to collectors and critics really be classified as folk art? The argument that answers these questions in the affirmative presumes that the artistic vision of a "true" naive is somehow isolated from the comings and goings of the world—specifically the authority of art history and the machinations of the art marketplace. Certainly it can be argued that the paintings of Henri Rousseau remained truly naive despite the fact that Rousseau himself regularly visited all the great museums of Paris and spent considerable time in the studios of his patrons Edgar Degas, Paul Gauguin, and Pablo Picasso.

Paul Lancaster's painting *Evening Forest* actually recalls Rousseau's famous jungle scenes from the first decade of the twentieth century. Lush and overgrown, Lancaster's scene depicts a woman and two children playing in a clearing in the woods. Writhing trees and undulating ferns surround the clearing. The trunks of the foreground trees are covered with colorful organic floral patterns reminiscent of tropical fabric patterns from the 1940s and the exotic tattoo and poster designs associated with the San Francisco Bay Area counterculture of the 1960s. Like the famous American watercolorist Charles Burchfield, Lancaster provides his audience with a glimpse of a sublime and fecund world where form and color suggest the sounds and movement of a primordial, vibrant, and even ecstatic universal life force. Obsessive and self-referential, Paul Lancaster's artistic vision is clearly dictated by a very private muse.

In the idiosyncratic paintings and sculptural constructions of Bessie Harvey we encounter a folk art expression diametrically opposed to the one embodied in the studied classicism of Charles Moore. Born in Dallas, Georgia, Harvey moved to Tennessee in the 1950s, living briefly in Knoxville and then settling permanently in nearby Alcoa. Like many African Americans in the South, Harvey spent much of her life battling adversity. Reminiscing about her past, the artist once remarked, "The story of my life would make *Roots* and *The Color Purple* look like a fairy tale."[9] Sometime after the death of her mother in 1974, Harvey began finding comfort in giving shape to certain stories and visions she conjured in her mind. She began making crudely constructed sculptures out of roots and odd-shaped pieces of wood, painting and overlaying them with found objects such as shells, marbles, beads, and glitter. Working until her death in 1994, Bessie Harvey created a vast array of works representing Bible characters and stories, figures from African history and folklore, and episodes from her own life as well as the lives of others in the African American community.

Discerning faces in the shapes of a twisted root, Harvey focused and exercised her creative imagination. Working the surface of the root to make these faces visible to others, she became an artist. Harvey perceived her art-making process as a highly spiritual activity. She felt profoundly in touch with the spirits she released from the wood she shaped. She also believed in the healing power of these spirits—and in the power of her work to uplift and to teach. Harvey saw her role as an artist as somewhat akin to that of a spiritualistic medium. Ironically, some observers in the community around her came to suspect that Harvey's eccentric personages and animals were actually voodoo figures—suspicions that deeply offended the artist's Christian ethic. Once in print, these allegations also confused the critical interpretations of Harvey's art.[10]

After 1983 Harvey began making two-dimensional works on paper. Using paint and collage, she created graphic works depicting faces and other images relating to her three-dimensional sculpture. The painting in this exhibition portrays a storyteller. The image in the painting is dark and mysterious and is rendered in a highly spontaneous style. Like many of Harvey's figurative sculptures, the storyteller has a masklike face punctuated by two intense, glowing eyes. A certain animal ferocity emanates from this painted visage. The storyteller seems to speak with a voice augmented by the ghost voices of generations of Harvey's African forebears. Harvey's paintings and sculptures are perhaps best described, stylistically, as a kind of visionary Neo-Expressionism. Uniquely among the artists in this exhibition, Bessie Harvey presents viewers with an intensely spiritual form of constructed, found-object folk art thematically addressed to issues of myth, belief, gender, and race. For many collectors and critics, Bessie Harvey's eccentric, imagistic style defined a new contemporary genre of expressionistic folk art.

We conclude our survey at yet another locale on the folk art map, where the heroic folk statuary of Enoch Tanner Wickham resides. Wickham, it seems, was a folk art monument maker who over the course of many years constructed an amazing sculpture park populated with gigantic concrete figures along the road that ran past his cabin outside the town of Palmyra, Tennessee. Wickham's art expresses the vision of an artist inspired by the heroism of the patriots, soldiers, and leaders he believed had shaped the history of his nation and his native state of Tennessee. Born in 1883, Wickham did not begin building his park until 1959. Once he commenced his project, however, he expended untold hours of exhausting labor building personal memorials to the politicians, war heroes, and historic figures he most admired. The list of honorees included Estes Kefauver, Andrew Jackson, Austin Peay, Daniel Boone, Sergeant Alvin York, the Kennedy brothers, and Wickham's own son, Ernest, who had died in France during World War II.

By the time of his death in 1970, Wickham had erected more than a dozen large-scale monuments in his park. In addition, he had also sited a sizable group of religious works along a nearby service road and had erected a towering "totem" crowned with a concrete eagle to preside over the whole. Finally, in a wry tribute to himself, Wickham placed a figure riding a snorting bull atop a pedestal inscribed as follows: "ET Wickham headed for the wild and woley [sic] west, remember me boys while I am gone."[11] Sadly, little remains of Wickham's work today. Over the past three decades vandals have relentlessly attacked, dismembered, and destroyed the Palmyra statues. The Sergeant York figure in this exhibition survives only because it was removed from the park years ago and preserved in the collection of Austin Peay State University in Clarksville.

Something of the essence of Wickham's park does live on, however, in an archive of photographs taken over the years by folk art enthusiasts who found their way to the Palmyra site. Just last year these photos were brought together and exhibited at Clarksville's Customs House Museum. Displaying the photographs alongside a few surviving fragments from the Wickham homestead and a newly constructed scale-model diorama of the park, the museum gave Tennesseans a long overdue acknowledgment of Enoch Wickham's impressive contribution to the history of American folk art. Mixing one small batch of cement at a time, Wickham doggedly built his dream in an act of creation that was altogether ambitious, patient, intimate, and reckless. The man behind the Palmyra monuments is remembered both for his sculpture and for the generosity of his spirit—a generosity he shares with most of the other artists in this folk art survey. According to a statement made by one of his friends, Wickham "just had a mental picture of different things that were good ... and he tried to give [them] a vivid life."[12]

The notion of artists trying to give good things a vivid life encompasses a lot. Rembrandt gave a vivid life to his self-portraits. Van Gogh also found a way to impart both vividness and life to his floral paintings. Georgia O'Keeffe vividly suffused her desert landscapes with the life force of nature, and Jackson Pollock revealed the vivid life energy he found in trails of pure color splashed across a canvas spread out on the floor beneath his feet. So, too, the folk artist. The cursory survey here should leave no doubt that an assemblage of works from the hands of several generations of Tennessee folk artists reveals the vividness of life on many levels. The visual chorus here pulses with the vitality of many separate artistic voices only now beginning to be orchestrated into the full score of Tennessee's overall cultural history. Connecting works of folk art to the larger life of a locale and all of its people, we can finally begin to experience and appreciate an artifact symphony in which cane makers are sculptors and country fiddlers become first-chair violinists in their own right.

NOTES

1. Doris Shadbolt, *Emily Carr* (Vancouver: Douglas and McIntyre, 1990), 78.

2. Holger Cahill, *American Folk Sculpture: The Work of Eighteenth and Nineteenth Century Craftsmen,* exh. cat. (Newark, N.J.: The Newark Museum, 1931), 13.

3. Quoted in Robert Bishop, *American Folk Sculpture* (New York: E. P. Dutton and Co., 1974), 321.

4. Jack Lindsey, "William Edmondson," *Miracles* (Philadelphia: Janet Fleisher Gallery, 1994), 12.

5. Herbert W. Hemphill Jr., *Twentieth-Century Folk Art and Artists* (New York: E. P. Dutton and Co., 1974), 141.

6. Author's personal photo archive, photo dated May 1963.

7. Quoted in Ken Beck, "Homer Green's Folk Art," *The Tennessean,* September 25, 1991, 1-D.

8. Estelle E. Friedman, conversation with the author, ca. 1967.

9. Quoted in Stephen C. Wicks, "Revelations in Wood: The Art of Bessie Harvey," in *Awakening the Spirits: Art by Bessie Harvey,* exh. cat., Knoxville Museum of Art in collaboration with Austin-East High School (Knoxville: Knoxville Museum of Art, 1997), 13.

10. Ibid., 18.

11. Janelle S. Aieta, "Enoch Tanner Wickham: A Biographical Sketch," in *E. T. Wickham: A Dream Unguarded,* exh. cat. (Clarksville, Tenn.: Customs House Museum, 2001), 67.

12. Ibid.

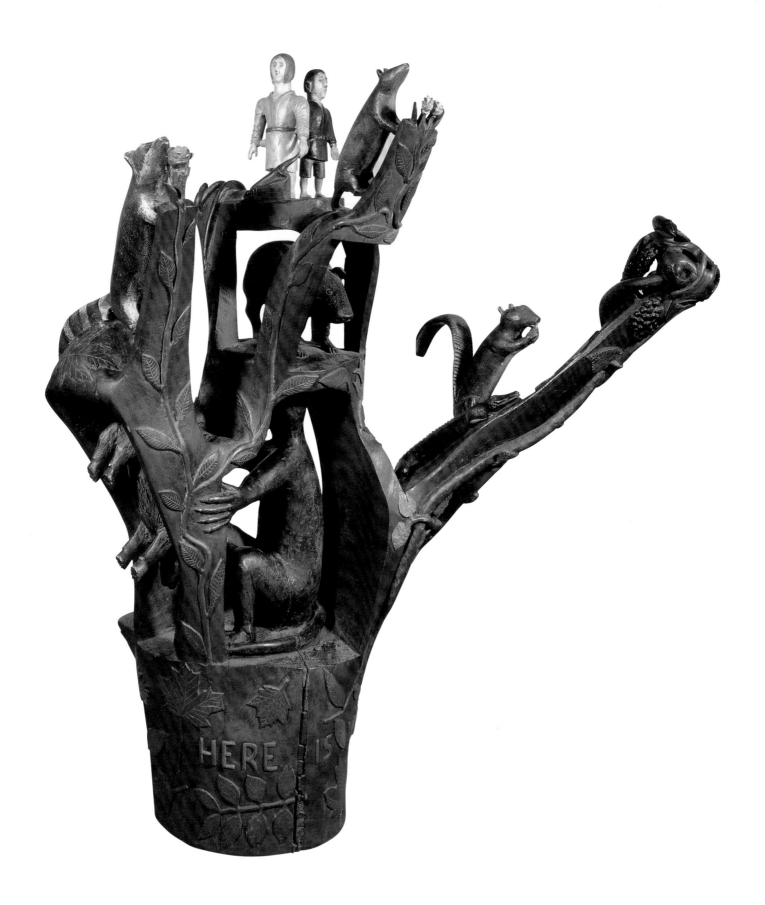

192 · **ANSELMO HARRIS**
b. Montgomery County, Tennessee
1849–d. 1938

Here Is Where We Play, ca. 1890
Wood and paint; 57 × 48 × 32 in.
Tennessee Agricultural Museum, M153

ANSELMO HARRIS WAS A RESPECTED community leader, farmer, and owner of a horse-training stable and flour mill in the Reelfoot Lake area. Using wood cleared from the land during farming, he created more than twenty large, whimsical sculptures that were inspired by history and daily occurrences. Showing denizens of the forest intermingled with a young boy and girl, *Here Is Where We Play* leads us through a fantastic evocation of childhood. Whether intentionally or not, it also calls to mind the story of Adam and Eve and their Edenic existence, or Edward Hicks's series of paintings titled *The Peaceable Kingdom.* NPC

193 · **THE SHOP SPRINGS CARVER**

Cane, ca. 1900
Wilson County, Tennessee
Eastern red cedar; 38⅜ × 1¾ in.
Collection of C. Tracey Parks

MANY DESIGNS SEEN HERE are repeated in other pieces by this carver. A downward-pointed branched floral device, near the midsection, the reeding, stylized leaves, and spiral features all figure prominently in works attributed to this artisan. The expressive man's bust profile is a departure from the carver's typical decorative vocabulary. CTP

194 · **THE SHOP SPRINGS CARVER**

Cane, ca. 1900
Wilson County, Tennessee
Eastern red cedar; 42⅞ × 1½ in.
Collection of C. Tracey Parks

MUCH OF NINETEENTH-CENTURY Wilson County was covered with cedar groves, causing one observer to remark that scarcely a farmer was without the tree on his lands. Cedar was the preferred medium for this talented carver who worked near Shop Springs. His known work consists of four canes, a child's rocking chair, and several small tables. CTP

195 · *Cane,* 1888
Middle Tennessee
Inscribed, scratched into surface near grip "L.T. 1888"
Hickory and paint; 34 × ⅞ in.
Collection of Monty and Linda Young

CARNIVALESQUE RED AND GREEN PAINT and the appearance of a heart, club, and diamond near the cane's grip provide playful references to card playing, a common form of entertainment in rural America. The history of this cane is unknown except that it was collected in the vicinity of Woodbury in Cannon County. CTP

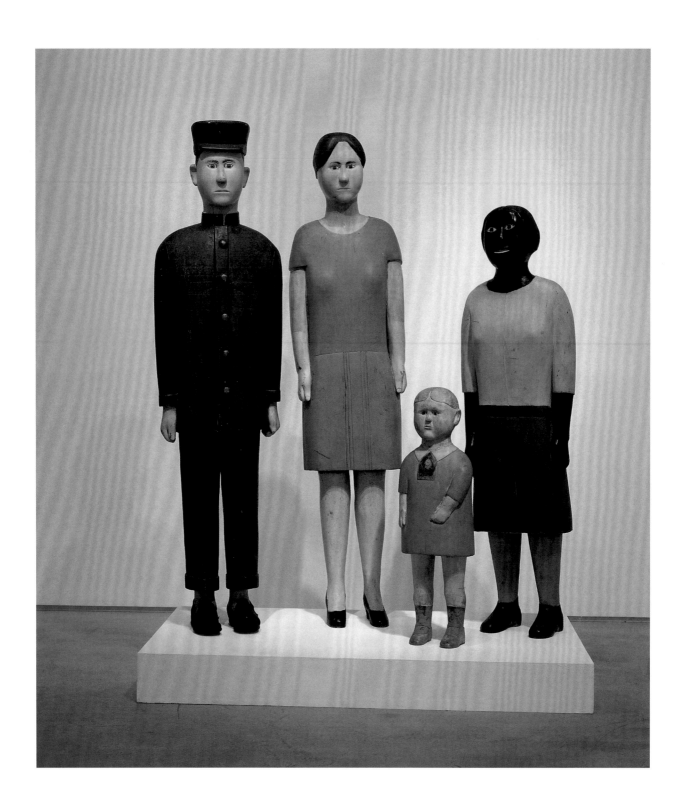

196 · **JOE C. LEE**
b. Sparta, Tennessee–d. Beaver Hill,
Tennessee 1941

The Buckeye Family, ca. 1925
Buckeye wood and paint; man, 56 × 16 × 8 in.;
white woman, 57 × 16 × 8 in.; child, 28 × 10 ×
7 in.; black woman, 49 × 15 × 8 in.
The Briskin Family Collection

ONE OF THE MOST RECOGNIZED and singular groupings in Southern folk sculpture, *The Buckeye Family* was carved sometime about 1925 from native Tennessee buckeye wood. While the work presumably was created from the artist's imagination, it is an exceptionally bold and monumental depiction of the type of family one might have seen in early-twentieth-century rural Tennessee, complete with its black nanny or maid. The figures remained on display for many years in Lee's store in Beaver Hill, Tennessee. NPC

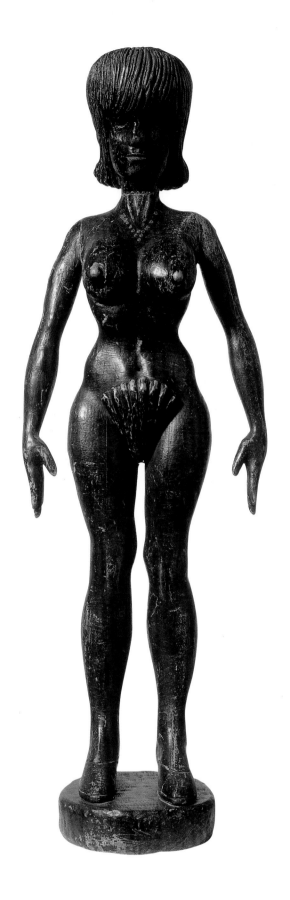

197 · **CLARENCE STRINGFIELD**
b. Erin, Tennessee 1903–d. Nashville,
Tennessee 1976

The Modern Girl in Modern Dress,
ca. 1966
Wood; 24 × 7¾ × 5 in.
Collection of Ned and Jacqueline Crouch

KNOWN PRIMARILY FOR HIS CARVED reliefs of country music personalities, Clarence Stringfield—a cabinetmaker by trade—also produced a series of both doll-size and life-size standing figures. This small carving of an abundantly endowed woman was originally displayed wearing a knee-length cotton dress made by Stringfield's wife. The art dealer and collector Myron King quotes the wife as saying, "It will not leave my house looking like that," and so the dress was made. NPC

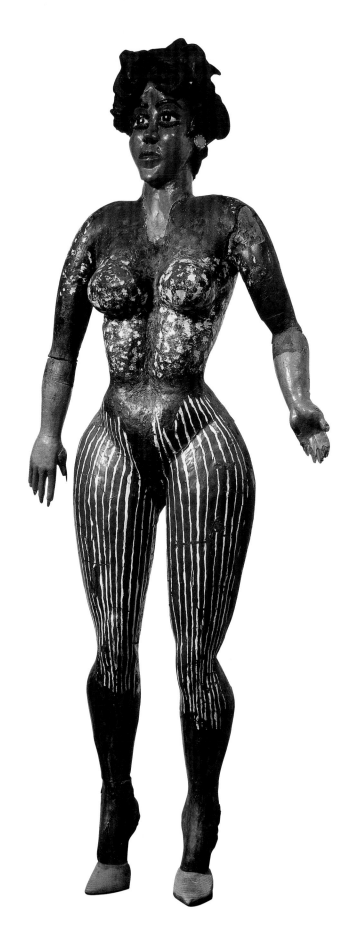

198 · J. B. WOODSON

Active Milan, Tennessee

Standing Woman, ca. 1950
Wood and paint; 50 × 20 × 9 in.
Collection of Ned and Jacqueline Crouch

ORIGINALLY CLOTHED in a pseudo-dance-hall outfit complete with tiara and high-heeled shoes, Woodson's *Standing Woman* is either the personification of a personal fantasy or the joyful celebration of someone he knew. This carving is one of only two pieces known to have been completed by the artist, the other being a large eagle with talons flared, standing over the body of a dead animal. Both sculptures were displayed in Woodson's front yard. NPC

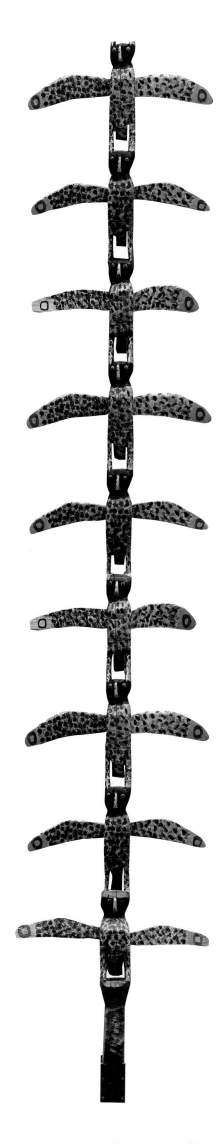

199 · **HOMER GREEN**

b. Coffee County, Tennessee 1910–
d. Coffee County, Tennessee 2002

Owl Totem, 1992
Wood and paint; 221 × 44 × 8 in.
The Caldwell Collection, West Tennessee Regional
Art Center, Humboldt, Tennessee, 9450

"I wasn't born, I was hatched." As is often the case with self-taught artists, the Coffee County native and part-time blacksmith, herbalist, and philosopher Homer Green became a carver after undergoing a life-changing event. In Green's case, a back injury forced him from a carpet factory assembly line into retirement. He began to produce fanciful critters, totems, and birds, all uniquely spotted with multicolored applications of paint. This owl totem is one of Green's largest and most heroic works. NPC

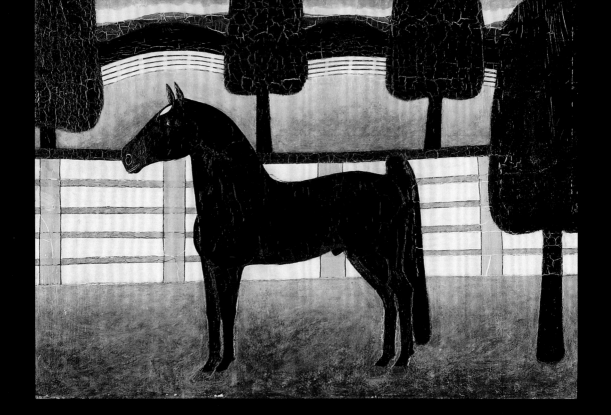

CHARLES MOORE
Active Nashville, Tennessee ca. 1950s

Black Horse, ca. 1950
House paint on cardboard; 18¾ × 27½ in.
Collection of Estelle E. Friedman

CHARLES MOORE WAS A BARBER by trade who painted as a hobby. Of the few paintings of his that survive, this image of a stolid black horse is considered by lovers of folk art to be classic in its folklike simplicity and directness. Individual forms within the painting have a cutout, layered, and stacked appearance. Rolling hills, structured fences, and stylized trees all fit tightly together to frame this proud animal. NPC

201 · **PAUL LANCASTER**

b. Lobelville, Tennessee 1939–
lives Nashville, Tennessee

Evening Forest, 1998
Oil on canvas; 40 × 40 in.
Courtesy of Grey Carter—Objects of Art and
the artist, 5114PL313C

PAUL LANCASTER'S ELABORATE PAINTINGS often depict woodland fantasies drawn from childhood memories of the West Tennessee farmlands of his Cherokee grandfather and great-grandfather. His imaginative images of crawling tree bark, butterfly-wing leaves, and firefly stars have been shown at the American Visionary Art Museum in Baltimore. Although self-taught, Lancaster has been inspired by reproductions of works by such modern masters as Pierre-Auguste Renoir and Henri Rousseau. He received Best of Show in the 1994 Tennessee All-State Exhibition. SWK

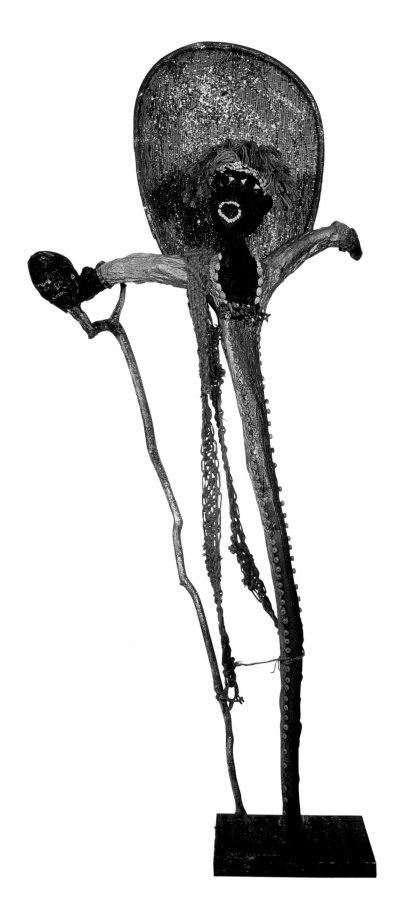

202 · **BESSIE HARVEY**
b. Dallas, Georgia 1929–d. Alcoa,
Tennessee 1994

Zulu Warrior, 1991
Wood, paint, and textile; 78 × 21 × 20 in.
Collection of Ben and Gertrude Caldwell

As did William Edmondson, Bessie Harvey received a message from God that started her on her path to becoming an artist. Although instilled with a strong Christian ethos, she embraced the notion that certain things found in nature, such as roots, branches, and stumps, contain a unique soul or spirit. Harvey sought to recognize and draw out these spirits through her art. Using swatches of fabric, paint, and found elements, she adorned the twisting branches and roots she found in the woods near her home, giving them faces and characteristics that she felt would reveal their souls to others. NPC

203 · **BESSIE HARVEY**
b. Dallas, Georgia 1929–d. Alcoa,
Tennessee 1994

The Storyteller, 1984
Mixed media; 14 × 11 in.
Collection of Faye Dean

HARVEY'S PAINTINGS AND SCULPTURES often show characters whose mouths are open to suggest talking, calling, or screaming. This is particularly apropos for this haunting image of a storyteller, who seems to be a conduit for tales of profound psychological depth and spiritual power. NPC

ENOCH TANNER "E. T."
WICKHAM
b. Montgomery County, Tennessee
1883–d. Palmyra, Tennessee 1970

Sergeant York, 1961
Cement, paint, and tin; 84 × 33 × 21 in.
Austin Peay State University permanent art
collection, Clarksville, Tennessee, 1997.005.0011a

STOIC AND STRAIGHTFORWARD, the courageous Sergeant Alvin C. York from
Tennessee was lionized in the United States for his role during a World War I battle in
which seventeen Americans defeated and captured a much larger German force. This work
was one of an assemblage of thirty or so larger-than-life painted concrete sculptures Wick-
ham produced and arranged in a woodland setting near Clarksville. NPC

Leslie King-Hammond

William Edmondson, Sculptor

William Edmondson emerged as a sculptor during an era when artistic traditions were in a state of transition and transformation. Artists were challenging the possibilities of figurative representation against those of abstraction. Within this historical frame Edmondson functioned with ease and matured within a relatively short period, especially remarkable given the fact that he started to make art late in life. His vision was self-assured, affirmed by the spirituality and cultural ethos of his African American heritage at a time when the question of a modernist vision consumed the intellects of the most established and urbane artists of the 1930s and 1940s. Edmondson's quiet confidence and sure hand produced creations that are heroic, ancestral, and monumental testimonials to his humanity, spirituality, and artistry.

Edmondson was an artistic success far beyond the cosmopolitan expectations of American culture and society between the world wars. Without benefit of Beaux-Arts training and with limited formal education, Edmondson transcended the norm and articulated his distinctive vision of modernism with lean, powerful forms that evoked authority with an absence of pretension, qualities that heightened and empowered his imagery. He was a man ahead of his time whose works resonated with a timelessness that has become the distinguishing mark of his contribution to the evolution of modernism. Edmondson kept on working, despite facing hurdles of opposition and denial of Herculean proportions, which besieged African Americans' quest for education, opportunity, and justice. William Edmondson's achievements are nothing short of remarkable.

William's parents were former "Edmondson and Compton slaves" who raised their family on the Compton plantation property in Davidson County, three miles from Nashville, Tennessee. He was the second child of five and grew up in the post-emancipation era when restrictions regarding race, color, and class made life difficult and cruel. The harsh realities of the times dictated that mulattoes who had lighter skin benefited from more privileges and opportunities than did those with darker skins. Given the Edmondsons' short physical stature, dark complexion, and African features, the family was relegated to the status of fieldhands. In 1890, when William Edmondson turned sixteen, he went to Nashville in search of a better job, later reflecting that "God don't intend nobody to work themselves to death. Slave time is over."[1]

In Nashville Edmondson worked as a laborer in the city sewer works; in 1900 he and his brother James worked for the Nashville, Chattanooga, and St. Louis Railroad. He lost his job with the railroad in 1907 after an accident injured his leg but soon began to work for the Women's Hospital. In 1931 he lost that job but found one as a stonemason's helper. This job was short-lived, however, as Edmondson's leg injury grew increasingly debilitating, forcing him to stay home. He began to gather discarded limestone from a surrounding field and around the city and with very basic tools and no formal training began to carve tombstones, then figures, stating that, "Jesus has planted the seed of carving in me."[2] Soon his backyard became a "yard show" of carved images, tombstones, birds, preachers, angels, and "critters," which he made for his "heavenly daddy" and the community.

The manifestation of the will to make things was neither new nor unusual in Edmondson's personality. Mary Brown, Edmondson's stepsister, recalled that her brother "was kind of shrewd. He just did a lot of things. He was a person to kind of experiment. He could fix shoes good as a shoemaker and do anything on his own, like stonecutting. He didn't have a lesson or nothing. He just always did kind of tinker around with things."[3] Edmondson's creative energy combined with the deep-rooted traditions of the African American community to become the constant source of his creations. His work gained increasing public attention, and in 1937 he became the first African American to have a one-person exhibition at the Museum of Modern Art in New York.

The Bible and the church were a crucial focus for African American communities in their efforts to create support systems. Biblical narratives and figures and animals from the folk tales of Uncle Remus were vital catalysts for Edmondson's artistic imagination. They helped him visually define, question, and challenge the physical and psychic parameters of the world in which he lived. *Lion*, imbued with majesty and confidence, is a symbol of courage. The figure's proud and

protective strut is convincing, despite the fact that Edmondson never saw a lion in reality.

Within the African American community the figure of the preacher holds a position of sacred authority. Edmondson carved a man dressed in a formal suit holding a Bible, "the Good Book," in his hand or high above his head numerous times throughout his career. Edmondson sought to honor the importance of the preacher and to highlight his ability to mediate between the earthly concerns of man and the omnipresent dominion of God.

The emotions arising from family, community, neighbors, and friends underline all that William Edmondson sought to achieve in his works. The figures in *Bess and Joe* are seated close together on a bench, and Joe's arm is around Bess. This is an image of caring, love, strength, and courage as exemplified by the polarities of male and female, soft and rough textures, folded arms of the female versus the open arms of the man. These figures are believed to be friends of Edmondson's who lived in the neighborhood. Their facial expression and composure demonstrate the comfort, ease, and support that exist between the two subjects. They embody all that Edmondson sought to convey in his work—his avowed belief in humanity and spirituality.

NOTES

1. As quoted in Edmund L. Fuller, *Visions in Stone: The Sculpture of William Edmondson* (Pittsburgh: University of Pittsburgh Press, 1973), 6.

2. Ibid., 3.

3. Ibid.

205 · WILLIAM EDMONDSON
b. Nashville, Tennessee 1874–
d. Nashville, Tennessee 1951

Bess and Joe, ca. 1935
Limestone; 16½ × 20¼ × 10 in.
Collection of the Cheekwood Museum of Art,
Nashville, Tennessee, Gift of Salvatore Formosa,
Sr.; Mrs. Pete A. Formosa, Sr.; Angelo Formosa, Jr.;
and Mrs. Rose M. Formosa Bromley in memory
of Angelo Formosa, Sr., wife Mrs. Katherine
St. Charles Formosa; and Pete A. Formosa, Sr.
and Museum Purchase through the bequest of
Anita Bevill McMichael Stallworth, 1993.2.3

THROUGH THE COUPLE'S STATELY posture and straight-ahead gaze, William Edmondson transforms his neighbors Bess and Joe into a majestic couple that exudes grace and dignity. He downplays individual features in favor of universal appeal but retains Joe's snap-brim cap and bow tie and Bess's curly hairdo and lace-collared dress. They fit together comfortably, she contented with arms folded in her lap, he affectionately placing his arm around her back. Bess and Joe sit as they might on a park bench, casually taking in the world around them. CMA

206 · **WILLIAM EDMONDSON**
b. Nashville, Tennessee 1874–
d. Nashville, Tennessee 1951

Lion, ca. 1938–40
Limestone; 22 × 35 × 7 in.
Collection of Mr. and Mrs. Henry Brockman

WHILE MANY OF EDMONDSON'S subjects are rendered in a static or "posed" position, his depictions of animals often suggest vitality and motion. Typical of this is his striding and confident lion, which projects a sense of stoic exuberance. This sculpture exemplifies Edmondson's ability to transform a block of Tennessee limestone into a rough, yet graceful, work of art. NPC

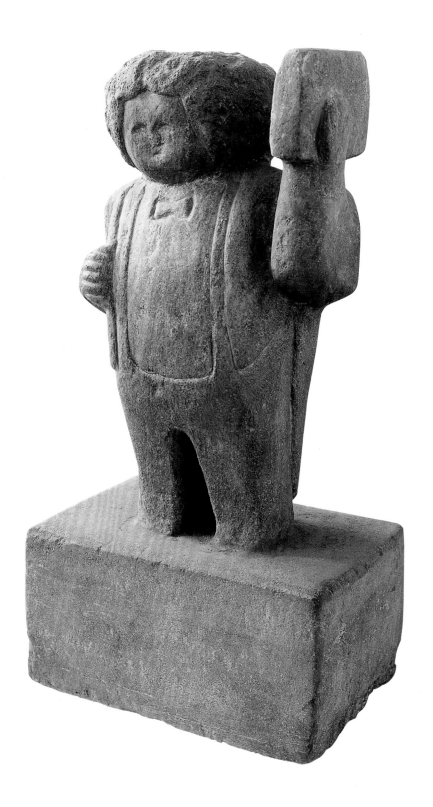

207 · **WILLIAM EDMONDSON**
 b. Nashville, Tennessee 1874–
 d. Nashville, Tennessee 1951

Preacher, ca. 1935
Limestone; 23½ × 12½ × 8¼ in.
Collection of Lucy Scott and Sam Kuykendall

WILLIAM EDMONDSON CREATED many sculptures depicting preachers, an indication of his respect for these community leaders, who are especially important within the African American community. In this example, the preacher—wearing a smart bow tie, long-tailed jacket, and suspenders—proudly lifts a large Bible with his left hand as if in the process of delivering a fiery sermon. Edmondson himself was a religious man who claimed to have been called to become a carver through a vision from God. KDW

208 · **EDWARD WESTON**
 b. Highland Park, Illinois 1886–
 d. Carmel, California 1958

William Edmondson, Sculptor, 1941
Gelatin silver print; 7½ × 9½ in.
Collection, Center for Creative Photography,
The University of Arizona, 81:110:104

EDWARD WESTON WAS ALREADY regarded as one of America's most innovative modern photographers when he, along with Louise Dahl-Wolfe, began documenting the life and work of the folk artist William Edmondson. Weston's photographs of Edmondson have a sense of monumentality befitting this important icon of twentieth-century folk art. The photograph on the right shows Edmondson's range of subject matter. NPC

209 · EDWARD WESTON

b. Highland Park, Illinois 1886–
d. Carmel, California 1958

Stone Sculpture, William Edmondson,
1941
Gelatin silver print; 7½ × 9½ in.
Collection, Center for Creative Photography,
The University of Arizona, 76:021:010

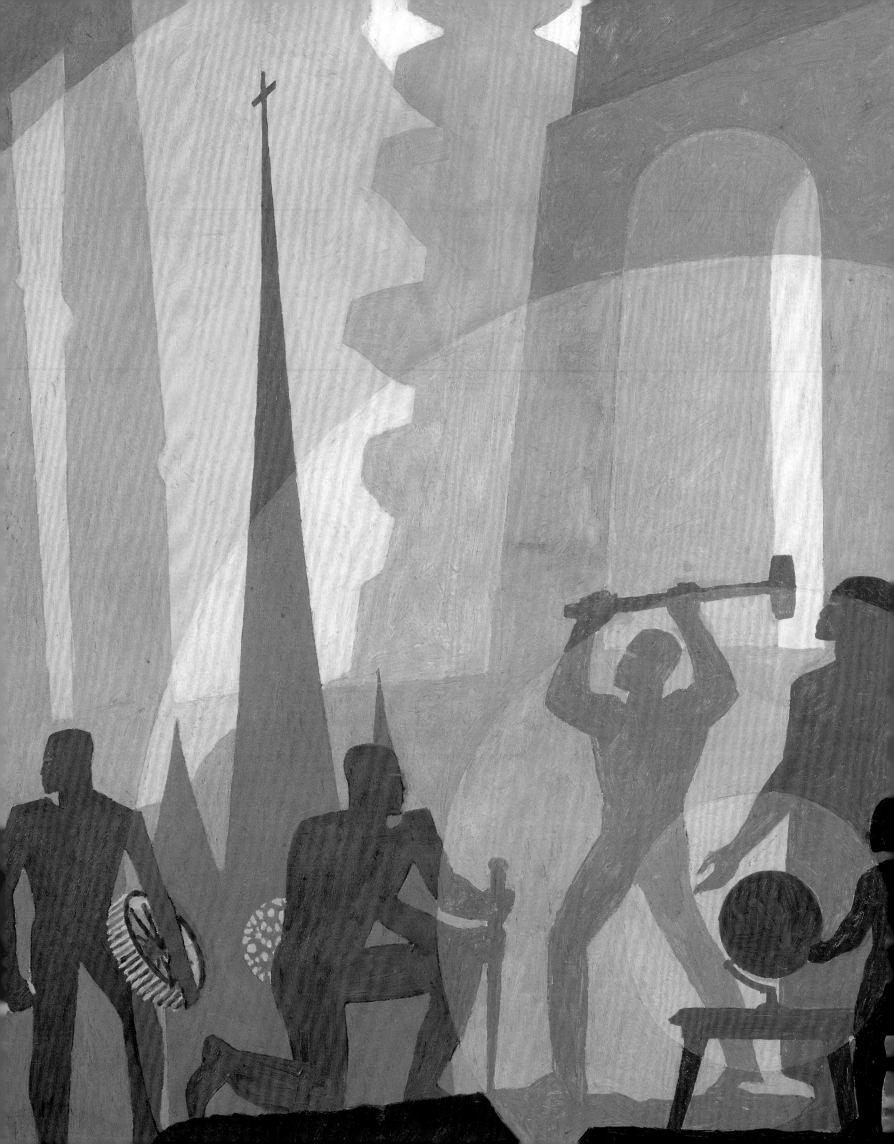

Susan W. Knowles

MODERN ART FOR MODERN TIMES

UNTIL THE ADVENT OF COLLEGE AND UNIVERSITY ART DEPARTMENTS IN THE LATE 1930S, the history of modern art and the development of the abstract idiom in Tennessee relied on contacts with art being produced elsewhere and artists who had been trained elsewhere. In the Wrst decades of the twentieth century, Tennessee artists, many of whom had received formal academic instruction at the National Academy of Design in New York, the Pennsylvania Academy of the Fine Arts in Philadelphia, the Art Institute of Chicago, or the Parisian academies, continued to create works very much like the representational painting and sculpture that had been exhibited at the Tennessee Centennial Exposition of 1897.[1] Tennesseans who did not travel out of the state would have had little direct access to the new forms of art being produced in Europe and New York. Programs and lectures at the few private art schools, art associations, and women's clubs more than likely featured European old masters, the French Impressionists, and their American counterparts. With the exception of the Brooks Memorial Art Gallery, which opened in 1916, there were no public museums in the state and no institutions showing up-to-date American art.[2]

Nevertheless, Tennessee artists and intellectuals following the national scene would at least have been aware of the huge wake left in the quiet waters of representational art by the Armory Show held in 1913 in New York. And the radical innovations of form and content proposed in the works of Paul Cézanne, Henri Matisse, Pablo Picasso, and Marcel Duchamp propelled scores of up-and-coming American artists, including some young Tennesseans, to explore the avant-garde.

The new styles would have been brought into Tennessee by intermediaries, like the pioneer abstract artist and professional teacher Will Henry Stevens, who had been spending summers in western North Carolina and nearby Gatlinburg since 1916, and the returning native sons Charles Cagle[3] and Philip Perkins,[4] who had gone away to art school. Glimpses of some of the new art might also have come through presentations sponsored by the American Federation of the Arts at local art association gatherings in Memphis, Nashville, Knoxville, and Chattanooga. There might have been stylistic echoes in the works of regional artists included in the annual Southern States Art League exhibitions that traveled throughout the region during the 1920s and 1930s. Or in the works of African American artists working in Europe, who were included in the first traveling show of African American art organized by the Harmon Foundation, which came to Nashville in 1929.

Echoes of modern "machine age" style could have been seen in Nashville in the early 1930s in the skyscraper imagery of the visiting Tennessee expatriate A. C. Webb[5] or Aaron Douglas, the widely published illustrator of New Negro movement books and journals, who was planning and executing a mural for Fisk University at that time. Douglas, whose dynamic compositions included diagonal rays of light and dark tones, also incorporated a stylized modern primitivism based on Egyptian and African motifs.[6]

Many Southerners, like my mother Margaret Anderson, who grew up on a tobacco farm near Clarksville, Tennessee, journeyed to Chicago in 1933 to see the exposition *A Century of Progress.* They would have seen whole galleries dedicated to the work of Cézanne, Matisse, and Picasso. By then accepted as masterpieces of modern art, all were on loan from American museums and collectors. Other galleries at the exposition displayed paintings by the American Regionalists Thomas Hart Benton and John Steuart Curry, and new works by such contemporary

Aaron Douglas, *Building More Stately Mansions,* 1944, detail, cat. no. 221

European and American artists as Salvador Dalí, Juan Gris, Giorgio di Chirico, Max Weber, Marsden Hartley, and Karl Knaths.

During the Depression years, Tennesseans might have met and even worked alongside the Federal Art Project/Works Progress Administration artists who received projects in the state in the late 1930s and early 1940s. Only a few Tennesseans, like the painter Burton Callicott in Memphis[7] and the sculptors Belle Kinney Scholz, Puryear Mims,[8] and William Edmondson of Nashville, were on the payroll of the WPA. The art that appeared in numerous federal post offices and courthouses around the state often reflected advanced styles. These were mostly dependent on the heavily sculptural figuration introduced by Matisse and Picasso, the "machine age" aesthetic of Léger and his circle, or the exaggerated expressionism of the rural and urban Social Realism of Benton and Ben Shahn. Since most WPA murals and sculptural reliefs depicted Tennessee people and their locales and were placed in newly constructed buildings that symbolized a progressive and prosperous future, any peculiarities of style appear to have been easily absorbed by the public imagination.[9]

Because modernist and regionalist approaches seem to have arrived almost simultaneously as impulses from the outside, the distinction between them may have been lost on a mass public encountering "modern" art for the first time in the mid- to late 1930s. However, for artists like Will Henry Stevens, who had come to the South to teach in the 1920s; Charles Cagle, Philip Perkins, and Aaron Douglas, who had come back from Europe and New York in the early 1930s; and Avery Handly, who had returned from Germany to his small Tennessee town in the mid-1940s, the public's lack of familiarity with the new tendency toward abstraction was an impediment. At one time or another, all five felt forced to paint in a more representational manner in order to sell their work.[10]

Wide acceptance of the abstract idiom in Tennessee became almost synonymous with the welcome of a new group of artist-teachers into the state in the 1940s and 1950s. The arrival of this generation of artists, who had credentials from art schools around the country and abroad, ushered in a new wave of influences, prominent among them the New York School of Abstract Expressionist painting. With this transplantation of artistic voices, the vocabulary of contemporary art in the South changed dramatically, creating excitement and upheaval. The wholesale transmission of the tenets of modern art to young Tennesseans would happen in the newly formed college and university art departments. Just as the tide was beginning to turn, the Nashvillian Robert Ryman left his music studies at George Peabody College and, aspiring to become a jazz musician, headed for New York City in 1950.

Since 1910 Nashville's Watkins Institute[11] had been offering basic adult art classes taught by local artists in its department of industrial arts, but the first art program in Tennessee to begin systematically recruiting professional artists for teaching positions had been the Memphis Academy of Arts (now Memphis College of Art), created in 1936 when the city took over the private James Lee Academy.[12] Fisk University had invited Aaron Douglas to chair its Fine Arts Department in 1939. Vanderbilt University, which employed the painter Marion Junkin as its first art teacher in 1942 and Mims as fine arts lecturer in 1949, never developed a studio art program, relying on the nearby art education department of George Peabody College for Teachers to train its would-be artists. What would soon be the largest university art program in the state was formed at the University of Tennessee in Knoxville in 1948, with extension courses in art offered at the university's Nashville campus. A full roster of art education classes was available at Memphis State College by 1950. Other teachers colleges, like Austin Peay State College and Tennessee A & I (now Tennessee State University), soon followed suit. The University of Chattanooga (now UT Chattanooga) had a two-person art department in 1951, Memphis State College (now University of Memphis) began offering the bachelor of fine arts degree in 1960, and Southwestern at Memphis (now Rhodes College) started an art department in 1962.

The Memphis Academy of Arts served as an important nexus for a developing Memphis art scene with an exciting schedule of talks and visits by prominent artists, designers, and architects during the 1940s and 1950s. The Nashville Artist Guild, formed in 1950, drew on the dedication and leadership of its founding members, among whom were Philip Perkins and Puryear Mims, to promote contemporary art and plow new ground for art in and around the state's capital city. The Knoxville Seven, a group of abstractionists who found their inspiration in nature, quickly coalesced around the University of Tennessee art department.[13] When the Tennessee Fine Arts Center at Cheekwood opened its doors in 1960, one of its inaugural exhibitions was *Tennessee Artists Now*, a statewide survey of contemporary art that included most of the newly arrived university instructors. Two statements in that show's catalogue reveal the vibrancy of a burgeoning statewide art scene. Martin Kellogg, an artist trained at the Boston Museum School, who had been living in both Nashville and Connecticut since 1934, offered advice to the new museum: "Should it have exhibitions in painting, the jury should be split and space for hanging split into academic and abstract. Do not encourage one without the other." Charles T. Young, a Mississippian and chair of the art department at Austin Peay State College, praised the pluralistic nature of Tennessee art at that moment: "the polyphonic art activities in Tennessee [are] the sign of a healthy art situation in which the individual may choose his own path for original and creative expression. Even though Tennessee, especially its education system, has

been slow to embrace art as a legitimate media of individual expression, more sporadic art progress has left its effect."[14]

The art historian Kirk Varnedoe believes that the success of modern art has always depended on the willingness of a contemporary audience to make a leap of faith, "to tolerate, pay attention to, or actively support, an unprecedented expansion of artists' prerogatives to create what a biologist might call 'hopeful monsters'—variations, hybrids, and mutations that altered inherited definitions of what could be."[15] In the optimistic postwar years, Memphis, Nashville, Knoxville, and Chattanooga seemed poised to welcome new artistic influences.

One of the few Tennessee university teachers born in the South was the Alabama artist George Cress, who had trained under Lamar Dodd[16] at the University of Georgia. Cress, whose early work was heavily influenced by Cubism, took his inspiration from the Tennessee landscape and has been widely acclaimed for his consistently abstract paintings. First hired to teach at the University of Tennessee in Knoxville in 1949, he soon left to become chair of the department of art at the University of Chattanooga, where he taught until retirement. Others, who at first found themselves cut off from previous sources of inspiration, saw their work changed by the new environment. The English-born Ted Faiers came to Memphis in 1952 fresh from studies with Will Barnet at the Art Students League in New York. His *Ceremony at Dawn,* of about 1955, celebrates the small garden behind his new house in a compact abstract symbol language. Walter Hollis Stevens, who rode into the quiet university town of Knoxville in 1957 on a wave of recognition for his highly energized Abstract Expressionist paintings, immediately began to transpose the energy of tumbling boulders and rushing streams in the nearby Great Smoky Mountains into his work.[17] The Viennese-born artist Eugene Biel-Bienne,[18] who was invited to teach at Vanderbilt in 1957, was a fully mature artist at a traumatic turning point in his life. Finding in Nashville a receptive audience for his dark Expressionism, he undertook some of the most ambitious canvases of his career. David Driskell, who came to Fisk University in 1966, and Arthur Orr, hired by George Peabody College in 1967, arrived as mid-career artists with established signature styles. Both Driskell—whose abstract figuration overlaid with African motifs signaled the rise of the Black Arts movement—and Orr—whose minimalist nonobjective canvases are boldly colored and geometrically shaped—helped mold the taste of a Nashville arts community ready and waiting to connect to the national scene. Driskell attracted students and artists to Fisk while organizing exhibitions that made important contributions to African American art history. Orr produced series after series of cutting-edge work, which resulted in his selection for the Whitney Museum of American Art's Annual Painting exhibition of 1969. That widely diverse

show, since described as "postminimal," anticipated Conceptual art, a movement that would soon bring the Nashville expatriate Robert Ryman to prominence for his revolutionary all-white paintings.

Although it took several generations for the state's professional art programs to become fully ensconced in the educational system, the artists who pioneered them moved the art community along more quickly by becoming active participants wherever they landed in Tennessee. The results of their efforts secured a future for artistic training programs in Knoxville and Memphis that rival any in the nation today. These artists also organized exhibitions for themselves and their colleagues and showed their work in institutions across the state. The catalogues that exist and the surprisingly modern works that found their way into museum collections reveal a conscious effort on the part of both artists and their audiences to build an artistic infrastructure for Tennessee's future.

The art critic Suzi Gablik has described the dilemma of modern art as one of the central contradictions of our era: "the mystique of modern art has always been that it is not generally popular, or even comprehended, except by an elite few."[19] In her view, both the drive toward pure abstraction and the socially engaged realist art of the 1930s and 1940s were alienating postures that ultimately failed to become part of the larger community. The opposite seems to have been true here in Tennessee, due perhaps to the widespread number of small and medium-size FAP/WPA projects, and also to the late arrival of the modernist impulse. Both occurred at propitious moments in Tennessee's development, and as a result, we find in our modern art history a wealth of distinctive artistic visions that seems fitting for a state so widely diverse in geography and population.

Notes

1. Prizes in the juried competition of contemporary American and European artists went to Dwight Tryon, Elizabeth Nourse, Irving Wiles, and Edmund C. Tarbell, among others. The only example of Impressionism among the loans of European and American masterpieces from public and private collections in Chicago, Cincinnati, Louisville, New York, Philadelphia, Pittsburgh, and St. Louis was a lone Claude Monet landscape from the Union League Club in Chicago.

2. The Nashville Museum of Art, founded in 1926, did not have its own building until 1941. It deeded its collections to the new Tennessee Fine Arts Center at Cheekwood in 1960. Nashville's Parthenon, a reconstruction of the popular art building at the Tennessee Centennial, opened in 1931 with a permanent donation of the James M. Cowan Collection, which included only established American artists who were members and associate members of the National Academy of Design. Chattanooga's Hunter Museum of American Art came into existence in 1951, and Knoxville's Dulin Gallery (predecessor of the Knoxville Museum of Art) opened its doors in 1961.

3. Charles Cagle, of Beersheba Springs, left Peabody College in the 1920s to study at the Pennsylvania Academy of the Fine Arts in Philadelphia. He

encountered the non-naturalistic color and broken-up illusionism of the Post-Impressionists Matisse and Cézanne at the nearby Barnes Foundation in Merion, Pennsylvania. Cagle returned to Nashville from 1931 to 1935 and taught at Watkins Institute and George Peabody College for Teachers. His style of patchy paint application and nonrealistic color proved inspiring to fellow members of the Studio Club, which he had helped to found.

4. The Waverly native Philip Perkins arrived in the Paris of the 1930s after a stint at the Art Institute of Chicago. He worked under the Cubists Louis Marcoussis and Fernand Léger in Paris. Later he shared a studio with the Swiss-French Surrealist Yves Tanguy in New York in the early 1940s and showed with Tanguy at the 1947 International Surrealist Exhibition at Galerie Maeght in Paris. Perkins returned to Nashville and taught extension classes for the University of Tennessee in Nashville during the late 1940s and early 1950s before leaving again for Europe, living in Spain and France until his return to Nashville in 1961. Perkins's paintings in Tennessee museum collections today reflect both Surrealist and nonobjective impulses.

5. The architectural painter and printmaker A. C. Webb Jr., whose father, Alonzo C. Webb, was supervisor of drawing in the Nashville Public Schools, attended the Art Institute of Chicago and the University of Illinois School of Architecture. He worked in the offices of the prominent New York architect Donn Barber before departing for Paris on the eve of World War I. Although he never returned permanently to Nashville, Webb was welcomed back in 1929, 1931, and 1937 for talks, demonstrations, and exhibitions at the Centennial Club, Peabody College, and Watkins Institute under the auspices of the Nashville Art Association.

6. See Amy Helene Kirschke, *Aaron Douglas: Art, Race and the Harlem Renaissance* (Jackson: University Press of Mississippi, 1995), 71–91, for a discussion of Douglas's style.

7. Callicott received a letter on May 31, 1935, from Thomas Hart Benton, praising the bold style of his 1934 WPA murals at the Memphis Natural History Museum. Callicott Papers, Archives of American Art, Smithsonian Institution. However, his early figurative style soon evolved into an abstract language intent on portraying Theosophical and cosmological ideals.

8. Puryear Mims (1906–1975) left Nashville for the Parisian Académie Julian in between earning his B.A. and M.A. degrees in English at Vanderbilt University, where his father was chair of the department. Thereafter, Mims changed course, heading for New York to seek out the American modernist sculptors Robert Laurent and William Zorach at the Art Students League. He interned briefly with the stone carver Gutzon Borglum at Mount Rushmore before returning to open a Nashville studio and teach art under the auspices of the WPA.

9. See Howard Hull, *Tennessee Post Office Murals* (Johnson City, Tenn.: Overmountain Press, 1996), and Carroll Van West, *Tennessee's New Deal Landscape* (Knoxville: University of Tennessee Press, 2001), for descriptions and locations of WPA art in Tennessee.

10. Rick Stewart, in his essay "Toward a New South: The Regionalist Approach, 1900 to 1950," in *Painting in the South,* ed. Ella-Prince Knox, exh. cat. (Richmond: Virginia Museum of Fine Arts, 1983), describes how Stevens, who taught at Newcomb College in New Orleans, felt the need to balance his nonobjective responses to the Southern landscape with representational imagery. Cagle, Perkins, and Douglas turned to portrait painting as a way to bring in supplemental income. Handly painted portraits of friends and neighbors and later embarked on a series of religious themes prompted by his conversion to Catholicism.

11. Founded in 1880 by Samuel Watkins as a free state school promoting knowledge of the physical and natural sciences, less than ten years later Watkins Institute was offering basic education classes at night to meet the growing needs of local citizens and foreign immigrants. In 1910 Edwin Gardner was hired to teach in the industrial arts department, which over the past thirty years has been expanded into fully accredited film, art, and interior design programs.

12. The James Lee Academy was founded by Florence McIntyre, a former student of William Merritt Chase. McIntyre founded the Memphis Art League, predecessor of the Brooks Memorial Art Gallery, in 1914.

13. According to the art historian Frederick C. Moffett (*Heart of the Valley: A History of Knoxville, Tennessee,* ed. Lucile Deaderick [Knoxville: East Tennessee Historical Society, 1976], 435), the Knoxville Seven were Robert Birdwell, Richard Clarke, Kermit "Buck" Ewing, Joanna Higgs, Philip Nichols, Walter Hollis Stevens, and Carl Sublett.

14. *Tennessee Artists Now,* exh. cat. (Nashville: Tennessee Fine Arts Center, 1960), unpaginated. The exhibition included many of the artists mentioned in this essay, such as Biel-Bienne, Cagle, Callicott, Cress, Faiers, Mims, Perkins, and Walter Hollis Stevens.

15. Kirk Varnedoe, *A Fine Disregard: What Makes Modern Art Modern* (New York: Harry N. Abrams, 1990), 21–22.

16. Dodd (1909–1996), a Georgian, had studied with John Steuart Curry at the Art Students League in New York.

17. Stevens, who had studied with the modern Expressionist Abraham Rattner at the University of Illinois, Champaign-Urbana, was featured in *Art in America's* "New Talent" issue, March 1957, several months before his arrival in Knoxville.

18. Residing in New York City just after World War II, Biel-Bienne had been supported by the Guggenheim Foundation, which required that he create nonobjective work and file monthly reports on his progress. Letters to and from foundation director Baroness Hilla Rebay reflect his difficulties with the artist-patron relationship. Biel-Bienne Files, Archives of American Art, Smithsonian Institution.

19. Suzi Gablik, *Has Modernism Failed?* (London and New York: Thames and Hudson, 1984), 12.

210 · **WILL HENRY STEVENS**
b. Vevay, Indiana 1881–d. Vevay, Indiana 1949

Gray Woodland (No. 1001), ca. 1941
Oil on canvas; 22 × 26 in.
Courtesy of Blue Spiral 1, Asheville, North Carolina

ONE OF THE SOUTH'S FIRST and most ambitious modernist artists, Stevens often created paintings that were inspired by the landscape of western North Carolina and East Tennessee. In this image of trees and forest floor, backlit by the sun, the charged outline of lighted rock ridges and vegetation imprints an abstract composition on the landscape. Stevens took his inspiration from nature but moved easily between representational and nonobjective depictions throughout his career. Combining the two approaches, *Gray Woodland* expresses both the dynamic energy and the dramatic solitude of the deep forests of the Great Smoky Mountains. SWK

211 · **EDWARD "TED" FAIERS**
b. Newquay, Cornwall, England 1908–
d. Memphis, Tennessee 1985

Ceremony at Dawn, 1955
Oil on canvas; 24 × 32 in.
Collection of Steve Conant, courtesy of David
Lusk Gallery, Memphis, Tennessee

KNOWN MOSTLY FOR HIS FIGURATIVE PAINTINGS, Ted Faiers also produced a large body of abstract works inspired by the example of his teacher and mentor Will Barnet. He was also influenced by Indian space painters, who used geometric and organic forms as well as colors and patterns that were reminiscent of traditional Native American pottery and weavings. In these sources and in Faiers's work, abstract symbolic elements are dynamically arranged within a relatively compressed space. DH-B

212 · EUGENE BIEL-BIENNE

b. Vienna, Austria 1902–d. Nashville, Tennessee 1969

Untitled drawing, from the suite *Images of War,* ca. late 1940s
Brown ink on paper; 23½ × 17¾ in.
Collection of Paul Harmon

EDUCATED AT UNIVERSITIES IN Vienna and Cologne, Eugene Biel-Bienne assimilated the influence of Viennese Expressionism and the School of Paris of the 1930s. During World War II, he came to the United States as a member of Roosevelt's Emergency Committee of Artists. After teaching in New York, Biel-Bienne joined the faculty of Vanderbilt University as professor of fine arts. He was a two-time recipient of a Guggenheim fellowship. This drawing of a standing man shows the influence of such German Expressionist artists as George Grosz and Otto Dix. PH

213 · EUGENE BIEL-BIENNE

b. Vienna, Austria 1902–d. Nashville, Tennessee 1969

Conundrum, from the suite *Variations,* 1957
India ink on paper; 24 × 18 in.
Collection of Paul Harmon

IN 1990 WALTER SHARP WROTE of Biel-Bienne's "disenchanted romanticism" and referred to the artist as "Balzac-with-a-brush." The expressive dry brush technique of this drawing, which combines the artist's interest in Expressionism with an appreciation for the summarily descriptive painting technique of Japanese *sumi-e,* is typical of the artist's work on paper in the decade or so before his death in Nashville in 1969. PH

PHILIP PERKINS
b. Waverly, Tennessee 1907–d. Nashville,
Tennessee 1970

Untitled, ca. 1965
Oil on paper; 19¼ × 15½ in.
Courtesy Stanford Fine Art

LIKE A WORKING TIMEPIECE POISED at the edge of a planet, these bright arcs
seem to move in space. Perkins was an artistic seeker who lived alternately in Europe and
America throughout his life. He developed a style of Abstract Surrealism that gave way
late in his career to the influence of the nonobjective paintings of Wassily Kandinsky and
the ambitious overall compositions of Color Field artists like Ellsworth Kelly. SWK

215 · **BURTON CALLICOTT**
b. Terre Haute, Indiana 1907–
lives Memphis, Tennessee

Broken Sunbeams #5, 1989
Oil on canvas; 42 × 26 in.
Memphis Brooks Museum of Art, Memphis,
Tennessee, Gift of Evelyne and Burton Callicott
92.9

BURTON CALLICOTT STUDIED AT THE Cleveland Institute of Art and was an instructor at the Memphis College of Art from 1937 to 1973. The main focus of Callicott's work has been the changing spectacles of nature—light playing a central role in many of his compositions. *Broken Sunbeams #5* is one of a series of works containing the rainbow spectrum, an element that he introduced into his painting in 1973. Through the years it evolved into an abstract symbol, reflecting his interest in Theosophical concepts of multidimensional perception and his efforts to visualize this higher level of spiritual insight. MM

216 · **WALTER HOLLIS STEVENS**
 b. Mineola, New York 1927–d. Deer Isle,
 Maine 1980

 Abstract Painting, 1971
 Watercolor on illustration board; 31 × 26⅞ in.
 Ewing Gallery of Art and Architecture, The
 University of Tennessee, Knoxville, Dale Cleaver
 Bequest, 1971.01.05

FROM 1957 UNTIL HIS DEATH, Walter Hollis Stevens was an advocate for abstract art in East Tennessee. Spending his summers in Maine and teaching at the University of Tennessee for the remainder of the year, Stevens was inspired by the natural landscape in which he enjoyed sketching and painting. In this watercolor from the early 1970s, Stevens has substituted illustration board for traditional watercolor paper. The smooth and non-absorbent surface of the board has allowed the artist to add and wipe away areas of paint with rags and brushes, thus producing an exceptional richness of color and form. SY

217 · **GEORGE CRESS**
 b. Anniston, Alabama 1921–
 lives Chattanooga, Tennessee

 Sequatchie Valley—Winter, 2002
 Oil on canvas; 23½ × 31¼ in.
 Collection of Solie Fott

SINCE HIS ARRIVAL IN EAST TENNESSEE in 1949, George Cress has been translating the landscape into the visual language of modernism. Painting on-site, he establishes a horizon line and rich tonal range with strong sweeps of the brush, then disrupts any illusion of depth by applying color equally in foreground and background. The Hunter Museum of American Art honored Cress, one of the state's most influential university teachers, with a fifty-year retrospective traveling exhibition in 1990. SWK

218 · DAVID DRISKELL

b. Eatonton, Georgia 1931–lives
Hyattsville, Maryland

The Moon Does See, 1973–74
Collage and egg tempera; 13 × 10½ in.
Collection of Earl J. Hooks

EVEN IN ABSTRACT WORKS LIKE THIS, David Driskell often employs a symbolic narrative that is concerned with expressing more than simply an interesting arrangement of colors. With the sun at top and the moon beneath, this painting seems to be about the space in between: a chaotic transition zone between darkness and light. The artist, who served as chair of the Fisk University art department from 1966 to 1976, is also a renowned collector and scholar on the subject of African American art. He was the curator of the seminal *Two Centuries of Black American Art* exhibition for the Los Angeles County Museum of Art. SWK

219 · ROBERT RYMAN

b. Nashville, Tennessee 1930–
lives New York, New York

Untitled, 1962–63
Oil on linen; 76½ × 77 in.
Collection of the Artist, courtesy of
PaceWildenstein, New York

ROBERT RYMAN ATTENDED George Peabody College for Teachers in Nashville, then moved to New York with the hope of becoming a jazz musician. While working as a security guard at the Museum of Modern Art, he was introduced to the story of modern art as a progressive movement toward pure form and away from subject matter. He began painting in 1953 and since 1955 has used a monochromatic palette, particularly white, to explore a wide range of tonalities and variations in the appearances of different kinds of paint and support. In his work, Ryman focuses on the most fundamental and material aspects of painting, achieving a spare lyricism in visual affect. MWS

220 · **ARTHUR ORR**

b. Rockford, Massachusetts 1938–
lives Nashville, Tennessee

Untitled, ca. 1975
Acrylic on canvas; 117¾ × 62¾ in. at largest
dimension
Collection of Nancy and Alan Saturn

THIS DISTINCTIVE SHAPED-CANVAS abstraction seems to hover between the influences of Arthur Orr's contemporaries Frank Stella, whose paintings of the 1960s feature hard-edged geometry, and Sam Gilliam, whose unstretched and draped canvases of the 1960s and 1970s are covered in soft, fluid forms. This painting includes both hard-edged, off-kilter box forms and softly merged earth tones between its gradated borderlines. By combining geometric with organic motifs, Orr may have intended to bridge the gap between humanity and nature. A similar work by Orr, *Flat Monument,* was included in the 1969 Whitney Annual. SWK

Amy Kirschke

Aaron Douglas's *Building More Stately Mansions*

Aaron Douglas was the preeminent visual artist of the Harlem Renaissance.[1] Within weeks of his arrival in Harlem in 1925, Douglas was hired by W. E. B. Du Bois, editor of the NAACP's *The Crisis,* and Charles S. Johnson, who edited the Urban League's *Opportunity,* to provide illustrations that would enhance the two magazines. Douglas was interested in forging a strong relationship between American blacks and Africa and believed his images could help create a sense of collective identity for the magazines' readers in a positive and innovative way. Douglas developed his own pan-Africanist signature style, a technique he used primarily in his illustrations and large-scale murals, in which he combined the influences of Egyptian art, West African art (especially Dan masks of the Ivory Coast), and Cubism.

Two important events helped Douglas develop a strong connection with modernist movements in art. The first was a one-year fellowship at the Barnes Foundation in Merion, Pennsylvania, in 1928. Albert Barnes had an impressive collection of art in his newly created foundation, including the works of Henri Matisse, Pablo Picasso, and Paul Cézanne, as well as a substantial collection of African art. Douglas and Gwendolyn Bennett were the first two African American artists to receive the prestigious Barnes grants. The second event that would greatly influence Douglas's modernist leanings was the year he lived in Paris. Douglas sailed for France in 1931, studied briefly at the Académie Grande Chaumière, and spent the rest of the year at the Académie Scandinave, located in James McNeill Whistler's former studio. His sketchbooks reveal an interest in Cubism as well as traditional drawing techniques. Other African American visual artists of the period also studied in Paris, including Hale Woodruff, Augusta Savage, and Palmer Hayden.[2]

Douglas developed a relationship with Nashville, and in particular Fisk University, when he was hired in 1930 to create a substantial mural series for Fisk's library, including a history of African American people in the New World. The series was very successful and well received by Fisk, and in 1939 Douglas was hired by the university as chairman and founder of the art department. He involved himself intimately with a group of Harlem Renaissance writers and scholars, among whom numbered at various times Charles S. Johnson,

who became the first black president of Fisk, Arna Bontemps, and Langston Hughes. He was instrumental in the acquisition of the Alfred Stieglitz Collection as well as a substantial Winold Reiss portrait collection, which were donated to Fisk by Georgia O'Keeffe and Winold Reiss, respectively. Until his retirement in 1966, Douglas taught while creating art and illustrations for Fisk University.

In 1944 Douglas was commissioned to paint *Building More Stately Mansions* for the International Student Center at Fisk. The title appears to be a biblical reference, but Douglas stated that he took the title for this work from "The Chambered Nautilus," a poem by Oliver Wendell Holmes. Douglas said he used the title to "create a starting point around which pertinent symbols might be collected, in the hope of giving greater illumination to the work."[3] He wanted to symbolize civilization coming together after World War II.

The panel was meant to represent the progression of cultures and civilizations from the dawn of recorded history to the present. Beginning at the upper left, Egyptian civilization, and therefore Africa, is symbolized by a pyramid and a sphinx. The large profile of the sphinx dominating the upper portion of the panel is a combination of Egyptian elements and the profile of a Dan mask of the Ivory Coast, a combination typical of Douglas's work. Several towering columns, capped by the entablature of a temple, represent classical Greek civilization. On the far right is a triumphal arch, recalling the spirit of Roman civilization. The pagoda-like structure near the center is intended to symbolize all Asian cultures and civilizations. The cross, spires, and rose windows of the Gothic cathedral in the center of the panel symbolize the cultures of medieval and modern Europe. Lower down on the left side Douglas placed a skyscraper, which he considered America's unique contribution to the architecture of the Western world. The fire and smoke rising from the skyscraper remind us of the two world wars in which the United States had fought.

Douglas placed a small log cabin in front of the skyscraper, which he stated symbolized a shield guarding the spirit of liberty and progress for many generations. The figures in the foreground show African Americans working in agriculture and construction, science,

symbolized by the beaker of fluid, and industry, represented by a cog. Concentric circles of light lead us to the final figures, a mother or teacher with two young children, and a globe. This technique, common in Douglas's work, shows his knowledge of Cubism and Orphism.

All the figures, not only the sphinx, are heavily influenced by Egyptian art. Douglas described his method of creating figures in a 1971 interview: "The head was in perspective in a profile flat view, the body, shoulders down to the waist turned half way, the legs were done also from the side and the feet were also done in a broad ... never toward you ... perspective. I got it from the Egyptians."[4] Shades of mauve and green dominate the composition.

Douglas stated that he wished to remind each new generation to "look back on, face up to, and learn from the greatness, the weaknesses and failures of our past with the firm assurance that the strength and courage certain to arise from such an honest and dutiful approach to our problems will continue to carry us on to new and higher levels of achievement."[5]

Douglas is showing all people, all civilizations coming together after the ravages of World War II. He places African Americans in a prominent position, dominating the lower half of the composition and providing a link with the ancient civilizations of Africa, via Egypt. The painting is atypical in that it employs his signature style, heavily influenced by modernism (which he usually used for illustrations and murals), rather than the more realistic, traditional style he more often reserved for his paintings (including his portraits and landscapes). While much of the symbolism contained in the panel can be found in some of Douglas's earlier illustrations and in his library murals at Fisk, the combination of elements here is unique.

NOTES

1. For more information on the life of Aaron Douglas, see Amy Kirschke, *Aaron Douglas: Art, Race and the Harlem Renaissance* (Jackson: University Press of Mississippi, 1995).

2. For more information on Harlem Renaissance artists in Paris, see Theresa Leininger-Miller, *New Negro Artists in Paris* (New Brunswick, N.J.: Rutgers University Press, 2001).

3. Aaron Douglas, interview by Jacqueline Fonvielle-Bontemps, "The Life and Work of Aaron Douglas: A Teaching Aid for the Study of Black Art," master's thesis, Fisk University, 1971, 53–55.

4. Aaron Douglas, interview by L. M. Collins, July 16, 1971, Black Oral Histories, Fisk University Special Collections, Nashville, Tennessee.

5. Douglas, interview by Fonvielle-Bontemps, 53–55.

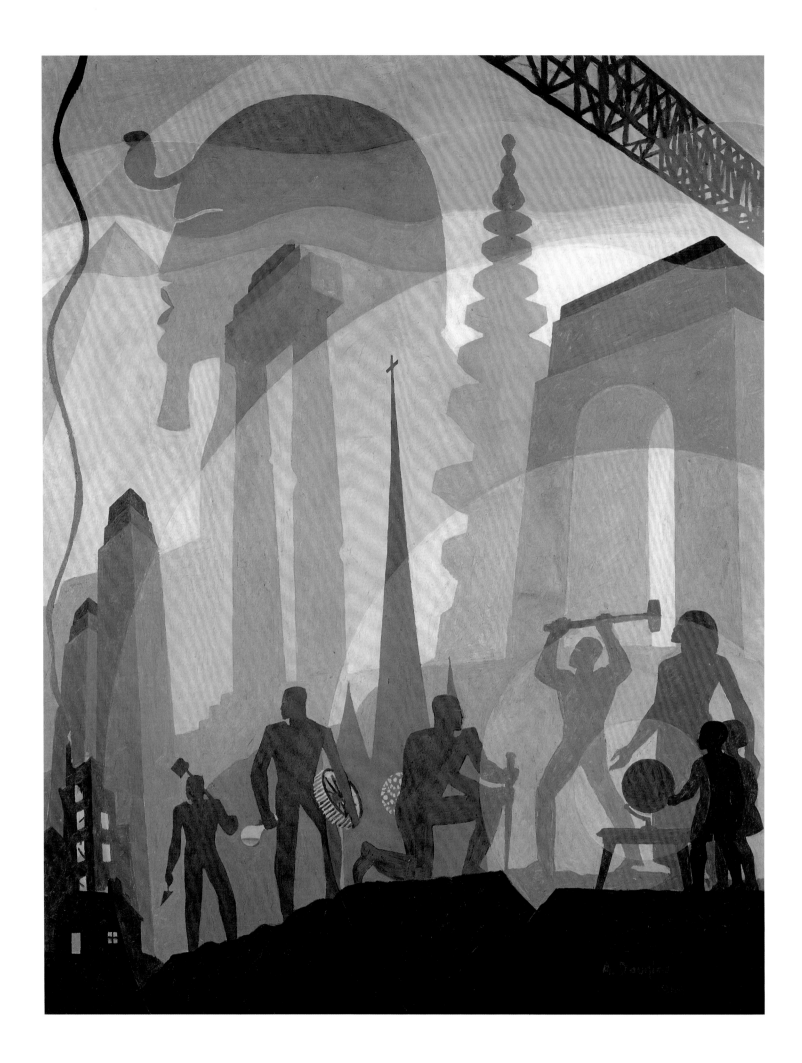

221 · AARON DOUGLAS

b. Topeka, Kansas 1899–d. Nashville,
Tennessee 1979

Building More Stately Mansions, 1944
Oil on canvas; 54 × 42 in.
Fisk University Galleries, Nashville, Tennessee

THIS PAINTING WAS CREATED IN 1944 for the International Student Center at Fisk University, where Aaron Douglas had been serving as chairman of the art department since 1939. It represents the progression of civilization from ancient times to the present day. Africa is symbolized by a pyramid and sphinx; classical antiquity through two columns and a triumphal arch; Asia by a pagoda-like tower; Europe by a Gothic church spire; and modern America is indicated through the skyscrapers in the bottom left corner. In the foreground are several figures—many with African features—that represent African and African American contributions throughout history. KDW

Lynn Jones Ennis

CONTEMPORARY CRAFT

THE STATE OF TENNESSEE HAS A RICH AND DIVERSE RELATIONSHIP WITH CRAFT, BOTH IN its traditional forms and in forms that have evolved from the studio craft movement. Each craft artist in this exhibition has spent varying amounts of time in Tennessee, yet the experience—whether a few years or an entire life—has left a mark on the work. There are several reasons for this, ranging from the example of Tennessee's early craft traditions to excellent settlement schools that included craft education in the curriculum. Natural beauty and Tennesseans' relationship to the land have also called craft artists to the state. Craft is categorized by the materials used, and all of these materials have a connection to the land: clay, fiber, glass, wood, and metal. Tennessee offers the artist a place to work and/or study in an environment that is connected to the land and promotes creativity.

The history of craft in the twentieth century is complex. This essay begins by addressing the Appalachian craft revival that is relevant to much of Tennessee. Then, an exploration of the artists represented in this exhibition places their work in the larger history of the latter part of the twentieth century and as a part of the contemporary studio craft movement. While it is only part of the story, it is one lens through which to look as we celebrate the art of Tennessee.

Craft at the turn of the twentieth century was seen as a form of rescue. The popular Arts and Crafts movement was started in England as a reaction against the dehumanizing nature of the industrial revolution. The once-agrarian worker was strapped to a rigid work schedule in a factory that left little room for individual expression. By contrast, the craft revival encouraged working skillfully with the hands and was meant to engender dignity and connection to the land. Although there were pockets of people still making objects for their own use—such as quilts and baskets—they were few in number, and the products of time-intensive crafts like weaving on a loom were being replaced by store-bought materials. Revivals were started by a number of organizations, many of them affiliated with churches as part of their home missionary work, and the southern Appalachian Mountains was one of the favorite locations for the reformers. The church was joined by governmental support for crafts education to enable people to make a little extra money.

The reformers were fueled by a romantic desire to return to making things the traditional way. Yet in many instances the real focus was the person making the object and not the object itself. Because the reformers were almost always trying to help the craftspeople economically, telling the story of the maker was seen as a good marketing tool. By the end of the twentieth century, however, this approach had shifted dramatically, and craft as an aesthetic object became paramount. One look at the recent works in this exhibition leaves no doubt that they exemplify the ideals of the studio craft movement.

The renewed interest in craft led to a search for more and better techniques, which in turn provided the foundation for formal educational programs of the mid–twentieth century. Many of the people working in the revival programs, particularly in the Appalachian region, were educated and had connections outside the region, creating a large network of interest throughout the Northeast and to some extent the Midwest.

Thus, what started out as a craft revival became a springboard into the investigation of new materials. Schools such as the Penland School of Crafts in western North Carolina and the Arrowmont School of Arts and Crafts

Craig Nutt, *Radish Salad Bowl*, 1998, detail, cat. no. 244

in Gatlinburg, Tennessee, remain in the forefront of craft education today. Arrowmont began as a settlement school but in 1945, under the direction of Marian Heard, joined forces with the University of Tennessee to create a vital craft program in which students could receive credit from the university. Heard was a graduate of Alfred University in New York State with a bachelor of science degree in ceramic design, and she also held a master's in fine and applied arts from Columbia University Teachers College. She began teaching at the University of Tennessee in 1936 in the Department of Crafts, Interior Design and Housing, College of Home Economics. Heard stayed on as director of Arrowmont from 1945 to 1977.

Although many of today's artists have received a bachelor and/or master of fine arts degree, such non-degree-granting programs as Penland, Haystack, and Arrowmont have also been important to the education of craft artists. After receiving training at these schools, many artists return as instructors. This practice of giving back to the community demonstrates that a key factor in the training of the craft artist is to sustain the legacy of the people with whom they have studied.

The creation of the G.I. Bill of Rights in 1944 was pivotal to the growth of the studio craft movement. This bill allowed many soldiers returning from World War II to attend college and training schools, and veterans constituted almost half of all college students in 1947. Schools such as Penland were also qualified under the G.I. Bill to take students.

After the war, there was renewed interest in working with metal. Memphis-born Earl Pardon became one of the leaders in this area. After serving in Germany during World War II, he attended the Memphis College of Art under the G.I. Bill, receiving his bachelor of fine arts degree in painting (1951) before going to Syracuse University for a master of fine arts (1959). Pardon participated in workshops sponsored by the precious metals dealers Handy and Harman, which were organized by Margaret Carver. Pardon revived enameling, and his work marks the important transition from the revival period to the new and exciting era of crafts in the post–World War II era. During his thirty-eight years as a teacher at Skidmore College and as a workshop instructor, he influenced a great number of jewelers. His own work is in museums and collections throughout the United States. Pardon's painterly eye can be seen in such work as the two brooches and the bracelet in this exhibition. His jewelry is truly "portable art."

The Memphis College of Art also played an important role in the life and work of the fiber artist Henry Easterwood. There he studied with the painter Dorothy Sturm. After receiving his bachelor of fine arts degree in 1958, he left, only to return in 1959 as chair of the fiber department. This was the beginning of forty years of teaching, working, and experimenting in the field of fiber and design. He was part of a movement, along with Ed Rossbach and Lenore Tawney, that would change the direction of fiber art in the United States. His influence reached far from Memphis, and in 1965 his work was included in an exhibition in New York. Easterwood's work was sold at the America House, affiliated with the American Crafts Council. Throughout his career he continued to try new techniques. In 1989 *Red Garden—Summer* was part of the exhibition *American Tapestry Weaving since the 1930s and Its European Roots,* at the University of Maryland, College Park, that explored the influence of four important early weavers who broke with tradition and created their own designs.

Fiber artists also expressed themselves in the more familiar medium of quilts. Since 1958 Bets Ramsey has been involved in teaching, writing, curating, and making. Her quilts move and sing, as does the example in the exhibition, *Diverse Opinions.* Educated in Tennessee, she received a bachelor's degree in art from the University of Chattanooga and a master of science degree in crafts from the University of Tennessee, the program in which Marian Heard was involved. Pushing the boundaries of her craft, Ramsey has exhibited in national and international exhibitions, while finding time to write such books as *Old and New Quilt Patterns in the Southern Tradition.* Her involvement in Tennessee has reached throughout the state and has touched many lives.

During her postgraduate studies in textile design at Indiana University in the early 1970s, the fiber artist Patti Lechman studied with Joan Sterrenburg, who had been a student of Ed Rossbach. Another beneficiary of the G.I. Bill, Rossbach was educated at Cranbrook Academy. In 1950 he moved to Berkeley, California, where he taught for many years and is known for his work in experimental basketry. Lechman has been influenced by his work, and having one of Rossbach's former students as a teacher opened a door to her own creativity. Lechman pursued a master of fine arts degree in ceramics from Michigan State University, graduating in 1975, and soon after moved to Memphis. Here she would teach and work, returning to fibers after a summer class in basketry at Penland. Her vessels are intricate, jewel-like objects that, while small in size, create powerful visions. Her choice of materials adds new dimensions to the creations, such as the knotted nylon in *Folded Space.*

Ceramics would benefit from some of the same post–World War II energy. The G.I. Bill educated such groundbreakers as Peter Voulkos. He spent time at Black Mountain College in North Carolina, where he encountered Josef Albers, John Cage, and Merce Cunningham, artists working on the edge in various media. Among the artists joining Voulkos in exploring clay was Earl Hooks. He received his bachelor's degree in the 1950s from Howard University, where he

studied with James V. Herring, Lois Mailou Jones, James A. Porter, and James L. Wells. There he came to understand in a deeper way his African past, and this connection would shape his work in the years to come. He continued his education, receiving a graduate certificate from the Rochester Institute of Technology as well as attending the School of American Craftsmen in New York in 1954–55. While in New York, his work, like Henry Easterwood's, was represented in the America House. He taught at Fisk University, serving as associate professor and chair of the art department. His understanding of the connectedness of people to a larger world is embodied in such ceramics as *Celestial Bodies,* a heavy earthen form that is decorated with stars and planets.

The potter Charles Counts was deeply influenced by Marguerite Wildenhain, who had been trained at the Bauhaus before coming to the United States in 1940. After earning a bachelor's degree in history (with a number of credits in art) from Berea College in 1956 and a master's in art from Southern Illinois University, Carbondale, in 1957, Counts apprenticed with Wildenhain at her studio and school at Pond Farm in California. Throughout his life Counts was involved in a number of far-ranging projects. From the establishment of Beaver Ridge Pottery in Tennessee (1959) and Rising Fawn Pottery on Lookout Mountain, Georgia (1963), he remained in the forefront of teaching. His influence on a growing number of potters, coupled with his work as a quilt designer and author, made him well known in the field of crafts. His own work and philosophy were deeply influenced by his time spent with Wildenhain. His *Untitled Jar* speaks to this association.

Born and raised in Memphis, Cynthia Bringle received her undergraduate education at the Memphis College of Art (B.F.A., 1962). Her interest in ceramics led her to both Haystack, a summer craft school in Maine, and Alfred University, where she graduated with a master of fine arts in 1964. While at Haystack, Bringle came to know Bill Brown, who in 1962 became the director of the Penland School of Crafts. Eventually Bringle came to Penland to live and work, and it is here that her legacy as a potter and teacher continues to grow. She is steadfast in her desire to create functional pottery, and her work begs to be used. Her *Vessel* shows the sculptural quality of her work. Bringle names Shoji Hamada and Robert Turner as potters who have influenced her work, and in turn she provides great guidance as a teacher and a mentor. A readers' survey in the June–August 2001 issue of *Ceramics Monthly* named Bringle as one of the thirteen "living potters and ceramic artists who have had the greatest impact on contemporary ceramics."

Bill Griffith came to Tennessee in 1987 and serves as assistant director of Arrowmont School of Arts and Crafts. His degrees in art education (B.S., Indiana State University, 1972; M.A., Art Education/

Ceramics, Miami University, Ohio, 1977) as well as postgraduate work, travel, and research throughout Japan, Ecuador, and Peru inform his work. *Dwelling* has an architectural quality that, with its clean lines, invites the viewer to contemplate, meditate, and perhaps slow down in a world speeding by.

The studio glass movement is a newcomer to the craft scene. One of the forerunners in the movement is Harvey Littleton, a direct beneficiary of the G.I. Bill of Rights. The Penland School was receptive to Littleton's ideas, and this relationship injected new energy into the region so close to Tennessee. Tommie Rush, who lives and works in Knoxville, received her bachelor of fine arts degree from the University of Tennessee in 1976 and has since studied at Arrowmont. Her luminous bowls and vases, such as *Botanical Bowl,* appear informed by designs from Art Nouveau. Sandblasted, their frosted look emits a softness that requires skill to achieve. Her work clearly speaks of the flora around her.

Curtiss Brock was educated at Goddard College, in Vermont (B.A., 1984), and at the University of Illinois, Urbana-Champaign, where he received his master of fine arts in 1994. From 1985 through 1996 he served as studio coordinator and faculty member at the Pilchuck Glass School in Seattle, known for one of its founders, the glass artist Dale Chihuly. Since 1989 Brock has been assistant professor and department head for the glass program at the Appalachian Center for Crafts in Smithville, Tennessee. He continues to teach at Pilchuck and at the Penland School. Brock has traveled and lectured in Japan a number of times. Japan is important to craft artists not only because of its deep traditions in craft and the recognition it accords craft artists but also because of its inspirational beauty. Brock is accomplished in a number of glass techniques and his work reflects his abilities. In his untitled glass sculpture, there is an organic connection to the earth that speaks of the artist's ties to nature. It makes the viewer stop and wonder: Was this dug from the earth?

Workers in wood often take a route different from university fine arts training. The 1950s found artists working in wood seeking their education in the form of apprenticeships that were sometimes combined with university studies in liberal arts. The furniture maker Craig Nutt fits this model. Educated at the University of Alabama, he majored in religious studies. Only later would Nutt study with a master furniture maker. His work reflects both his skill as a master woodworker and his use of wit and humor to engage viewers to rethink what they already visually know. Such is the case with *Radish Salad Bowl.* Nutt's work has a sense of the magical and whimsical that depends on the high degree of workmanship necessary to create such an intricate piece. He takes furniture making to yet another level, pushing the boundaries to invite another degree of inquiry and craftsmanship.

The vibrancy of the crafts produced by those who live or have studied in Tennessee speaks to the ongoing impact that this state has on the making of objects. The Appalachian Center for Crafts, which opened in 1979, became a division of Tennessee Technological University in 1985. Arrowmont School of Arts and Crafts still attracts artists from all over. Today, Tennessee artists contribute significantly to the international studio crafts movement, as more artists choose to live, work, and study in a state that has so much to offer.

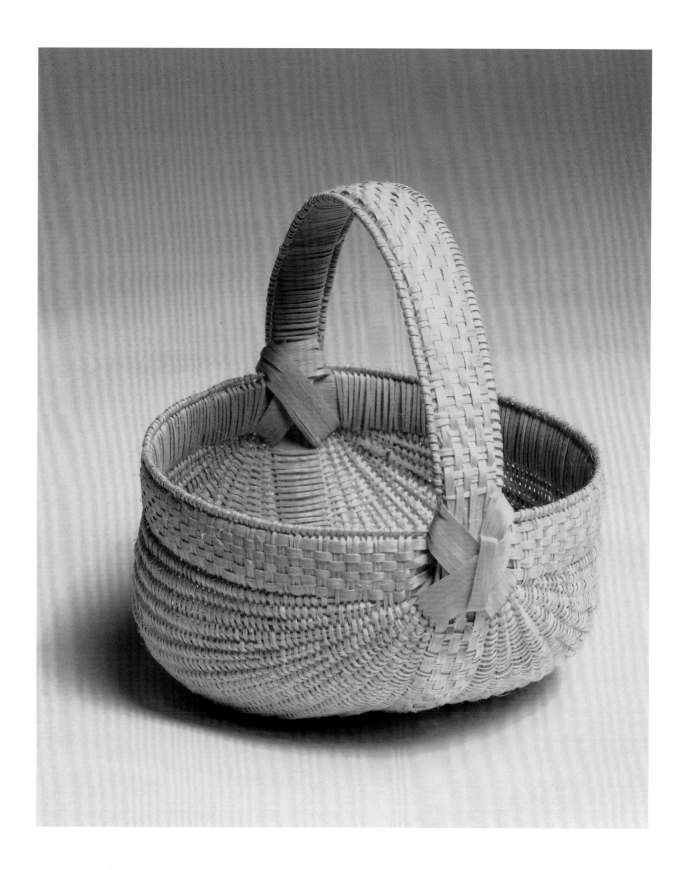

222 · **MARY HALEY PRATER**

b. Cannon County, Tennessee—
lives Cannon County, Tennessee

Basket

White oak; 14 × 19 × 16 in.
Collection of the Museum of Appalachia,
Norris, Tennessee

MARY HALEY PRATER is primarily known for her sets of nesting baskets and miniature baskets. Prater, the youngest of six basket-making sisters, was raised in the Short Mountain community. In this example, Prater's use of narrow splits and flattened ribs, combined with folded square knots (or bow wrapping), identifies the basket, one of six that nest as a set, as Cannon County in origin. JCC

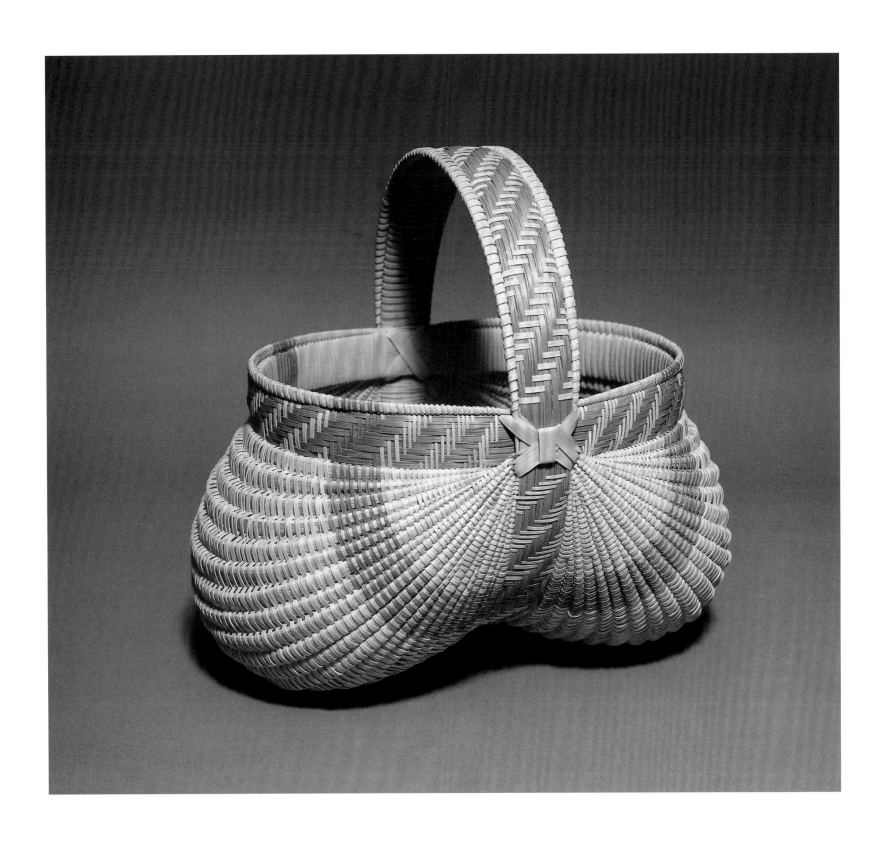

223 · **DEE MERRITT GREGORY**
b. Cannon County, Tennessee 1954–
lives Cannon County, Tennessee

DENNIS GREGORY
b. Smith County, Tennessee 1954–
lives Cannon County, Tennessee

Gizzard Basket, 2001
White oak; 10½ × 9¾ × 8 in.
Tennessee State Museum Collection, 2002.49.21

CANNON COUNTY, TENNESSEE, is home to many extraordinary basket makers, most of whom produce traditional forms such as this gizzard basket. In this refined example, the handle is joined to the rim hoop with a folded square knot (or bow wrapping). The basket features coiled top rib, coiled handle ribs, narrow splits, and flattened ribs. The body of the basket has been constructed with a plain weave, and the spine has been decorated with a varied twill pattern. JCC

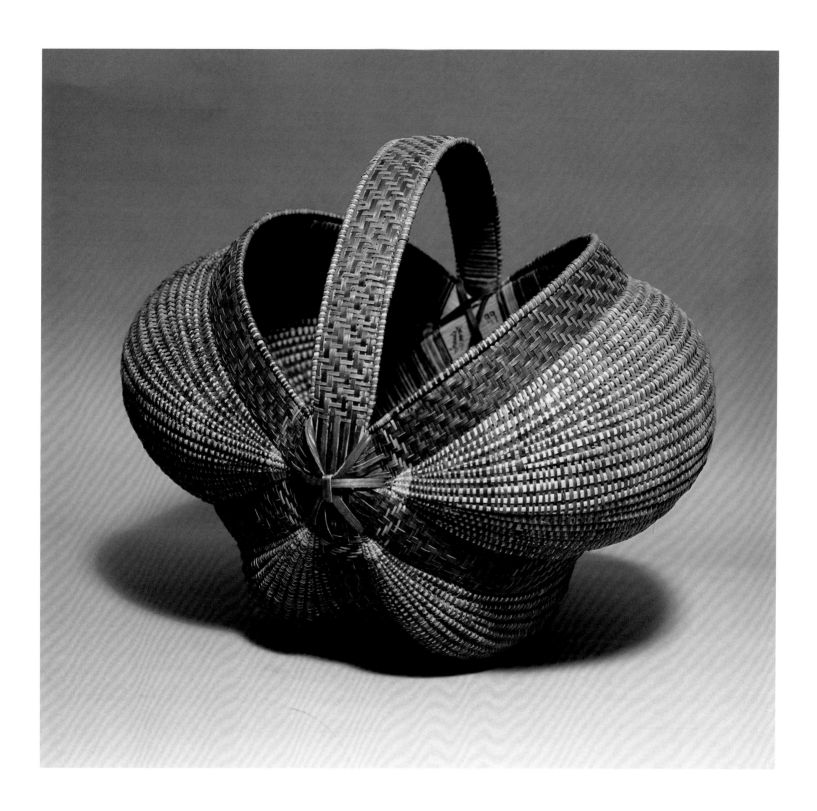

224 · **TREVLE HALEY WOOD**
b. Cannon County, Tennessee 1930–
lives Sylva, North Carolina

Butterfly Basket, 1999
White oak; 15⅞ × 13 × 10¾ in.
Tennessee State Museum Collection, 2001.68.8

THIS UNUSUAL FORM, AN INNOVATION OF WOOD'S, is constructed of three hoops, which intersect with an elaborate knot. The use of three hoops results in three spines. The narrow ribs bulge out to form four distinct sections. The name of this basket comes from the side view, which resembles a butterfly with outstretched wings. The handle and rim have been stabilized with ribs, which are wrapped in a coil pattern. The body of the basket has been constructed with plain weave (with occasional compensating skips). The splits have been dyed red, blue, brown, yellow, and pink, most probably with Rit. The pink and yellow splits are limited to use around the knot. JCC

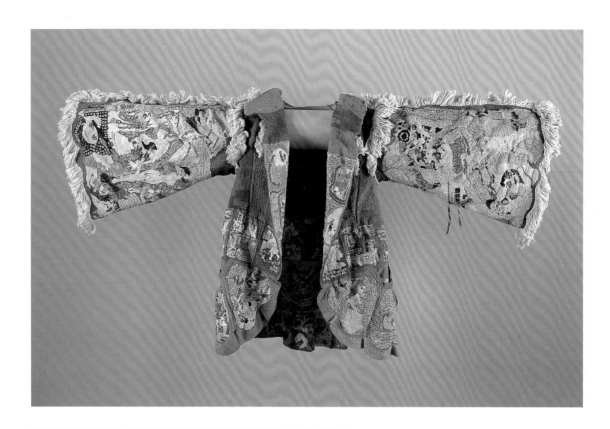

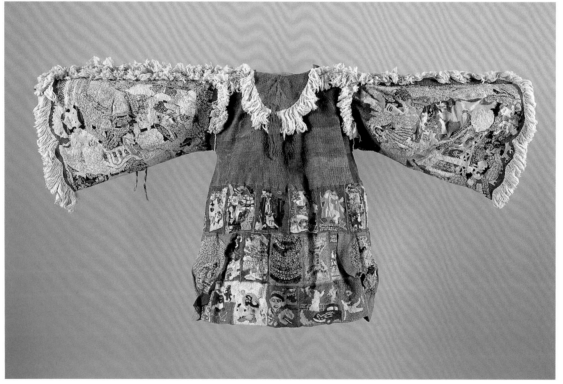

225 · **MYRLLEN**

Active Knox County ca. 1920–73

Coat, 1948–53
Cotton, plastic, and satin; 33 × 57 × 13 in.
Tennessee State Museum Collection, 2003.1

MYRLLEN (PRONOUNCED LIKE MERLIN) created this coat at Eastern State Psychiatric Hospital (now Lakeshore Mental Health Institute) in Knoxville. It was her outlet for the images and words that crowded her mind. She carefully selected her materials from the institution's rag bag, unraveling colored fabrics to get threads for the meticulous embroidery that covers every inch of the surface. Myrllen worked on the coat for five years, until a drug was found to calm her visions, after which she sewed no more. Unusually, the fringed shoulders and sleeves are held together by buttons, rather than seams, and the front closes like a fur coat, with two interior buttons joined by a string. Each scene was embroidered separately on a small square of fabric and then joined to the others. CJA

226 · **HENRY EASTERWOOD**

b. Villa Rica, Georgia 1934–d. Memphis, Tennessee 2002

Red Garden—Summer, 1979
Wool on linen warp; 66 × 90 in.
Federal Express Corporation

Henry Easterwood's *Red Garden—Summer* is part of a series of large tapestries begun in 1979. His bold, abstracted forms, meticulously woven in the contrasting textures of *Red Garden—Summer,* exemplify Easterwood's maxim that "innovation and tradition are mutually compatible." Easterwood established himself as an exceptional weaver and a superb teacher early in his career. On the 1959 retirement of his former professor, Viola Joyce Quigley, Easterwood became head of the fiber department at Memphis College of Art until 1999. He emphasized excellent technique and promoted knowledge of new directions in contemporary fiber art both in his own work and through his work with students. CT

227 · **ARLYN ENDE**

b. New Orleans, Louisiana 1932–
lives Sewanee, Tennessee

On the Second Wind, 1999
Woven copper, velvet inlay, and tufted wool;
50 × 48 × 6 in. overall
Collection of April and Bill Mullins

ARLYN ENDE EXPRESSES "UNDETERRED HOPE" through her pair of woven wings, *On the Second Wind.* Employing a rich combination of materials and techniques, Ende conveys "the excitement and diversity of universal longing toward freedom." Noted for her large-scale textile hangings, Ende has invented both methods and tools for the expansion of traditional fiber techniques. Ende's textile constructions, fiber sculptures, collages, wall *tapetas,* and rugs have been commissioned by private collectors and for public spaces throughout the United States. Ende maintains her Deepwoods studio in Sewanee, Tennessee. CT

228 · **MARTHA CHRISTIAN**
 b. St. Louis, Missouri 1943–
 lives Nashville, Tennessee

 Continental Drift, 1999
 Woven textile, linen warp and wool weft, dye;
 40½ × 78½ in.
 Courtesy of the artist

MARTHA CHRISTIAN STATES, "The deliberate pace of tapestry weaving demands not only a significant amount of time and materials but a commitment to theme." *Continental Drift* reflects Christian's interest in prehistoric events in the region that is now Tennessee. She explores this theme by incorporating shapes from maps that explain tectonic plate movements and other geologic changes over time. In addition to her studio work, Christian has taught weaving at Rhodes College, Vanderbilt University's Sarratt Studios, and the Appalachian Center for Crafts. CT

229 · **PATRICIA LECHMAN**
 b. Fort Bragg, North Carolina 1946–
 lives Memphis, Tennessee

Folded Space, 2000
Knotted nylon; 4½ × 5⅞ × 4¼ in.
Memphis Brooks Museum of Art, Memphis,
Tennessee; funds provided by Howard Foote with
matching funds provided by Pfizer, Inc., 2001.12.2

PATTI LECHMAN IS AN ASSOCIATE PROFESSOR of art at Shelby State Community College in Memphis, and she has worked as a fiber artist for more than twenty-five years. Because of the religious and magical connotations associated with the vessel, the concept of the basket has taken on a spiritual significance for her. Lechman's small knotted forms have evolved from functional containers to abstract shapes that merely suggest their prototype. In recent works, such as this one, the vessels have been opened up, revealing their inner core. MM

BETS RAMSEY'S QUILT *DIVERSE OPINIONS* was created for an exhibition of presenters' work at the 1988 American Craft Council's Southeast Conference in Tuscaloosa, Alabama. Unsure where the inspiration for the piece came from, Ramsey could not decide what to call it until she finally hit on "Diverse Opinions" because it seemed to be like her husband and herself (she never told him the title). Ramsey's childhood love of needlework led her to her lifework of making and researching quilts. Ramsey balances her career as an artist with her deep commitment to art education through teaching, writing, and curating. CT

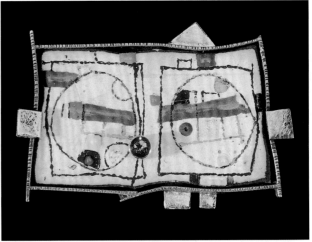

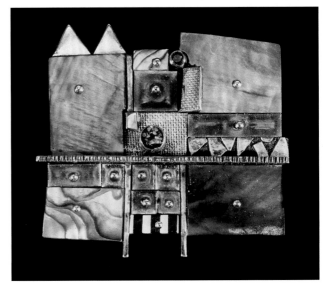

231 · **EARL PARDON**
b. Memphis, Tennessee 1926–d. Boston,
Massachusetts 1991

Bracelet #1379, 1989
Sterling, 14K gold, enamel, shell, ebony, ivory,
abalone, and gemstones; 8½ × 1 in.
Collection of Martha Connell

232 · **EARL PARDON**
b. Memphis, Tennessee 1926–d. Boston,
Massachusetts 1991

Brooch #1525, 1990
Painted enamel, sterling, 14K gold, and blue
topaz; 1⅜ × 2⅛ in.
Collection of Martha Connell

233 · **EARL PARDON**
b. Memphis, Tennessee 1926–d. Boston,
Massachusetts 1991

Brooch #1208, 1988
Sterling, 14K gold, shell, abalone, enamel, ivory,
ebony, and rhodolite; 1½ × 1⅝ in.
Collection of Martha Connell

WHILE TRAINING AS A PAINTER at the Memphis
Academy of Art in the early 1950s, Earl Pardon became
interested in jewelry as "portable art." These three pieces
demonstrate his ability to combine a painter's eye with a
jeweler's skill. On sterling silver plaques, Pardon soldered
together flat sections of gold with a variety of materials
to create intricate collagelike forms, as demonstrated in
Bracelet #1379 and *Brooch #1208.* An abstract design adorns
his enameled *Brooch #1525.* NFC

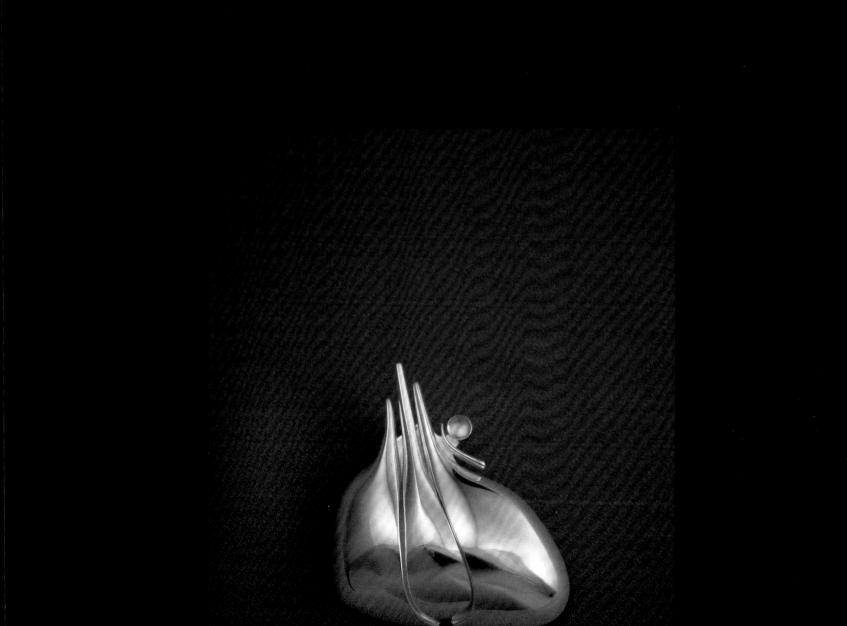

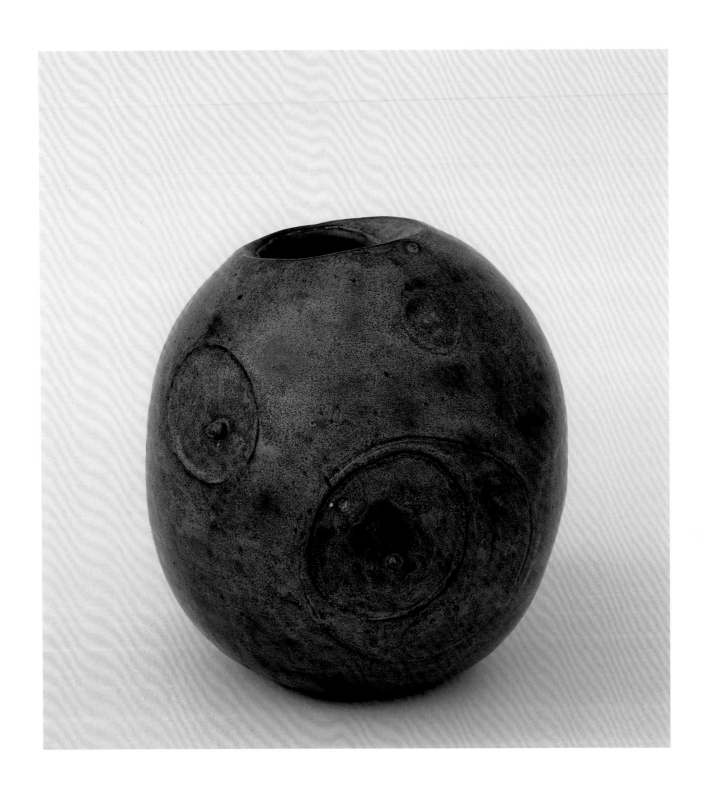

235 · **EARL J. HOOKS**
b. Baltimore, Maryland 1924–lives
Nashville, Tennessee

Celestial Body, ca. 1975
Stoneware with chrome glaze, 9 × 8½ × 8¼ in.
Courtesy of the artist

A RETIRED PROFESSOR WHO TAUGHT for many years at Fisk University, Earl Hooks has been an accomplished painter, photographer, sculptor, and ceramist. Most of his work emphasizes human form, proportion, or scale. In *Celestial Body,* he decorated a nearly spherical vessel—whose rough simplicity and earthy coloration make it appear to have been excavated at some ancient burial site—with raised dots that stand for stars and planets. The union of earth and sky suggests that the two are not in opposition, but parts of a greater whole. MWS

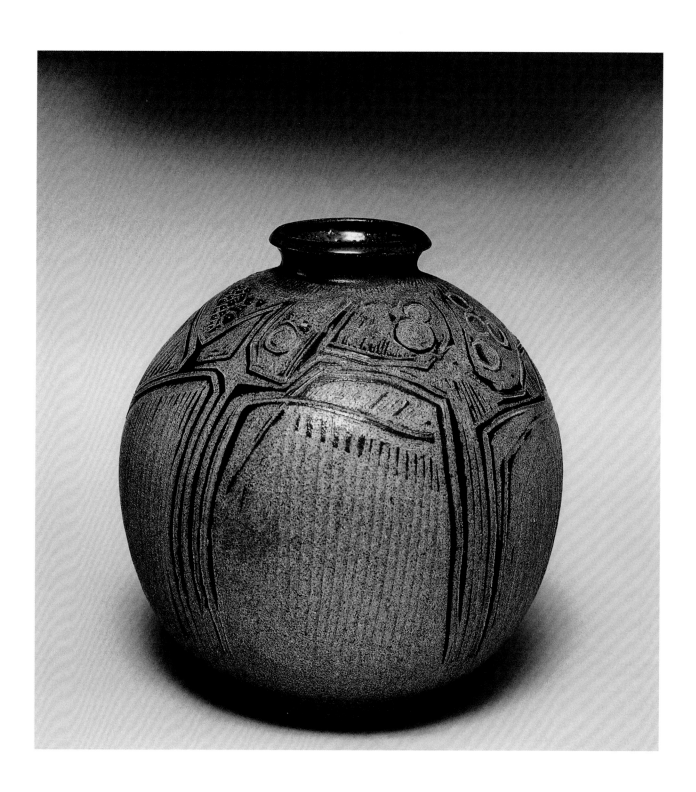

236 · **CHARLES COUNTS**

 b. Oak Ridge, Tennessee 1940–
 d. Maiduguri, Nigeria 2000

Jar, 1972
Stoneware and nepheline syenite glaze;
10½ × 9¾ in.
Collection of Timothy Weber

A PROMINENT AND INFLUENTIAL CRAFTSMAN who lived and worked in the Oak Ridge area for many years, Charles Counts was a potter, quilt and rug designer, poet, writer, arts advocate, and teacher. His love of craft and education drew him to Nigeria for the last fifteen years of his life. There he established a pottery studio that trained and provided income for local artisans. This wheel-thrown stoneware jar is decorated with slips and sgraffito. Its surface imagery was inspired by the mountains around his Rising Fawn Pottery in Georgia. The thin, transparent feldspar base glaze allows the decoration to show through while the cobalt interior glaze serves as an accent. TW

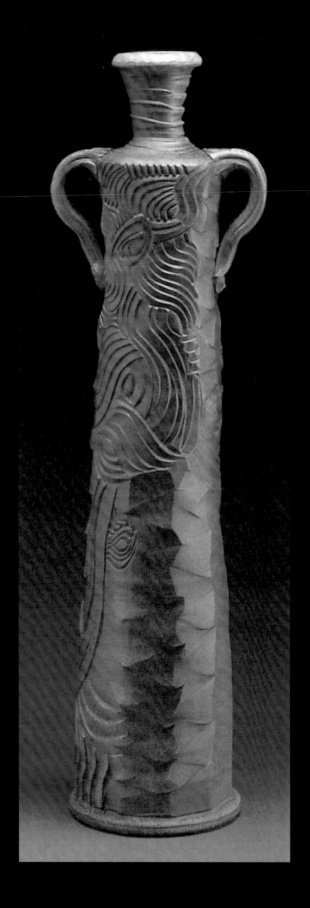

237 · **CYNTHIA BRINGLE**
b. Memphis, Tennessee 1939–
lives Penland, North Carolina

Vessel, 1998
Stoneware and salt glaze; 33 × 10 × 9 in.
Purchased by Friends of the Gallery, Gallery of
Art and Design, North Carolina State University

CYNTHIA BRINGLE'S FIRST STUDIO was outside of Memphis. For the past thirty-five years, she has maintained a workplace in the arts community around Spruce Pine, as well as a close relationship with the internationally renowned Penland School of Crafts in North Carolina. In addition to being a teacher, Bringle exhibits her work worldwide. This wheel-thrown vessel was achieved by stacking cylinders, then finishing the top with a strong shoulder, neck, and lip. The two handles were pulled from moist clay. Strong surface carving is accentuated by the effect of wood firing and salt glaze. TW

238 · **TIMOTHY WEBER**
b. Fayetteville, North Carolina 1950–
lives Nashville, Tennessee

Introspective, 2001
Raku clay and bamboo; 7 × 5½ × 3½ in.
Courtesy of the artist

IN THE EARLY 1970S TIMOTHY WEBER apprenticed under the master ceramist
Charles Counts, whose work followed Bauhaus dicta of simplicity and elegant function-
ality. Of equal importance to Weber was the influence of Japanese ceramics, notable for
their humble earthiness, use of asymmetry to stress the value of the handmade over the
mechanical, and associations with Japanese architectural forms. All these elements, except
for functionalism (with no opening, the object cannot be used as a vessel), come together
in Weber's raku ware. The work is rich in association with Third World forms; it variously
calls to mind a hut, complete with front door, chimney, and bamboo TV antennas, or an
antique oil lamp with a bamboo wick. MWS

239 · **BILL GRIFFITH**
b. South Bend, Indiana 1949–
lives Gatlinburg, Tennessee

Dwelling, 2000
Stoneware; 18 × 13 × 12 in.
Courtesy of the artist

THE CERAMICS ARTIST BILL GRIFFITH has his studio in Gatlinburg's Arrowmont School of Arts and Crafts, where he is also the assistant director. Drawing on his interest in world cultures and ancient architecture, Griffith builds his dwellinglike forms from simple slabs of stoneware. The surface of his monumental-seeming *Dwelling* receives color, texture, and depth from flame licks and melting ash deposits that occur during firing. TW

240 · **FRANK MARTIN**
 b. Oklahoma City, Oklahoma 1960–
 lives Maryville, Tennessee

Teapot, 2002
China clay; 7 × 8 × 6 in.
Courtesy of the artist

THIS TEAPOT BY THE UNIVERSITY OF TENNESSEE professor Frank Martin shows his unorthodox approach to traditional ceramics. Starting with wheel-thrown forms with hand-built additions, Martin composes the elements into a functional tea-pot. This piece is made from a vitreous, translucent, tofu-colored clay body, fired at 2100 degrees Fahrenheit. Using colorful overlapping glazes and drawing with glaze stains, Martin achieves a unified, sculptural, yet painterly form. TW

241 · **TOMMIE RUSH**
 b. Mobile, Alabama 1954–
 lives Knoxville, Tennessee

Botanical Bowl, 2003
Blown glass; 6 × 19 × 15 in.
Courtesy of the artist

THIS BOWL INCORPORATES SEVERAL traditional hot-glass techniques. The production process includes gathering, blowing, and manipulating molten glass. Gardening and botanical motifs inspired the bowl's fluid lines and flowing, elegant edges. The soft and sensual surface is achieved through acid etching and sandblasting. TW

242 · CURTISS BROCK

b. Albuquerque, New Mexico 1961–
lives Smithville, Tennessee

Untitled, 2001
Glass; 4 × 12 in.
Courtesy of the artist

CURTISS BROCK DIRECTS THE GLASS PROGRAM at the Appalachian Center for Crafts in Smithville, Tennessee. This cast and gathered piece incorporates many layers of poured, molten glass. The base is formed by sand-casting, using a method called off-hand casting. The upper portion is made from clear molten glass embedded with a variety of materials such as oxides, colored glass cullett from Germany, and gold and silver leaf interspersed throughout the layers to create the color and pattern. TW

JOHN JORDAN
b. Nashville, Tennessee 1950–lives
Antioch, Tennessee

Pair of Black and White Vases, 2001
Wood; 8 × 8⅞ in. (black); 7⅞ × 8⅝ in. (white)
Collection of Ruth and David Waterbury,
01-14, 01-15

THE INTERNATIONALLY RECOGNIZED wood turner John Jordan, whose studio
is in Antioch, transforms green Tennessee ash into graceful vase forms. After letting the
wood air-dry for several months, he shapes the surface by carving, filing, sanding, and then
wire brushing to accentuate the radial grain pattern. The contrast between the ebonized
and bleached pair is emphasized by the linear patterns that curve in opposing directions.
Airy, soft forms are carved at the mouth to achieve a delicate, sensitive lip. TW

244 · **CRAIG NUTT**

b. Belmond, Iowa 1950–lives
Kingston Springs, Tennessee

Radish Salad Bowl, 1998
Lacquer on carved wood, 56 × 21 × 17 in.
Smithsonian American Art Museum, Gift
of the James Renwick Alliance, 1999.5A–L

THE MASTER FURNITURE ARTIST Craig Nutt's imaginative constructions of vegetable forms seem to have "grown" from deep within the artist, who is both a gardener and the possessor of a whimsical sensibility. Most of the components for this piece started on the lathe, where the basic shapes were roughed out of various close-grained woods. Carving, filling, scraping, and sanding refined the shapes of these forms, which were then joined and painted using lacquers and dyes for lifelike color. Nutt's novel functional sculpture has earned him a place among America's elite woodworkers. TW

245 · **AKIRA BLOUNT**
　　b. Columbus, Ohio 1945–lives
　　Bybee, Tennessee

Redbud Angel, 2002
Mixed media; 36 × 13 × 11 in.
Courtesy of the artist

AKIRA BLOUNT OFTEN WALKS through the woods to collect natural materials and develop ideas that she includes in her dolls. She uses fiberfill as the foundation, which is then layered with cotton knit cloth. With a needle and thread, Blount shapes the head and hands, then covers these elements with a layer of fine gauze to create a smooth surface. By using a combination of manufactured and natural materials, she invents dolls that seem delightfully animated and full of whimsy. TW

246 · **MANUEL**

b. Coalcomán, Mexico 1933–lives
Nashville, Tennessee

Lavender Wagon Wheel Suit, 1974
Wool and silk-blend tropical striped gabardine
with rayon embroidery thread and rhinestones;
coat, 33 × 24 in.; pants, 45 in.
Collection of Porter Wagoner Enterprise

PORTER WAGONER, ONE OF THE MOST FAMOUS figures in country music, has
become known through his television and Grand Ole Opry appearances for elaborate
rhinestone-laden outfits displaying his trademark wagon wheels. This suit was made by
Manuel, who moved from Mexico to southern California in the mid-1950s and eventually
became a designer for Hollywood's Nudie Cohn in the 1960s. In 1973 Manuel started his
own clothing business and in 1989 moved it to Nashville. He has designed images and
clothing for such celebrities as Elvis Presley, Johnny Cash, Dwight Yoakam, and Elton
John. Manuel sewed the word "HI" into the inside flap of this jacket and the others he has
made for Wagoner so the performer could flash the greeting to his audience. MB

247 · **SHERMAN CAMPBELL**
Active East Tennessee

Banjo, early 20th century
Iron and wood; 34 × 9⅝ × 3 in.
Country Music Hall of Fame and Museum,
75.12.09

HOMEMADE INSTRUMENTS CONSTRUCTED FROM household items provided hours of entertainment for families throughout Appalachia. Sherman Campbell of Washburn, Grainger County, Tennessee, made the body of this banjo from the oblong metal lid of a cooking pot; the lid's handle can be seen on the back of the instrument. Worn areas on the neck, taken from a guitar and cut down to size, give testimony to the key in which this instrument was generally played. NFC

248 · **SHO-BUD GUITARS**
HAROLD "SHOT" JACKSON
b. Wilmington, Delaware 1920–
d. Nashville, Tennessee 1991

BUDDY EMMONS
b. Mishawaka, Indiana 1937–lives
Nashville, Tennessee

Pedal Steel Guitar, ca. 1967
Wood and steel; 30 × 33¼ × 18¼ in.
Country Music Hall of Fame and Museum, X.164

IN THE LATE 1950s the country music guitar greats Shot Jackson and Buddy Emmons pooled their talents in a venture called Sho-Bud Guitars, and by the 1980s they were considered the leaders in the manufacture and development of pedal steel guitars. The cabinet of this four-pedal steel, once owned by Don Warden, is made of bird's-eye maple; the neck between the changer and key head is rosewood. Sho-Bud's signature diamond, heart, spade, and club decals embellish the fret board. NFC

249 · BO RIDDLE

b. Fort Smith, Arkansas 1956–
lives Batesville, Arkansas

Cowboy Boots, 1995
Dyed leather; 15½ × 12½ × 4½ in.
Collection of George Ducas

BO RIDDLE, WHOSE GREAT-GRANDFATHER was a boot maker during the Civil War, made his first pair of moccasins as a child from the inner tube of an old tire. He started making boots in 1976 and moved to Nashville in 1982 to make boots for country-western singers while pursuing his own music career. These boots were created for the singer-songwriter George Ducas, using a "cutout and overlay method" Riddle has nearly perfected. RH

Mark W. Scala

NEW DIRECTIONS CONTEMPORARY ART IN TENNESSEE

THROUGH MOST OF THIS SURVEY OF TENNESSEE ART, IT HAS BEEN THE ABILITY OF AN artist's work and life story to remain in our collective memory that has shaped the determination of significance. Yet how can one apply this measure to the works of the present? The record that tells which of today's artists will have lasting significance is currently being formed, a process that is affected, in part, by such projects as this very publication. The measure of significance today may be more about individual aesthetic achievement than, as in the past, the artist's overall impact on the community or state. Artists today are more transient than ever before; for many, their works may have no bearing on Tennessee experience and little relationship with the tastes of Tennesseans. Even more than elsewhere in this survey, the works in the contemporary section reflect the pluralistic condition of art across the nation as it happens to appear in this state. Some of the artists included here are relative newcomers; others have been here for nearly their entire lives, although they may have studied art out of state. Some, often younger, artists are engaged in idioms that reflect the technologies and content of the international art world; others are pursuing original personal visions that have quietly matured over many years. Most have earned master's degrees in art, often studying with professors who are themselves too mobile to have absorbed and transmitted any regional influences. In Tennessee and across the country, university art departments train students to be creators of expressions that not only are highly personal but also reflect critical ideas with relevance to the larger art world. The artists in this section of the exhibition have effectively intertwined these two paths, and many have received national exposure through museum and gallery exhibitions in other cities; a few are creating work that, if it has not yet yielded such acclaim, in the opinion of the curators will do so in the near future. In Tennessee today, there are hundreds of excellent artists; this survey cannot begin to represent them all properly. At best it can serve as a sampling of the variety and quality that continue to be produced in every region of the state.

Today, the lack of defining characteristics in Tennessee's art stands in sharp contrast to the art of the Southern regionalist movement of recent decades, when many artists sought to identify and utilize artistic characteristics that were peculiar to their environment and heritage and would provide a viable alternative to the internationalism of the mainstream (read New York–dominated) art world. Over the past three decades, William Christenberry has created sculptures and photographs of Alabama's roadside shacks and frightful Klansmen; Bill Dunlap has rendered romanticized views of the agrarian traditions in north Mississippi and the Shenandoah Valley of Virginia; Douglas Bourgeois has painted stories of psychological duress, sexual obsession, and religious malaise, saturated in the tropical heat of Louisiana; James Surls has created sculptures that conjure images of folk art root carvings of the east Texas woodlands. Often inspired by folk and visionary art by such Southerners as Howard Finster and Bessie Harvey, these artists have created an eccentric and expressive art that encapsulates the region's taste for the Gothic, the tragicomedies arising from tensions between modernity and tradition, and, above all, the land and its ghosts.

Only a few of the artists in this survey overtly employ such regional inflection, and when they do, it is a result of the desire to convey personal experiences, not to capture the innate sensibilities of a geographic area. Among them is the painter and sculptor Andrew Saftel, who lives in Pikeville. The layered iconography in

Kell Black, *Beetles,* 2001, detail, cat. no. 264

Saftel's paintings is drawn from memories, philosophical musings, and bits and pieces of present-day society. It is also frequently inspired by found artifacts that have an aura of historical significance —maps, diaries, tools. His rough-hewn sculptures often combine figures and found objects to evoke the storytelling and folk art traditions of the rural countryside in which he lives. Saftel was born in New Bedford, Massachusetts, and studied art at the San Francisco Art Institute, so his evocations of place are not so much celebrations of his own roots as they are an acknowledgment of the importance of examining the microcosm of locale, wherever one might happen to live, within a broader national or even international context.

Chattanooga's Jim Collins, a native of West Virginia, also uses found objects, generally vestigial remnants of nineteenth-century Victoriana or signs and fragments of rural twentieth-century life as it was sometime before 1950. Whereas Saftel wants to merge past and present and combine local and international influences to reflect the intersections that shape his identity, Collins looks to the past with a wistful and sly appreciation for the weirdness of the ads and other images with which our forebears lived. A former art professor at the University of Tennessee, Chattanooga, Collins evokes such sources as folk art and the eccentric Surrealism of the artist Joseph Cornell, who created asssemblages of oddly affecting images and objects within small and immaculately crafted boxes—worlds unto themselves.

This blending of the influence of one's immediate environment and personal history with allusions to the broader culture was also the focus of Yone Sinor's work. A Cherokee sculptor from Nashville whose stone carvings represent universal themes of human dignity and struggle, Sinor created powerfully twisting, heavily muscled figures, articulated with a rough vigor that was meant to evoke the energy and earthiness of Native American traditions in Tennessee.

Another kind of regionalism, one that is rooted in a deeply empathetic observation of the natural world, is at work in the Sewanee artist Jim Ann Howard's meticulous depictions of Tennessee's flora and fauna. Howard's drawings and watercolors merge the empiricism of such naturalists as John James Audubon with the lyricism of a poet who discovers spiritual nourishment in the graceful details of nature.

Like Howard, the Memphis painter Veda Reed, who studied under Burton Callicott at the Memphis College of Art and then taught there until her retirement, draws a parallel between nature and the inner life, though her images are based on views of her native Oklahoma and the New Mexican desert rather than the landscape around Memphis. With their brooding atmospheres and dynamic compositions, Reed's paintings belong to the tradition of depicting nature as a metaphor for human emotions, which are typically seen as being more natural than cultural.

Another transplanted Oklahoman, Vanderbilt University professor Marilyn Murphy also frequently includes images of nature in her paintings and drawings. For her, however, the landscape, and such elements as fires, tornadoes, and floods—which she uses as symbols for human paranoia, loss of control, and the cleansing force of change— are reflections of the individual as a social rather than a natural being. Murphy creates unsettling narratives by placing human figures within these elements, often employing irony to emphasize her characters' self-deluded conceits.

Just as the use of satire and irony to subvert the authority of manners, customs, and unjust laws has a substantial pedigree in Southern letters, ranging from the works of Tennessee Williams to Flannery O'Connor, it also plays a role in much of Tennessee's contemporary art. Employing the narrative and expressionistic approaches of the Southern regionalists, Barbara Bullock comments with sharply drawn satire on racial and other social conflicts in the state, region, and nation. Such paintings as *The Hate That Hate Produced* have an aesthetic inventiveness, emotional power, and universal relevance that show Bullock to have been an artist who was a humanist rather than a social critic who was a political cartoonist (although her works have the unabashed clarity of any effective propaganda). Jed Jackson, a professor at the University of Memphis, displays a similar satirical thrust in his depictions of people who are corrupted by power, greed, lust, and various other sins, misdemeanors, and felonies. *C.E.O.* was inspired by the corporate scandals of 2002, when it emerged that such businesses as Enron had created a culture that came to epitomize for many the dangers of unregulated capitalism. Vanderbilt University professor Michael Aurbach's sculptures likewise address the abuse of power, but with a subtler, if more mordant irony. His *Secrecy* series is composed of structures that evoke the architecture of authority—dictators' palaces, churches, corporate headquarters, academia. Covered with highly reflective sheet metal and containing wordplays and symbols that comment on the secrecy that is required to maintain power, the sculptures at once attract with their glossy beauty and repel with their chilling associations. Robert Durham's *Deconstructing Baby* takes on another manifestation of authority, the arena of the academician. Like Aurbach's sculpture, the painting employs an accessible and sardonic symbolism. It centers on a smirking baby holding scissors, who is about to cut apart, or physically "deconstruct," an art magazine, poking fun at the critical model of deconstructivism that has dominated critical discourse on art in the past several decades.

A more intellectual gamesmanship is at work in Beauvais Lyons's *Planche 144*, which is from a series of lithographs that parody nineteenth-century anatomical prints. Despite their aura of scientific objectivity, these prints seem exotic because they show only

partial views that are isolated from the whole context of the body—one can vaguely recognize the part of the body they are supposed to represent, but their anatomy seems unreal, as if to suggest that the nineteenth-century model from which the prints are derived was speculative at best. Other series in the artist's oeuvre include the creation of a pseudo–folk art collection and the fabrication of images that are presented as "proof" of the discovery of a lost—though in actuality completely imaginary—Mesopotamian culture. The artist has given the name The Hokes Archives to this group of series, which calls into question the role of the aesthetic artifact and its interpretation—or misinterpretation—in shaping our perception of cultures past or present.

Tennesseans pursuing a more straightforward realism, although in very different ways, include John Baeder, Sylvia Hyman, and Kell Black. Baeder has long been drawn to relics of the American past, such as trains and diners, and in 1972 began depicting these subjects—using photographs and postcards as source material—with meticulous realism. He continues to create visual homages to his favorite subject, the diner, a vernacular American form that is rapidly disappearing from the streets of urban and small-town America. Sylvia Hyman is also well known for her trompe-l'oeil ceramic sculptures of boxes and baskets filled with rolled "documents" and "mail." The small size of these sculptures and the sense that they contain cryptic keepsakes give them an engaging preciousness and sense of mystery. Another delightful twist on hyperrealism is provided by Kell Black, a professor at Austin Peay State University in Clarksville. A master of the antique art of cut-paper sculpture, Black creates simulacra of a wide range of images, from medical diagrams to the work on view in this survey, an arrangement of cut-paper beetles that suggests the display of an entomologist's collection.

More than ever before, Tennessee's community of artists has migrated here from other places, both within the United States and beyond its borders. Many of the state's newest arrivals, who often came to teach in universities and colleges, have brought with them a focus on transnational content rather than local experience. Like Lyons, the Hong Kong–born artist Paul Pak-hing Lee represents artifacts that symbolize cultural forces, but in a codified way that he leaves to the viewer to translate. A professor and chair of the art department at the University of Tennessee, Lee creates photographs taken from videotapes of airplanes in flight. Although elegant and luminous, these images show little identifiable geographic or functional context, so that they might be interpreted as having any number of referents—to the graceful beauty of a bird in flight, to surveillance, attack, exploration, or recreation—depending on the cultural background and personal experiences of the viewer. Suta Lee (no relation), an immigrant from the Republic of China

(Taiwan) who teaches at Austin Peay State University, is equally unconcerned with reflecting his specific locale, instead creating paintings that represent images of architecture, carvings, and decorative patterns from around the world, taken out of context and reshuffled for expressive purposes.

Tennesseans often have a global perspective to match that of immigrant artists. Anderson Kenny, who is from Nashville and studied architecture at the University of Tennessee, creates whimsical paintings that mirror the humanistic focus of much global postmodern architectural practice. Kenny seeks to describe society's increasing levels of complexity and interactivity in his evocations of diagrams, maps, blueprints, and architecture ranging from backwoods shacks to unbuildable utopian structures.

A very different cultural evocation is evident in the Murfreesboro artist James Gibson's elongated anthropomorphic sculptures. Although they are inspired by the tall, notch-legged forms of grave markers from southern Sudan, colorful works like *Mardis Marker* are intended as metaphors for any kind of marker, which the artist describes as "conspicuous objects to help someone in their travels,"[1] but which also may mark important points in the passage through life.

The earliest modern precedent for art that transcends borders is, of course, abstraction, which, when it is intended to be a manifestation of an artist's inner sensibilities, has relevance whether created in New York, Rome, or in a city or town in Tennessee. Prominent among Tennesseans who have developed distinctive abstract idioms is Memphis's Pinkney Herbert, whose current paintings feature dynamic arrangements of organic forms, lines, and patches of color. These works have a quality of incompleteness, which, combined with Herbert's gestural brushwork, suggests that, to the artist, the action of painting directly on the canvas, with no alterations or underpainting, can be a metaphor for the raw energy and state of flux that characterize unresolved conflicts within the psyche.

In contrast to Herbert's formal and emotional disequilibrium, the overall abstractions of the Joelton painter Jane Braddock are meant to trigger a meditative state reflecting her interest in Hindu mythology. In *The Sea and the Bells (Neruda),* she has built up layers of highly reflective artificial gold leaf and deeply colored acrylic paint, which subtly allude to the lustrous gold and rich pigmentation of much of the religious art of Southeast Asia.

Several other works in this section of the exhibition are made from an unusual combination of materials, some of which were manufactured for nonartistic purposes. These materials were chosen for their intrinsic expressiveness but also because they evoke associations ranging from archaeology to modern-day industry. The University of Memphis professor Greely Myatt constructs two- and

three-dimensional works from everyday objects, which at once make reference to, and are dislocated from, their real-life function. *Storm* is composed of signs cut into the shapes of cartoon "conversation bubbles" and arranged haphazardly, so that their semiotic functions are reduced to a layered cluster of monosyllabic grunts. Using even more unusual materials, the Nashville artist Carrie McGee creates luminous constructions from sections of Plexiglas that have been transformed through the application of rust, paint, and various other substances. Also exploring the poetic power of materials, the Fisk University professor Alicia Henry combines paper, leather, fabric, plastic, paint, coffee, and other media in her masklike images and effigy figures, which examine the relationship between the individual and the community through themes of play, death, and mourning.

The sculptures of the Nashville artist Adrienne Outlaw, which are descended from the Surrealist Meret Oppenheim's famous fur-lined teacup—with its intimations of domesticity, sensuality, and death— utilize such provocative animal substances as porcupine quills, fur, and hide, contained or are penetrated by products like pins, wires, electrical supplies, and mesh screening. Although these materials are often associated with pain and death, the delicate beauty and textural vitality of their arrangements make them inviting to view and to touch, triggering the repulsion-attraction mechanism that often characterizes the human response to both the natural and the artificial realm.

More conventional materials such as glass and clay are manipulated, transformed, or altered in highly original ways by the Knoxville artist Richard Jolley and the Watertown ceramist Jason Briggs. Although he is widely recognized as a master in the process of modeling hot glass, Jolley also creates mixed-media works that integrate glass with metal and other materials, which have often been treated with various chemicals to yield a rich and unpredictable appearance. Briggs creates abstract constructions of porcelain, whose forms are reminiscent of fungi, sweet potatoes, or internal organs. The sculptures' surfaces are often embedded with such materials as hair and gauze, giving them the unsettling appearance of biological laboratory creations or alien life forms.

From Andrew Saftel's probing inquiries into the relationship between the individual and his environment to the disturbing social dystopias of Michael Aurbach or Barbara Bullock, the works of Tennessee's most engaged contemporary artists demonstrate the irrelevance of state boundaries in the creation of beauty or construction of meaning. Today's ease of travel and access to art and art criticism on an international stage make geographic isolation seem less a burden than it was in the past. But even today, working at a distance from the critical mass of artists, galleries, museums, and art writing can come with the price of being disengaged from systems of support.

The former Mint Museum curator of contemporary art Jane Kessler, paraphrasing the critic Donald Kuspit, also warns of "A certain ease of living engender[ing] an unhealthy complacency which can potentially remove that necessary edge that often imbues an artist's work with substance." However, she continues, "isolation from the mainstream can provide a rare freedom to pursue individual ideologies. Without the direct pressure of ever-insistent art-world phenomena, the strong-minded artist may be able to make a more singular and thereby stronger visual statement."[2]

In today's art world, wherever they might live and work, the artists who really stand out are those who have a compelling vision that they refine and nurture with all the intensity and passion that they can muster. In a place like Tennessee, where it is difficult to earn national recognition, much less a living as an artist, there is something truly worth celebrating about those who pursue these visions, as much for their intrinsic value and the artists' personal satisfaction as for the reward of the marketplace or critical acclaim. While this exhibition and catalogue are intended to promote increased awareness and appreciation of Tennessee's visual arts as a whole, it is also meant to honor those who have invested their time and creative energy in making their communities, and this state, a congenial environment for the visual arts.

NOTES

1. James Gibson, conversation with the author, March 16, 2003.

2. Jane Kessler, then curator of contemporary art at the Mint Museum, paraphrased Donald Kuspit's remarks made in the panel discussion "Southern Experiment: A Critic's Forum," which took place in Atlanta in 1984. The quote is from her essay "Southern Comfort/Discomfort," in *Southern Exposure: Not a Regional Exhibition*, exh. cat. (New York: The Alternative Museum, 1985), 8.

250 · **JIM COLLINS**
 b. Huntington, West Virginia 1934–
 lives Chattanooga, Tennessee

Summer Wind, 1993
Mixed-media collage; 14 × 14 in.
Courtesy of the artist

COLLINS OFTEN USES COMMERCIAL ARTIFACTS from a bygone era to signify memory, decay, and loss. This simple assemblage, featuring a Royal Crown Cola sign combined with an image of a couple, has a powerful expressiveness arising from the arrangement of colors and the patina of age and rust. For many Southerners growing up before the 1960s, RC Colas were a dietary staple; they were particularly refreshing during a hot summer's day before the widespread use of air conditioning. MWS

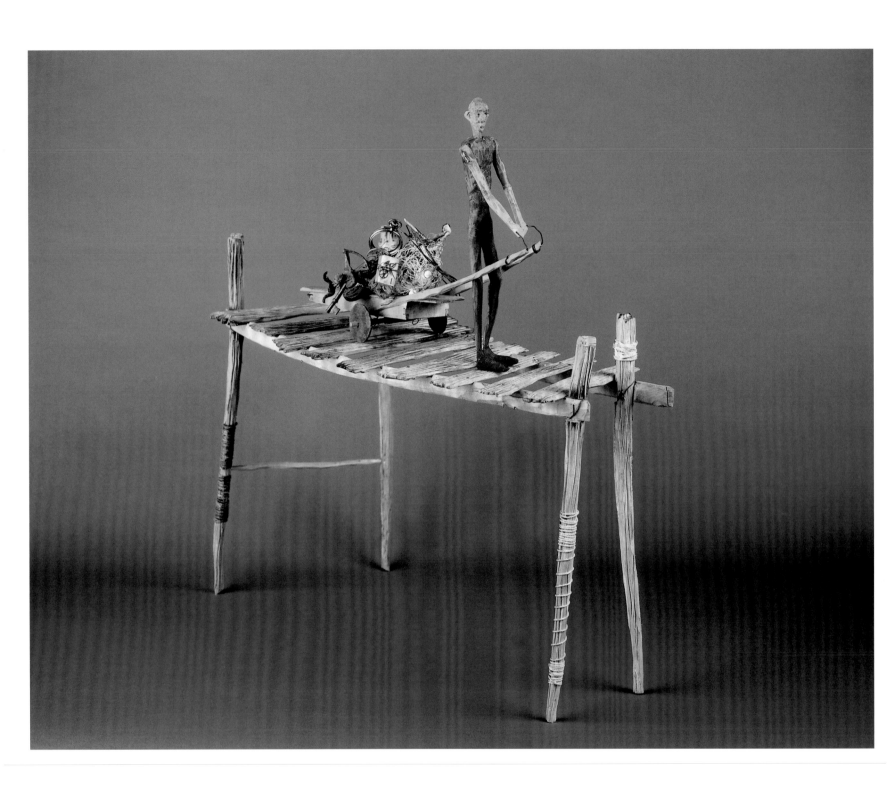

251 ▲ **ANDREW SAFTEL**

b. New Bedford, Massachusetts 1959–
lives Pikeville, Tennessee

*What's All That Stuff You Have Piled
Up in That Thing You're Pulling Behind
You,* 1993
Carved wood and found objects; 25 × 24 × 11 in.
Courtesy of the artist

SAFTEL'S ART SEEKS TO ESTABLISH poetic dialogues between abstract form and narrative imagery, and between civilization and the natural world. Best known for his mixed-media paintings and works on paper, the artist began making freestanding sculpture in the early 1990s; *What's All That Stuff* . . . is among Saftel's earliest forays in this genre. Its rugged, hand-carved surface gives the central figure a weathered vulnerability that speaks of struggle, transition, and perseverance. A cart loaded with found objects suggests physical and psychological residue that shapes identity and affects the course of an individual's journey through life. While the dock can be seen as a symbolic point of arrival or departure, it also refers to those along the Massachusetts coastline where Saftel spent his youth. SW

252 · ANDREW SAFTEL

b. New Bedford, Massachusetts 1959–
lives Pikeville, Tennessee

Greenhouse, 2002
Acrylic and found objects on carved birch
panels; 86 × 78 in.
Courtesy of The Lowe Gallery, Atlanta–
Los Angeles, and the artist

In his mixed-media paintings, Andrew Saftel creates rich environments of delicately orchestrated color and form. Each is the result of a complex blend of techniques —carving, routing, embedding, stenciling, staining, brushing, and dripping—that alludes to natural processes of erosion, sedimentation, growth, and decay. Hovering within fertile atmospheres of modulated color are bits of eclectic cultural debris that are used for both their formal and narrative qualities. While drawing heavily on the artist's personal history, Saftel's paintings encourage contemplation of larger themes such as humanity's relationship with the environment, the passage of time, and the winding path of civilization's progress through the ages. SW

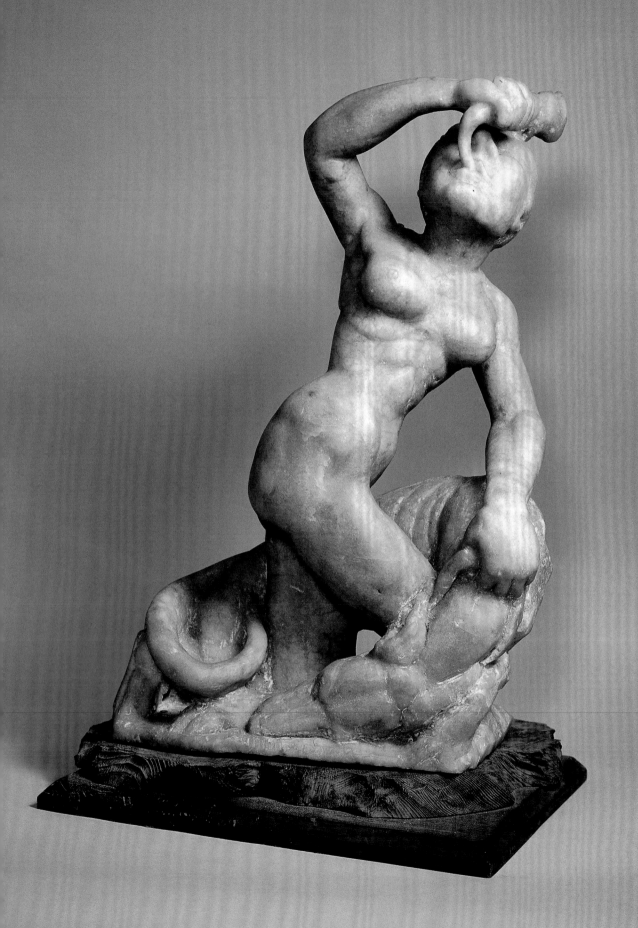

253 · YONE SINOR

b. Lincoln County, Tennessee 1942–
d. Nashville, Tennessee 1999

Diana, 1983
Stone; 17¼ × 11½ × 6¼ in.
Collection of Ann and Gerald Calhoun

THE CHEROKEE DESCENDANT YONE SINOR explored the woods and waterfalls of the Cumberland Plateau as a child. Her depiction of the ancient goddess Diana, whom the Romans had regarded as a forest deity, might just as well be a Woodland Indian huntress with well-muscled body and high cheekbones. Ever mindful of her bicultural upbringing, Sinor chose themes that reached into the past and spoke to the present, of her people and her gender. She chose stone for its permanence. SWK

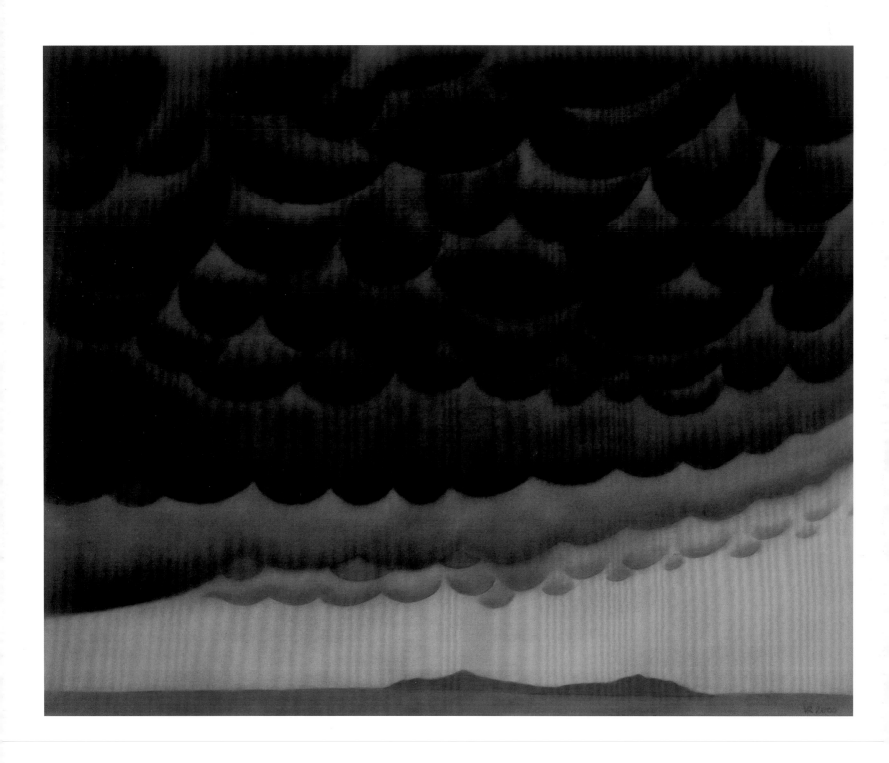

254 · **VEDA REED**

b. Granite, Oklahoma 1934–lives
Memphis, Tennessee

Mammatus II, 2000
Oil on canvas; 40 × 60 in.
Collection of Robin and Peter Formanek

BORN IN OKLAHOMA, Veda Reed finds inspiration in the vast Southwestern land-scape. In particular, her work reveals her fascination with unusual and captivating cloud formations, which occur frequently over the flat terrain of that region. While the ominous mammatus clouds may foretell an approaching storm, Reed's canvas reveals an unusual quietness and solitude. DH-B

255 **JIM ANN HOWARD**
b. Nashville, Tennessee 1948–
lives Sewanee, Tennessee

Appalachian Springboard, 2002
Casein, walnut ink, plant and mineral dyes, and
watercolor on "Renaissance" handmade paper;
19½ × 50 in.
Courtesy of Zeitgeist Gallery and the artist

APPALACHIAN SPRINGBOARD, showing a flooded section of the Little River near
Townsend, Tennessee, was created on-site, in the tradition of nineteenth-century plein-air
landscape painters who relied on their capacity of observation to honestly transcribe the
details of the given world. To make this watercolor, Howard painted the scene on separate
sheets of paper and then glued them together in an uneven arrangement that reinforces
the downward motion of water as it flows over rocks. MWS

256 · JED JACKSON

b. Fayetteville, Arkansas 1954–
lives Memphis, Tennessee

C.E.O., 2002
Oil on wood; 24 × 24 in.
Courtesy of the artist

JED JACKSON TAKES A SATIRICAL and complex approach to convey his vision of the darker realities that shape contemporary America. Drawing inspiration from urban American Scene paintings, pop culture, fashion magazines, and movies, Jackson creates colorful and dynamic paintings that capture the ironies of our society. In *C.E.O.* the use of pop-up thought bubbles provides a glimpse into the malevolent emotional state of the main character—corrupt corporate America. DH-B

257 · **BARBARA BULLOCK**
 b. Nashville, Tennessee 1946–
 d. Nashville, Tennessee 1996

 The Hate That Hate Produced, 1992
 Acrylic on canvas; 50 × 38½ in.
 Collection of Dr. Albert Z. Holloway

BARBARA BULLOCK WAS ACHIEVING wide recognition for her colorful and scathing brand of social realism when she died of cancer in 1996. Works like *The Hate That Hate Produced* demonstrate Bullock's empathy for individuals who are confronted with the overwhelming forces of poverty, racism, or violence. Warning of the cyclical nature of violence, the painting shows a young man with a pistol, surrounded by men and women he has shot. These characters all share his facial features, as Bullock seeks to convey the idea that by engaging in violence, the hate-filled youth is damaging only himself and his people. MWS

258 · **MICHAEL AURBACH**
b. Wichita, Kansas 1952–lives Nashville,
Tennessee

Witness: Conspiracy No. 3, 1998
Mixed media; 40 × 36 × 15 in.
Courtesy of the artist

MICHAEL AURBACH'S SECRECY series examines ways that secrets generate and perpetuate power. He created three works on the theme of "speak no evil, hear no evil, and see no evil." The third of these, relating to sight, is *Witness: Conspiracy No. 3.* The structure of the sculpture suggests the pyramid on the back of a one-dollar bill. The eye of vigilance is replaced with a camera lens, implying surveillance, while the scale, a symbol of the reckoning that comes after death, holds film on one side and a feather on the other to suggest that the documentation of a life has more weight, even in the hereafter, than the human spirit. MWS

259 · **MARILYN MURPHY**
b. Tulsa Oklahoma 1950–
lives Nashville, Tennessee

Cane Fire, 1989
Graphite on paper; 18 × 25 in.
Courtesy of the artist

RESEMBLING PEOPLE FROM ADVERTISEMENTS from the 1950s (a time viewed by many as one of robotic conformity), the characters in Marilyn Murphy's works are often engaged with forces of nature or from within the repressed self that threaten disruption. The desire to suppress or control these forces is the subject of this drawing. Here a man manipulates knobs in a booth from which he appears to be orchestrating the controlled burning of a cane fire (such fires are a part of the harvesting process that Murphy has witnessed in Australia). For Murphy, fire represents the barely containable force of emotions or nature. The seemingly mild-mannered technocrat has the means to keep it in check, but, with a flick of the wrist, he can as easily unleash the fire, causing a conflagration of profound intensity. MWS

Planche 144

260 ˄ **BEAUVAIS LYONS**

b. Hanover, New Hampshire 1958–
lives Knoxville, Tennessee

Planche 144, 2002
Lithograph; 28 × 22 in.
From the Collection of the Hokes Archives

SINCE MOVING TO TENNESSEE IN 1985 as the self-appointed director of The Hokes Archives, Beauvais Lyons has continued to create parodies that call into question the legitimizing role of various art-world types, including academics, collectors, and museum curators. *Planche 144* is from a series of lithographs that evoke medical illustrations from a nineteenth-century textbook. While seemingly scientific, their fanciful anatomy recalls the bizarre constructed dolls of the artist Hans Bellmer. Simultaneously disturbing and comical, these prints illustrate Lyons's skill as a draftsman, printmaker, and visual trickster. SY

261 · **ROBERT DURHAM**

b. Nashville, Tennessee 1954–lives
Nashville, Tennessee

Deconstructing Baby, 2002
Oil on canvas; 32 × 48 in.
Courtesy of Cumberland Gallery and the artist

ROBERT DURHAM'S PAINTINGS FREQUENTLY combine people and props in tableaux that involve a pun or have a double meaning. *Deconstructing Baby* shows a baby with scissors who looks ready to cut an art magazine to pieces. To Durham, the baby can be understood either as a symbol of critics who spend more time deconstructing their subject—that is, dissecting the forces and motivations that go toward its making—than actually responding to its aesthetic properties or as a symbol of the artist himself (Durham often depicts this very baby as his dark alter ego), who would like to dismantle critics' overreliance on highly academic texts, as symbolized by the art magazine. MWS

262 · JOHN BAEDER

b. South Bend, Indiana 1938–
lives Nashville, Tennessee

Newport Diner, 1988
Oil on canvas; 42 × 66 in.
Collection of Judy and Noah Liff

JOHN BAEDER HAS LONG BEEN FASCINATED with the railroad dining cars that were part of the vernacular architecture of urban and small-town America from the 1930s through the 1950s. To Baeder, the diner has a symbolic import beyond its nostalgic associations with the past. He considers it to be an archetype of maternal strength, a symbolic hearth where a nation received comfort and nourishment during the difficult years of depression and war. Baeder also loves vintage automobiles, which to him are symbols of masculinity and mobility. This painting shows a 1947 Frazer parked in front of a diner in Newport, New Hampshire. MWS

263 · **PAUL PAK-HING LEE**
b. Hong Kong 1962–lives Maryville, Tennessee

Untitled/Airplane Diptych, 2000
Digital video frame on C-prints; 40 × 60 in.
Courtesy of the artist and Greg Kucera Gallery, Seattle, Washington

PAUL LEE WAS BORN IN HONG KONG, attended high school in Wales, and lived in New York, Michigan, Ohio, Texas, and Washington before coming to Knoxville. His experience as an immigrant and itinerant has had an effect on his work, which focuses on the differences between historical and personal perspectives that make translation between languages or cultural values difficult. Lee often represents objects in motion, which to him are symbols of shifting or unfixed meanings. His current work shows airplanes in flight, taken from videotapes and digitally manipulated to deemphasize the landscape around them, making them more generic and, by minimizing their context, more indecipherable. MWS

264 · **KELL BLACK**
b. Atlanta, Georgia 1959–
lives Clarksville, Tennessee

Beetles, 2001
Paper; 14 × 11½ × 1 in.
Courtesy of the artist

KELL BLACK'S PAPER INSECTS are laid out shadow-box fashion, like entomologists' specimens that have been pinned to a board for display and study. Black, an Austin Peay State University professor best known for majestic charcoal drawings, turned to paper-model making about five years ago. Rendering pieces of furniture, appliances, and puppets with adept "scissor hands," Black has moved his art from flat representation to whimsical simulation of the real world. SWK

265 · **SYLVIA HYMAN**
b. Buffalo, New York 1917–lives Nashville, Tennessee

Crate of Stuff, 2002
Stoneware and porcelain clay; 12 × 11½ × 10½ in.
Collection of David and Peggy Rados

SYLVIA HYMAN HAS CREATED a trompe-l'oeil self-portrait in the form of a two-handled wooden box filled with memorabilia. Using fine porcelain clays and original glazes, she has fashioned a roll of sheet music, a leather-bound book, a manual of the potter's craft, and a self-addressed letter—all indicative of things she holds dear. SWK

266 · SUTA LEE
b. Republic of China 1952–lives
Clarksville, Tennessee

Still Life—Table with Flowers, 1999
Oil on canvas; 84 × 96 in.
Courtesy of the artist

BORN IN TAIWAN AND CURRENTLY A PROFESSOR at Austin Peay State University, Suta Lee makes works that reflect the internationalism of his experiences. What looks at first like a lush arrangement of flowers in a vase is in fact a symbolic study of pattern and color. Indian paisley motifs are combined with the floral designs Lee once saw on a European tapestry, creating crosscurrents of East and West. SWK

267 · **JANE BRADDOCK**

b. Richmond, Indiana 1946–lives Joelton, Tennessee

The Sea and the Bells (Neruda), 2002
Acrylic and artificial gold leaf on canvas;
39½ × 28½ in.
Courtesy of the artist

JANE BRADDOCK'S WORK HAS BEEN INFLUENCED by a trip she took to Tibet, Nepal, and southern India, where she learned of the philosophical depth of the Hindu concept of Shakti, Sanskrit for divine force or energy. In *The Sea and the Bells* (the title is taken from a line of poetry by Pablo Neruda), Braddock uses the reflectiveness and beauty of gold as a physical manifestation of light, which for many cultures symbolizes spiritual attainment. Cool colors and energetic brushstrokes are visible beneath and through the gold, providing a counterpoint to the warm and shimmering light. MWS

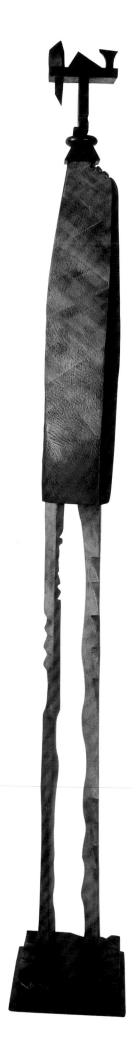

268 · **JAMES GIBSON**
b. Charleston, West Virginia 1937–
lives Murfreesboro, Tennessee

Mardis Marker, 2001
Wood and paint; 73½ × 9 × 9 in.
Tennessee State Museum Collection, 2002.62

JIM GIBSON, A LONGTIME PROFESSOR AT Middle Tennessee State University,
studied art in the late 1950s and early 1960s, a time when formalism—art whose sole aim
is to explore relationships between purely nonobjective forms—was emphasized in the art
world and in academia. He wrote his master's thesis on the then-taboo subject of subject
matter and has since married a modified formalism to a subject matter that is implied
but never literally depicted. *Mardis Marker,* with spindly red legs and a curious abstract
configuration at its "head," is easily read as a witty abstraction of a person, although this
association is not based on a direct depiction of human anatomy. Its title comes from
his wife's family name, Mardis, and Gibson's interest in the form of grave markers from
Sudan. MWS

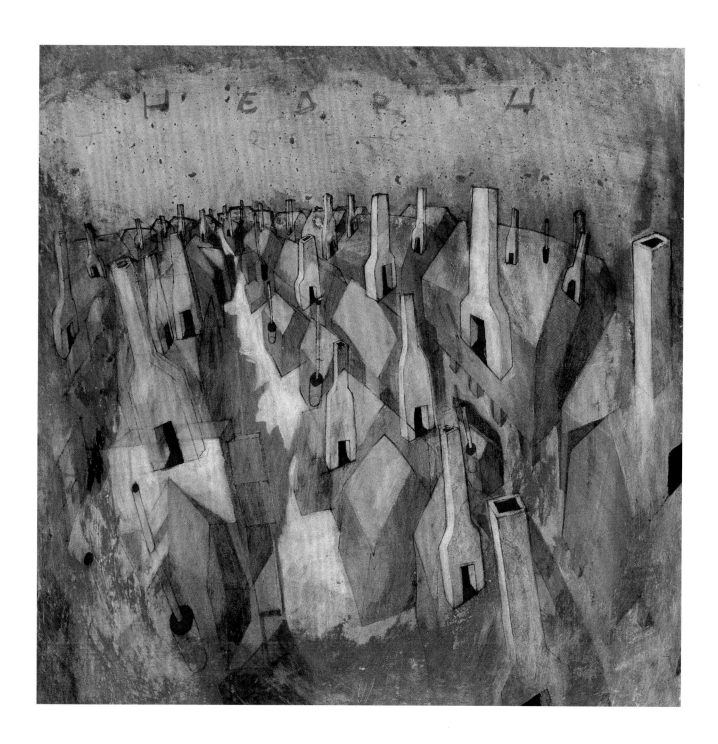

269 · **ANDERSON KENNY**
b. Nashville, Tennessee 1971–lives
Nashville, Tennessee

Hearth, 2002
Gesso, ink, tempera, and graphite on
terra-cotta; 18 × 18 in.
Courtesy of the artist

ANDERSON KENNY "FLOATS" IMAGES of buildings or other types of construction
in richly colored atmospheres, in which human figures and diagrammatic elements are
also suspended. In *Hearth,* the chimneys and other openings in a neighborhood of tall
houses are marked with a red light, denoting the warm invitation of a hearth. While the
painting's title might suggest domestic comfort, the red has an ominous association with
blood, and the scene is shown in a chill blue twilight, evoking the densely packed ghettos
of northern Europe, or perhaps a scene from a novel by Charles Dickens. MWS

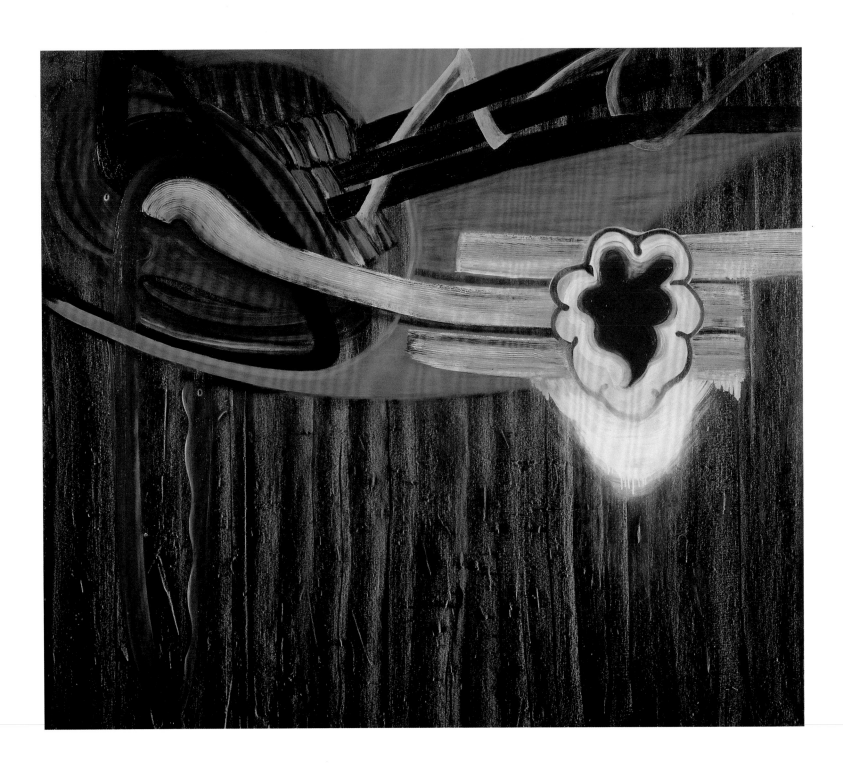

270 · PINKNEY HERBERT

b. Charlotte, North Carolina 1954–
lives Memphis, Tennessee

Transplant, 2002
Oil on linen; 69½ × 79½ in.
Courtesy of David Lusk Gallery, Memphis,
Tennessee, and the artist

PINKNEY HERBERT DREW INSPIRATION from several sources for his bold, monumental painting *Transplant.* His admiration for African sculptural forms, patterns, and motifs is coupled with his personal look at mortality as he takes an X-ray-vision approach to the subject of a heart transplant. Herbert has literally scraped away the surface of the painting as a metaphor for the way a surgeon might remove layers of skin and muscle during an operation. The painting has a sense of paradox; for most people the image of the human interior is difficult to look at, yet Herbert has found in it an extraordinary beauty and vitality. DH-B

271 · GREELY MYATT
b. Aberdeen, Mississippi 1952–
lives Memphis, Tennessee

Storm, 2000
Wood and paint; 71 × 48 in.
Courtesy of David Lusk Gallery, Memphis,
Tennessee, and the artist

NOTED FOR HIS USE OF MIXED MEDIA and found objects, Greely Myatt is also
known for his keen sense of humor and for the playfulness of his sculptures. Constructed
from reclaimed painted signs, *Storm* makes use of the speaking balloons found in comic
strips. Each balloon, which playfully takes on the form of a storm cloud, is fitted together
as if part of a giant jigsaw puzzle. The pieces are filled with indecipherable fragments of
numbers, letters, and phrases, giving the viewer the overwhelming sensation of turbulent
layered conversations. DH-B

CARRIE MCGEE

b. Cincinnati, Ohio 1954–lives Nashville,
Tennessee

Small Ladder, 2000

Rust, acrylic, oil, plastic rod, metal leaf, linen,
and wood; 30 × 10 × 2 in.

Collection of Joel and Nelda Shumaker

THE SLOW WORKING OF RUST, a natural process that leaves its physical mark, is a
metaphor for time and memory in the works of Carrie McGee. Manufactured materials,
such as acrylic rods and hardware fixtures, take on new meaning when assembled, as here,
into a glowing shuttered window or, perhaps, a ladder for the mind's ascent. McGee's
application of lapis lazuli blue, aquamarine, and gold pigments transforms ordinary mat-
ter into something altogether luminous and jewel-like. SWK

273 · **ADRIENNE OUTLAW**

b. Orlando, Florida 1970–lives Nashville, Tennessee

Construct, 2003

Plexiglas, quills, and mirror; 14¼ × 11⅛ × 6¼ in.
Collection of Russell Love

ADRIENNE OUTLAW FREQUENTLY USES PORCUPINE quills in her sculptures. Pierced through hides, foam rubber, or other pliable materials, the quills are arranged in structures that recall such natural forms as spiny sea urchins or the teeth and skeletons of animals. *Construct* features two such skeletal configurations, composed of quills whose interpenetrating points hold the entire structure together. Outlaw has taken materials associated with pain and death and transformed them into a miniature architecture of graceful beauty and tensile strength. MWS

274 · **ALICIA HENRY**
b. Chicago, Illinois–lives Nashville,
Tennessee

Untitled, 2002
Mixed media; 36 × 24 in.
Courtesy of the artist

THE FISK UNIVERSITY ART PROFESSOR Alicia Henry uses fabric, paper, and other materials in constructed works that refer to the human body. This untitled work shows facial features, which themselves are masklike in their impassivity, whose halves have been stitched together to suggest the construction of a mask or the scars of traumatic surgery. These motifs suggest the human desire to protect psychological identity with a social facade, and the pain that can result from such concealment. MWS

RICHARD JOLLEY

b. Wichita, Kansas 1952–lives Knoxville, Tennessee

Polarity, 1999

Glass, copper, and aluminum; 29 × 28 × 8 in.
Courtesy of the artist

WIDELY RECOGNIZED FOR HIS ALLURING, colorful glass figures modeled in the round, Richard Jolley began a series of mixed-media works in the mid-1990s that explored the expressive possibilities of combining glass with other materials. *Polarity* consists of an enigmatic, silhouetted torso defined by plate glass and treated copper. The resulting tone is one of detachment, solitude, and introspection. Like an archaeological relic, a deeply modeled green head is visible among the fragments within the torso and serves as a subtle reference to Jolley's signature glass sculpture. SW

276 · JASON BRIGGS

b. Wausau, Wisconsin 1972–lives
Watertown, Tennessee

Crème, 2003
Porcelain, hair, and gauze; 8 × 13 × 6 in.
Courtesy of the artist

THIS PORCELAIN SCULPTURE looks as if it might once have been alive. Its porous surface is like skin, or dry sand at the seaside. Varied textures are delineated by moving lines that accentuate its flowing organic shape, while orifices exude lavalike swirls, suggesting sea snails or floating wisps of foam. A resident professional artist at the Appalachian Center for Crafts in Smithville, Tennessee, Jason Briggs, who is an accomplished wheel thrower as well as sculptor, also teaches at Belmont University in Nashville. SWK

SUGGESTED READING

PREHISTORIC NATIVE AMERICAN ART

Brose, David S., James A. Brown, and David W. Penney. *Ancient Art of the American Woodland Indians.* New York: Harry N. Abrams, 1985.

Chapman, Jefferson. *Tellico Archaeology: 12,000 Years of Native American History.* Knoxville: The University of Tennessee Press, 1995.

Cox, Stephen D., et al. *Art and Artisans of Prehistoric Middle Tennessee.* Nashville: Tennessee State Museum, 1985.

Hudson, Charles. *The Southeastern Indians.* Knoxville: The University of Tennessee Press, 1976.

Significant exhibitions on archaeology and the Native Peoples of Tennessee can be found at:

The Frank H. McClung Museum, The University of Tennessee, Knoxville. http://mcclungmuseum.utk.edu

The Tennessee State Museum, Nashville. http://tnmuseum.org

Chucalissa Museum, Memphis. http://cas.memphis.edu/chucalissa

YOUNG TENNESSEE AND THE SPIRIT OF AMERICA

Dangerfield, George. *The Era of Good Feelings.* New York: Harcourt, Brace and Company, 1952.

Eaton, Clement. *The Growth of Southern Civilization.* New York: Harper & Brothers, 1961.

Finger, John R. *Tennessee Frontiers: Three Regions in Transition.* Bloomington: Indiana University Press, 2001.

Nye, Russel B. *Society and Culture in America, 1830–1860.* New York: Harper & Row, 1974.

TENNESSEE MAPS

Cumming, William P. *The Southeast in Early Maps.* 3d ed., rev. and enl. by Louis De Vorsey Jr. Chapel Hill and London: University of North Carolina Press, 1998.

Ristow, Walter W. *American Maps and Mapmakers: Commercial Cartography in the Nineteenth Century.* Detroit: Wayne State University Press, 1985.

Schwartz, Seymour I., and Ralph E. Ehrenberg. *The Mapping of America.* New York: Harry N. Abrams, 1980.

Woodward, David, ed. *Five Centuries of Map Printing.* Chicago and London: University of Chicago Press, 1975.

RICHARD "DICK" POYNOR

Harsh, Nathan, and Derita Coleman Williams. *The Art and Mystery of Tennessee Furniture and Its Makers through 1850.* Edited by C. Tracey Parks. Nashville: Tennessee Historical Society and Tennessee State Museum Foundation, 1988.

Warwick, Rick. "Dick Poynor, Master Craftsman." *Williamson County Historical Society Journal,* no. 8 (1977): 117–18.

———. "Dick Poynor." In *Leiper's Fork and Surrounding Communities.* Franklin, Tenn.: Heritage Foundation of Franklin and Williamson County, 1999.

POTTERY

Bivens, John, Jr. *The Moravian Potters in North Carolina.* Chapel Hill: University of North Carolina Press, 1972.

Burrison, John A. *Brothers in Clay: The Story of Georgia Folk Pottery.* Athens: University of Georgia Press, 1983.

Comstock, H. E. *The Pottery of the Shenandoah Valley Region.* Winston-Salem: The Museum of Early Southern Decorative Arts, 1994.

Greer, Georgeanna H. *American Stonewares: The Art and Craft of Utilitarian Potters.* Exton, Pa.: Schiffer Publishing, 1981.

Zug, Charles G., III. *Turners and Burners: The Folk Potters of North Carolina.* Chapel Hill: North Carolina University Press, 1986.

NINETEENTH-CENTURY QUILTMAKING

American Quilt Study Group. *Quiltmaking in America: Beyond the Myths.* Nashville: Rutledge Hill Press, 1986.

Ramsey, Bets. *Old and New Quilt Patterns in the Southern Tradition.* Nashville: Rutledge Hill Press, 1987.

Ramsey, Bets, and Merikay Waldvogel. *The Quilts of Tennessee: Images of Domestic Life prior to 1930.* Nashville: Rutledge Hill Press, 1986.

TEXTILE ART

Edmonds, Mary Jaene. *Samplers and Samplermakers: An American Schoolgirl Art, 1700–1850.* Exh. cat. Los Angeles County Museum of Art, 1991.

Hall, Eliza Calvert. *A Book of Hand-Woven Coverlets.* Boston: Little, Brown, 1912.

Hulan, Richard H. "Tennessee Textiles." In *ANTIQUES in Tennessee.* Reprint from *The Magazine Antiques,* August–December 1971, 386–89.

Shein, Joseph D., and Melinda Zongor. *Coverlets and the Spirit of America: The Shein Coverlets.* Atglen, Pa.: Schiffer, 2002.

ANTEBELLUM PAINTING

Hoobler, James A. *Distinctive Women of Tennessee.* Exh. cat. Nashville: Tennessee Historical Society, 1985.

Kelly, James C. "Landscape and Genre Painting in Tennessee, 1810–1985." *Tennessee Historical Quarterly* 44 (summer 1985).

———. "Portrait Painting in Tennessee." *Tennessee Historical Quarterly* 46 (winter 1987).

TENNESSEANS ON THE NATIONAL STAGE

Bergeron, Paul H. *Antebellum Politics in Tennessee.* Lexington: University Press of Kentucky, 1982.

Remini, Robert. *Andrew Jackson and the Course of American Freedom, 1822–1832.* New York: Harper & Row, 1981.

———. *Andrew Jackson and the Course of American Democracy, 1833–1845.* New York: Harper & Row, 1984.

Williams, Frank B. *Tennessee's Presidents.* Knoxville: University of Tennessee Press, 1981.

PAINTING IN TENNESSEE, 1865–1920

Gerdts, William H. *Art Across America: Two Centuries of Regional Painting, 1710–1920.* New York: Abbeville Press, 1990.

Kelly, James C. "Landscape and Genre Painting in Tennessee, 1810–1985." *Tennessee Historical Quarterly* 44 (summer 1985).

———. "Portrait Painting in Tennessee." *Tennessee Historical Quarterly* 46 (winter 1987).

Walker, Celia S., et al. "A Century of Progress: Twentieth-Century Painting in Tennessee." *Tennessee Historical Quarterly* 61 (spring 2002).

TWENTIETH-CENTURY FIGURATIVE AND NARRATIVE ART

Knox, Ella-Prince, ed. *Painting in the South, 1564–1980.* Exh. cat. Richmond: Virginia Museum of Fine Arts, 1983.

Walker, Celia S., et al. "A Century of Progress: Twentieth-Century Painting in Tennessee." *Tennessee Historical Quarterly* 61 (spring 2002).

West, Carroll Van, ed. *Creating Traditions, Expanding Horizons: 200 Years of the Arts in Tennessee.* Knoxville: University of Tennessee Press, in press.

TENNESSEE FOLK ART

Hall, Michael D., and Eugene W. Metcalf Jr., eds. *The Artist Outsider: Creativity and the Boundaries of Culture.* Washington, D.C.: Smithsonian Institution Press, 1994.

Hemphill, Herbert W., Jr. *Twentieth-Century American Folk Art and Artists.* New York: E. P. Dutton and Co., 1974.

Lipman, Jean, and Alice Winchester. *The Flowering of American Folk Art, 1776–1876.* New York: Viking Press, 1974.

Loughauser, Elsa, et al. *Self-Taught Artists of the Twentieth Century.* New York: Museum of American Folk Art, 1998.

WILLIAM EDMONDSON

Cheekwood Museum of Art. *The Art of William Edmondson.* Jackson: University of Mississippi Press, 1999.

Fletcher, Georganne, ed. *William Edmondson: A Retrospective.* Nashville: Tennessee Arts Commission, 1981.

Fuller, Edmund L. *Visions in Stone: The Sculpture of William Edmondson.* Pittsburgh: University of Pittsburgh Press, 1973.

MODERN ART FOR MODERN TIMES

Kelly, James C. "Landscape and Genre Painting in Tennessee, 1810–1985." *Tennessee Historical Quarterly* 44 (summer 1985).

———. "Portrait Painting in Tennessee." *Tennessee Historical Quarterly* 46 (winter 1987).

Knox, Ella-Prince, ed. *Painting in the South, 1564–1980.* Exh. cat. Richmond: Virginia Museum of Fine Arts, 1983.

Walker, Celia S., et al. "A Century of Progress: Twentieth-Century Painting in Tennessee." *Tennessee Historical Quarterly* 61 (spring 2002).

West, Carroll Van. *Tennessee's New Deal Landscape.* Knoxville: University of Tennessee Press, 2001.

———, ed. *Creating Traditions, Expanding Horizons: 200 Years of the Arts in Tennessee.* Knoxville: University of Tennessee Press, in press.

Aaron Douglas

Kirschke, Amy. *Aaron Douglas: Art, Race and the Harlem Renaissance.* Oxford: University Press of Mississippi, 1995.

Leininger-Miller, Theresa. *New Negro Artists in Paris: African American Painters and Sculptors in the City of Light, 1922–1934.* New Brunswick, N.J.: Rutgers University Press, 2001.

Sims, Lowery Stokes. *Challenge of the Modern: African-American Artists, 1925–1945.* New York: Studio Museum in Harlem, 2003.

New Directions: Contemporary Art

Art Papers. Atlanta: Atlanta Art Papers, 2000– (periodical).

Kessler, Jane, and John Howatt. *Southern Exposure: Not a Regional Exhibition.* Exh. cat. New York: The Alternative Museum, 1985.

Kuspit, Donald B. "The Postwar Period, 1950–1980." In *Painting in the South, 1564–1980,* edited by Ella-Prince Knox, 145–62. Richmond: Virginia Museum of Fine Arts, 1983.

———. *The Rebirth of Painting in the Late Twentieth Century.* New York: Cambridge University Press, 2000.

New Art Examiner. Chicago and Washington, D.C.: New Art Association, 1985– (periodical).

Nosanow, Barbara Shissler. *More than Land or Sky: Art from Appalachia.* Exh. cat. Washington, D.C.: Smithsonian Institution Press, 1981.

Pennington, Estill Curtis. *Look Away: Reality and Sentiment in Southern Art.* Spartanburg, S.C.: Saraland Press, 1989.

———. *A Southern Collection.* Coll. cat. Augusta, Ga.: Morris Museum, 1992.

Risatii, Howard. *Postmodern Perspectives: Issues in Contemporary Art.* Upper Saddle River, N.J.: Prentice-Hall, 1998.

Sandler, Irving. *Art of the Postmodern Era from the Late 1960s to the Early 1990s.* New York: HarperCollins, 1996.

Severens, Martha. *The Southern Collection.* Coll. cat., Greeneville County Museum of Art. New York: Hudson Hills Press, 1995.

INDEX OF ARTISTS

Page numbers in **bold** type refer to the location of catalogue entries, each of which includes a color reproduction of the work.

Allen, J. W., *Sugar Chest*, cat. 47, **83**

Arnaud, Michel, *Afternoon "Blues" at Tootsie's*, cat. 188, **253**

Audubon, John James, 338; *Tennessee Warbler*, cat. 108, **145**

Aurbach, Michael, 338, 340; *Witness: Conspiracy No. 3*, cat. 258, **350**

Baeder, John, 339; *Newport Diner*, cat. 262, **354**

Barnard, George N., 171, 242; *Nashville from the Capitol*, cat. 140, **187**; *Tennessee State Capitol*, cat. 141, **187**

Bean, Baxter, *Horseman or (Saddle) Holster Pistols*, cat. 18, **41**

Bell, Samuel, *Gravy Ladle*, cat. 64, **96**

Benton, Thomas Hart, 219–21, 238–39, 286; *The Sources of Country Music*, 241; *Study for "The Sources of Country Music,"* cat. 165, **223**

Biel-Bienne, Eugene, 287, 288 n18; *Conundrum*, cat. 213, **291**; *Images of War*, cat. 212, **291**

Black, Kell, 339; *Beetles*, cat. 264, 336, **356**

Blankets, cats. 98–102, **134–35**

Blount, Akira, *Redbud Angel*, cat. 245, **330**

Braddock, Jane, 339; *The Sea and the Bells*, cat. 267, **359**

Branson, Lloyd, 200–201; *Women at Work*, cat. 156, **209**

Briggs, Jason, 340; *Crème*, cat. 276, **368–69**

Bringle, Cynthia, 307; *Vessel*, cat. 237, **322**

Brock, Curtiss, 307; *Untitled*, cat. 242, **327**

Brown, Sarah Ann, *Sampler*, 133, cat. 105, **138**

Bull, John, *"Kentucky" or "Pennsylvania" Long Rifle*, cat. 14, **38–39**

Bullock, Barbara, 338, 340; *The Hate That Hate Produced*, cat. 257, **349**

Cagle, Charles, 285–86, 287–88 n3

Cain Pottery, *Jar*, cat. 79, **112**; *Jar*, cat. 80, **113**

Calhoun, William Henry, 190; *Goblets*, cats. 75 & 76, **107**; *Pitcher*, cat. 77, **108**

Callicott, Burton, *Broken Sunbeams #5*, cat. 215, **293**

Cameron, James, 141–42; *Belle Isle from Lyon's View*, cat. 118, 34 detail, **155**; *Colonel and Mrs. James A. Whiteside…*, cat. 117, 140 detail, **154**

Campbell, John, *Beaker*, cat. 69, **100**; *Punch Ladle*, cat. 59, **95**; *Small Pitcher*, cat. 71, **102–3**; *Trophy Milk Pitcher*, cat. 72, **102–3**

Campbell, Sherman, *Banjo*, cat. 247, **332**

Cane, cat. 195, **265**

Carey, Henry Charles, 42; *Geographical, Statistical, and Historical Map of Tennessee*, cat. 23, **48–49**

Cartier-Bresson, Henri, 242; *Tennessee Family*, cat. 181, **246**

Chambers, George W., 201; *In the Tennessee Mountains*, cat. 157, **210**

Christian, Martha, *Continental Drift*, cat. 228, **315**

Clark, Edward, *Uncle Dave Macon*, cat. 185, **250**

Clark, Frederick Harvey, *Beaker*, cat. 70, **101**

Cloar, Carroll, 220–21; *The Goose Herder*, cat. 173, **231**; *Where the Southern Cross the Yellow Dog*, cat. 172, 218 detail, **230**

Cochran, Levi, *Table*, cat. 36, **70**

Cognata, Larry M., *Corm*, cat. 234, **319**

Collins, Jim, 338; *Summer Wind*, cat. 250, **341**

Cooper, Washington Bogart, 141, 170, 200; *Portrait of Ellen Thomas*, cat. 151, **204**

Cooper, William Browning, 142, 170; *Andrew Johnson*, cat. 138, **185**

Cope, Nancy Jane Patterson and Susie Drucilla Greer, *Milky Way Quilt*, 126, cat. 93, **129**

Counts, Charles, 307; *Jar*, cat. 236, **321**

Coverlet, 132, cat. 104, **137**

Craven, T. W., *Jar*, cat. 90, **123**

Cress, George, 287; *Sequatchie Valley—Winter*, cat. 217, **295**

Crouch, Philbrick McLeod, 220–21; *Prelude*, cat. 170, **228**

Dahl-Wolfe, Louise, 282; *Still Life*, cat. 189, **254**

Decker Pottery, 110; *Ring Bottle*, cat. 83, **116**

Delaney, Beauford, 220–21; *Portrait of Ahmed Bioud*, cat. 168, **226**

Delaney, Joseph, 220–21; *Macy's Day Parade*, cat. 169, **227**

Dodge, John Wood, 141–42; *Portrait of Elizabeth McGavock Harding*, cat. 114, **151**; *Portrait of General William Giles Harding*, cat. 113, **150**; *Portrait of Mary Eliza Washington*, cat. 111, **148**; *Portrait of Mrs. Arena P. Whitlock*, cat. 115, **152**; *Posthumous Likeness of Felix Grundy Eakin*, cat. 112, **149**

Donigan, George Washington, *Beaker*, cat. 69, **100**; *Small Pitcher*, cat. 71, **102–3**; *Trophy Milk Pitcher*, cat. 72, **102–3**

Douglas, Aaron, 238–39, 285–86, 300–301; *Building More Stately Mansions*, cat. 221, 284 detail, **302–3**; *Philosopher*, 239

Driskell, David, 287; *The Moon Does See*, cat. 218, **296**

Dudley, Marianne, 126; *Crazy Quilt*, cat. 95, **131**

Dunn Pottery, 110; *Compote*, cat. 88, **121**

Durham, Robert, 338; *Deconstructing Baby*, cat. 261, **353**

Dury, George, 141; *Self-Portrait*, cat. 116, **153**

Dycus, Ellen Catherine Rogers, *Blankets*, cats. 96 & 97, **134**

Earl, Ralph E. W., 141–42, 162–63, 166–69, 190; *Andrew Jackson*, 167, cat. 126, **172–73**; *The Ephraim Hubbard Foster Family*, cat. 124, **164**; *Equestrian Portrait of Andrew Jackson*, cat. 125, **165**

Easterwood, Henry, 306–7; *Red Garden—Summer*, cat. 226, **313**

Edmondson, William, 260, 276–77, 282–83; *Bess and Joe*, cat. 205, **278–79;** *Lion*, cat. 206, **280;** *Preacher*, cat. 207, **281**

Eggleston, William, 242–43; *Memphis*, cat. 190, **255**

Elliston, Joseph Thorp, 92, 190; *Punch Ladle*, cat. 56, **94;** *Sauce Ladle*, cat. 54, **94;** *Sugar Tongs*, cat. 66, **97;** *Teaspoons*, cat. 65, **97**

Ende, Arlyn, *On the Second Wind*, cat. 227, **314**

Faiers, Edward "Ted," 287; *Ceremony at Dawn*, cat. 211, **290**

Flint, F. P., 190; *Beaker*, cat. 67, **98;** *Punch Ladle*, cat. 58, **95**

Floyd, John, *Water Cooler*, cat. 84, **117**

Frank, Robert, 242; *Restroom in Memphis*, cat. 183, 248

furniture, unattributed, *Biscuit Rock*, cat. 44, **78;** *Case and Bottles*, cat. 48, **84;** *Chest*, cat. 31, **66;** *Chest*, cat. 37, 50 detail, **71;** *Clock Case*, cat. 27, **61;** *Corner Cupboard*, cat. 33, **68;** *Desk with Bookcase*, cat. 28, **62–63;** *Ladies' Work Table*, cat. 39, **73;** *Secretary with Bookcase*, cat. 41, **75;** *Sideboard*, cat. 29, **64;** *Desk and Bookcase*, cat. 24, **58;** *Sideboard Sugar Chest*, 80, cat. 49, **85;** *Side Chairs*, cats. 34 & 35, **69;** *Sugar Chest*, cat. 46, **82;** *Table*, cat. 42, **76;** *Upholstered Reclining Chair*, cat. 146, **193**

Gaul, William Gilbert, 171, 194–95, 201; *Following the Guidon*, cat. 147, **196;** *Rafting on the Cumberland River*, cat. 158, **211;** *Waiting for Dawn*, cat. 148, **197**

Gibson, James, 339; *Mardis Marker*, cat. 268, **360**

Gillespie, John, *Cupboard*, cat. 26, **60**

Goodrich, James Harry, 201; *Mother and Child*, cat. 162, **215**

Gowdey, Thomas, *Presentation Urn*, cat. 134, **181**

Grannis, Robert, *Hank Williams at the Grand Ole Opry*, cat. 186, **251**

Green, Homer, 261; *Owl Totem*, cat. 199, **269**

Gregory, Dee Merritt, *Gizzard Basket*, cat. 223, **310**

Gregory, Dennis, *Gizzard Basket*, cat. 223, **310**

Griffith, Bill, 307; *Dwelling*, cat. 239, **324**

Grindstaff, William, *Figural Jug*, cat. 85, **118**

Grooms, Red, 221; *Dans les Metro*, cat. 176, **234;** *Times Square in the Rain*, cat. 177, **235**

Guiteau, C., *Beaker*, cat. 68, **99**

Gutherz, Carl, 200; *Light of the Incarnation*, cat. 154, **207**

Handly, Avery Jr., 219–21, 286; *The Segregationist Motorcade…*, cat. 167, **225**

Hankins, Cornelius Haly, *Still Life with Onions*, cat. 159, **212**

Harris, Anselmo, 259; *Here Is Where We Play*, cat. 192, **264**

Harvey, Bessie, 262, 337; *The Storyteller*, cat. 203, **273;** *Zulu Warrior*, cat. 202, **272**

Haun, C. A., *Jar*, cat. 82, **115**

Haun Pottery, *Jar*, cat. 81, **114**

Healy, George Peter Alexander, 169; *Portrait of Andrew Jackson*, cat. 135, **182;** *Portrait of James K. Polk*, cat. 136, **183**

Heaton, Amos, *Amos Heaton Family Horn*, cat. 17, **40**

Hedgecough, George, 110; *Grave Marker* cat. 86, **119**

Hendrix, Nancy O., 133; *Sampler*, cat. 106, **139**

Henry, Alicia, 340; *Untitled*, cat. 274, **366**

Herbert, Pinkney, 339; *Transplant*, cat. 270, **362**

Hergesheimer, Ella Sophonisba, 201; *Redbud Time at Olde Belle Meade Mansion*, cat. 163, **216**

Hicks, James G., 52; *Sideboard*, cat. 32, **67**

Hine, Lewis, 219, 221, 242; *A Group of Nashville Newsies…*, cat. 180, **245**

Hodge, James, *Punch Ladle*, cat. 60, **95**

Hooks, Earl J., 306–7; *Celestial Body*, cat. 235, **320**

Houston, James B., 80, 190; *Bureau*, cat. 145, **192;** *Card Table*, cat. 144, **191**

Howard, Jim Ann, 338; *Appalachian Springboard*, cat. 255, **347**

Hyman, Sylvia, 339; *Crate of Stuff*, cat. 265, **357**

Ingerle, Rudolph, *October in the Smokies*, cat. 164, **217**

Jackson, Jed, 338; *C.E.O.*, cat. 256, **348**

Jar, cat. 87, **120**

Johnson, Amy Terrass, 126, 132; *Crazy Quilt*, cat. 94, **130**

Jolley, Richard, 340; *Polarity*, cat. 275, **367**

Jones, Shreve, and Brown, *Presentation Ewer*, cat. 73, **104–5**

Jordan, John, *Pair of Black and White Vases*, cat. 243, **328**

Kenny, Anderson, 339; *Hearth*, cat. 269, **361**

LaFever, Riley, *Figural Chicken Waterer*, cat. 89, **122**

Lancaster, Paul, 261–62; *Evening Forest*, cat. 201, **271**

Lea, Isaac, 42; *Geographical, Statistical, and Historical Map of Tennessee*, cat. 23, **48–49**

Lechman, Patricia, 306; *Folded Space*, cat. 229, **316**

Lee, Joe C., 260; *The Buckeye Family*, cat. 196, 258 detail, **266**

Lee, Paul Pak-hing, 339; *Untitled/Airplane Diptych*, cat. 263, **355**

Lee, Suta, 339; *Still Life—Table with Flowers*, cat. 266, **358**

Lutz, Ann Adelia Armstrong, 200; *Untitled*, cat. 155, **208**

Lyon, Danny, *Nashville, Tennessee, 1962, Sit-in…*, cat. 184, **248–49**

Lyons, Beauvais, 338–39; *Planche 144*, cat. 260, **352**

Manuel, *Lavender Wagon Wheel Suit*, cat. 246, **331**

Martin, Frank, *Teapot*, cat. 240, **325**

Martin, Isaac, *Punch Ladle*, cat. 55, **94**

Maryville Woolen Mills, 132; *Coverlet*, cat. 103, **136**

McBride, Joseph, 190; *Bureau*, cat. 25, **59**

McCowat, Thomas, *Punch Ladle*, cat. 61, **96**

McElroy, Matthew Lile, 80–81; *Jackson Press*, cat. 38, **72**

McGee, Carrie, 340; *Small Ladder*, cat. 272, **364**

Meade Brothers, *Samuel Houston*, cat. 130, **177**

Mims, Puryear, 286, 288 n8; *Hertha*, cat. 171, **229**

Moore, Charles, 261; *Black Horse*, cat. 200, **270**

Morrell, Jim, *Desk and Bookcase*, cat. 45, **79**

Morse, Jedidiah, 42; *A Map of the Tennessee Government*, cat. 20, **45**

Murphy, Marilyn, 338; *Cane Fire*, cat. 259, **351**

Myatt, Greely, 339–40; *Storm*, cat. 271, **363**

Myrllen, *Coat*, cat. 225, **312**

Native American art, 19–21; *Bird Effigy Pipe*, cat. 4, **25;** *Bottle with Appliqué Heads*, cat. 11, **31;** *Dog Effigy Bottle*, cat. 8, **28;** *Engraved Shell Mask*, 18 detail, cat. 7, **27;** *Fluted Spear Point*, 20, cat. 1, **22;** *Gorget (Pendant)*, 21, cat. 5, **26;** *Kneeling Male Figure*, 3, cat. 10, **30;** *Mace*, cat. 12, **32;** *Owl Effigy Bottle*, cat. 9, **29;** *Pop-eyed Birdstone*, cat. 3, **24;** *River Cane Double-Weave Basket with Lid*, cat. 13, **33;** *Shell Necklace*, 21, cat. 6, **27;** *Spear-Thrower Weight*, cat. 2, **23**

Newman, Robert Loftin, 142, 200; *Mother and Child*, cat. 153, **206**

Newman, Willie Betty, 201; *Still Life: Pewter Pitcher and Cherries*, cat. 160, **213**

Nutt, Craig, 307; *Radish Salad Bowl*, cat. 244, 304 detail, **329**

Orr, Arthur, 287; *Untitled*, cat. 220, **298–99**
Outlaw, Adrienne, 340; *Construct*, cat. 273, **365**

painting, unattributed, *Belmont*, 142, cat. 119, **156;**
 J. K. Polk Stump Speaking, 166 *detail*, 169, cat. 132,
 179; *The Market at Nashville*, cat. 179, **244;**
 Skirmish on Lookout Mountain, 171, cat. 143, **189**
Pardon, Earl, 306; *Bracelet #1379*, cat. 231, **318;**
 Brooch #1208, cat. 233, **318;** *Brooch #1525*,
 cat. 232, **318**
Peabody, John, *Presentation Urn*, cat. 134, **181**
Perkins, Philip, 285–86, 288 n4; *Untitled*,
 cat. 214, **292**
Pettrich, Ferdinand, 167–68; *Bust of Andrew
 Jackson*, cat. 127, **174**
Plumbe, John Jr., 170; *James K. Polk and His
 Cabinet*, cat. 137, **184**
Poynor, Richard "Dick," 56, 90; *High Chair*,
 cat. 52, **91;** *Side Chair*, cat. 53, **91**
Prater, Mary Haley, *Basket*, cat. 222, **309**

Quarles, James or John B., *Desk*, cat. 30, **65**

Ramsey, Bets, 306; *Diverse Opinions*, cat. 230, **317**
Ransom, Alexander, 170; *Near Fort Donelson*,
 cat. 142, **188**
Raworth, Edward, *Punch Ladle*, cat. 57, **94**
Reed, Osmon, *Presentation Ewer*, 169; cat. 133, **180**
Reed, Veda, 338; *Mammatus II*, cat. 254, **346**
Richmond, Barton, 190; *Beaker*, cat. 67, **98;** *Punch
 Ladle*, cat. 58, **95**
Riddle, Bo, *Cowboy Boots*, cat. 249, **334–35**
Rifle, cat. 16, **38–39**
Rose, John, 56–57; *Secretary*, cat. 40, 54 *detail*, **74**
Rush, Tommie, 307; *Botanical Bowl*, cat. 241, **326**
Ryman, Robert, 287; *Untitled*, cat. 219, **297**

Saftel, Andrew, 337–38, 340; *Greenhouse*, cat. 252,
 343; *What's All That Stuff…*, cat. 251, **342**
Sawyer, William, 220–21; *Kelly's Barber Shop*,
 cat. 178, **236–37**
Shackelford, William Stamms, 142; *James O.
 Shackelford, Jr.*, cat. 110, **147**
Shahn, Ben, 221, 238–39, 242, 286; *Peabody*, 240;
 Untitled (Murfreesboro, Tennessee), cat. 182, **247**
Shaver, Samuel M., 142; *Double Portrait*, cat. 109,
 146
Sho-Bud Guitars (Harold "Shot" Jackson and
 Buddy Emmons), *Pedal Steel Guitar*, cat. 248,
 333
Shop Springs Carver, The, *Canes*, cats. 193 &
 194, **265**

silver, unattributed, *Pair of Silver Candelabra
 (Jackson's Candelabra)*, 168, cat. 128, **175;**
 Pitcher, cat. 78, **109;** *Spanish milled dollar*, 93;
 Tea Service, cat. 74, **106**
Sinor, Yone, 338; *Diana*, cat. 253, **344–45**
Smith, Daniel, 42; *A Map of the Tennessee
 Government…*, cat. 21, **46;** *Tomahawk Owned
 by Daniel Smith*, cat. 22, **47**
Smith, John M., *Punch Ladle*, cat. 62, **96**
Spencer, Jack, 243; *Man with Fish*, cat. 191,
 256–57
Stephen, Walter B., 111; *Vase*, cat. 91, **124–25**
Stevens, Walter Hollis, 287, 288 n10; *Abstract
 Painting*, cat. 216, **294**
Stevens, Will Henry, 285–86; *Gray Woodland*,
 cat. 210, **289**
Stewart, Charles Pinkney, 200; *Four Men on a
 Corner*, cat. 152, **205**
Stockdale, John, 42; *A Map of the Tennessee
 Government*, cat. 20, **45**
Stokes, John, *Wedding in the Big Smokies*, 198 *detail*,
 cat. 150, **203**
Storelli, Félix Marie Ferdinand, *Souvenir de Tokouo*,
 cat. 107, **144**
Strickland, William, 52; *Model of the Tennessee
 State Capitol Tower*, cat. 139, **186**
Stringfield, Clarence, 261; *The Modern Girl in
 Modern Dress*, cat. 197, **267**
Stuart, C., 169; *David Crockett*, cat. 131, **178**

Timberlake, Henry, 42; *Draught of the Cherokee
 Country*, cat. 19, **44**
Trentham, Mary Ann Walker and Nancy Jane,
 126; *Nanny's Quilt*, cat. 92, **128**
Troye, Edward, 141; *Gamma*, cat. 122, **159**

Wagner, James E., *Tennessee State Capitol from
 Morgan Park*, cat. 121, 2 *detail*, **158**
Weber, Timothy, *Introspective*, cat. 238, **323**
Weston, Edward, *Stone Sculpture, William Edmond-
 son*, cat. 209, **283;** *William Edmondson, Sculptor*,
 cat. 208, **282**
Whitfield, Eunice, 126; *Crazy Quilt*, cat. 95, **131**
Wickham, Enoch Tanner "E. T.," 262–63;
 Sergeant York, cat. 204, **274–75**
Wiggers, Ernest, *Punch Ladle*, cat. 63, **96**
Wildner, Werner, 220–21; *Man with Umbrella*,
 cat. 174, **232;** *Nude with Rose*, cat. 175, **233**
Wiley, Anna Catherine, 201; *Mother and Daughter
 in Garden*, cat. 161, **214**
Winchester, William Jr., 86–87, 190; *China Press*,
 cat. 50, **88;** *Looking Glass*, cat. 51, **89**

Withers, Ernest C., *The Two Kings, Elvis Presley and
 B. B. King…*, cat. 187, **252**
Wolfe, John, *Safe*, cat. 43, **77**
Wolfe, Meyer, 221; *The Conversation*, 219, cat. 166,
 224
Wood, Joseph, *Portrait of Sam Houston*, 168,
 cat. 129, **176**
Wood, Thomas Waterman, 141–42, 170; *Portrait
 of Della Callender*, cat. 120, **157;** *Southern
 Cornfield…*, cat. 123, **160–61**
Wood, Trevle Haley, *Butterfly Basket*, cat. 224, **311**
Woodson, J. B., 261; *Standing Woman*, cat. 198,
 268
Wyant, Alexander Helwig, 199–200; *Tennessee*,
 cat. 149, 14 *detail*, **202**

Young, Jacob, *Tennessee Long Rifle*, cat. 15, **38–39**

Frist Center for the Visual Arts
Nashville, Tennessee

This book is published in conjunction with the exhibition *Art of Tennessee* (September 13, 2003–January 18, 2004), organized by the Frist Center for the Visual Arts.

The Frist Center gratefully acknowledges First Tennessee and its employees statewide as Exhibition Sponsor of *Art of Tennessee.*

Library of Congress Control Number: 2003103193
ISBN: 0-9725779-1-2 (cloth)
ISBN: 0-9725779-2-0 (paper)

Distributed by The University of Tennessee Press for the Frist Center for the Visual Arts.

Frontispiece: Attributed to James E. Wagner, *Tennessee State Capitol from Morgan Park*, ca. 1857–60, detail, cat. no. 121
Title page: Southeastern Native American, *Kneeling Male Figure*, 1300–1500 C.E., cat. no. 10

Copyedited by Fronia W. Simpson
Proofread by Laura Iwasaki
Designed by Jeff Wincapaw
Typeset by Jennifer Sugden
Photography by Bill LaFevor unless otherwise noted
Color separations by iocolor, Seattle
Produced by Marquand Books, Inc., Seattle
 www.marquand.com
Printed and bound by C&C Offset Printing Co., Ltd., China

Photography Credits

Cat. nos. 24, 28, 33, 42, 43, 79–85, 87–89, 92, 109, 155, 156, 203, 216, and 222: Charles Brooks

Cat. no. 6: Courtesy of the National Geographic Society; cat. no. 93: Courtesy of The Quilts of Tennessee; cat. no. 107: Courtesy of the New Orleans Museum of Art; cat. no. 131: David Nester; cat. nos. 136 and 137: Courtesy of the James K. Polk Memorial Association, Columbia, Tennessee; cat. no. 149: Photograph © 2003 The Metropolitan Museum of Art; cat. no. 165: © T. H. Benton and R. P. Benton Testamentary Trusts/Licensed by VAGA, New York, NY; cat. no. 168: © Beauford Delaney Estate; cat. nos. 172 and 173: © Carroll Cloar Estate, Patricia S. Cloar; cat. nos. 176 and 177: © Red Grooms; cat. no. 180: King Visual Technology, Fort Washington, Maryland; cat. no. 181: © Henri Cartier-Bresson/Magnum Photos; page 239: George Adams, courtesy of Fisk University Galleries, Nashville, Tennessee; cat. no. 182: © 2003 President and Fellows of Harvard College; cat. no. 184: © Danny Lyon, courtesy of Edwynn Houk Gallery; cat. no. 185: © Edward Clark, courtesy of The Arts Company; cat. no. 186: © The Grannis Archives, courtesy of The Arts Company; cat. no. 187: © Ernest C. Withers; cat. no. 188: © Michel Arnaud—from the book *Nashville: The Pilgrims of Guitar Town;* cat. no. 189: © 1989 Center for Creative Photography, Arizona Board of Regents; cat. no. 190: © Eggleston Artistic Trust; cat. no. 191: Courtesy of Cumberland Gallery; cat. no. 200: Photograph © Harlee Little 2003; cat. nos. 208 and 209: © 1981 Center for Creative Photography, Arizona Board of Regents; cat. no. 211: © *Ceremony at Dawn,* by Ted Faiers; cat. no. 219: Courtesy of the Artist and PaceWildenstein, New York, © 2003 Robert Ryman; cat. no. 229: Patricia Lechman; cat. nos. 231–33: Deloye Burrell, courtesy of Connell Gallery; cat. no. 237: Courtesy of the Southern Highlands Craft Guild; cat. no. 243: David Peters; cat. no. 244: John Lucas; cat. no. 245: Jerry Anthony; cat. no. 250: Ruth Grover; cat. no. 251: Gary Heatherly; cat. no. 252: Courtesy of the Lowe Gallery, Atlanta–Los Angeles; cat. no. 254: Courtesy of David Lusk Gallery, Memphis, Tennessee, and the artist; cat. no. 255: © Jim Ann Howard 2002; cat. no. 256: © Jed Jackson 2002; cat. no. 257: Reproduction courtesy of the Reid Family; cat. no. 261: © Robert Durham; cat. no. 262: © John Baeder 1988; cat. no. 263: © Paul Lee 2000; cat. no. 273: © Adrienne Outlaw 2003

Cat. nos. 1–5, 7–11, 13, 15, 17, 18, 22, 30, 37, 40, 112, 117, 118, 123–27, 129, 130, 133, 135, 138, 140–42, 148–50, 153, 154, 157–59, 161, 163, 164, 168, 169, 172, 181, 182, 184, 187, 190, 196, 199, 201, 205, 208–11, 215, and 221: courtesy of the owners

Cat. nos. 228, 234, 239–42, 258–60, 263, 267, 269, 271, 272, 275, and 276: courtesy of the artists